Japanese popular prints

from votive slips to playing cards

Rebecca Salter

A & C Black
London

Acknowledgements

I would like to express my heartfelt gratitude for the help and support of countless people and organisations throughout the world, without whom this book would not have been written. Their extraordinary generosity has made it possible.

Great-Britain Sasakawa Foundation

The publishers gratefully acknowledge the support of the Japan Foundation in the publication of this book.

First published in Great Britain in 2006

A & C Black Publishers Limited
38 Soho Square
London W1D 3HB
www.acblack.com

ISBN-10: 0-7136-6517-3
ISBN-13: 978-07136-6517-8

Copyright © 2006 Rebecca Salter

CIP Catalogue records for this book are available from the British Library and the U.S. Library of Congress.

Book and cover design:
Geoffrey Winston at WinstonWPA
Copy editor: Rebecca Harman
Project Manager: Susan Kelly
Editorial Assistant: Sophie Page

Printed in China

Front cover: *Fuda* (see fig. 93, p.98)

Back cover: Successful Actors Climb Mount Fuji *sugoroku* (detail of fig.185, p.171), courtesy of Edo-Tokyo Museum

Frontispiece: *Ichimatsu chiyogami* (see fig.211, p.195)

Picture credits

JAPAN

Kumon Kodomo Kenyūjo (Kumon Children's Research Institute), figs.6, 8, 30, 44, 51, 72, 76, 78, 129, 130, 145, 147, 150, 153, 166, 172, 176, 193, 204

Tokyo Metropolitan Central Library, Special Collections Room, figs.5, 13, 21, 27, 48, 54, 73, 86, 138, 146, 149 (right), 154, 156, 157, 167, 179, 181, 187, 189

Edo-Tokyo Museum, figs.4, 45, 55, 102, 106, 139, 140, 151, 168, 169, 173, 175, 180, 185, 186, 188, 190, 191, 192

Insatsu Hakubutsukan (Printing Museum), figs.31, 32, 33, 38, 39, 40, 42, 47, 49, 57, 58, 60, 70, 71, 127

Collection of Advertising Museum, Tokyo, figs.7, 11, 14, 20, 64, 66, 67, 68, 110, 112, 113, 116, 141

Toyama Shi Sato Hakubutsukan (Toyama Municipal Folk Museum), figs.23, 118, 119, 121, 122, 123, 124, 125, 126

From the website of the National Diet Library, Japan, figs.25, 34, 35, 43, 59, 94, 133

Doi Toshikazu Collection, figs.88, 103, 104, 105, 107, 108, 109

Kanagawa Prefectural Museum of Cultural History, figs.74, 75, 114, 137, 148, 149 (left)

Ōmuta City Miike Playing Card Memorial Museum, figs.195, 197, 198, 199, 200, 205

Japan Toy Museum, figs.46, 170, 194, 207

Nagoya Broadcasting Network Ltd.,Co., figs.22, 79, 80, 163

Kobe City Museum, figs.2, 12, 53

Paper Museum, Tokyo, figs.1, 28, 177

Pyonpyondō, Tokyo, figs.214, 215, 216

Gallery Sobi, Tokyo, figs.143, 144

Kawanabe Kyōsai Memorial Museum, figs.136, 152

Kidō Hiroko Collection, figs.18, 219

Naito Museum of Pharmaceutical Science and Industry, figs.87, 117

Courtesy of the National Museum of Japanese History, figs.131, 134

Tobacco and Salt Museum, Tokyo, figs.65, 171

Dasoku-an, fig.158

Fujisawa City Board of Education, fig.62

Isao Collection, fig.155

Isetatsu, Tokyo, fig.212

The Japan Ukiyoe Museum, fig.81

Kōzanji, Kyoto, fig.161

National Institue of Japanese Literature, fig.115

National Theatre of Japan, fig.132

Private collection, Japan, fig.142

Sugoroku Museum www.sugoroku.net, fig.182

Sumo Museum, fig.41

S. Watanabe Color Print Co., fig.159

Tokyo Matsuya Co. Ltd., fig.208

The Tsubouchi Memorial Theatre Museum, fig.174 (402-0236~8)

Yamashita Kazumasa Collection, fig.63

US

Loan courtesy of the Amarillo Museum of Art, Amarillo, Texas, Gift of Dr. & Mrs William T. Price, fig.17

Loan courtesy of Dr. & Mrs William T. Price, Amarillo, Texas figs.26, 69

American University: Dōchū Sugoroku, Charles Nelson Spinks Collection, American University, figs.183, 184

Irwin Weinberg Collection, figs.77, 220

Museum of Art, Rhode Island School of Design, Gift of Mrs Gustav Radeke, fig.178 (photography by Erik Gould)

Museum of Art, Rhode Island School of Design, Gift of George Pierce Metcalf, fig.196 (photography by Erik Gould)

Museum of Fine Arts, Springield, MA, Raymond A. Bidwell Collection, fig.164

EUROPE

Staatliche Museen zu Berlin-Preussischer Kulturbesitz Museum für Ostasiatische Kunst, figs.95 (Inv. Nr. 6280-04.597), 162 (Inv. Nr. 6200-04.1249), 165 (Inv. Nr. 6175-05.309)

Bristol City Museum and Art Gallery, figs.82, 85

© Copyright the Trustees of the British Museum, figs.36, 203

David Bannister, fig.52

Reproduction by permission of The Syndics of the Fitzwilliam Museum, Cambridge, fig.3

Rijksmuseum, Amersdam, fig.37

All other photographs courtesy of the author

Contents

6 Notes

8 Foreword

10 history, method, context

12 A brief history of printing in Japan

19 The woodblock technique

23 Edo society

28 The art of play

40 knowledge, news, views

42 Books

47 Calendars *koyomi*

51 Programmes and lists *banzuke* and *zukushi*

58 News-sheets *kawaraban* and *shinbun nishiki-e*

62 The art of travel – maps, guides and gazetteers

72 Advertising *hikifuda*

80 The outside world *Nagasaki-e*, *Yokohama-e* and *saya-e*

92 faith, fortune, general well-being

94 Votive slips and exchange slips *senjafuda* and *kōkanfuda*

108 Catfish prints *namazu-e*

114 Medicine prints *baiyaku-e*

120 Smallpox prints and measles prints *hōsō-e* and *hashika-e*

125 Obituary prints *shini-e*

130 leisure, pleasure, play

132 Playful prints and toy prints *asobi-e* and *omocha-e*

164 Board games *sugoroku*, *jūrokumusashi* and *menko*

183 Playing cards *karuta*

193 Decorative papers *karakami*, *chiyogami*, *pochibukuro* and *fūtō*

202 and finally …

204 Artists' outlines

205 Glossary

207 Selected bibliography

208 Index

Notes

Historical eras

Nara	710–794
Heian	794–1185
Kamakura	1185–1333
Muromachi	1333–1568
Azuchi Momoyama	1568–1600
Tokugawa (Edo)	1603–1868
Meiji	1868–1912
Taishō	1912–1926
Shōwa	1926–1989
Heisei	1989–

(Discrepancies can occur in the translation of the Japanese calendar to Western dates.)

This book predominantly covers the Tokugawa (commonly known as Edo) period (1603–1868) and the Meiji period (1868–1912).

Between 794 and 1868 the imperial capital of Japan was Kyoto. In 1603, after years of war, Ieyasu of the powerful Tokugawa family had himself proclaimed shogun, ultimately based in the eastern city of Edo. The emperor remained in Kyoto, but real power now rested with the shogun in Edo who effectively ran a military government. Answerable to him were regional daimyo (feudal lords) who controlled the 250 domains with some autonomy. The warrior class (samurai) were given social status, although not necessarily wealth, because of their role as protectors. Farmers, craftsmen and merchants ranked below them in the social hierarchy.

Between about 1639 and 1854 the shogunate had a policy of national seclusion (sakoku) and made strenuous attempts to close the country to the outside world in order to strengthen their authority. Travel abroad for Japanese people was forbidden and only the Dutch and Chinese were allowed access through Nagasaki port. The seclusion came to an end when American ships led by Commodore Matthew Perry appeared off the coast not far from Edo in 1853 demanding Japan open her borders. The years between Perry's arrival and the beginning of the Meiji era in 1868 were marked by crisis after crisis. Finally in January 1868 it was announced that rule by the emperor was restored (known as the Meiji Restoration). The emperor moved from Kyoto to Edo (now renamed Tokyo) and the imperial government took charge. The Meiji period saw a rapid move towards westernisation, commonly known as *bunmei kaika* (civilisation and enlightenment).

Language

Japanese language uses three alphabets:

1 *kanji* = Sino-Japanese characters (reasonable literacy requires knowledge of 1800). *Kanji* are used to write the main concepts of a sentence.
2 *hiragana* = A 48-letter phonetic syllabary. Used for grammatical purposes and can be used for writing in place of *kanji* so that more adults (and children) are able to read it.
3 *katakana* = A 48-letter phonetic syllabary now mostly used to write words from other languages in Japanese.

Transliteration

Macrons have been added to long vowels except for Japanese words now commonly used in English.

Japanese words are italicised, except for those (eg sumo, ukiyo-e) which have become Anglicised.

Japanese names appear in Japanese order, family name first, followed by given name.

Artists used a variety of names that changed frequently during their career. For simplicity's sake the name by which they are most commonly known is used throughout.

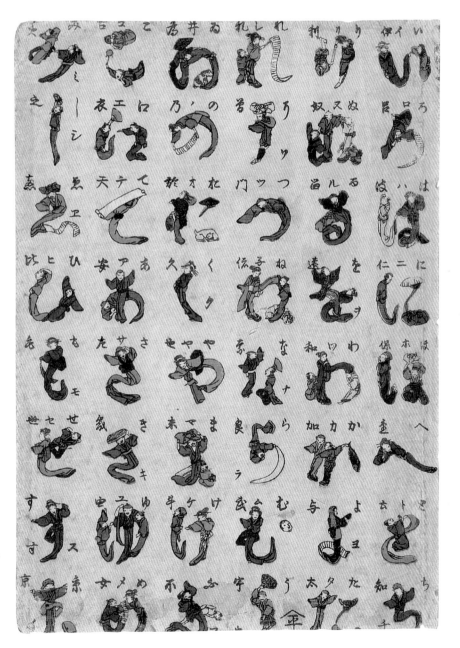

fig.1

Iroha alphabet in human form

Jintai iroha

Anon

1830–44

This print is a witty rendering of the *hiragana* phonetic alphabet with each letter in human form – some struggling valiantly with rolls of text. The characters are laid out in what is called the *iroha* (basic ABC) arrangement which forms a Buddhist poem on the transitory nature of life. Reading downwards from the top right it begins *i-ro-ha-ni-ho-he-to-chi-ri-nu-ru-o* (colours are fragrant but they soon fade). The sound of each letter in all 3 alphabets is given above the letter form. For a Japanese child embarking on remembering the basic alphabet, such prints must have been a wonderful way to learn.

The same *iroha* alphabetical order forms the basis of many card games (see fig.198, p.186 and fig.204, pp.190–1).

Foreword

I am approaching the subject of this book not as an academic expert in Japanese woodblock prints but as an artist with a love and knowledge of the technique in all its applications and guises. Connoisseurs of Japanese print are familiar with the so-called Golden Age of woodblock in the late 18th century and the work of such masters as Utamaro, Sharaku and the later talents of Hokusai and Hiroshige. I would hesitate to claim that the eclectic mix of prints introduced in this book equals the finest works of the Golden Age in terms of artistic merit or technical prowess, but I do feel that they reveal fascinating cultural and historical connections that extend into many unexpected areas of Japanese tradition. Above all else though, they exemplify the visual playfulness, curiosity and sophistication characteristic of the Edo period (1603–1868). This acute understanding of the power of the image, the appetite for it, and the infinite possibilities offered by a common visual language, were indulged during the reclusive Edo era. It was also these strengths that helped to make the process of re-opening to the outside world and the cultural shifts involved more bearable during the upheavals of the late 19th century.

The Western view of Japanese woodblock is very much coloured by our initial contact, which was primarily through the single sheet print (*ichimai-e*). This form grew out of Japan's already rich print tradition largely developed through books, often illustrated. Although visually very sophisticated, illustrated books are not as attractive or as accessible to a Western audience unable to read them, so they have been largely overlooked. The prints I have been researching would not have been valued as 'high art' and their target audiences, often women and children, would likewise not have been considered of high social status. This has had implications for the survival of the objects themselves. Single sheet prints, valued abroad, left Japan in huge numbers and thus survived destruction by earthquake, fire and war. The essentially ephemeral objects I am looking at here were not so fortunate. As a result,

relatively few remain even though they must have been produced in sufficient quantities to cover production costs. They may be modest in terms of production and target audience, but these objects have the ability to shed light on woodblock's social role as a tool for education and dissemination of knowledge and information, religious practice, cultural cohesion and above all else as a source of fun and amusement for both adults and children.

The heroes of this story are the carvers and printers of the woodblock world and they remain largely unacknowledged. As E F Strange says in his 1931 publication, *Japanese Colour Prints*,[1] 'These men were, then, essentially of the people. They made for a living what it best paid them to make: and this simple fact is worth keeping in mind in view of the glamour which certain European critics, dazzled by their amazing and (from our point of view) unaccountable skill, have endeavoured to throw over them'. We have become familiar with the names of the artists and some of the publishers responsible for bringing prints to the market, but the names of the craftsmen are rarely known. Their extraordinary technical skill has never been in doubt. When the prints first appeared outside Japan, the subject matter and composition were startlingly fresh and unfamiliar, but the technique too was considered extraordinary. For the inhabitants of downtown Edo (now Tokyo), a visit to the local carver or printer was not unlike a visit to a copy bureau now. Between them the carver and printer held the skills that were the sole means of mass reproduction available at the time. These were skills that could not only produce objects of desire and delight, but potentially of political and hence social importance too. The ruling shogunate kept an ever-watchful eye on the world of print. Woodblock may have skilfully reflected the playful life and times of the urbanite, but it could never claim to have become a real vehicle for social change by reflecting the harsh lot of the rural peasant.

Many of the objects I examine here were produced in the late

1 Edward F Strange (1931), *Japanese Colour Prints*,
 Victoria and Albert Museum, London, p.131–132.

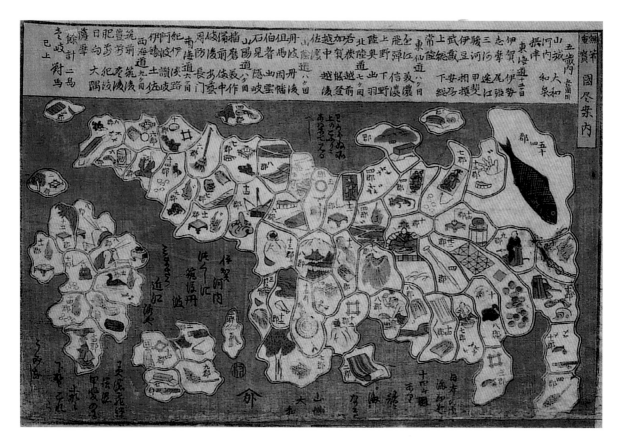

Edo and early Meiji periods, towards the end of woodblock's long supremacy. These modest prints became alternatives to the production of the single sheet print in an attempt to prolong the craftsmen's livelihood a little longer. Finally, woodblock succumbed to a combination of the decline in the traditional domestic context for the output and the introduction of more efficient and less labour intensive mechanical methods of printing from the West. It was no contest and woodblock lost its place as the method of mass reproduction. Woodblock clings on today in a niche role as a producer of souvenirs, reproducer of paintings or a medium for individual artists. In this book, as a devotee of the technique, I would like to highlight some of the curious delights of woodblock's twilight years and at least give the artists and craftsmen a belated but decent send off. I hope the diverse objects I have assembled will bear witness to their visual flair and technical prowess, and illustrate the role played by a modest printing method in the extraordinarily sophisticated development of one particular country's culture and visual language.

Rebecca Salter, 2006

fig. 2

A Rebus Guide to the Regions
Muhitsu chōhō kuni zukushi annai
Anon
1830–44

With a broad appeal, even for the illiterate, this map of Japan substitutes pictures for words to identify each region.

In the centre of the large island (Honshū) the mountain (*yama*) combines with castle (*shiro*) to make Yamashiro, the ancient name for the Kyoto area. The enormous fish (top right) is a Japanese bluefish (*mutsu*) representing an area of the same name, now part of Aomori prefecture. Far left, the lower tip of Kyushu island shows half a scabbard (*sa* of *saya*) and a wife (*tsuma*) to make Satsuma.

This map is a classic *hanji-e* (rebus print, see p.146) and would have been accessible even to those unable to read.

history
method
context

fig. 3

Block Cutting and Printing *surimono*
Katsushika Hokusai
c.1825

This exquisitely printed *surimono* (see p. 48) shows the poet Nanzan (sometimes thought to be the *surimono* artist Yashima Gakutei) engaged in carving an intricate text block with a large knife. In the foreground, a rather elegantly dressed lady holds her sleeves out of the way as she prints. The prints about to be printed are in a pile in front of her, the finished ones to her left. The designs on her kimono are highlighted with silver and embossing – a technique also used to define the edges of the paper in the pile and the wood grain in the box on the table next to Nanzan.

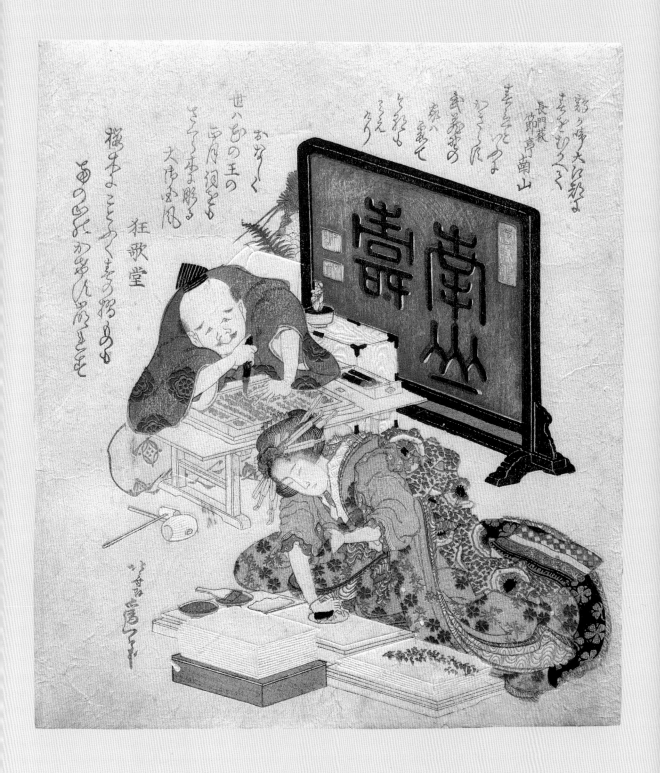

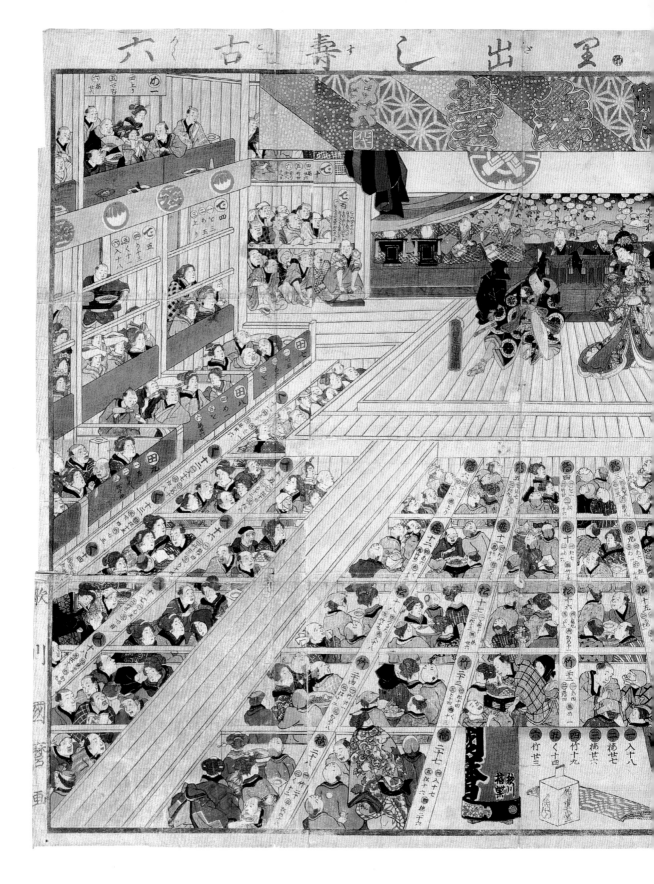

A brief history of printing in Japan

In order to fully appreciate the origins and complexities of the objects introduced in this book, a brief history of the technique which made them all possible is important. Woodblock printing is not a technique unique to Japan, but it is arguably the prints of this country which have given it the highest profile worldwide. The oriental method of woodblock is distinguished by its use of water-based colours and no press. The invention of paper (c. AD 105) and this method of woodblock both originate in China, and knowledge of the techniques is thought to have found its way to Japan in the wake of the spread of

fig. 4

Theatre scene *sugoroku*
Shinpan waridashi sugoroku
Utagawa Kunimaro and Utagawa Kunisada
1860

This print is a stunning example of not only a theatrical *sugoroku* (board game, see p.164) but also the genre of *uki-e* (perspective prints). The receding lines emphasised by the floorboards and boxes give an impression of perspective, but owe more to dynamism than accuracy. There are over 300 people shown in the audience for a performance of the journey scene from *Yoshitsune Senbonzakura* (*The 1000 Cherry Trees of Yoshitsune*). Extraordinary attention to detail is shown in the expressive faces and hands, and in the ways the richer and poorer clientele are portrayed. The pit area (*doma*) was cheaper than the gallery seats (*sajiki*). The *hanamichi* (flower path) extends (left) into the audience, many of whom are paying little attention to the play and instead are tucking into lavish meals. The striped curtain traditionally used in kabuki (*jōshikimaku*) (see fig. 211, p.195) can be seen gathered up to the left of the stage.

It is a *tobi* (jumping) *sugoroku* format (see p.164) with players starting lower centre and leaping from box to box as they make their way to the goal on stage. The actors are noted as being the work of Utagawa Kunisada.

² SHINTO

Shinto is Japan's indigenous religion with practice based around sacred time and space and a panoply of *kami* (divinities) which oversee human activity. Purification rituals, offerings and festivals (*matsuri*) all form part of Shinto. The most important Shinto shrine and popular pilgrimage destination is at Ise in Mie prefecture and comprises an inner and outer sanctuary.

In the early years of Buddhism in Japan, the two religions became intertwined only to move apart during the Edo period when Shinto began to look again at its roots. By the Second World War, Shinto had become tainted with nationalism which led to its disestablishment after the war.

Buddhism. The simple black and white reproduction of Buddhist scriptures was woodblock's initial role. With the arrival of Buddhism, Japan's indigenous belief, Shinto², was joined by a religion that came armed with a simple but powerful tool of dissemination – woodblock. It maintained a didactic and propagandising element to its character until its dying days in the face of mechanised Western print production methods. Its major early role was to spread a foreign faith (Buddhism). One of its last roles was, through words and pictures, to ease the introduction of Western knowledge and customs.

Although the origins of woodblock lie in China, the earliest known surviving examples are Japanese. In 770 Empress Shōtoku ordered the production of printed Chinese texts, each to be placed in a miniature pagoda *Hyakumantō* (One million pagodas). By 987, the expression *surihon* (printed book) is recorded in Japan and is evidence of at least knowledge, if not production, of the printed book. Over the centuries, this embryonic world of print diversified to encompass books, single sheet prints and printed decorated papers. But the engine of growth was still provided by the demands of religious practice.

The spread of Buddhism within Japan and its fragmentation into different sects fuelled the need for print. In a country that was still largely illiterate there was an appetite for simple and cheap devotional pictures. These consisted of not much more than a printed black outline image, sometimes hand-coloured in red, and were kept as devotional objects or pasted on the doors of houses as amulets. Votive slips (*senjafuda*, see p. 94) still produced today have roots in this earliest incarnation of woodblock. Although by no means considered objects of monetary value, these early prints attest to the technical ability of the block carvers and printers. This reservoir of skill later enabled the rise of the secular strand of Japanese woodblock which is commonly called *ukiyo-e* (literally 'pictures of the floating world'). Confusingly, although avowedly secular in this context, the term actually derives from a Buddhist expression. The Buddhist origin of the word *ukiyo* refers to the transient and essentially sorrowful

nature of ordinary existence. As used in a secular context, especially with reference to the entertainment world, *uki* meaning 'sorrow' was replaced with the *kanji* with the same sound meaning 'floating', and came to refer to the fleeting pleasures of the brothel or theatre – in short, living for the moment. Ukiyo-e (e means 'picture') is now commonly used for prints but can also refer to paintings with the familiar subject matter of the world of pleasure.

The increasingly sophisticated skills of the carvers and printers were initially harnessed to produce illustrated books, mostly in black and white and occasionally hand-coloured. Before the 1740s, hand-colouring was the only option with the inevitable limits on output. Printed multicolour work first appeared in Japan around 1765. But before that significant development, the book illustration had to, metaphorically, escape from its covers and establish an identity as a single sheet print. One of the first major artists to become known in the genre was Hishikawa Moronobu (c.1618–94), a textile designer from what is now Chiba prefecture, renowned particularly for *tan-e* (outline prints with *tan* [red lead] applied by hand). Another *tan-e* artist, Okumura Masanobu (c.1684–1764), was credited with the innovation of *urushi-e* (lacquer prints) and *hashira-e* (long narrow prints) designed to fit the dimensions of the pillars in a Japanese house. He also made prints called *uki-e* (perspective prints) which experimented with Western-style perspective based on a central vanishing point (see fig. 4, pp.12–13). These prints often portrayed crowded kabuki theatres or later sumo tournaments, both favourite leisure interests of the print-buying classes. The imported perspective technique added to the visual excitement of the prints and was in contrast to the traditionally employed oriental styles of perspective.

The polychrome printing technique which enabled the flowering of ukiyo-e is generally accepted to have appeared around 1765–66. It was first seen in a New Year's calendar produced for a group of Edo dilettanti. The vagaries of the lunar calendar, used in both China and Japan, meant that official calendars

(koyomi) had to be produced to confirm the order of the long and short months (see p. 47). Some privately produced versions 'concealed' the information about the months within a design and became favourite commissioned items of these dilettante groups. In both China and Japan, privately produced prints by enthusiastic amateurs contributed to the growth of colour printing. As the commissioned woodblocks were a reflection of the social standing of the commissioner, the finished prints made for these groups boast what would now be called 'high production values'. The devotion of the amateur to woodblock can still be seen in Japan today in the groups of senjafuda (votive slips) connoisseurs.

An ingenious, yet simple, technical invention made these multicoloured masterpieces possible. The problem with colour printing is a very basic one; as each colour is added to the print the registration must be perfect so that the colours sit accurately within the thin black outline. Poor registration leaves the finished print looking colourful but perhaps a little rustic. The simple invention of carved registration marks (kentō) added to the block allowed the paper to be placed exactly on each block in turn and made the sophisticated multicolour prints feasible. The correct term for these complex multicoloured prints is nishiki-e or brocade pictures.

An early star of nishiki-e, Suzuki Harunobu (1724–70) emerged from an earlier career designing for the dilettanti. He recognised the design possibilities of the single sheet print and, by harnessing the skills of the craftsmen, Harunobu established the single sheet print as a medium in its own right. It stood alone, as neither a pale imitation of painting (largely the preserve of the upper classes) nor as glorified book illustration. The style of Harunobu's prints is elegant and slightly dreamy, and even though his subjects inhabited the harsh world of the pleasure quarters, he invested them with a simple elegance which referred back to Japan's more courtly indigenous style of painting, Yamato-e. These gentle references back to the refined traditions of Kyoto offer a telling contrast to the brasher mores of urban Edo society.

The artistic (but not necessarily technical) golden age of Japanese woodblock in the late 18th and early 19th centuries covers the careers of many great artists. Apart from the artistry and technical innovation which played such a large part, the growing wealth of the inhabitants of Edo and the entrepreneurial activities of publishers also contributed to the boom. Two of the most influential artists were Kitagawa Utamaro (1753–1806) and Tōshūsai Sharaku and between them they have bequeathed us a revealing record of the two most important of Edo worlds – the pleasure quarters, especially Yoshiwara[3] and kabuki theatre[4]. Utamaro is primarily known for his portraits of women which, unusually for the time, attempt to explore the psychology and individual character of the person, rather than merely offering them as a stereotype.

Practically nothing is known about the life or very brief career of Sharaku, apart from the

[3] YOSHIWARA

Separated from its surroundings by walls and a moat, Yoshiwara was the most famous of the government's licensed centres for prostitution. Founded in 1617 it grew to contain over 200 establishments and as many as 5000 inhabitants. Laid out as a grid, the streets were planted with willows; a symbol of 'entertainment quarters' adopted from China. The system within Yoshiwara was highly complex and stratified and a variety of entertainment was offered. Geisha were professional entertainers whose role did not necessarily extend to 'special favours'. Originally the preserve of the warrior classes, monied merchants too became patrons. There are many stories of financial ruin brought about by the cost of trying to redeem a Yoshiwara denizen. Processions of the high-ranked licensed courtesans (oiran) through the streets became a popular attraction.

[4] KABUKI THEATRE

Kabuki's origins lie in Kyoto with an all female troupe of performers in the early 17th century putting on a type of variety show which was considered too risqué by the shogunate. By the early 18th century kabuki had matured into real theatre and men had taken over both male and female roles. Kabuki became an extravaganza of acting, music and dance with lavish costumes and complex (often moving) sets. Acting dynasties developed; one of the most influential in Edo began with Ichikawa Danjūrō I (1660–1704) who developed the aragoto (rough) style of acting, perfect for bold, macho characters. This style became synonymous with Edo kabuki.

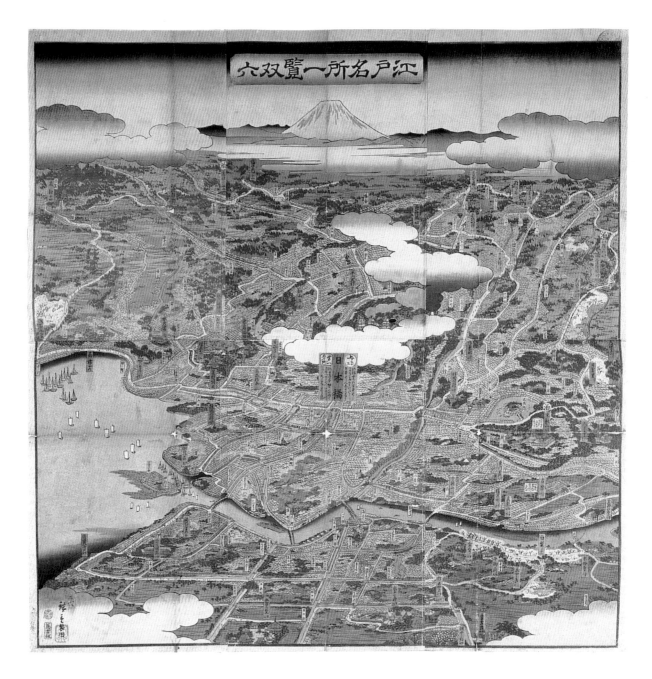

fig. 5

Famous Views of Edo *sugoroku*

Edo meisho ichiran sugoroku

Utagawa Hiroshige II

1859

This glorious bird's eye view of Edo is presided over by the majestic Mount
Fuji on the horizon. The departure and finishing point of the *sugoroku* game
is the same – Nihonbashi marked in a red cartouche in the centre just below
Edo castle. The players are treated to a trip round the famous and familiar
shrines, temples and seasonal beauty spots of Edo, all labelled in red. This
elevated view of Edo is of course a total fantasy, there was nowhere high
up enough to offer such a sweeping vista (see also fig. 53, p. 64).

fig. 6

The Mysterious Cat from the 53 Stages
Gojūsantsugi no uchi neko no kai
Utagawa Yoshifuji
1848–49

The popularity of travel and the *Tōkaidō* from Edo to Kyoto in particular led to the subject appearing in many fields. Based on a scene from the Edo period playwright Tsuruya Nanboku's 1825 play of horror and ghosts *Tōkaidō Yotsuya Kaidan*, this *yose-e* (see p.139) shows the spooky cat from Okazaki (a stop on the *Tōkaidō*).

The cat's face is made up from other cats, the bulging eyes from bells and the tongue from a cat's collar. The nose is the rear view of a crouching cat and the tongue is overprinted with grainy wood to give the rasping texture.

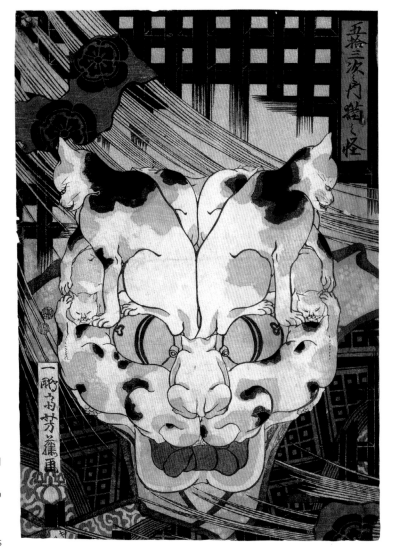

stunning full-head portraits of kabuki actors he left behind. The actors were the Hollywood superstars of their day and Sharaku's prints must have fulfilled every fan's desire for a compelling portrayal of their hero.

Beneath the cultural exuberance exemplified in the work of these two artists ran an undercurrent of government attempts to keep the lid on the world they were representing. The delights of the floating world were an effective diversion for the money and energies of the Edoite, but the excesses on occasion disturbed the more sober Confucian spirit of the ruling shogunate. Periodic introduction of restrictions and attempts to crack down led to house arrest for many artists including Utamaro. This cat and mouse game with the authorities did, of course, act as an artistic challenge to many; ambiguous references in prints could be understood and enjoyed by those in the know and would often pass unnoticed by the authorities.

As woodblock entered its final phase before facing the challenge of Japan reopening to the outside world, its focus of interest changed. Two masters of landscape came to the fore; Katsushika Hokusai (1760–1849) and Utagawa Hiroshige (1797–1858). Travel and

pilgrimage had become popular leisure activities for all classes and fuelled a desire for not only practical information through maps and guides but also single prints as souvenirs of famous places. Those unable to travel could enjoy a 'virtual' journey through Hiroshige's *53 Stages of the Tōkaidō* or Hokusai's *36 Views of Mount Fuji*. An exotic touch was added to many of the prints of this period through the import (possibly via China) of a much sought after new pigment – Prussian blue. The single brushed sweep of vibrant blue in the sky of these prints became a hallmark and no doubt a valuable sales point.

None of the artists mentioned above were still working during the later woodblock years

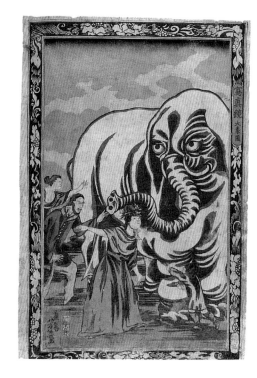

fig. 7
Photographic-style Portrait of a Giant Elephant
Shashin kagami ōzōzu
Utagawa Yoshiiku
c.1863

As well as being a charming example of the interest elephants aroused in late Edo, this print is an excellent example of the ad hoc addition of Western pictorial elements to woodblock before it finally gave way to mechanical printing. The blue sky is broken by scudding clouds and the elephant himself is rendered in chiaroscuro in a rather unconvincing way. European woodblock had used two or more blocks to create tonal shading since the 15th century. Even though this elephant was a popular attraction in Nishi Ryōgoku (in Edo) it seems likely that the print was produced before the artist had seen him. The whole print is surrounded in an ornate picture frame border. The title of this print marks the first use of the term 'shashin' for photograph.

covered in this book. A giant of the period, however, was Utagawa Kuniyoshi (1797–1861)[5]. Although best known for warrior prints which reflected the militaristic undercurrents of the time, he was also responsible for some of the most light-hearted and humorous works in this book. His followers in the Utagawa school, Utagawa Yoshitsuya (1822–66), Utagawa Yoshitora (c.1850s–70s), Utagawa Yoshiiku (1833–1904) and Utagawa Yoshifuji (1828–87) all worked in woodblock's difficult declining years. An efficient commercial printing and publishing industry had been built on the popular appetite for topical images reflecting the times. The audience which had sustained the print so effectively was declining, and Western printing methods were being introduced. But a living still had to be made by the remaining artists and craftsmen trained in the old technology. They were obliged to explore other avenues. Yoshifuji, for example, became well-known for *omocha-e* (toy prints), made very cheaply and sold to children. The standard of production was undeniably inferior to earlier prints, but this does not mean that these prints are not worthy of attention (see p.132). They may have been made as throwaway items (and indeed few remain) but they demonstrate a visual sophistication reminiscent of earlier prints and can reveal subtle insights into the forces working to change Japanese society from within and without.

[5] KUNIYOSHI

Born the son of a textile dyer, Kuniyoshi appears to have had a feel for design and colour from an early age. Together with Kunisada (1786–1864) he was one of the leading pupils of Toyokuni (1769–1825). He trained in actor and beauty prints and was apprenticed until 1814, when he set up on his own and took the name Kuniyoshi. His early years were a struggle and were marked by rivalry with his less-talented fellow pupil, Kunisada, who became the nominal head of the Utagawa school in 1844. Kuniyoshi was a superb draftsman and clearly had knowledge of Western pictorial traditions which he incorporated in his work. He is perhaps best known for his heroic warrior themes, but he also produced landscapes, beauties, theatrical scenes and *surimono* and, particularly relevant to this book, comical or playful prints. A combination of humour and subterfuge were vital in avoiding the attention of (and punishment by) the authorities.

Kuniyoshi was well-known amongst his contemporaries for being a great cat lover and around the 1840s they frequently appear in his prints, and he was shown in all his portraits with a cat. Kuniyoshi was also known as a kind master and trained many pupils of whom Yoshitora and Yoshikazu were perhaps the most able. He even trained his eldest daughter who worked under the name Yoshitori. In 1855, around the time of the great earthquake, he became ill and rather depressed making his last few years not particularly productive. He died of gout in April 1861.

The woodblock technique

Historical accounts of the familiar images of Japanese woodblock are illuminating but rarely give a real insight into the production of the prints themselves. The images and the world they portray are so enticing that it is easy to overlook the system which made them possible. The organisational drive behind the production of prints was undoubtedly the publisher. He needed flair, insight and entrepreneurial skills, and combined with the artist, carver and printer was responsible for bringing the prints to market. Perhaps the best known and most influential publisher of the Golden Age was Tsutaya Jūzaburō (1750–97)[6]. Of all the artists he published, perhaps his greatest find was the mysterious Sharaku. His identity remains unknown and in a working career which lasted less than a year all his prints were published by Tsutaya.

It is thought that in the late Edo period there were approximately 200 publishers in Edo alone. In order to keep this number in business, it is clear that there must have been at least 500 carvers to keep up with the flow of work at particularly busy times such as new year. Costings for the prints are not easy to estimate – they sold for about the price of a bowl of noodles – an amount within the reach of many of the inhabitants of downtown Edo. In the production of a print, the cost of the paper would have been a significant proportion of the total. It is suggested that the blocks and carving accounted for 10% of the cost and printing for 3%. This is an indication of the tight margins the skilled craftsmen were working to.

Production process

The publisher, with a keen eye for the vicissitudes of the market, would commission an ink and brush drawing from his artist of choice, which was then transferred to thin *mino* paper (*hanshita-e*) as the outline to be carved. A particular carver may have been chosen because he was skilled in that genre, interpreted that artist's work well or merely because he had no work at the time and was available. Carvers formed themselves into a guild, and only guild members could be used. A publisher without sufficient influence to engage the best carver was ridiculed within the woodblock world. Once the carver had been selected, he would paste the *hanshita-e* face down onto a block of prepared cherry wood. Cherry was the preferred wood because it was dense enough to sustain fine carved lines and was strong enough to survive the sometimes large editions printed. Before use, the wood was seasoned for 10–15 years to reduce shrinkage and movement, cut to size and then planed in three directions to give a steel-like surface. Blocks were an expensive part of the process, so both sides were used and frequently old blocks were planed and reused.

Once the *hanshita-e* had dried on the block, camellia oil was rubbed lightly onto the surface so that the brush line could be seen more clearly through the fibres of the paper. Using a sharp pointed knife (*hangitō*), the carver carefully cut either side of the line to produce an outline keyblock. As a brush line was often thicker than the finished carved line, part of the carver's role was to interpret the character of the artist's line and reflect it

[6] TSUTAYA JŪZABURŌ
One of the most important Edo period print publishers, Tsutaya Jūzaburō first opened his shop by the main gate of Yoshiwara but later moved to Nihonbashi. He was a gifted entrepreneur and man of great learning who steered a course between satisfying the customer's demand by riding the waves of popularity and staying on the right side of the authorities most of the time. He published such prominent artists as Utamaro, the mysterious Sharaku and Santō Kyōden (see p.73) as well as numerous prints, books and maps. At New Year, he would produce a range of new books (mostly light fiction) which could sell as many as 10,000 copies from the first printing.

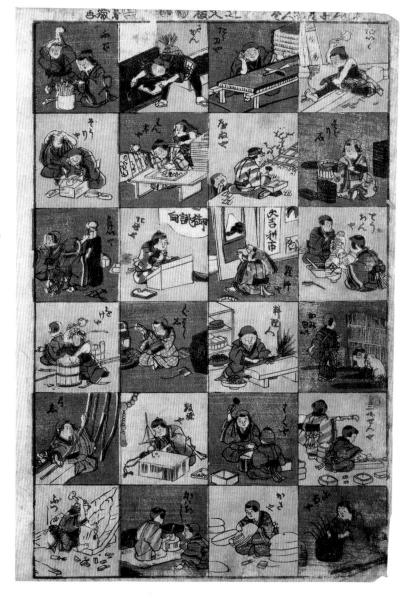

fig. 8

Traditional trades *zukushi*

Shinpan kodomo shokunin zukushi
Utagawa Yoshiiku
1852

This *zukushi* (see p.54) showing
children practising traditional crafts
and trades is a light-hearted
representation of the skills which
sustained Edo. Trades shown include
lantern-making, *tatami* mat making,
Buddhist carving and carpentry.

A child is shown as a woodblock
carver on the second row down
energetically carving a block with a
wide chisel and mallet.

in his carving. Carvers of such skill were highly
regarded, perhaps even more than the artist.
An apprenticeship of at least ten years was
required for fine carving, and some never
progressed beyond the lower rungs of the
profession. The most skilled were known as
atamabori (literally 'head carvers'). They
carved the most complex areas such as head,
hair, hands and especially feet, a traditional
erogenous zone! The next rank was *dobori*
(literally 'body carvers'). They could carve slightly
less complicated areas, leaving the easiest
parts for the least skilled or those in training.

The initial flowing cuts of the *hanshita-e* by

the *hangitō* were followed by the use of
gouges to clear around the line to be printed,
leaving it standing in relief. To enable the
individual colours of the print to be accurately
registered, registration marks (*kentō*) were
also carved onto the block. There are two
kentō on the long side of each block; an
L-shaped mark in the bottom right-hand
corner (*kagi kentō*) and a straight mark
(*hikitsuke*) just over halfway along the long
edge. Regardless of whether the finished print
was portrait or landscape format, it was
always printed with the long side towards the
printer. During printing, the paper was placed

fig. 9
Ishii Tōruo carving a block in the traditional way seated cross-legged at a low desk with a flask of water suspended in front of the light bulb to spread light more evenly.

in these carved indents, guaranteeing accurate colour registration. The keyblock and its attendant *kentō* act as the master for the production of the individual colour blocks which make up the print.

The carved keyblock and the *kentō* marks were inked with black *sumi* ink and printed onto thin *mino* paper. The artist would indicate the colours for the final print on one of the printed keyblocks (it is not thought that he actually coloured one in) and this would be used as the master. A keyblock with *kentō* printed on *mino* paper would again be pasted onto a block (face down) for each colour. If colours were far enough apart in the design, it was possible to use one block for several colours, thus reducing wood and carving costs. The colour blocks were carved through the pasted paper in the same way as the keyblock. When all the blocks were carved, they would be taken to the printer chosen to print the edition. The technical skill of printers varied and if blocks were reprinted for any reason they were not necessarily reprinted by the same workshop. This, together with deterioration of the blocks, accounts for some of the variation in quality seen in the finished prints.

Like carvers, printers too served a long apprenticeship but varied in skill at the end. The most skilled printed the multicolour prints well-known in the West. These prints demanded not only accurate registration but also the ability to print special effects such as *bokashi* (gradation often used in skies), or embossing (*karazuri*). The next level of printer

generally worked in one colour (black *sumi* ink) printing books or pictures. For illustrated books, registration still needed to be accurate otherwise the pages would not match when bound into the cover. The lowest grade of printer produced everyday items such as wrapping paper, decorative paper, *senjafuda* (votive slips) and children's toys or games. Although the method and materials were the same, the items were low cost everyday objects so the technical requirements were less exacting. The design qualities of these objects were often high, particularly in the dying years of woodblock when work was harder to find and the better artists and printers used their talents in this area to make ends meet.

For those familiar with Western relief printing, the Japanese version can appear deceptively simple. The colours used are pigments mixed with a binder and diluted with water. They are applied to the relief part of the block and brushed with a horse-hair brush, adding a little *nori* (rice paste) to act as a basic extender to flatten the colour. Very small amounts of colour are used, but produce a vibrant effect on the dampened paper as the pigment soaks into the fibrous paper through the pressure applied in printing. The papermakers also deserve to be mentioned for their contribution to this extraordinary art. Papermaking too came to Japan from China, but the Japanese further refined it by devising a technique called *nagashizuki* which produces robust long-fibred paper suitable for woodblock. As the printing process is water-based, the paper has to be strong, fibrous and able to absorb the colour without distortion. Any movement in either paper or blocks would throw out the registration system. Watching printers work, it is clear how susceptible the materials they use are to changes in the weather. The arrival of the rainy season, for example, can require tiny adjustments to the *kentō* while the printer works to allow for the effects of the humidity on the wood and the paper.

The edition of prints would be printed colour by colour, keeping them damp in between until the whole edition was finished. The printers generally worked from light colours to dark, but this rule could change

fig. 10
Matsuzaki Keizaburō seated at his traditional printing table. The pigments, baren and brushes are kept to his right, the prints to be printed in front and the completed prints to his left.

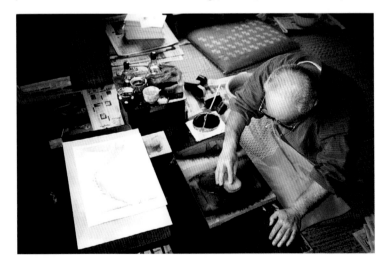

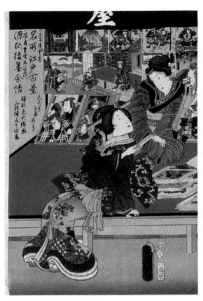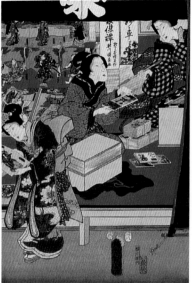

fig. 11

The Print Shop of Uoya Eikichi
Imayō mitate shinōkōshō – shōnin
Utagawa Toyokuni III (Kunisada)
1857

This print is from a series which casts beauties in the role of everyday people and their trades. In this case the setting is the typical late Edo print shop (*ezōshiya*) of Uoya Eikichi. Displayed at the back are actor prints, warrior prints, beauty prints as well as prints from Hiroshige's *100 Famous Views of Edo* (which were published by Uoya Eikichi). Illustrated books are displayed bound in piles and in the foreground a fresh delivery of prints has arrived sandwiched between wooden boards.

depending on the relative size of the colour area and the part of the print it represented. Adding special effects like *bokashi* (gradation) to a print would not only increase the time it took to complete the print, but would correspondingly increase the production costs. *Bokashi* areas are brushed by hand and need to be printed several times to ensure both richness of colour and smoothness of gradation. However, the inclusion of such extra touches, especially using the new imported Prussian blue would conceivably make the prints more saleable and therefore worth the extra effort. *Bokashi* does appear occasionally in cheaper printed articles such as wrapping paper or votive slips but not brushed as many times to such a high standard.

Oriental woodblock does not require a press, prints are hand burnished with a printing pad called a *baren*, which too has its roots in China and Korea but took on its current form in Japan. The *baren* itself is modest in size (about 15 cm [6 in.] in diameter) and appearance but, due to its complex construction, is very effective at transferring ink to paper through pressure. The core of the *baren*, made from a coil of hand-twisted split bamboo leaf, can be as much as 25 metres (27 yards) long and is immensely strong and resilient. The imprint of the twists on this coil can often be seen as streaks in the colour on the reverse of a print. The coil is supported by

a backing made from approximately 50 sheets of thin paper, cut into circles and laminated over a shaped former. The outside covering is made from a bamboo leaf which is kept lubricated with a little camellia oil so that it slips quickly and easily over the back of the print. Speed was of the essence for the printer; the materials he used and the way he worked all were aimed at keeping up his rate of production. Time really was money.

When the prints had been printed, dried and the margins trimmed to size, they were bundled together and despatched for sale. There was already an established method of distribution for books, and prints became part of that system. Some booksellers concentrated on academic works, others known as *ezōshiya* (print shop) specialised in illustrated light reading and prints. Piles of prints were stacked in the shop with new arrivals hung up for view, rather like washing on a line. Eye-catching new publications would be snapped up by eager buyers and taken home to be pasted onto screens, walls or kept in albums. Although thousands were probably produced of some of the more popular prints (exact edition sizes are unknown) the way they were displayed, together with the ravages of earthquake and fire, mean that relatively few survived undamaged.

Edo society

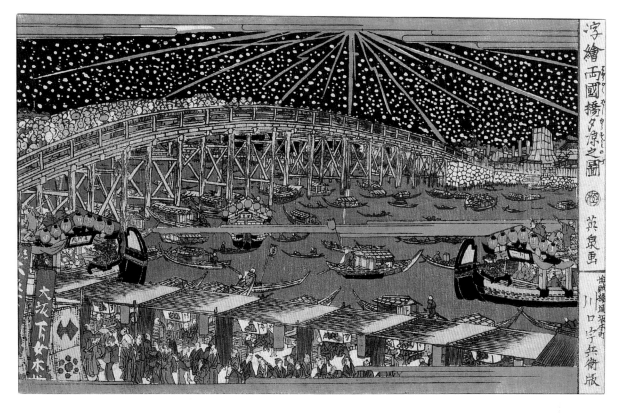

fig. 12

The Cool of a Summer Evening at Ryōgoku Bridge
Uki-e Ryōgokubashi yūsuzumi no zu
Keisai Eisen
late Edo period

One of the most popular sites in Edo and an escape from the oppressive summer heat was the relative cool of one of Edo's many riverbanks near Ryōgoku bridge. Between late May and late August, fireworks and messing about in pleasure boats transformed the bridges and rivers of Edo. Ryōgoku Bridge was at the centre of the Ryōgoku River Festival which was held on the 28th day of the 5th month to mark the opening of the summer season. The longest bridge in Japan, its elegantly curved outline became a symbol of Edo.

The backdrop for the spectacular development of woodblock in Japan was undoubtedly the city of Edo and its inhabitants. As Japan emerged from centuries of internal war, and with the implementation of Tokugawa rule, both the cultural and political focus of Japan moved east. The area around Kyoto and Osaka (Kamigata) in the west had always been regarded as the heart of the country and continued to house the emperor. Many of the cultural practices we now consider typically Japanese grew out of the society built around the court. In the first decade or so of the 17th century an insignificant village called Edo on the Musashino plain became the seat of the Tokugawa dynasty and of course today is

fig. 13

Comparison of 3 Cities – Kyoto, Osaka and Edo
Kyo no kidaore, Osaka no kuidaore, Edo no nomidaore
Utagawa Kunisada II
late Edo period

In the spirit of the cultural rivalry this witty print
represents the character of the inhabitants of each of the
three major cities – at the top – the elegance of Kyoto
(Kyoto people spend their money on clothes) – in the
centre the trading wealth of Osaka (Osaka people spend
their money on food) and at the bottom the newcomer,
Edo (Edo people spend their money on drinking).

known as the metropolis of Tokyo. The
emperor remained in Kyoto holding cultural
sway, the new dynasty of Tokugawa shoguns
in Edo held political sway. What is now
referred to as the Edo period saw a relatively
benign game of cultural oneupmanship
between the two centres, until the triumph
of Edo with the Meiji Restoration and the
emperor's move east. The end of the Edo
period and the beginning of Meiji (1868) not
only produced momentous political changes
but also saw Japan re-open to the outside
world after more than 250 years of relative
seclusion. The new ideas, information and
influences that came with that re-opening all
needed to be assimilated and absorbed so
that Japan could embark on its accelerated
journey to modernity. Woodblock, still the
means of mass reproduction, played a
significant role in this spread of information
and knowledge, often artfully disguised to
make it easier to absorb.

Visitors to contemporary Tokyo would find
it hard to envisage the original Edo. From a
small village, by the 18th century it had
developed to become the world's largest city
of over one million inhabitants. Out of a total
Japanese population of about 30 million, as
many as 7% lived urban lives. Edo was a city
of rivers, with 70% of the land, the high
areas (Yamanote), occupied by the samurai
classes. Temples and shrines covered 15%
and the common townspeople were corralled
into the downtown areas (*shitamachi*). This
geographical and social division is not unlike
London's West End and East End. The
population density in the downtown areas
was extraordinary, but it was this part of the
burgeoning city which provided the energy
behind the development of what has come
to be recognised as Edo culture. A true scion
of Edo (*Edokko*) was only recognised after
three generations of residence and as Edo
was essentially a new town, few would have
qualified in the early days. An *Edokko* is to
Tokyo what a Cockney is to London, and
arguably they have both been the subject
of over-romanticisation. The Cockney
should be born within the sound of Bow
bells, an *Edokko* should grow up able to
see the gargoyles on Edo castle roof. More

importantly for the fortunes of the city, he should be something of a spendthrift and, vital to the vibrant culture of Edo, display the spirit of *iki* (chic) at all times. This is the thread which weaves the creative story of woodblock, the quintessential Edo art. Also, in a city run by authoritarian bureaucrats, the other Edo quality of *hari* (spirit, strength of character) was fundamental to survival.

Whatever his strength of character and innate sense of fun, the *Edokko* still had to find a way to function within a feudal system based on a rigid Confucian model, with four main class divisions. Complex sumptuary laws (not always effectively enforced) regulated such details as the permitted kimono cloth for each class or the sumptuousness of wedding feasts. The warrior class (*shi*) held political power centrally through the Tokugawa dynasty, and regionally through the daimyo (feudal lords). But within this class there was a considerable range of fortune – or misfortune. Samurai had social status, were allowed to have surnames (unlike the common people), carry two swords and some maintained sizeable households. Others fell on hard times and were driven to borrow from the increasingly wealthy merchants. The social dilemmas in the samurai ranks – often mired in genteel poverty versus the lower status but wealth of the merchant – formed the basis of many a drama or novel. Lending to the samurai was a high risk business for merchants as they were not an easy group from whom to recover unpaid debts and many went bankrupt as a result.

Below the warriors were the farmers (*nō*), ranked relatively highly because they were responsible for growing the rice which was effectively currency. Their labours were seen as valuable to society but the reward was status rather than financial. Even though they had money, there were restrictions on the goods that could be sold in villages. Life was harsh, made up mostly of hard work, frugal living and strict local control. Occasional

chances to escape the daily grind under the pretence of pilgrimages for religious devotion were seized upon.

Craftsmen (*kō*) and merchants (*shō*) were effectively categorised together below farmers as *chōnin* (townspeople), although craftsmen ranked slightly higher as they had the skills to make weapons such as swords for the samurai. Merchants were accorded little rank or political status on the grounds that their primary occupation of moving goods around and selling them was considered essentially unproductive. In return for their socially lowly

In the late 17th century the ukiyo-e artist Torii Kiyonobu was responsible for making the link between the print, the fan and the celebrity. A round fan (*uchiwa*) produced with the portrait of an actor became a bestseller, and *uchiwa* became a favourite accessory for women (men carried folding fans). The glamorous customers in this print add the necessary endorsement and act as an advertisement for the shop's product. The fan design was printed on paper first (see fig. 28, p. 39) and then pasted onto a bamboo skeleton (see fig.141, pp.136–7).

Selling fans was a summer business, so in the autumn the shops sold tangerines and calendars in the winter.

position, however, they were left relatively free to make money, which some, but by no means all, did with spectacular success. The way the very wealthy chose to spend their money – on kabuki theatre, the pleasure quarters and generally having a good time – created the character of Edo culture which was so powerfully portrayed in woodblock. Historically the upper classes had the opportunity to see themselves and their culture reflected pictorially in paintings and screens, but the development of woodblock

as a cheap means of reproduction made this possible for the merchant classes. The appetite for reflection of the self, with the accompanying social and cultural reinforcement was a powerful force and, as reality TV has shown, remains undiminished today.

With Edo established as the new centre of power, the challenge for the Tokugawa rulers was to maintain the fragile peace throughout the regions. Japan had been torn apart for centuries by local conflicts and the newfound sense of stability was welcome. In 1634 the shogunate introduced a creative way of trying to ensure the loyalty of the regional daimyo called *sankin kōtai* (alternate attendance). Each daimyo was required to alternate residence between his home domain and Edo where he had to maintain a lavish household. While he was away from Edo, his family were effectively held hostage there, ensuring good behaviour and no hint of rebellion from far-flung regions. The other advantageous side-effect of the *sankin kōtai* system was (as far as the shogun was concerned) that this peripatetic existence consumed huge amounts of the daimyo's money, and also generated business opportunities in Edo, not least in the upkeep of their considerable residences. This system lasted until 1862 when it was relaxed and the vitality of Edo was dented by the exodus of families which ensued.

To make the whole system work, an efficient transport infrastructure developed with five major highways leading out of Edo. The regular processions of daimyo and their retinue, not to mention the occasional foreign mission, must have been an extraordinary sight, and as a result the art of travel entered the cultural lexicon of the period. Leisure travel, often thinly disguised as pilgrimage, became a fashionable activity, reflected in the sets of prints such as Hiroshige's *53 Stages of the Tōkaidō* which illustrate the experience both for those who travelled and those left behind. These are not the only woodblock prints to reflect the trend, *sugoroku* game boards based on the *Tōkaidō* were produced as were card games. *Senjafuda* (votive slips) designed to be used on pilgrimages following a circuit of temples were also part of this culture on the move. With metropolitan woodblock images spreading to the regions via this arterial system of roads, cultural communication in both directions during this period was swift. News of the latest trends in fashion and culture was disseminated countrywide remarkably quickly and as Edo's new migrants left the provinces, they brought their regional influences to Edo.

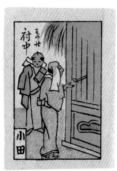
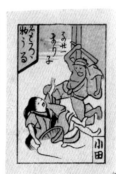

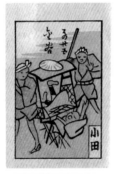
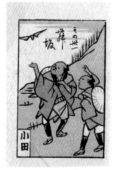
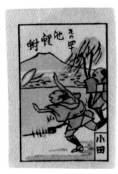
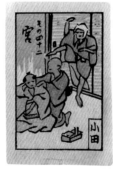
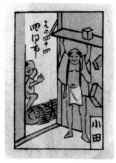

fig.15

Matchbox labels

early 20th century

These woodblock printed matchbox labels pick up on the theme of experiences on the road popularised by the book *Tōkaidōchū Hizakurige* by Jippensha Ikku (see p.16). Under the guise of pilgrimage or not, these men are clearly making the most of their freedom.

Matches were an early industrial import from the West, but the labels were initially produced in woodblock using Japanese themes. Some imitated the appearance of engraved western labels.

JAPANESE POPULAR PRINTS

Perhaps the most extraordinary feature of Edo life was the gender imbalance; men outnumbered women two to one and had generally come to the city from elsewhere. The boom-like development of Edo which pulled in workers from all over the country to satisfy demands for builders, craftsmen, shopkeepers and ordinary labourers created this imbalance. The lot of the poorest workers, living several to a room in a back street hovel was unenviable and surely far-removed from the glitter of the entertainment areas portrayed in the prints. In reality only the wealthiest of merchants could truly afford to indulge an appetite for profligate spending and play, and there were numerous examples of families brought to ruin through excess. The majority of Edo's inhabitants would have experienced the excitement of kabuki or the Yoshiwara vicariously through the medium of print. This indirect experience contributed to a prevailing sense of otherworldliness which served to disguise the harsh realities for those actually living and working in the pleasure quarters.

Although to some extent the government turned a blind eye to this brash mercantile culture, from time to time it would introduce and attempt to apply sumptuary laws to try and rein in excesses and remind the merchants of their place. Getting round these restrictions with disguised or covert displays of wealth became an essential characteristic of Edo chic. Restrictions on the cloth that different classes were allowed to use for their kimono, for example, led to the production of some impressively decorated (but out of sight) linings!

Early Edo was, to some extent, a work in progress. It did not have the cultural confidence of Kyoto derived from centuries of influence and it was not yet fully itself. As a city of migrants, initially the common reference points would have been back to the courtly traditions of the old capital, Kyoto. As the Edo period progressed, however, and the city established its own identity, the links back to the ancient capital weakened, although even today there is still an undercurrent of rivalry. The pace of development and the needs of the growing population pulled goods and services in from all over the country. Different vocational groups migrated from various parts of the country and settled in enclaves distinguished by occupation. One of the most influential enterprises in terms of how business practices developed was a dry goods store called Echigoya, founded by a man from Ise, a province known for its traders. His innovation was to trade in cash rather than using the traditional 'trusted customer' credit-style trading. With a growing and shifting city population, he thereby greatly enlarged his potential customer base, but not without resentment. A common saying complained that 'Edo is too full of *Iseya* (shops operated by Ise men), *Inari* (shrines) and dog dirt'.

For the hard-working Edoite, affordable entertainment often revolved around the temples, shrines and accompanying annual events. In such a densely packed city, public open space was precious and limited. Edo suffered frequent and devastating fires which, of course, disproportionately affected the crowded poor areas, although attempts were made to widen roads as fire breaks and to enlarge temple and shrine precincts to provide safe public space. Both Buddhism and Shinto had religious importance at times of celebration, anxiety or sorrow, but in addition the temples and shrines often hosted popular entertainment such as sumo wrestling or special festivals which became fixed points in the Edo calendar. Asakusa Temple, also known as Sensōji (which survives in rebuilt form today), was a major Edo temple and held several important festivals. The cool of Edo's many river banks also made them particularly welcome venues during the hot summer. River bank spectacles of wandering entertainers, exotic imported animals and straightforward freak shows were hugely popular (see fig.29, p.41). All helped to assuage the tremendous appetite for the new, the unusual, the entertaining and the plain grotesque, and above all for play which was a pressure release for this urban culture.

fig.16
A four-unit *fuda* (see p.94) shows a dramatic scene of a district watchtower and in the distance firemen and their standard (*matoi*) silhouetted against the blaze they are fighting. Another *matoi* features in the foreground. The town fire brigades were divided into 48 groups and each assigned a letter from the *i-ro-ha* alphabet and a *matoi*. The firemen themselves were often volunteers from the construction trade, accustomed to heights and danger.
(See also fig.167, p.156.)

The art of play

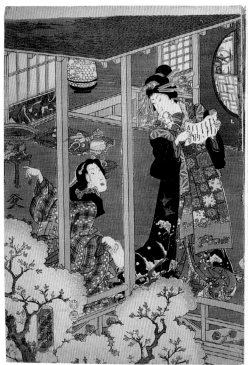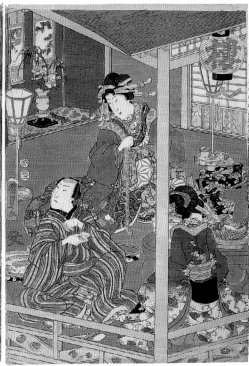

fig.17

Interior of the Licensed Quarters
(two panels of a triptych)
Utagawa Kunisada
1856

This print gives an idea of the luxurious fantasy created for the delight of the visitor to entertainment quarters such as Yoshiwara. The standing courtesan grips a torn envelope in her teeth as she excitedly scans a letter, most probably from a lover. For those unable to afford a visit to Yoshiwara, prints such as this must have fuelled their own fantasies of an exotic world about which they could only dream. It was a world of theatre every bit as lavish as kabuki.

Having been left relatively free to accumulate wealth, the merchant classes needed to find ways of spending it. With the country effectively closed to the outside world since the late 1630s, conspicuous consumption had to be internally generated in a climate of overt social and political control. Exhortations to compliant behaviour were posted on public noticeboards on street corners and punishments for transgression included, amongst others, chaining of the hands. The artist Kuniyoshi spent 60 days with his hands chained for overstepping the mark. The neat, but some would say hypocritical, solution to the opposing forces of the desire for control by the shogunate and the desire for fun by the people who could afford it, was to corral the fun into discrete areas. The Yoshiwara pleasure quarters in Edo, the Shimabara in

Kyoto and Shinmachi in Osaka were the best known of these. The pleasure quarters and the kabuki theatre became the primary outlets for the playful spirit of the Edoite with means.

The use of the English word 'play' as a translation of the Japanese word *asobi* can lead to misunderstanding because 'play' seems more firmly identified with children and not wholly acknowledged as part of the adult world. In ancient times in Japan, children were considered to possess the spirit of the divine; therefore play too was respected as divine. This led to a cultural proximity between the divinity of play and religious places. Shrines hosted games such as sumo, archery and tug of war, all of which had ritual aspects which survive today even though they have moved as sports into the secular world. The uninhibited behaviour, the release from

JAPANESE POPULAR PRINTS

constraint associated with play have always been culturally recognised in Japan.

Roger Caillois (1962)[7] divided play into four categories: competition, chance, mimicry, and dizziness/disorder.

Intellectual competitive games inevitably require more time to practice so it is no surprise that they were the preserve of the leisured classes. Competitive matching games (*awase*) developed out of the courtly games of poetry or picture matching (*uta-awase* and *e-awase*). The direct predecessor of the card games shown in this book (see p.183) was *kai-awase* (matching shells). The two shell halves were spread out and the players competed to see who could match most pairs.

Interest in the advantage to be gained through the mysterious powers and forces of chance dates back to ancient times. Fortune slips (*omikuji*), still sold in shrines and temples, were the simplest way of trying to divine the future. The introduction of dice from India via China and the accompanying board games afforded further opportunities to promote chance over skill. The most well-known board game, *sugoroku* (see p.164) is now essentially the preserve of children, but in earlier times had an adult role. The extreme devotion to the lure of chance (gambling) has always been kept under strict control in Japan. The assumed detrimental effects of gambling on the Confucian work ethic has guaranteed it a place on the margins of society.

Mimicry, simulation or the indulgence of fantasy was most obvious in the development of theatre and the ritualised etiquette of the pleasure quarters, both geographically constrained and defined. Dolls, masks or costumes offered a temporary alternative identity which was a brief respite from the strictures of a controlled society. In the visual arts, including print, *mitate-e* (see p.133) offered similar escape. The dizzying, disorientating energy and excitement of festivals, often linked to the agricultural calendar, afforded an opportunity for an ecstatic release of tension. The feasting and carousing associated with annual events such as cherry-blossom viewing are an essential part of this cycle of catharsis. Unlike more formalised warrior culture, popular culture used play to push boundaries.

In addition to the physical benefits of play, there are mental and profoundly aesthetic qualities too. Myth and ritual, often the preserve of established religions, in the Edo period found their place in such secular arenas as the Yoshiwara. Woodblock connoisseurs who formed their own groups of enthusiasts absorbed myth and ritual into their identities, of which playful language was also a part. Japanese has relatively few sounds, so only through context or the written character can the true meaning of a word be confirmed. *Shi*, for example, can have the following meanings: death, four, city, poetry and many

7 Callois, R. (1962), *Man, Play and Games*, Thames and Hudson, London, p.12–26.

fig.18
Souvenirs of Edo
Edo Miyage
This set of *pochibukuro* (see p.197) represent the spirit of Edo's cultural identity.
1 The kabuki character Sukeroku: Flower of Edo wears a band dyed Edo purple – one of the most expensive and sought after colours derived from the gromwell plant.
2 This envelope shows a Sharaku-style actor's portrait.
3 A design in tribute to Edo's heroic firefighters.
4 A cloth in the blue tie-dye pattern known as *mameshibori* – popularised by Ichikawa Danjūrō VIII (see p.128) as a towel tied round his face in the drama Genyadana.

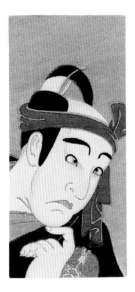

more. This homophonic nature predisposes Japanese to the art of word play. An important technique in *waka* (traditional Japanese 31-syllable poetry) exploits puns by using phrases which can be read in two or more ways. From court poems extolling the fleeting beauty of nature to ribald verse, language has always been a fundamental element of play within Japanese culture. In addition, the essentially pictorial nature of the written language from the Chinese based pictograms (*kanji*) to the phonetic alphabet allows for complex visual as well as verbal amusement.

Iki/tsū/hari

Having acquired the money and the appetite for play, the essential quality for the true Edoite was to nurture the style with which to conduct himself and that was described as *iki* (chic). *Iki* is urban and urbane, an appreciation of the artfully nonchalant. The underlying aesthetic and moral attitude of *iki* displays an understanding of beauty, an appetite for the sensual, and an acceptance of wealth without a clinging attachment to money and a playful attitude to rules. The inelegant opposite, the boor (*yabo*), may help with definition. The country bumpkin, new to Edo and unfamiliar with the sophisticated ways of the city, was the butt of humour and beyond the social pale. By contrast the *iki* Edoite, having served time in the pleasure quarters, was *au fait* with the ways of the world, and this knowledge of the codified and nuanced meanings marked him out from his newly arrived neighbour. A knowing understanding of life and its vicissitudes and an ability to maintain a degree of distance was part of the character. Within the nature of *iki* is an echo of the Heian period (794–1185) aesthetic of *mono no aware*, which can be roughly described as an appreciation for the essentially ephemeral quality of beauty in nature. The heyday for Edo *iki* was the early 19th century during a time of high levels of migration to the city, and *iki* was, to an extent, the Edoite's response to the influx.

The Osaka/Kyoto version of *iki* finesse (*sui*) can be traced back earlier than *iki* and although *iki* and *sui* are often written in Japanese using the same *kanji*, there is ongoing scholarly dispute as to whether the concepts are identical.

But no matter how stylish, it was important for an Edoite to be a man of taste, to display *tsū* (savoir-faire, connoisseurship) which was essentially *iki* put into practice. He should be knowledgeable about a particular subject, often the Yoshiwara, and display that understanding without appearing arrogant. The complete opposite again was the unfortunate *yabo* (boor) and someone just pretending to be in the know was dismissed as an even more unfortunate *hankatsu* (literally a man of half knowledge). The authentic *tsū* had a sophisticated insight into the human condition and the ways of the world honed amongst the people of teeming metropolitan Edo.

But underpinning these slightly difficult-to-translate aesthetic qualities was the fundamental Edo quality of *hari*, which can be defined as spirit or pluck. It was this characteristic which was potentially of most concern to the authorities if its focus turned away from the realm of play to the realm of politics. *Hari* was highly prized in Yoshiwara courtesans, but perhaps the Edo character which best embodied this quality was the fireman. Fires were common and the ability to tackle them rested with the slightly daredevil antics of the self-appointed firemen. They had little more than huge courage and a hand pump. The annual firemen's acrobatic display became a common theme within woodblock prints.

Woodblock as a medium served to reflect the worlds within which the leisured Edoite operated; Yoshiwara, kabuki and sumo. For the participants these prints would perhaps be reminders of happy times, for the outsider they would illuminate a world beyond their own and ultimately for the Westerner they confirmed a belief in the exotic and unfathomable Orient.

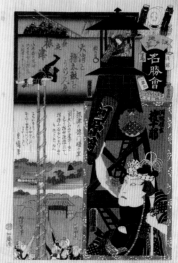

fig.19

Famous Products of Edo
Edo no meisho
1863

This *harimaze-e* (pasted print) is a complex example on the theme of Edo firemen. *Harimaze-e* were composite prints often the work of several artists (4 in this example) and were produced in imitation of the traditional practice of decorating screens with scattered pictures. These affordable prints could be cut up and used in the same way. In this print Toyokuni III was responsible for the tattooed actor, Yoshitoshi for the acrobatic ladder scene, Yoshitora and Kunihisa II the tower and top section.

The playgrounds

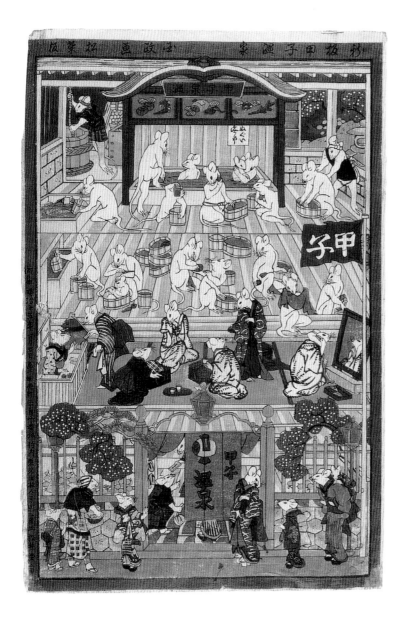

Yoshiwara

The growth of Edo's extraordinary pleasure quarters was to some extent fuelled by the fundamental gender imbalance of the city. With men outnumbering women by two to one there was obvious scope for the provision of entertainment of a kind. One of the few pleasures of the hard-working migrant to Edo would have been a visit to the public bath. Services not strictly related to cleanliness were often available. The city was also scattered with thriving brothels which, by the mid-17th century, had been tidied up into special districts of which the most famous was Yoshiwara. The name means literally 'field of reeds', but *yoshi* came to be written instead with a more suitable homophonous character meaning 'good fortune'. Yoshiwara was walled off and surrounded by a canal with only one gate to stop not only the women escaping, but also the men from leaving without paying. As *chōnin* (townspeople) grew wealthy, they became able to join members of the warrior class in enjoying Yoshiwara's delights (although strictly speaking

fig. 20
Kōshi Bath
Kōshi onsen
Utagawa Kunisada III
1882

In this charming anthropomorphic scene, mice replace humans for a visit to the bath. Bathhouses were not only places to get clean, but also popular social venues and in some cases operated as brothels. Edo had relatively few wells, so most people used the public bath (see also fig. 68, pp. 76–77). Although the influence of Western perspective is noticeable in this print, the composition actually follows the Oriental tradition of 'ascending' the picture plane as it recedes.

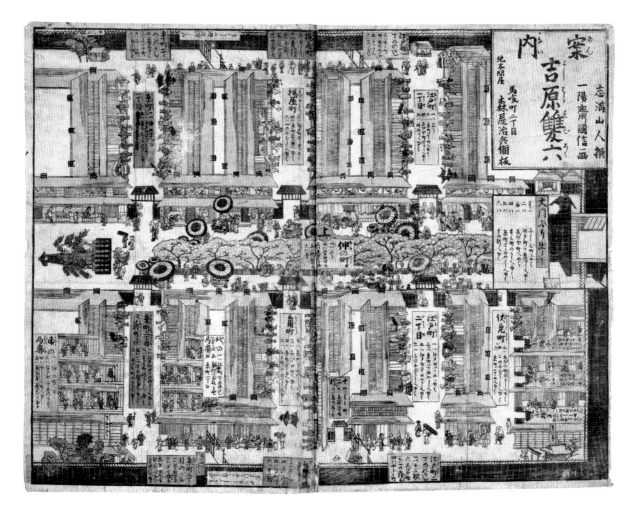

fig. 21

Yoshiwara Guide *sugoroku*
Annai Yoshiwara sugoroku
Utagawa Kuninobu
late Edo period

It is no surprise that as one of Edo's most celebrated places, Yoshiwara also featured as a *sugoroku*. It is a *tobi sugoroku* (see p.164) with the starting point at the main entry gate (centre right) and the finishing point in the centre. Although following a street plan format, the scene is simultaneously viewed from several angles – the barred facades of the buildings are shown even though to be accurate only the roofs would be seen and at the same time we are treated to lively scenes inside the houses. *Oiran* (courtesans) are parading under the huge umbrellas and cherry blossom along the main street.

this was against their code of Bushido).

After the great fire in 1657 when over 100,000 died and half the city was destroyed, Yoshiwara was moved further away from the centre, expanded in size and unlike the old Yoshiwara it was allowed to operate at night. The nocturnal nature of the new Yoshiwara gives the image of the pleasure quarters familiar from woodblock prints. The visitor to Yoshiwara would arrive by horse or palanquin (sometimes incognito under a broad-brimmed hat) to find a network of streets lined with lavish establishments to which the courtesan was summoned. The brothel owners fashioned an exotic world of luxury and magic, totally removed from the realities of everyday life. The reality of life, however, for the women working in the Yoshiwara was, in truth, far from magical. They were sold into bondage, and saddled with almost permanent debt

often exacerbated by illness, an inability to work or a lack of customers. A common theme of novels and drama was the financial and family consequences for a merchant of trying to buy the freedom of a Yoshiwara woman he loved. For new recruits, brokers scoured the countryside, buying up the excess daughters of impoverished families. Beginning as an attendant to a courtesan, a girl would pass through the complex Yoshiwara system before finding her place in the hierarchy of prostitutes. The high ranking *oiran* could walk freely in the quarters; the lower ranks sat on show in barred rooms. To disguise the assorted and possibly rather rough regional dialects of the imported women, a unique Yoshiwara language called *kuruwa kotoba* developed.

Once in Yoshiwara, the women were essentially captive except for the occasional day's leave to attend a family funeral for

example. For this reason the frequent and devastating fires in Yoshiwara were often welcomed. Until the place could be rebuilt, the brothel owners would establish temporary quarters *karitaku* (often in temple precincts) which gave the women at least a fleeting illusion of freedom. The owners too were not unhappy with the ad hoc arrangements, as the regulations were less strict so more money could be made. For many of these wretched women, however, a harsh working life of apparent glamour ended in an anonymous grave at the local temple, Jokanji in Minowa.

The appearance of woodblock prints of courtesans in the West is undoubtedly responsible for one of the most tenacious images of Japan and Japanese women. The dazzling world of theatrical splendour which attracted the Edo customer, had an equally magnetic effect on the western viewer. When first produced, these woodblock print portrayals of ghostly beauties dressed in the most luxurious of kimonos helped make the courtesans fashion icons of their day. As souvenirs of Edo too, the images were carried nationwide and took with them knowledge of metropolitan style. The more prosaic role played by woodblock in the pleasure quarters was in the production of practical guidebooks to the Yoshiwara. This detailed information as to the delights offered by each establishment was essential for the suave Edoite to be seen as a connoisseur of the quarters (see fig. 38, p. 51). The alternative world created within the confines of the Yoshiwara became the platform for the loosening of the Confucian strictures of mainstream society. Wealthy merchants rubbed shoulders with samurai (who had to leave their swords at the gate) and in the atmosphere of both carnal and intellectual pleasures indulged in a certain amount of irreverent lampooning of the status quo.

Kabuki

The kabuki theatre was another diversion which transcended the rigidities of class boundaries. Kabuki began on a Kyoto riverbank in 1603 but it reached its magnificent maturity nearly 100 years later before audiences of merchants, warriors and especially women. The early rather erotic form of kabuki performed by women (then later young boys) was deemed dangerous to the public good, so thereafter theatre became a male preserve, with certain actors specialising in female roles (*onnagata*). The world of kabuki and the fanatical devotion it attracted was viewed by the authorities as being potentially dangerous to public order, and as much in need of containment as the pleasure quarters.

fig. 22
Seven Costume Changes in the Looking-glass
Shinpan nanahenge sangaitate no sugata mi
Katsushika Hokusai
late Edo period

This print by Hokusai reflects the popularity of kabuki. Designed to be cut out, the actor is offered a variety of costumes. Ichikawa Yaozō III stands ready in front of his dressing mirror to assume the six other roles artfully laid out on the sheet.

Kabuki plays fell into three broad categories: historical, domestic and dance pieces. The prevailing moral values of Edo period society and the conflict between personal desire and passion and Confucian traditions of duty are common themes explored in the plays. As its popularity boomed, kabuki productions became increasingly lavish and the actors more and more famous. Visitors were drawn

fig.23

Ichikawa Danjūrō as Matsuōmaru
Matsuura Moriyoshi
late Edo period

This *baiyaku-e* (medicine print see p.114) shows a member of the famous Edo kabuki acting dynasty Ichikawa Danjūrō in the role of Matsuōmaru. Like most medicine prints, this print is not as sumptuous in its technical quality as *yakusha-e* (actor portraits) because it was distributed as a free gift.

fig.24

Actor's accoutrements *zukushi*
Shinpan shibai dōgu zukushi
late 19th century

This *zukushi* (see p.54) shows many of the effects of a working kabuki actor. The actor's presence is as a reflection in the mirror wearing *kumadori* make-up (see p.194) and he is surrounded by many of the small props from lanterns to swords required for particular roles.

in to the theatre from the countryside for what would be an all day affair. The stage sets were not only highly decorated but also included sophisticated structural innovations such as trapdoors and revolving stages. Skilled carpenters with abilities honed working on the expanding city crossed over into producing the fantasy world of kabuki. It is easy to imagine how otherworldly the kabuki theatre – with its dazzling costumes, fast action and innovative sets – must have seemed to a country visitor. A hint of this glamour could be shared with the people back home through the medium of the woodblock print souvenir.

But however awe-inspiring the sets of kabuki theatre, the real stars were the famous actors, some of whom reached iconic status in their popularity. Perhaps the greatest stars of the Edo stage came from the Ichikawa

Danjūrō dynasty. Unlike Osaka kabuki, which specialised in softer style (*wagoto*) acting in stories based on the trials and tribulations of love, Edo kabuki favoured a rougher style (*aragoto*) suited to swashbuckling action drama. A bold style of make-up called *kumadori* added to the dramatic effect (see fig.209, p.194). Successive generations of Danjūrō actors made their name acting out on stage the Edoite's robust image of himself. In addition to the woodblock actor portraits (*yakusha-e*) produced almost as pin-ups, the more sombre memorial portraits in woodblock (see p.125), *shini-e* give a further indication of the devotion of the fans for particular actors. In addition, for the information-hungry connoisseur, theatre programmes, playbills, listings and rankings (*banzuke*) of actors were all published in woodblock to satisfy the fan's appetite (see p.51).

Sumo and other spectacles

Sumo, even in the 21st century, still retains elements of ritual and pageant which reveal its courtly origins. The exaggerated physical presence of the sumo wrestler is reinforced by his role as a pseudo warrior and performer. The wrestlers originally plied their heroic trade in sponsored tournaments in the grounds of shrines and temples, but by the 18th century these bouts were formalised into two annual rounds, held in spring and autumn to take advantage of good weather. A procession of sumo wrestlers with their above-average height and enormous waistlines must have been an impressive sight. Particularly successful wrestlers became popular heroes and the favourite subject for woodblock portraits. Constraining their bulging bodies within the confines of a single sheet of paper was a considerable compositional challenge. Special techniques of deep embossing using the elbow or heel to print were developed to do full justice to their awesome physique. Group portraits of wrestlers, or plain lists of names (*banzuke*) were printed in woodblock as programmes showing the tournament line-up.

A less formalised type of entertainment popular nationwide were *misemono* (sideshows). The origins of the temporary nature of *misemono* lay in the occasional practice of revealing to the public normally-concealed temple images. The image processed through the streets with accompanying booths and spectacles, drawing huge crowds in its wake. Early sideshow structures were rather ad hoc and temporary, largely open to the elements and on public ground near rivers, in parks or in temple and shrine grounds. Later such events moved indoors and were held in variety halls called *yose* (Japanese Vaudeville). As well as dramas, popular entertainments were divided into three main areas: freak shows concentrated on the bizarre with exotic animals from overseas (a camel was brought by the Dutch in 1821), rare plants or people with an unusual appearance. Shows of beached or dead whales were also enormously popular, though the smell must have been a disincentive (see fig. 29, p. 41). Stunt-based spectacles included acrobatics, magic and expositions of martial arts. In this field, impoverished samurai could make a modest living with demonstrations of swordsmanship. Rather more sober sounding attractions, arguably very Japanese in nature, were demonstrations of skills such as basket-weaving, glass cutting or mechanical dolls

fig. 25

Life-size dolls in Asakusa Okuyama

Asakusa Okuyama ikiningyō
Utagawa Kuniyoshi
1856

The area around Asakusa was one of the main venues for *misemono* (sideshows). In February 1855 a life-size display of dolls representing 'people from strange lands' was staged. They had abnormally long arms and legs, and holes in their chests not unlike people visited by the wandering Asahina (see fig. 51, p. 62). Made by Matsumoto Kisaburō from Kumamoto, the figures were essentially high quality papier-mâché on bamboo frames and were said to be astonishingly lifelike. Artists including Kuniyoshi are known to have visited the spectacles and the prints portraying what they had seen were published a few months later – timed, no doubt, to profit from their popularity.

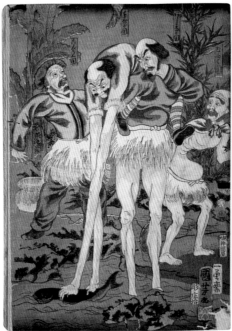
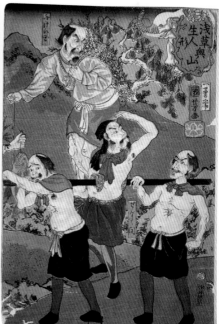

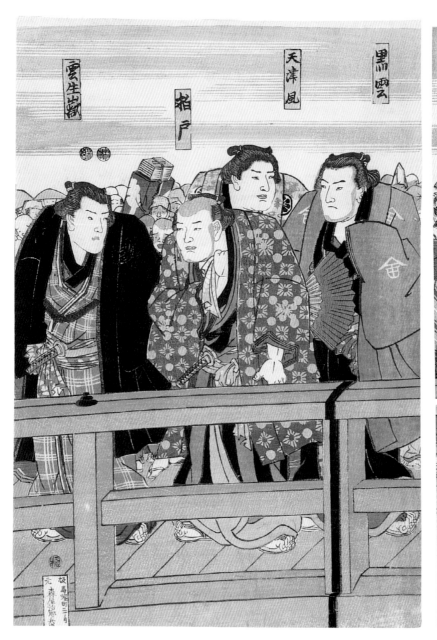

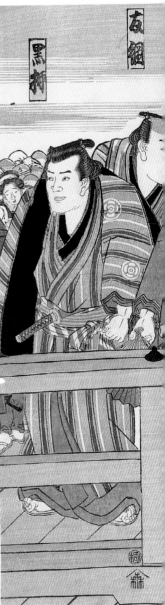

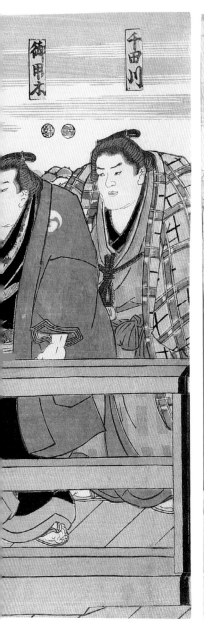

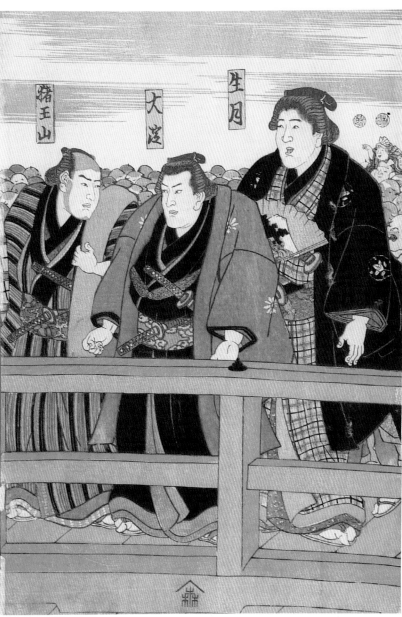

fig. 26

Wrestlers Standing on a Bridge
unsigned but probably Utagawa Kunisada
c.1847–50

The role of the sumo wrestler combined not only sports hero but also
remnants of religious and court ritual which added to their social standing.
As this triptych graphically shows, their enormous size set them apart from
the ordinary people barely visible in the background behind the leviathans in
front. In the left panel, the pack of books covered in a blue cloth carried by a
kashihonya (lending library, see p.46) can be seen – he has clearly taken time
off to enjoy the spectacle.

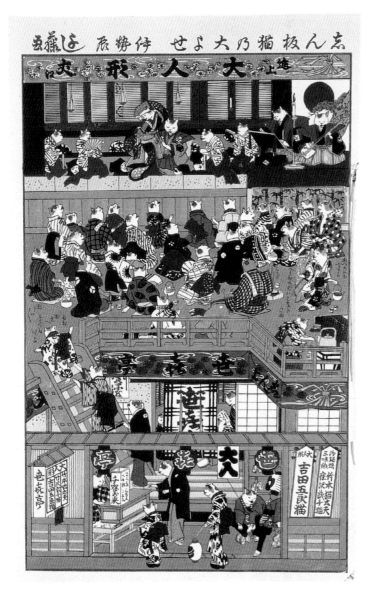

fig. 27

Cat's Variety Show
Shinpan neko no ōyose
Utagawa Yoshifuji
early Meiji period

A cast of cats attend a performance of a puppet ballad drama (*ningyōjōruri*)
in a typical small playhouse – a contrast to the much grander (and more
expensive) kabuki theatres. *Yose* were generally managed by people from
the community – firemen, carpenters, etc., who would convert a building to
put on a show. Female performers were a particular attraction, though not
popular with the authorities. *Yose* were mostly in downtown areas and were
patronised by the working classes and the occasional samurai.

(*karakuri*). *Ashigei* (foot skills) were bizarre
favourites, with performers able to sew or
arrange flowers with their feet! When
telescopes and other viewing devices were
introduced from the West, they too became
a popular attraction.

Because of their temporary nature,
sideshows seemed to escape the attention
and by extension the regulatory attempts of
the authorities. A ticket for a sideshow was
markedly cheaper than a day-long visit to the
kabuki theatre, so it brought this entertainment
within the reach of a much wider audience.
Occasionally programmes were printed in
woodblock in advance and distributed to
places such as bathhouses and barbers, but
mostly it seems the delights were advertised
at the grounds on the day. The insatiable
curiosity of the Edoite guaranteed a good
crowd. By the Meiji period, the natural
showmanship of the city took advantage of
the technical innovations imported from the
West and built spectacular and permanent
structures to draw the crowds. The two most
extraordinary were a massive replica of Mount
Fuji (see fig. 185, p.171) and a viewing tower
in Asakusa, Ryōunkaku, sadly demolished after
the great earthquake of 1923. Built in 1890 out
of brick, it was 50 metres (162 feet) high with
12 storeys and the added novelty of a lift (see
fig. 191, p.179). Fortunately both the replica
of Fuji and Ryōunkaku were immortalised in
woodblock print before they disappeared.

Schema

fig.28
Fan print
Uchiwa-e
Utagawa Sadahide
late Edo, early Meiji periods

Printed in the shape of an *uchiwa* fan ready to cut out and paste to bamboo (see fig.141, p.136–7), this scene has a bold, rather stern-looking silhouette of a man holding a folding fan projected onto the *shōji*. The grain of the woodblock can be seen clearly in the black. An elegant (and uneaten) meal is visible to the left and in the foreground a woman looks on. The concealed shadowy presence was a popular theme in prints (see pp.142–3) and in some ways echoed the courtly Heian aesthetic of screened seclusion.

Within the broad sweep of Edo period cultural activity briefly outlined, a common factor, and the one which concerns me here, is the role played by the technique of woodblock printing. From its initial incarnation as the medium for the transmission of Buddhist knowledge, through the polychrome glories of the Golden Age recording the highlights of the Floating World to its twilight years struggling to explain, explore and come to terms with the myriad of innovations in the Meiji period, woodblock rose to the challenge. It developed from simple black and white, and reached levels of dizzying multicoloured complexity very early before giving way to Western mechanical efficiency. There is, of course, a risk of over-inflating its importance; woodblock remained the medium rather than the message. Woodblock made it all possible but it had the advantage of functioning in a culture with an unusually high level of visual sophistication. In this book I have assembled a collection of images and objects with woodblock in common, and through them I hope to paint a larger picture of the world they illustrated. Many of the objects selected functioned in a variety of cultural areas, but in an attempt to establish a framework I have divided them into three main groups:

1　**knowledge news views** will look at prints which continued the information and educational theme of woodblock;

2　**faith fortune general well-being** will explore the link between faith, belief, health and woodblock; and

3　**leisure pleasure play** will illustrate the many ways in which a visual medium was both playful itself and promoted cultural play.

Some objects, *sugoroku* (game boards) for example, could happily sit in all three categories. The concept of *sugoroku* was so flexible that it was used in many forms but for simplicity's sake I have assigned it a home in the last section as that is its primary function now.

I hope that as well as revealing the inherent beauty and interest of the objects selected, I will be able to provide many happy hours of cross referencing between items. Many of the main cultural elements and influences at work have their roots in earlier periods of Japanese history but still take starring roles which can be traced through all three sections of the book.

Rebecca Salter, 2006

Books

The extraordinary variety of printed objects which developed in Japan all grew out of the reservoir of skill and knowledge which was nurtured in the world of book printing. With a document-driven bureaucracy based on the Chinese model and the adaptation of Chinese script for Japanese writing, by the 8th century literacy grew steadily. However, the use of woodblock printing did not begin to usurp the copyist until nearer the 12th century. The various Buddhist sects used woodblock printing to propagate the word for devotional reasons as part of a belief in the sacred power of text. The situation changed radically, however, by the late 18th century. Not just the printed word, but the technique of printing itself had made extraordinary inroads into the lives of the Japanese, covering everything from books to printed ephemera. Visitors to Japan today can still see the influence of this in the scale of Japanese publishing and magazine industries. This early spread of print was accompanied by an impressive social expansion of literacy.

Children of the warrior classes were educated at home and in private academies, but with the peace of the Edo period and the bureaucratic control systems that developed, it became increasingly important that a broad range of people could read and write. Written correspondence was even part of Yoshiwara etiquette (many prints show women reading and writing) and it could almost be said that illiteracy was regarded as vulgar. Village headmen were required to keep records and merchants had to balance the books, so basic learning became important. Only after 100 years or so of Tokugawa rule did the delights

of literacy begin to extend to the commoners, mostly through *terakoya* (temple schools). Instruction was received in reading, writing, abacus and etiquette. More boys than girls attended, but Japan did avoid the gender imbalance in literacy still seen in many countries today, aided by the availability and relative cheapness of text with pictures. As Japan re-emerged in the Meiji era, her literacy rate was on a par with, or possibly even exceeded, many European countries.

With an image of Japan as a highly literate nation, however, perhaps one of the biggest surprises for visitors to Japan today is the prevalence of comic books. The close proximity of text and illustration rarely commands interest beyond adolescence in the West, but in Japan it seems acceptable for all ages and flourishes in *manga* (comic books) and, by extension, filmed animation. The early roots of this format can be found in illustrative forms such as *emakimono* (picture scrolls) where word and picture are of equal importance. As they were hand painted, these scrolls were of course reserved for the aristocratic classes, but the same skilful combination of word and image manifested itself when illustrated printed books appeared, and were made available to a far wider audience from all social backgrounds.

Early foreign visitors to Japan were struck by the difference in nature between the solid, leather-covered, text-only Western book and the soft paper, illustrated pages and generally floppy nature of the Japanese book. Even with a cover, the books could not be displayed upright and were arranged for sale in piles. But the characteristic of the Japanese

fig. 30

A *sugoroku* depicting a temple school (*terakoya*) classroom
Dōshi kyōkun tenarai agari sugoroku
Utagawa Kunisato
1857

The children in this *sugoroku* version of school are working with varying degrees of ability and concentration. The younger ones in particular appear to be messing around and an older girl is in tears. New recruits start bottom right and make their way through the system (with some enforced stops on the way) to success in the game and graduation at the top. The number of the stage appears on the leg of the desk. All the teachers are women as it was one of the few jobs open to them at the time.

Schema

fig. 28
Fan print
Uchiwa-e
Utagawa Sadahide
late Edo, early Meiji periods

Printed in the shape of an *uchiwa* fan ready to cut out and paste to bamboo (see fig. 141, p. 136–7), this scene has a bold, rather stern-looking silhouette of a man holding a folding fan projected onto the *shōji*. The grain of the woodblock can be seen clearly in the black. An elegant (and uneaten) meal is visible to the left and in the foreground a woman looks on. The concealed shadowy presence was a popular theme in prints (see pp. 142–3) and in some ways echoed the courtly Heian aesthetic of screened seclusion.

Within the broad sweep of Edo period cultural activity briefly outlined, a common factor, and the one which concerns me here, is the role played by the technique of woodblock printing. From its initial incarnation as the medium for the transmission of Buddhist knowledge, through the polychrome glories of the Golden Age recording the highlights of the Floating World to its twilight years struggling to explain, explore and come to terms with the myriad of innovations in the Meiji period, woodblock rose to the challenge. It developed from simple black and white, and reached levels of dizzying multicoloured complexity very early before giving way to Western mechanical efficiency. There is, of course, a risk of over-inflating its importance; woodblock remained the medium rather than the message. Woodblock made it all possible but it had the advantage of functioning in a culture with an unusually high level of visual sophistication. In this book I have assembled a collection of images and objects with woodblock in common, and through them I hope to paint a larger picture of the world they illustrated. Many of the objects selected functioned in a variety of cultural areas, but in an attempt to establish a framework I have divided them into three main groups:

1 **knowledge news views** will look at prints which continued the information and educational theme of woodblock;

2 **faith fortune general well-being** will explore the link between faith, belief, health and woodblock; and

3 **leisure pleasure play** will illustrate the many ways in which a visual medium was both playful itself and promoted cultural play.

Some objects, *sugoroku* (game boards) for example, could happily sit in all three categories. The concept of *sugoroku* was so flexible that it was used in many forms but for simplicity's sake I have assigned it a home in the last section as that is its primary function now.

I hope that as well as revealing the inherent beauty and interest of the objects selected, I will be able to provide many happy hours of cross referencing between items. Many of the main cultural elements and influences at work have their roots in earlier periods of Japanese history but still take starring roles which can be traced through all three sections of the book.

Rebecca Salter, 2006

knowledge
news
views

fig. 29
Post Office News no. 832
Yūbin Hōchi Shinbun no. 832
Tsukioka Yoshitoshi
1876

A stunning example of a *shinbun nishiki-e* (illustrated newspaper print) this print is by the founder of *Yūbin Hōchi Shinbun* (Post Office News) Tsukioka Yoshitoshi. Imported aniline colours which had been produced in England in the 1850s were in common use in Japan by the late 1860s and are prominent in this print. The whale itself is printed using a traditional woodblock technique called *urushizuri* (lacquer printing) to give a dense shiny black.

 The print shows the thronging crowds drawn to see a beached whale in Fukagawa bay in central Tokyo and indicates the temporary nature of the structures built for such unexpected attractions and gives an idea of their popularity. The eager onlookers, some clearly suffering from the overpowering smell of the exhibit, are dressed in traditional kimono, occasionally with added elements of Western dress, showing how relatively quickly new customs were adopted. Perhaps the most animated parts of the composition are the expressive hands – almost cartoon-like in their simplicity. Bold calligraphic panels in the centre proclaim the arrival of the whale. (See pp. 60–61 and also fig. 128, p. 121.)

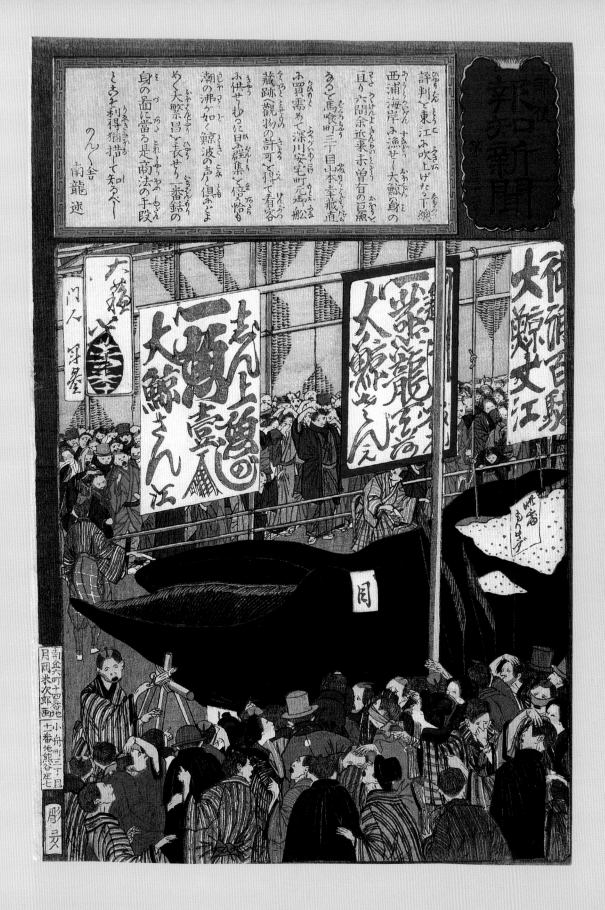

Books

The extraordinary variety of printed objects which developed in Japan all grew out of the reservoir of skill and knowledge which was nurtured in the world of book printing. With a document-driven bureaucracy based on the Chinese model and the adaptation of Chinese script for Japanese writing, by the 8th century literacy grew steadily. However, the use of woodblock printing did not begin to usurp the copyist until nearer the 12th century. The various Buddhist sects used woodblock printing to propagate the word for devotional reasons as part of a belief in the sacred power of text. The situation changed radically, however, by the late 18th century. Not just the printed word, but the technique of printing itself had made extraordinary inroads into the lives of the Japanese, covering everything from books to printed ephemera. Visitors to Japan today can still see the influence of this in the scale of Japanese publishing and magazine industries. This early spread of print was accompanied by an impressive social expansion of literacy.

Children of the warrior classes were educated at home and in private academies, but with the peace of the Edo period and the bureaucratic control systems that developed, it became increasingly important that a broad range of people could read and write. Written correspondence was even part of Yoshiwara etiquette (many prints show women reading and writing) and it could almost be said that illiteracy was regarded as vulgar. Village headmen were required to keep records and merchants had to balance the books, so basic learning became important. Only after 100 years or so of Tokugawa rule did the delights

of literacy begin to extend to the commoners, mostly through *terakoya* (temple schools). Instruction was received in reading, writing, abacus and etiquette. More boys than girls attended, but Japan did avoid the gender imbalance in literacy still seen in many countries today, aided by the availability and relative cheapness of text with pictures. As Japan re-emerged in the Meiji era, her literacy rate was on a par with, or possibly even exceeded, many European countries.

With an image of Japan as a highly literate nation, however, perhaps one of the biggest surprises for visitors to Japan today is the prevalence of comic books. The close proximity of text and illustration rarely commands interest beyond adolescence in the West, but in Japan it seems acceptable for all ages and flourishes in *manga* (comic books) and, by extension, filmed animation. The early roots of this format can be found in illustrative forms such as *emakimono* (picture scrolls) where word and picture are of equal importance. As they were hand painted, these scrolls were of course reserved for the aristocratic classes, but the same skilful combination of word and image manifested itself when illustrated printed books appeared, and were made available to a far wider audience from all social backgrounds.

Early foreign visitors to Japan were struck by the difference in nature between the solid, leather-covered, text-only Western book and the soft paper, illustrated pages and generally floppy nature of the Japanese book. Even with a cover, the books could not be displayed upright and were arranged for sale in piles. But the characteristic of the Japanese

fig. 30
A *sugoroku* depicting a temple school (*terakoya*) classroom
Dōshi kyōkun tenarai agari sugoroku
Utagawa Kunisato
1857

The children in this *sugoroku* version of school are working with varying degrees of ability and concentration. The younger ones in particular appear to be messing around and an older girl is in tears. New recruits start bottom right and make their way through the system (with some enforced stops on the way) to success in the game and graduation at the top. The number of the stage appears on the leg of the desk. All the teachers are women as it was one of the few jobs open to them at the time.

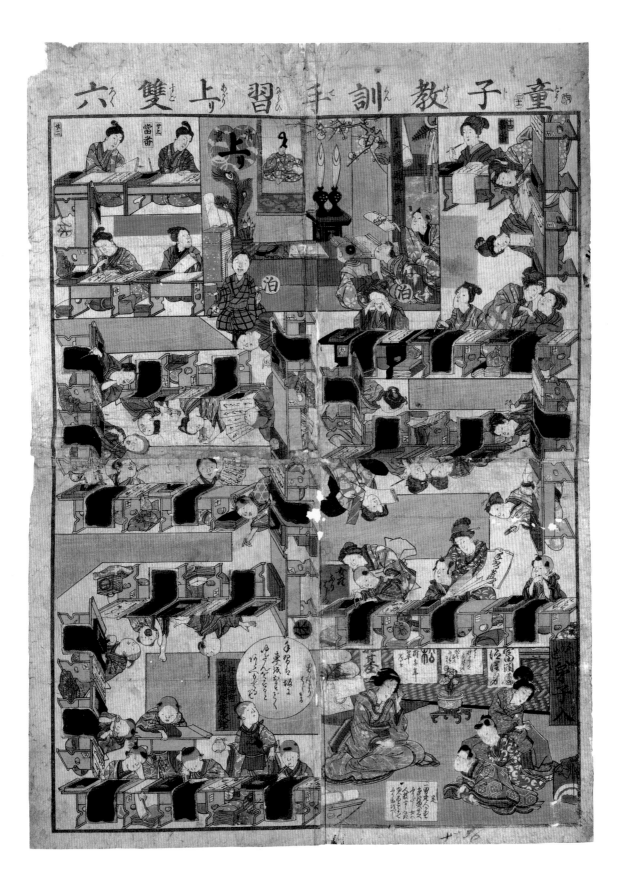

book which is most in need of explanation is its persistence in using the block printing method even after the introduction of moveable type. In most cultures, the flexibility of moveable type ensured it quickly usurped carved blocks.

Moveable type appeared in Japan in the late 16th century from two very different sources. Jesuit missionaries brought European printing technology of cast type printed with a press to spearhead their attempts to spread Christianity. Korean type technology was brought back to Japan by the invasion in 1592–98. Korea had had type from the late 14th century in both wood and metal, printed by hand using a pad rather than a press. Japan's brief flirtation with moveable type used mostly wood-carved letters rather than cast type. The most significant example was *Sagabon* (Saga books) produced in Kyoto by the artist Honami Kōetsu between 1596 and 1624. They used beautifully embellished papers which emerged from the Kyoto hand-decorated paper tradition and later spread through the medium of woodblock printing to a wider audience as *karakami* and *chiyogami* (see p.193). Although *Sagabon* combined moveable type text and illustration, it was the compositional advantages offered by the single block that led the Japanese to drop the apparently superior type technology and revert to their earlier method. They preferred the integration of word and picture as part of a 'whole' carved from one block.

The characteristics of the single carved block not only satisfied a cultural/stylistic preference for combined illustration and text, but it also suited the construction of the Japanese language. Japanese was first written using imported Chinese characters (*kanji*) and knowledge of these was largely restricted to men. A syllabic script, *hiragana* was devised and used especially by women. Modern Japanese combines ideograms and two syllabic alphabets, *hiragana* and *katakana* (primarily used for imported words). In Japan, cultural importance has always been placed on the running cursive calligraphic hand which can be successfully copied in block printing, but is difficult to achieve with discrete blocks of moveable type. In addition,

if carved blocks are kept, reprinting is easy and can be undertaken by more or less anyone. A reprint with moveable type would require a literate typesetter and a considerable investment in type. In addition, there was a tradition traced back to the importation of Chinese books of adding phonetic readings (*rubi*) by the side of each *kanji*. As Chinese and Japanese used common ideograms, this made Chinese books comprehensible. Later, in Japanese books, phonetic notations were also added to *kanji* to help the less literate reader. This simple device increased the number of people who could read (you actually only needed to master the shorter phonetic alphabet). This notation was hard to do with moveable type, but extremely easy if the phonetic readings were carved together with the text and illustration. When English text was first introduced, it was annotated in the same way (see fig. 78, p. 86).

The process of book printing follows essentially the same process as that used to produce a single sheet print. A copyist prepared a *hanshita* (master copy) from a manuscript which would be pasted face down and carved as described earlier (see p.19). As this method allows the exact reproduction of the manuscript, a good calligrapher could be specially chosen for certain projects, or for less important publications it could be written in-house. The appreciation of the quality and appearance of the calligraphy chosen was part of the enjoyment of the book. Once printed, the pages were adjusted for alignment and then passed to the binder to be sewn. Binding was often the preserve of the women in the publisher's household. A single printed sheet composed of two pages of the book was folded down the centre and the two cut edges were sewn (*fukurotoji* or bag binding). The paper was only printed on one side as water-based woodblock colours penetrate the fibres of the paper and it would be impossible to print legibly on both sides of the average book paper.

This method of production not only yielded a set of blocks which could be re-used, but also, if for any reason the blocks were destroyed, an extant book could be cannibalised and used as the master (by

pasting and recarving) for a reprint. Block text also allowed corrections through 'planting' new wood where required in the block. This method (called *umeki*) was used to replace worn areas, make corrections, change names or update the publisher's details. There are stories of less scrupulous publishers using the technique to change the title on the block and sell the same book twice. It is hard to

fig. 31

False Purple, Rustic Genji
Nise Murasaki inaka Genji
text: Ryūtei Tanehiko (1783–1842)
illustrations: Utagawa Kunisada

A classic *gōkan*, this popular parody was based on the 11th century story of court life, *The Tale of Genji* by Murasaki Shikibu (*murasaki* means purple). The text (written in *kana* script with a few simple *kanji*) flows around the images and is an excellent example of the close relationship between woodblock word and image. It was published in serial form between 1829 and 1842 and was widely believed to include references to intrigues in the 900-strong harem of the shogun, Tokugawa Ienari. Part of the appeal of the series was also the lavish illustrations by Kunisada. Not surprisingly it fell foul of the *Tenpō* Reforms of 1842. Ryūtei was thrown in jail where he died, possibly by his own hand or from sheer despair.

know how many books were published from a set of blocks, but some estimates run to 8000 for a popular work. The production of the blocks was the main initial investment as the labour to print was relatively cheap.

The most profound effect of the choice of a carved block over moveable type was visual. The illustrated book industry has its origins in the Kyoto/Osaka region where the earliest black ink printed books would have been either hand-coloured or stencilled. The Edo invention of multicoloured printing removed monotone printing limitations and the industry burgeoned nationwide. Dry and worthy Chinese texts were transformed by the juxtaposition of image and text and occasionally colour. Some of the best artists were attracted to the book format, and their artistic prominence would no doubt have

added to sales. Even after the innovation of full colour printing, books remained predominantly black line with a coloured frontispiece. Although not as vibrant as the prints, the reader was offered enjoyment on several levels; the calligraphic style of the text, the illustrations and their links with the text and the content of the book itself, which on occasions contained disguised characters to evade censorship restrictions. The Japanese reader became proficient at unlocking the riddle of word and picture, a skill which was transferred to lighthearted publications such as *moji-e* (word prints) and *hanji-e* (rebus prints) (see pp.145–9). The skilful combination of word and picture which grew out of the illustrated book tradition was instrumental in the spread of knowledge to a larger audience including children. The same visually-based method of presenting information can be seen in Meiji period prints designed to introduce knowledge of Western customs and language.

Professional workshops supplanted the dominance by temples, and a new commercial energy was provided by the publishers who, with a keen eye for the market, organised the production, and managed the business of censorship, often by self-policing to their benefit. The authorities tended to be reactive, clamping down on things which seemed to be getting out of hand, but there were perennial subjects which attracted their attention. Calendars could only be officially produced, political or sensational tabloid-style stories and erotica were frequently the subject of censorship.

A major genre of books, *kusazōshi* (literally 'weed/grass tales') was illustrated light fiction, employing familiar tales. Variations in this category derived their names from the colour of the cover: *akahon* (red books) were mostly children's folk tales; *kurohon* (black books) and *aohon* (blue-green books) were similar and covered popular dramas, ghostly and heroic tales. But the most notable development was *kibyōshi* (yellow books) which peaked in the mid to late 18th century and boasted authors of the best literary merit telling amusing tales of social mores. The *kibyōshi*

format was a slim volume of only a few pages and sold for about the price of a glass of sweet saké or a trip to the public bath. The paper used was thin and sometimes recycled, which in a paper culture was a worthwhile industry. As *kibyōshi* grew in popularity through their lively text and illustrations, publishers experimented with grouping books together as *gōkan* (bound volumes). *Gōkan* were less light-hearted in style, often taking their cue from kabuki tales and to some extent satisfying the popular appetite for tales of revenge and violence. As Japan opened to the West, the reading public were offered a new opportunity to find out about the worst excesses of human nature. Early illustrated newspapers *shinbun nishiki-e* (see p.60) tapped a rich seam of often fictitious tales of murder and mayhem.

Another popular genre of the 1770s and 1780s was *sharebon* (witty books). These were mostly short novels based in the pleasure quarters on witty dialogue such as that between courtesan and customer. Their content meant that they were the natural subject of close scrutiny by the authorities resulting in some authors spending time in chains. One of the best known writers, Santō Kyōden (see p.73) spent 50 days in manacles and his publisher Tsutaya Jūzaburō was fined. By the early 19th century, *ninjōbon* (romantic novels) were the prime source of concern to the authorities as a reflection of moral laxity. More edifying publications were *ōraimono* (textbooks used in temple schools), and *setsuyō*, which could be classed as household encyclopedias or dictionaries. The sort of practical advice and knowledge contained in these books also appeared in an attractive visual form in *sugoroku* (see fig.189, pp.176–7) and *zukushi* (see p.55).

Whatever the official line may have been on the content of the publication, the combined industry of publishers, writers, artists, carvers and printers was responsible for a phenomenally popular product. The publishing machine was capable of producing attractive illustrated books to satisfy the demands of the growing class of readers, both adult and child, particularly in urban areas. In Europe at the time, a fully illustrated children's book would have been only for the wealthy.

The last vital link in the chain was distribution. Illustrated books were sold together with prints at *ezōshiya* but in addition the contribution of the *kashihonya* (lending library) should be acknowledged.

fig.32
A *terako* (school) reading primer
Terako dokushō senjimon
1799

This school text book shows on the left page *kanji* in hand-written form flanked by their standard form and readings in *kana*. The right hand page (clockwise from top left) gives explanations of papermaking, brushes, ink and inkstones. The text uses both *kanji* and *kana* script with notation giving the reading carved next to difficult *kanji*. As with all Japanese books, the paper sheet is printed on one side only with two pages. This sheet is folded down the centre and the two cut edges sewn into the spine. The paper used is quite thin and the text of the other page shows through in the white areas.

The American scholar Edward S. Morse (1838–1925) writes of seeing an itinerant *kashihonya* wandering the streets with a huge pack of books on his back covered with a blue cloth, although by the time of his visit in the late 19th century, they were already in decline from their peak of about 800 in Edo alone (see fig.26, pp.36–7). They both sold and lent books and their customers came mostly from samurai-class homes, wealthier *chōnin* (townspeople) and even Yoshiwara. The representation of books and reading in prints of the pleasure quarters attest to female literacy. The social upheavals at the end of the Edo period and beginning of Meiji also affected *kashihonya*'s business. As demands changed, their peripatetic way of life and pivotal role in the spread of knowledge and literacy was superseded by reading rooms and libraries.

Calendars *koyomi*

Strange as it may seem to those of us accustomed to a deluge of free, privately produced calendars in December, the calendar in Japan was an official publication of great importance. The influence of the Confucian belief linking calendrical concerns with the state of governance and the harmony of the realm led to a certain amount of official control over their publication and distribution. Initially they were supervised by the court or the main Shinto shrine at Ise, and when the Tokugawa dynasty took control, they did their best to supervise publication and prevent private printing.

The desire to possess a calendar (*koyomi*) was not a matter of idle curiosity. Until the adoption of the Gregorian calendar in 1873, Japan's civil calendar was the combined lunar-solar based model with all the resulting irregularities. Farmers needed to know the best time for planting and harvesting and followed an ancient Chinese solar calendar. The lunar year was divided into long months (30 days) and short months (29 days) to a total of about 354–355 days. When the months got out of step, an intercalary month was added to make up the difference. An intercalated year could contain 385 days. An official body decided the order of the long and short months in advance, so it was not possible to predict from one year to the next what the calendar would be. Years were specified either by number in an era (such as *Bunsei* 8 which is 1825) or according to the traditional system, named after the 12 Chinese zodiac animal signs and ten stems based on the five elements (each appearing twice). This gives a sexagenary cycle of date

fig. 33

Ise calendar showing the first 5 months
Isegoyomi
1825

1825 was a year of 354 days. This calendar was published in Ise and distributed nationwide by *oshi* (literally 'master'). They travelled as agents of the shrine, handing out amulets and calendars and receiving supplications. They also helped arrange pilgrimages for devotees. The calendar shows the long and short months for the year as well as monthly advice and important dates such as the spring equinox.

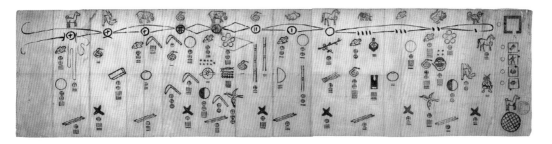

fig.34

Agricultural calendar
Tayamagoyomi
1802
Iwate prefecture

The parts of the official calendar useful to the farming population have been
extracted and hand-drawn and printed (stamped) using carved wooden stamps.
The dog on the right refers to 1802 in the animal zodiac. The box (top right)
shows the lucky direction and the 4 boxes below, unlucky directions. The months
are numbered along the top from 1–12 using a combination of strokes and circles.
A circle with a cross inside it equals 10. The angry-looking devil on the 2nd of the
1st month represents *Setsubun*, the eve of the spring and a day to dispel demons
by scattering beans. This *Tayamagoyomi* is an example of a *mekuragoyomi* (blind
calendar) – designed for those unable to read.

combinations which are helpful for dating
prints. The origin of this system lies in a
complex web of Chinese beliefs including
heavenly signs, auspicious days, directions
and zodiacal animals. Days were named in
the same way and likewise deemed lucky
or unlucky. To wash your hair on the day of
the horse could result in it turning red!

The simplest printed *koyomi* gave
straightforward information, the most
important being the order of the months,
and were published by licensed producers.
Calendars came in many guises: simple ones
with just the long/short months, compact
ones for travellers with lucky directions of
travel and *mekuragoyomi* (literally 'blind
calendar') for the illiterate with pictures to
indicate the months. In effect, *koyomi*
combined elements of calendars, horoscopes
and advice manuals. Despite attempts to
regulate production, modest private editions
of *koyomi* had been produced and exchanged
as New Year gifts for some time. The
significant event for the history of colour
woodblock happened in 1765 with the
publication of a multicoloured *egoyomi*
(picture calendar). For two years there was an
extraordinary boom in the production of these
privately commissioned calendars, and the

technical innovations which resulted gave
birth to the whole polychrome woodblock
industry. Within *egoyomi* the important
information about the long and short months
was liberated from the strictures of the official
calendar format and became part of the visual
language. The characters representing the
months (*dai*, large for the long months and
shō, small for the short months) were
cunningly concealed within the composition
of the print. For the visually sophisticated
connoisseurs who produced and exchanged
the *egoyomi*, deciphering the hidden signs
and meanings within the print were part of
the enjoyment. The characters of *dai* and *shō*
appear in many ways; in the pattern of
clothing, on walls or in objects, as alternating
large and small objects, hidden in text or as
decorative letters or numerals. They were
printed privately to coincide with the New Year
and often included a suitable poem, were not
for sale and were exchanged between friends
often at gatherings of poetry circles.

By the early 19th century, the tradition of
exchanging *egoyomi* had evolved into a new
type of commissioned print, *surimono* (literally
'printed thing'). *Surimono* too were published
privately and included a poem and a seasonal
or calendrical reference. *Egoyomi* continued to

fig. 35

Morioka illustrated calendar

Morioka egoyomi

1845

The northern prefectures of Iwate and Aomori became known for producing objects which used pictures instead of words (rebus) to convey meaning, thus making them accessible to the illiterate. Buddhist scriptures using this rebus principle were produced, in addition to practical pictorial calendars, which included farming information plus the all important long and short months.

In this woodblock example from 1845 the centre top panel shows it as the year of the snake plus the Japanese era name *Tenpō* 16 (*ten* = sable; *h(p)ō* = ear of rice). On the top right, a long sword signifies the long (30 day) months (2,4,5,7,9 and 11) and on the left, a short sword shows the short (29 day) months (1,3,6,8,10 and 12). The main body of the calendar is packed with information given pictorially in a classic example of *mekuragoyomi* (blind calendar).

Key (using approximate dates from the Western calendar)

1

16th March

Hachijūhachiya – literally 88th night from the beginning of spring and the day to sow rice.

hachi = bowl
jū = box
hachi = bowl
ya = arrow

2

8th May

Taue – time to plant rice shows a picture of rice planting

3

9th August

Kari – time to harvest shows a picture of harvesting

4

11th Feb: 12th April: 12th June: 13th August: 14th October: 15th December

Hassen – a period of 12 days (6 times a year) unlucky for marriage matters! If it rains on the first day, it will rain for 8 days.

ha = 8
sen = a 2-handed plane-like tool shows 8 tools

5

Hōgaku – direction

For that year the lucky direction was between the bird (west) and monkey (west south-west).

fig.36

Egoyomi – picture calendar
Cat in the guise of a monk
Neko no sōjō
Ōkubo Kyosen
1765

In this witty example of an *egoyomi*, the long months
are shown (although they are now very faint) in the
centre of the chrysanthemum motif on the cat's robes.
The cat, however, is more interested in the rat
disappearing out of the picture frame in the claws
of a bird.

be printed, but after the flurry of 1765–66
they never quite reached the same level of
production and *surimono* production peaked
between about 1793–1835. As *surimono*
were privately commissioned and produced
in small quantities to be distributed to fellow
enthusiasts in the group, they could afford to
use some of the most time-consuming and
expensive skills offered by the printer. As well
as employing full-colour, many *surimono* were
embossed, which enhanced the tactile as well
as visual pleasure of the high quality paper
used. *Surimono* offer a masterclass in
attention to detail and technique.

The refined elegance of *surimono* was not
only revealed in the technical prowess behind
their production, but also in the sophisticated
combined compositions of image and word.
They showed exceptional sensitivity in the
association of an appropriate image (perhaps
seasonal or thematic) with the content of the
chosen verse. And, as with the production of
books, the skill of the calligrapher contributed
to the beauty of the finished work. The theme
of the poem prompted the picture, and for
the recipient the thrill of unravelling the
concealed cross-references between text and
image was compounded by the visual/tactile
delight. The skills honed in the flowering of
surimono later found their way into the
production of items which had a much
broader audience. The subtle use of seasonal
imagery sometimes combined with words can
be found later in stationery items printed for
a far wider audience than the aesthetes of
surimono circles.

fig.37

Surimono of mushrooms
Anon
1861

This *surimono* has the classic juxtaposition of text and
image, with the relative size difference between the
rather jaunty and suggestive mushrooms to indicate
the long (large) and short (small) months.

Programmes and lists *banzuke and zukushi*

Banzuke

The word *banzuke* covers a wide range of printed publications from programmes and playbills to guide books, some illustrated, others plain text. What has become recognised as the *banzuke* format grew out of the Edoite's love of grouping and ranking. Originally produced to list or rank actors and sumo wrestlers, *banzuke* turned into a popular formula. Creating 'best ten, best hundred' lists was a popular Edo parlour game and is a journalistic ruse still used today. Enjoyment lay in the enumeration and marshalling of quantities of information and the banter involved in arranging it all in order. This activity has a long history in Japan, one of the earliest examples being the late 10th century author Sei Shonagon who made lists of hateful things, elegant things, etc.. Although the Edo activity was playful in spirit, *banzuke* rankings did have a practical application, especially in the three important entertainment worlds of Yoshiwara, kabuki and sumo. The sophisticated connoisseur had, above all else, to be in the know, and these highly visual prints were packed with information.

Yoshiwara *banzuke*

An early *banzuke* related publication was the *Yoshiwara Saiken*, (Yoshiwara guide) which began as a single sheet map, starting at the main entry gate and listing in order the names of the houses and their star courtesans. It was reissued first as an easier-to-handle horizontal booklet then finally as a vertical format book in the 1770s. The content was edited to fit

but continued to suggest a route through the Yoshiwara, outline the delights on offer, give an indication of prices and above all else a rating system. The name of each courtesan was listed in large characters, with her attendant's (*kamuro*) name in small letters beside. The business of the publisher, Tsutaya Jūzaburō, grew handsomely on the back of this popular and practical publication.

In true Edo spirit, however, a spoof volume was produced, *Yoshiwara Mitate* (Parody of Yoshiwara). The courtesan's names were replaced with the names of ukiyo-e print masters, and in tiny letters beside, the type of prints they specialised in. It is said that after complaints from the publisher of the real guide, the blocks were destroyed.

fig. 38
Guide to the Yoshiwara district
Yoshiwara saiken
1792

A page from the *Yoshiwara saiken* with the street running down the centre and the pleasure houses (together with all the details) listed either side. The text is laid out like a map, rather than following the orientation of the book itself (the writing on the top half is upside-down). Published annually, the guide included all the *iki* man about town needed to know. (See also fig. 21, p. 32.)

fig. 39

**Ichimura theatre
'face-showing' *banzuke***
Ichimura-za kaomise banzuke
1802

Ichimura-za was one of the
3 main theatres in Edo. These
announcements of the line-up and
programme for the new season
were an eagerly awaited annual
event for fans. The amount of
information crammed into a single
black and white sheet is almost
overwhelming. The text employs the
special stylised writing (*kanteiryū*)
and amongst the actor's portraits
their family crests are given
prominence and especially noticeable
is the three concentric box crest
(*mimasu*) of the Ichikawa dynasty.

Kabuki *banzuke*

The kabuki world was perhaps the most
prolific producer of *banzuke*. The highest
profile was the *kaomise banzuke* (literally
'showing of faces') published in November
at the start of the new season. The single
sheet format, crammed with portraits and
information about the coming season,
lasted until the early Meiji period. There was
tremendous competition to be the first to get
hold of this information. *Kaomise banzuke*
were published once a season, but as the
opening approached, other *banzuke* were
produced to whet the theatre-goer's appetite.
Tsuji banzuke (crossing *banzuke*) were pasted
on noticeboards at street corners, and, as well
as portraits, often reproduced the display
board of ornately written names posted
outside the theatre. *Banzuke* were also
distributed to teahouse guides (*dekata*),
barbers and bath houses. Visitors to kabuki

arrived at the theatre by two routes; the
less well-off through the front entrance,
the wealthier via adjacent *chaya* (teahouses)
which could attract more customers by being
the first with the latest *banzuke*.

Ehon banzuke (picture book *banzuke*) was
more like a theatre progamme, in small book
format with an envelope cover. It included
the theatre name, performance dates, main
scenes, a short pictorial version of the play,
names of the characters and actors and a
brief résumé. The Edo playboy on his way
home from a night on the town could stop
by the theatre in the morning for the first
part of the performance and take home an
ehon banzuke as an excuse for his absence.

Yakuwari banzuke (role *banzuke* – also
called *mon banzuke* because it showed the
mon [crests] of the actors) was a three page
book for the real kabuki devotee with details
of the actor's names, affiliations, crests and

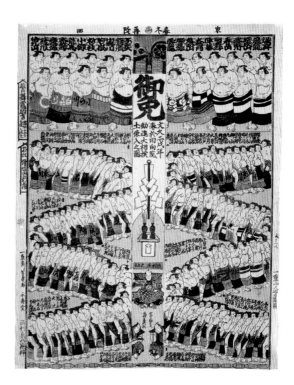

fig. 40
Sumo *banzuke*
1849

A classic *banzuke* format with the division into east to the right and west to the left. The wrestler's names appear in descending order beginning with *ōzeki* (second highest rank). On the right the *ōzeki* is Tsurugiyama from Edo, on the left Hidenoyama from Morioka.

fig. 41
Sumo *banzuke*
1880

This colour-printed version of a sumo *banzuke* replaces the words with pictures of wrestlers. The highest ranking are ranged across the top led by famous wrestlers Shiranui to the left and Unryū to the right. Two cascading chorus lines of the lower ranks flank the central panel and the diminutive figure of the referee.

rankings. These *banzuke* used *kanteiryū*, a special style of writing devised in the 1770s for kabuki purposes. A thick brush was preferred for the calligraphy and the letters curled in on themselves in a rounded full form, giving the impression of being squeezed within the confines of the space. This style was said to represent a packed theatre with no empty seats, and by implication a thriving business. Convoluted *kanteiryū* script was, however, a challenge for the copyist and carver.

There were two main schools of artists involved with kabuki publications – the Utagawa school which specialised in actor portraits (rather like pin-ups) and theatrical scenes, and the Torii school whose members were more akin to in-house designers. Their link with kabuki began in the late 1600s when they specialised in painting the external

theatre sign boards using a characteristic bold curved style of writing. It was this script which went on to influence the design of *banzuke*.

Sumo *banzuke*
Kabuki may have been popular with women, but the facilities at sumo tended to be rather basic so it remained a predominantly male interest. Since the Meiji period, sumo has been organised as a national sport, but originally wrestlers were part of the daimyo's retinue. Wrestlers came from the regions with their daimyo and wrestled under his banner with the convention that sumo from the same clan did not play each other. For the curious onlooker, a phalanx of muscle-bound wrestlers accompanying the daimyo on his journey must have been an impressive sight. From the sumo wrestler's point of view

though, this close relationship was not necessarily advantageous. Daimyo political rivalries could spill over into the wrestling arena and affect their chances of promotion.

Sumo had bases in Osaka and Kyoto, but inevitably Edo became the focus. Matches took place in the open air, twice a year in April and November. The design of the sumo *banzuke* published to accompany the bouts has remained more or less unchanged and bears some similarity to old Ise *koyomi* (calendars). They are divided into vertical sections, a team listed on each side (east to the right, west to the left). The two sides are divided by a centre panel at the top of which are the characters *gomen kōmuru*, loosely meaning 'with permission'. A special writing style of bold strokes (*sumomoji*) was used for sumo, reflecting the power of the wrestlers. The permission to print and distribute sumo *banzuke* was restricted. In addition to the official programmes, pictorial *banzuke* were also produced and sold for particularly popular bouts.

Mitate banzuke (Parody banzuke)

The sumo and kabuki *banzuke* format became a style classic which was imitated in other areas. Towards the end of the Edo period, when the Tokugawa hold on power was beginning to show signs of weakness, satirical works became popular. To avoid repercussions the target of the satire was of necessity disguised, but for those in the know, and those who could discern the hidden meaning, the *frisson* of excitement was real. Many parodies were purely visual, parody *banzuke* used text. They covered such diverse themes as listings/rankings of the wealthy, the poor, the powerful, strange people, disasters, famous places, regional food, poems, writers and even (imitating sumo rankings) characteristics of good and bad wives. For the record, a good wife does as she is told, a bad wife is jealous.

Zukushi

Zukushi is not an easy word to translate, the best description perhaps would be 'an enumeration of things'. Although not directly related to *banzuke*, they do both share the

characteristic of being packed with information. There is a conceptual link with Chinese studies of medicinal plants and the later craze for Western-style natural history classifications in the Meiji period. *Zukushi* are, unlike *banzuke*, highly visual and consist of single sheet prints with an arrangement of similar/related objects, sometimes with no words other than a simple title. They are like early pictorial encyclopedias and for children in particular, *zukushi* were an attractive and

fig. 42

Ranking list of cooking methods – fish and fowl
Gyochō ryōri banzuke
late Edo period

A parody *banzuke* ranking and comparing cooking methods for fish and fowl. The *ōzeki* dish to the right is bream sashimi, to the left, carp sashimi. The format imitates a sumo *banzuke* but the script used is rather more elegant.

enjoyable way of absorbing information. As a visual reflection of the Edo appetite for knowing about things and collecting information, they are a wonderful testament to the sophisticated design skills of the artists. The layout of the objects on the page and the concentration on the creation of an engaging pattern result in informative and highly

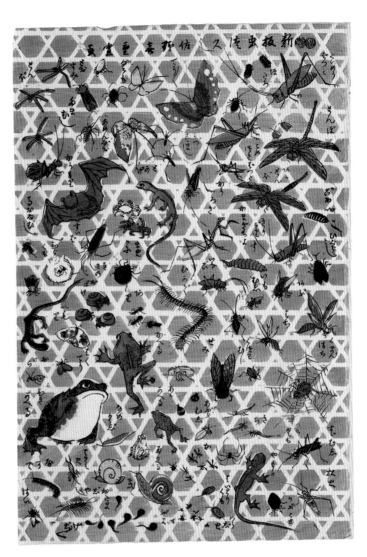

fig. 43

Horse *zukushi*

Shinpan uma zukushi

Utagawa Yoshifuji

late 19th century

Zukushi fit broadly within the category of toy prints
(*omocha-e*) (see p.132) and this lively collection of horses
is by the master of the genre, Yoshifuji. As well as giving
a basic indication of the varieties and bearing –
differences in mane and tail, etc. – it also shows an
assortment of tack. The proud-looking horse in the
centre top is a sacred Shinto horse and contrasts with
the downcast-looking country horse near the bottom.

The word *shinpan* appears in the title of most toy
prints and literally means 'new impression'. The inclusion
of the word gives an idea of how eagerly the latest
prints were awaited. *Zukushi* were generally produced
in the *ōban* format (39 × 26.5 cm/15 × 10 in.).

fig. 44

Insect *zukushi*

Shinpan mushi zukushi

Utagawa Hiroshige II

c.1848–53

A classic *zukushi*-style enumeration of named insects.
Even though it was designed for children, setting the
insects against a *kagome* (woven bamboo) background
results in a sophisticated composition worthy of adult
appreciation. At the time, frogs and lizards were
classed as insects.

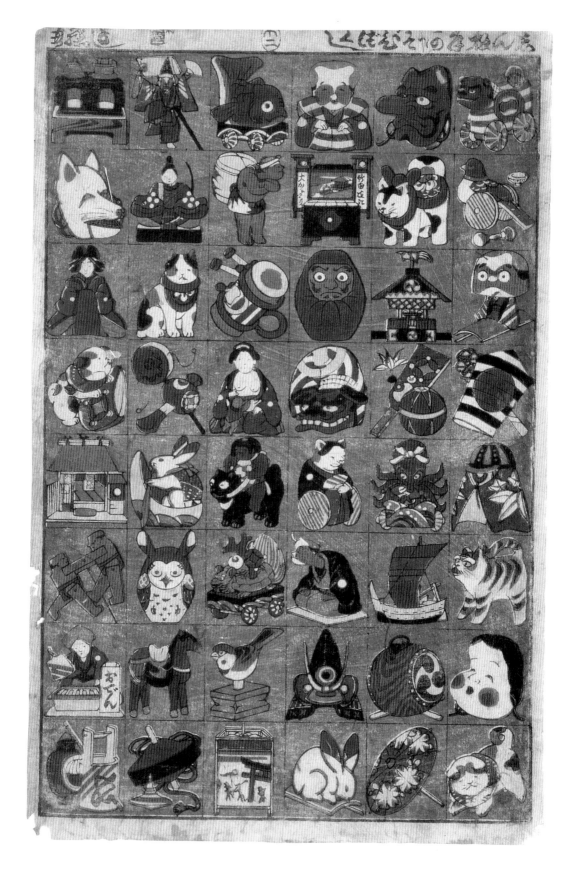

decorative items. Some are very clearly aimed at children with displays of toys or dolls to be cut out. Others are designed to be kept as one sheet and used for learning. In the Meiji period, *zukushi* showing Western objects were produced to help acquaint the Japanese with the unfamiliar new arrivals.

Unlike *banzuke* there is no particular element of ranking, but *zukushi* do portray a delight in marshalling a tremendous array of objects, creating a rhythm or pattern between them and, within that, identifying similarities and differences. Such a deluge of information was joy to the Edo heart. Even today, the densely packed layout of many Japanese magazines and guide books continues to reflect the concept of *banzuke* and *zukushi* and an obsession with detailed information.

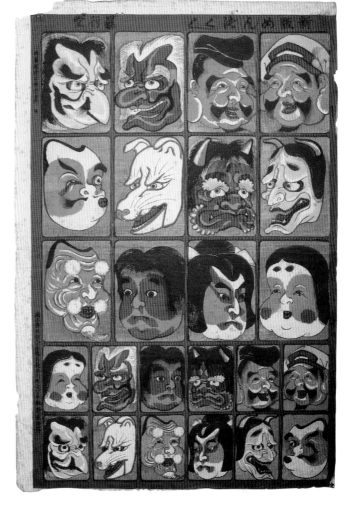

fig. 46

Mask *zukushi*

Shinpan men zukushi

late Edo period

In this *zukushi*, the sheet is divided into two sizes of grid and each mask is shown twice. The sheet could be kept whole, cut out and formed into tiny books or pasted on card and used to play *menko* (see p.182). Masks play an important role in both Japanese festivals and drama and most of the characters shown would have been familiar to children.

Top right hand corner: Daikokuten – one of the Seven Lucky Gods (*Shichi Fukujin*). He manages to be not only the patron of bankers and financiers, but also undertakers and advertising agents (see p.95).

3rd row down, far right: Otafuku (also called Okame; Ofuku) is easily recognizable with her exaggerated moonface and highlighted pink cheeks. She is traditionally regarded as the goddess of mirth (see fig.138, p.134).

fig. 45

Toy *zukushi*

Shinpan teasobi zukushi

Utagawa Yoshifuji

1858

This is another example by the master, Yoshifuji, but in this case the items are dispersed within a grid format rather than scattered over the sheet. The toys illustrated here are of historical interest as they would clearly have been popular in the late Edo period. The standard of printing is basic but sufficiently colourful to appeal to a child.

Top row: second from right = a *tengu* mask (see p.186)

5th row: far left = a complete *tatebanko* (construction print – see pp.162–3)

bottom row: third from left = a *mawaritōrō* (lantern) with silhouetted figures – see pp.144–5)

News-sheets *kawaraban and shinbun nishiki-e*

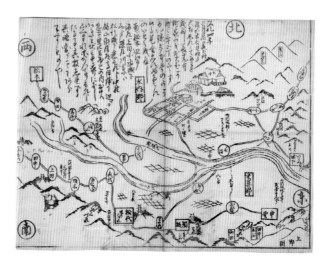

fig. 47
Shinshū (Nagano prefecture) Earthquake *kawaraban*
Shinshū daijishin kawaraban
March 1847

Kawaraban

The later years of the Edo period leading up to the Meiji Restoration (1868) were marked by grumbling dissatisfaction with the status quo. Epidemics of cholera, smallpox and measles, together with failed harvests, made the plight of many particularly acute. Any criticism, whether written or pictorial, had to be concealed as satire or written obliquely. Veiled references appeared first as wall scribbling and then later in printed form, most notably as single news-sheets, *kawaraban*. The earliest broadsheets can be dated back to 1615 though use of the word *kawaraban* is first recorded in the mid-1800s and is of uncertain origin. The character used to write *kawara* means 'roof tile' (roof tiles were made of clay), and is thought to refer to the suggestion that *kawaraban* were originally produced by incising and printing off clay, although no tablets survive. The translation of *kawaraban* as 'tile prints' is literal but makes no reference to their character. An alternative etymology prefers another meaning of *kawara* (river bank), which was traditionally the place for outcasts and misfits in Japanese society and often the location of informal performances. Kabuki, for example, began on a Kyoto riverbank. It is quite plausible that these often seditious publications were distributed by the socially marginalised people from these areas. In a controlled feudal society, the main direction of news and information was from the top down. *Kawaraban* offered an alternative route and were frequently subjected to attempts at repression. The directness and versatility of woodblock suited the production process of

kawaraban as speed and news-worthiness were vital. The form was very simple; an illustrated single sheet with text explanation. These were produced quickly and the print quality was generally poor so they are valued more for historical interest than artistic or technical merit. *Kawaraban* were not produced daily or even regularly so no one knew when the next one would come out or what subject it would cover.

One of their main (and less contentious) roles was in spreading news and information particularly after fires, floods, volcanic eruptions and earthquakes. The report of a fire for example could include a schematic map, the damaged area shown in black with occasionally the seat of the fire marked. Numbers of houses destroyed, casualties and places of evacuation were also often included. In this genre, the best known *kawaraban* were produced after the catastrophic earthquake on 2 October 1855, with Edo at the epicentre. As many as 14,000 houses may have been destroyed and thousands died, with Yoshiwara particularly badly hit. The first *kawaraban* appeared on the morning of 3 October with few hard facts but a powerful illustration of the destruction. Further editions appeared by 7 October with more detailed facts and figures. Amidst the destruction, the

As most *kawaraban* were produced in a single colour (with no need for registration), larger sheets of paper (*hanshi*) could be used. This *kawaraban* is 39.5 × 53 cm (15 × 21 in.). It shows the location of the Shinshū earthquake near Zenkō-ji – a temple which was a popular pilgrimage destination. Several mountains in the ranges shown are marked as having suffered a landslide as a result of the tremors, and it is thought that as many as 30,000 people may have died. The haste with which this *kawaraban* was produced shows clearly in the rough quality of the carving and the patchiness of the black printing. A line running across the entire print (one third of the way down from the top) probably indicates a join in the block. (See also fig.113 p.110.)

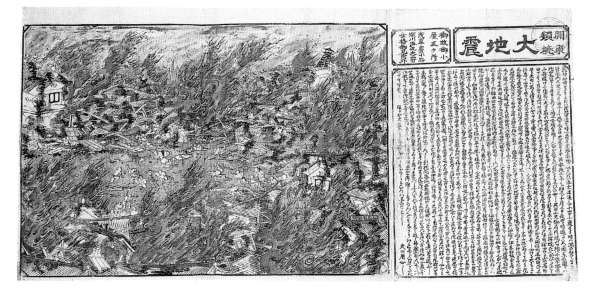

fig. 48

Kantō Earthquake *kawaraban*
Kantō ruisho ōjishin
1855

On October 2 1855 at about 10 pm
the Edo area was at the epicentre of
a magnitude 6.9 earthquake. The
illustration not only shows the
physical destruction, but also the
fear and consternation as the
residents flee in the path of the
inevitable fire. After the earthquake
it is thought that as many as 400
kawaraban editions may have been
published. The same disaster was
responsible for another print
phenomenon – *namazu-e* (catfish
prints) (see p.108).

artists, carvers and printers of Edo managed
a news-gathering task worthy of the most
intrepid television news crew.

The other main fare for *kawaraban* was
the sensational. Stories of double suicides
and revenge killings were popular subjects.
Outright fabrications such as monsters,
ghosts, and human and animal freaks also
boosted sales. Any political content had to
be carefully disguised, although by the time
Commodore Perry arrived off the coast in
1853 demanding Japan open her borders,
control had weakened to the extent that over
40 *kawaraban* reported the event, although by
no means favourably to foreigners! To try and
curb the excesses of *kawaraban*, the authorities
had tried to persuade the publishers into a
loose, self-regulating association. This had the
effect of slowing down their output to such
an extent that they lost out in speed and
news-worthiness to the unregulated producers
and so were effectively sidelined.

Because of the extensive network of roads,
news (and rumour) travelled fast in Edo-period
Japan. The inns along the way (for example
on the *53 Stages of the Tōkaidō*) were natural
places for the exchange of news between
travellers. These post stations were required
to report to Edo by relay runner any irregular
incidents. An official message could be carried
from Kyoto to Edo in as little as two and a
half days, news of an 1860 earthquake in
Kyoto reached Edo by this means.

Government messengers had priority access
to ferries and horses and were allowed to
travel at night. On their arrival in the capital,
runners were pumped for information by the
publishers so they were able to be the first
with the news of events elsewhere.

The production and distribution of
kawaraban was a slick operation. When a
story broke, the publisher would engage a
writer, (sometimes a popular literary figure or
essayist) to cover the event, and at the same
time commission an artist to produce an
illustration. The finished copy of both was
handed to the carver. If there was too much
copy for one block, two were carved and then
printed together (*yosehan*) on one sheet.
Kawaraban were generally just printed in
black, apart from some of the more dramatic
editions, such as those produced after the 1855
earthquake. Small publishers managed the
whole production in-house, larger outfits used
separate craftsmen, as in the ukiyo-e system.

On the streets of Edo the hot-off-the-block
kawaraban were sold by vendors and in print
shops (*ezōshiya*), where they were stacked in
a pile with one copy hung up to attract
attention. A single sheet cost around 4 *mon*
(a bowl of noodles was 16 *mon*), versions
with several pages cost as much as 30 *mon*.
On the street they were sold by *yomiuri*,
salesmen wearing large straw hats or knotted
towels to conceal their identity from the
authorities. Calling out '*sa taihen da, taihen*

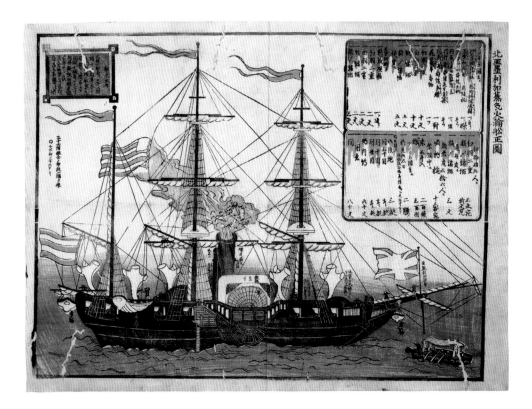

fig. 49

North American Paddle-wheel Steamship Kawaraban
Kita America jōkikarinsen kawaraban
1854

The American Commodore Perry appeared off Edo in 1853 (and again in 1854) in what appeared to the Japanese to be enormous black ships. They were quite unlike their own vessels or Dutch ships with which they had become familiar. This *kawaraban* is unusual in that it is in colour and is very well-observed. Few artists would have actually seen the ships, so some print portrayals were clearly based on other ships they had seen. The box at the top right gives details of the gifts being sent to the American president. There seems to be a little confusion over the correct flag design.

da' ('hey – it's terrible, it's terrible') they would read or sing just enough of the story to persuade customers to buy. Some pointed to the copy with a chopstick as they read or sang. They often worked in pairs and were sometimes pretty young boys with fine voices, and a *shamisen* (three stringed instrument) accompaniment. Their sales pitch was a much livelier affair.

Through this informal but highly effective system, people both in Edo and the regions were able to access alternative information to the official version. However, accurate reporting of an event was not common practice, so there was considerable scope for embellishment. The Edo period reader could only weigh up the several versions and come to his own conclusion. The authorities, who may have known the full facts, were content with the confusion sewn by this uncertainty, as long as one version of a story did not appear to gain ascendancy as the correct one. By the early Meiji period, however, the sensational stories which had been the staple of the *kawaraban* had found a new incarnation in *shinbun nishiki-e* (illustrated newspaper prints) with bigger and brasher pictures.

Illustrated newspaper prints – *shinbun nishiki-e*

One of the earliest newspapers in Japan, the *Tokyo Nichinichi Shinbun* (now the *Mainichi Newspaper*) was published in 1872 with a run of about 1000 copies. It proved to be so popular that within about six months production had grown fivefold, a powerful indication of the thirst for news and stories. Printed as a single sheet, it contained official notices as well as world news and even became a popular souvenir of the capital. However, the newspaper did not have space to include the phonetic alphabet annotation mixed in the text, so only the educated could read it. The absence of the annotation effectively limited the audience. Spotting a potential market, *shinbun nishiki-e* were produced by artists and craftsmen to cater for the less literate. The juiciest stories chosen from the familiar diet of news, murder, revenge, illicit love, kabuki stars, ghosts and freaks were extracted and produced as single sheet colour prints. The cartouche on the print carries a number in the series rather than a date. Very often the text concludes with a brief outline of the moral that can

be drawn from the tale.

Shinbun nishiki-e continued the illustrated *kawaraban* format with text as part of the composition, although the pictures themselves were much more dramatic and sensational and, due to the arrival of aniline dyes, colourful. In a semi-literate society, the bold pictures and the addition of a phonetic alphabet (*hiragana*) in the text to assist with the more difficult *kanji*, guaranteed as large an audience as possible. The rather overwrought composition is closer to popular printed books than the slightly more spare layout of ukiyo-e, and is all contained within a border, not unlike a Western picture frame. The possibilities offered by carving text and picture on one block, used so expertly in books, were still being explored. The copy was mostly written by popular writers of light novels, and the artist who was most active, and in fact was joint founder of *Tokyo Nichinichi Shinbun* (*Tokyo Daily News*), was Utagawa Yoshiiku. He was the son of a Yoshiwara brothel owner and had been a pupil of Utagawa Kuniyoshi. A fellow pupil, Tsukioka Yoshitoshi, was almost as influential in creating the 'look' of *shinbun nishiki-e*. He produced about 50 prints for another publication, *Yūbin Hōchi Shinbun* (*Post Office News*) although his career as a solo artist eventually took precedence over newspaper work. The design of *Yūbin Hōchi Shinbun* has a clear separation between text and picture and, even though still produced on one block, almost anticipates the final switch to typesetting with pictures in discrete boxes.

Shinbun nishiki-e peaked in 1875–76, and around this time Yoshiiku founded another format paper, *Hiragana Eiri Shinbun* (*Illustrated* Hiragana *News*), which leeched popularity from the earlier versions and hastened their demise. The new paper combined picture and text but used only the phonetic language, *hiragana*, making it easier to read for a larger audience. By about 1879, the illustrated newspaper was in decline and the switch began from traditional woodblock to mechanical means. The machinery was, of course, imported so the costs were high, whereas woodblock production had utilised the remaining print system of relatively low-paid craftsmen. With the disappearance of

these news-sheets, apart from the war pictures during the Sino-Japanese (1894–95) and Russo-Japanese (1904–05) wars, woodblock's noble role as a purveyor of news through a visual medium had finally come to an end. As a provider of fun and entertainment, woodblock limped on a little longer.

During their brief flowering *shinbun nishiki-e* found a market both within Tokyo and as souvenirs taken home to all parts of the

country, no doubt spreading alarm and fascination at extraordinary metropolitan affairs. As woodblock began its decline, sales of other styles of prints became increasingly dependent on foreign buyers for whom the popular themes were, predictably, beautiful women, landscape, etc. The subject matter, and the fact that foreigners could not read the text, meant that *shinbun nishiki-e* aroused little foreign interest and so were particularly vulnerable to the vicissitudes of the domestic market. With some interpretation, however, *shinbun nishiki-e* give a graphic and fascinating insight into a society undergoing significant social change. The more modest *kawaraban* before them and the daily papers laid the foundations for a news-hungry society which, based on newspaper and magazine circulation, could be said to continue today.

fig. 50
Tokyo Daily News no. 472
Tokyo Nichinichi Shinbun no. 472
Utagawa Yoshiiku
1870s

In this print the drama unfolds beneath the disinterested gaze of two rather lumpen cherubs, a design feature clearly influenced by Western publications. A sailor called Masakichi, caught in a high wind on his way to Wakayama (on the coast near Osaka) loses all his cargo, his mast breaks and he is left floating helplessly as the wind and rain get stronger. Before he dies he is determined to leave a letter, so calmly he writes to his mother and wife. He puts their address on a box, includes 150 yen and a lock of his hair and then jumps to his watery death. Four years later the box was washed up in San Francisco and returned to his family.

This tale not only celebrates Masakichi's stoic heroism but also gently points out the benefits of Japan opening to the world. If Japan had remained closed, the grieving family would never have received news of Masakichi's last heroic minutes.

The design closely follows the book format of illustration mixed with text which includes the phonetic alphabet annotation to make it accessible. The rival Post Office News (see fig. 29 p.41 and fig. 128 p.121) separates the text and image more definitively.

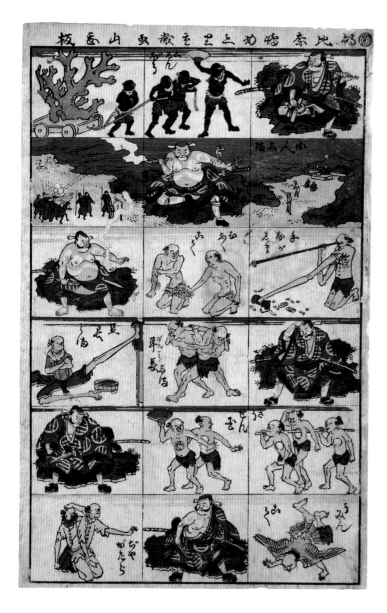

The travel boom which struck Japan particularly during the early 19th century came about through the coincidence of discrete circumstances. In the 7th century it had been apparent that an efficient network of roads was important as an artery of government. By the Edo period this infrastructure had grown to become one of the main conduits of Tokugawa rule, facilitating the *sankin kōtai* system by which the regional daimyo kept a presence in Edo and in turn were kept in check (see p. 26). The craze for travel took advantage of the presence of this system of communications, and a currency-based economy amongst the merchant classes gave them the cash to indulge in leisure. Samurai, meanwhile, had to live on a fixed income paid in rice. Rural dwellers did find ways to join in the 'culture of movement' (*kōdōbunka*, an expression

fig. 51

Asahina's Island Journey
Asahina shimameguri
Utagawa Shigetoshi
1861

This toy print gives an impression of Japan's fantasy idea of the world beyond their shores. Based on the travels of a 13th century general, Asahina, this fanciful tale became a bestseller for the Edo author Kyokutei Bakin (1767–1848) and a popular subject for toy prints. Among the places he visited were the islands of the black people, small people (shown scaling Asahina with ladders, some dressed as firemen carrying standards), long-armed people (using a telescope to see), naked people, long-eared people, long-legged people, men with holes in their chests, winged people and people from Jakarta – a place which would have been known because Dutch traders brought their servants from Jakarta with them to Japan (see fig. 71, p. 81). Life-size papier-mâché dolls with similarly bizarre forms were exhibited in 1855 in Asakusa (see fig. 25, p. 35).

first coined by the scholar Nishiyama Matsunosuke),[8] but their ties to the agricultural calendar made it harder to accomplish. Woodblock publishing responded to this new social trend by becoming the provider of information and knowledge required to take part. Maps, guidebooks, gazetteers, diaries and pictures of famous sites all fed this voracious appetite for knowledge. In a period of Japan's history when access to the outside world was officially forbidden, the Japanese were gripped by a madness of movement within the confines of their own country. Encouraged by an efficient publishing business, Japan developed an organised system of travel well before the days of Thomas Cook.

The earliest Japanese maps were primarily for the benefit of aristocrats and temples to define the boundaries of land owned. By the late 17th century trigonometry and surveying had been learned from the Dutch and employed in map making, and in 1691 a fairly accurate scale map of the *Tōkaidō* was produced. Disastrous fires in Edo led to attempts to impose some form of planning on the city, with adequate fire breaks and wider roads, and maps were produced on an almost annual basis to update information. A map of Edo produced in the 1780s was so large that it covered several *tatami* floor mats. Its size was possible because Japanese hand-made fibrous paper was strong enough to be pasted together into a large sheet and could survive repeated foldings and unfoldings. Reading maps was clearly a physical as well as a mental activity. The detail that was required, the names of each household (only the upper classes had surnames at the time) needed a considerable amount of space. As the map was not designed to be hung up and viewed from a fixed angle, the text was written facing in all directions using a mixture of *kanji* and *hiragana*. Pouring over the map searching the narrow streets and names for a destination was in many ways an act of 'parlour' exploration.

The relationship between the two parts of the growing city of Edo was telling; the daimyo part of the city had 70% of the land while 80% of the population lived on the rest.

The livelihoods of the latter relied to a large extent upon supplying goods and services to the former so knowledge of the layout of Edo and the names of residents was important. Detailed area maps (*kiriezu*) were produced in the 1750s for different parts of Edo, initially in just two colours. Later when colour printing became possible, colour coding was added; yellow for streets, green for fields, blue for water, red for temples/shrines, grey for the downtown areas and black for boundaries became standard. The name of the resident was printed pointing towards the house entrance.

As well as the more traditional ground plan, dramatic bird's eye view maps were also produced. The former style of map was initially an approximation of the real geography, but as surveying methods improved they became fairly accurate to scale, giving the traveller a feel for the distances involved and the man-hours required to walk. Bird's eye maps on the other hand afforded a fantasy view of the world. Apart from the chance mountain-top panorama, no person was able to see the world in this way. The maps ignored actual physical distances but instead offered an exhilarating rendering of relationships between places of cultural or religious significance. This free-wheeling attitude to accuracy was reflected in the *sugoroku* board games based on travel which became stylised versions of real journeys and offered a vicarious experience of travel to those unable to experience the real thing.

Apart from travel on official business, which was restricted to certain classes, the best opportunity to travel for ordinary people was the chance to join a pilgrimage to one of the many sacred sites of Japan. From the Heian period, aristocrats had gone on pilgrimage to shrines and temples in the area around Kyoto, and in the Edo period this opportunity became available to a broader range of people. The most important Shinto destination for pilgrimage was the main

8 Nishiyama Matsunosuke (1997), *Edo Culture*, University of Hawai'i Press, USA.

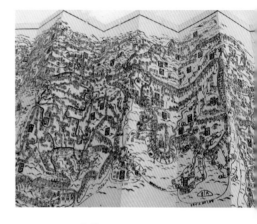

fig. 52

Detailed Handy Map of Japan
Dainippon hayabiki saiken ezu
1835

Published in Nara, this is a highly detailed but simple black and white folding map showing the main highways, sea connections and pilgrimage routes. Edo is marked in the centre of the fold to the right, Osaka in the centre of the fold to the left. The *Tōkaidō* snakes out of Edo to follow the coast towards Kyoto in the west. Topographical features are shown, and distances between stops marked in *ri* (one *ri* was approximately 4 km/2.5 miles).

fig. 53

Famous Places of the *Tōkaidō*
Tōkaidō meisho zue
Katsushika Hokusai
1818

This print by Hokusai is a classic of bird's eye cartography. There is little regard for accurate geography but instead emphasis on the significant places. The virtual traveller begins bottom right at the Edo departure bridge (Nihonbashi) and follows the winding road encircling the sacred Mount Fuji before arriving top right at Kyoto (see also fig. 5, p.16).

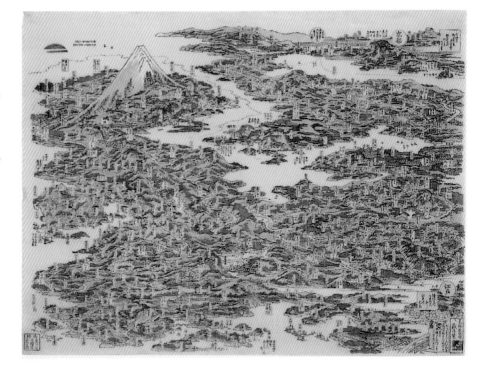

9 KANNON

Kannon is one of Japan's most popular bodhissatvas and represents infinite compassion and the power to protect from danger. Originally male, in female form Kannon became the bodhissatva for childbirth.

shrine at Ise dedicated to Amaterasu Ōmikami, the Sun goddess. The shrine sustained a network of *oshi* (circuit priests) who travelled the country setting up confraternities (*kō*) in preparation for group pilgrimages to Ise, which for complicated calendrical reasons were supposed to take place every 60 years.

Estimates of the numbers visiting Ise in the 1830 pilgrimage range from three to five million. These official pilgrimages were known as *okagemairi* (blessings pilgrimages), and the pilgrim needed permission and papers to travel, and on the road they were showered with alms and gifts. During the Edo period a fashion developed for unofficial pilgrimages called *nukemairi* (runaway pilgrimages). A person (often women or children) would 'go missing' without permission and set off ostensibly on pilgrimage. Even though their disappearance may have caused hardship at a critical time in the agricultural cycle, these absences were indulged, almost as a rite of passage and the pilgrim went unpunished on his or her return, as they often brought back a gift to atone for their absence.

It would, however, be a mistake to interpret either type of pilgrimage as an expression of boundless religious zeal. For many, this was one way to, however briefly, escape the strictures of everyday life, and often the pilgrimages were in fact cover for travel designed to indulge in the earthly delights offered on the road. Some commentators suggest a division of 70% enjoyment, 30% belief. A well-known Japanese proverb '*tabi no haji wa kakisute*' can be roughly translated as 'whatever you get up to when travelling can be forgotten' and gives an indication of the tone of many excursions.

In addition to Shinto destinations, Buddhist pilgrimages based on temple circuits – for example, the 88 Shingon sect temples of Shikoku or the 33 temple *Saikoku Junrei* dedicated to Kannon[9] near Kyoto – became popular. These required a visit to each temple and were clearly a major undertaking few could contemplate, so enterprising regions produced their own local versions which could be accomplished more easily and would presumably afford the same religious benefits as the original. It would take a month to do the 88 temples of Shikoku, but the 1756 copy circuit in Edo could all be visited in six days and you could sleep at home at night. Pilgrim's associations (*kō*) were formed to

fig. 54

Blessings Pilgrimage for a Rich Harvest
Hōnen okagemairi no zu
Utagawa Yoshiiku
late 1800s

This print depicts a mass, almost hysterical, outbreak of dancing in 1867 which became known by the chant 'Éjanaika' ('it's alright') and occurred at a time of momentous political change and reform. It began in Aichi prefecture (near Nagoya) and spread as far as Edo. Rumours circulated that amulets from Ise shrine and other religious icons were falling from the sky as a sign of better times ahead. People dressed up in extraordinary outfits, took to the streets dancing and chanting, going into the houses of the better off and helping themselves to food. Nudity and transvestism were not uncommon. Officials tried to control the outbreak by arresting people who claimed to have seen things falling from the sky. At a time of political and economic turmoil, *Éjanaika* can be interpreted as a mass reaction to oppression. Others see it as an extreme form of the periodic mass pilgrimages to Ise.

fig. 55

People on their way to Mount Ōyama and Mount Fuji
Takanawa ōkidonō Ōyamakō to Fujikō
Utagawa Kuniyoshi
1830–44

Both Mount Fuji and Mount Ōyama with Afuri Shrine at its summit were popular destinations for pilgrims. This Kuniyoshi print shows members of different pilgrimage associations (*kō*) in their respective uniforms. Members of *Fujikō* (towards the front) traditionally wear white and carry a climbing stick. The other pilgrims, some shouldering portable shrines, look more robust and include several members with a full tattoo. Kuniyoshi himself may well have belonged to such a pilgrim's association and may also have been tattooed.

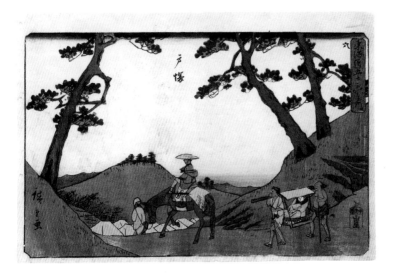

fig. 56

**Totsuka stage 6 from the *Gyōshō
53 Stages of the Tōkaidō***
Utagawa Hiroshige
c.1845

This *Tōkaidō* scene shows travellers
coming down the hill towards
Totsuka. The traveller riding the
horse appears to be enjoying the
ride while a woman huddles in a
sedan slung between two rather
grumpy-looking carriers.

organise the outings and spread some of
the costs. Pilgrimages were particularly
popular in Edo with firemen, small business
owners and grandparents, all hoping to
acquire merit of some kind. The pilgrim set
out equipped with straw sandals, a straw hat,
a blank book, votive slips, paste and a book
of hymns. At each temple a slip was pasted,
a hymn was sung and an entry made in the
book by the priest. As the number of pilgrims
increased, this hand-written entry became a
woodblock stamp.

Of all the great journeys in Japan, it was
undoubtedly the *Tōkaidō* linking Kyoto and
Edo that has became the most well-known
road and the one most represented in both
word and picture. The orderly progression of
the 53 stages of the road became best known
through the medium of woodblock and for
the new city of Edo it became both a physical
and metaphorical link with the past and
Japan's cultural heart, Kyoto. Although a
secular route, there is, however, a link with
early Buddhism in the familiar 53 stages.
Zenzaidōji (Sanskrit name Sudhana Sreshthi-
daraka) was said to have been surrounded
at birth by gold and treasure but later, on
meeting the bodhisattva Monju (Manjusri in
Sanskrit), he decided to seek truth and
enlightenment by visiting 53 wise persons
including monks, nuns, kings, gods and
even a ship's carpenter. This staged journey
of enlightenment became a template for
Buddhist training and is echoed in the famous

Tōkaidō where the knowledge offered at
the 53 stages was of a more prosaic nature,
although for many it may well have been
a life-changing experience of a kind.

For travellers embarking on these
adventures, information about what to
expect, where to go, how to behave when
you got there and above all else what to
avoid, was of the utmost importance.
Members of associations (*kō*) kept informal
diaries full of information for subsequent
parties and in 1810 Yasumi Roan, a veteran
traveller, published *Ryokō Yōjinshū*
(A Collection of Travel Precautions) which
gave copious practical advice. There is a
familiarity to the concerns; how to behave,
what not to eat or drink, how to protect your
belongings, who to avoid (in particular the
allegedly disease-ridden prostitutes at the
inns) and how to stay out of fights. The
many remedies suggested for motion-sickness
while riding in a palanquin were no doubt of
particular relevance to the traveller able to
afford the luxury of being carried.

An illustrated woodblock novel *Tōkaidōchu
Hizakurige* (Shanks' Mare) by the master
humourist Jippensha Ikku (1765–1831),
follows the Rabelaisian exploits of two
loveable rogues, Yaji and Kita, as they travel
the *Tōkaidō*. The story was issued in parts
(first appearing in 1802) following their
escapades and misadventures as they travelled,
and it is pretty clear that even if they had read
a book of travel advice they had not heeded

fig. 57

A Collection of Travel Precautions

Ryokō yōjinshū
Yasumi Roan
1810

This humorous illustration of a sturdy leg offers advice on the best points to apply moxibustion to relieve the aches and pains of the road. The book gives copious advice on such matters as the importance of good sandals, treatment for blisters and remedies for fatigue.

fig. 58

Shanks' Mare

Tōkaidōchū Hizakurige

Jippensha Ikku

1802–09

The humour in *Shanks' Mare* revolves around the exploits of Yaji and Kita on the road and their meetings with and misunderstandings of locals and their customs. The different types of baths they encountered was a subject of particular interest to them.

its contents. The story of their comic journey was much imitated and their exploits illustrated, especially in travel *sugoroku* (see fig. 184, p. 170 and fig. 104, p. 104). The popularity of Yaji and Kita probably came from there being a degree of authenticity to their experiences.

Over-indulgence in many forms was one of the attractions and dangers of the road. The guide books were assiduous in listing not only practical information such as distances between stations, the names of inns, etc. but also the delights on sale at the various stages. Each stop developed an identity with its own famous product from yam soup at Maruko, native pictures at Ōtsu (see fig. 111, p. 109) to harlots at Okazaki. One of the most popular souvenirs, however, was a woodblock print of the famous beauty spots on the road.

As well as books of advice, another popular genre called *meisho-zue* (gazetteer) satisfied the desire for information on and a reminder of famous places. The encyclopaedic *Tōkaidō Meisho Zue* (*Tōkaidō* Gazetteer) was first published in 1797 and quite possibly influenced Ikku's novel as well as Hokusai and Hiroshige's landscape series. References through word or picture to famous beauty spots had always been an important element of traditional Japanese culture and with the mass production capabilities of woodblock this enjoyment spread to a wider audience. The famous places were not only renowned for their scenic beauty, but their importance was reinforced by the sheer weight of cultural reference. Illustrated books as well as the more well-known single sheet prints of Hokusai and Hiroshige fed this thirst for images and could of course be appreciated

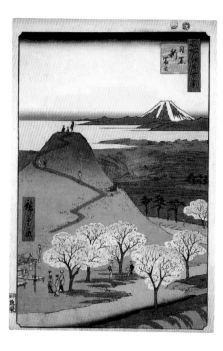

fig. 59

New Fuji in Meguro (*from the series* 100 Famous Views of Edo)

Meguro shin Fuji

Utagawa Hiroshige

1856–58

A replica Mount Fuji built in Meguro in 1819 dominates the foreground of Hiroshige's print. The zigzag path imitates the path used by pilgrims to ascend the real Fuji – itself a quiet presence in the distance. The cherry in bloom is an inaccurate but fanciful addition – the replica (and real) Fuji's open season would have been in the summer.

JAPANESE POPULAR PRINTS

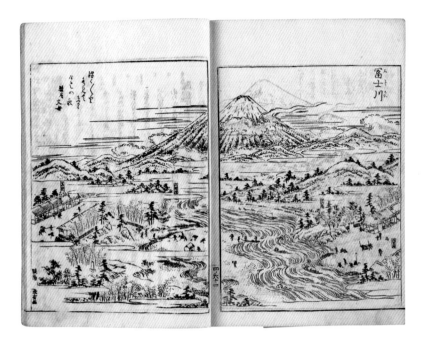

fig. 60
Tōkaidō gazetteer
Tōkaidō meisho zue
1797

This gazetteer is an illustrated
encyclopaedic account of the
highlights of the *Tōkaidō*. Although
Hiroshige did travel the road, it is
likely that he and other artists took
information from the gazetteer for
their prints. Drawn from a high
viewpoint, Fuji rises majestically in
the distance with travellers crossing
the river in the foreground. A ghost
Fuji printed on the previous page
shows through the paper.

by those unable to read. Hiroshige actually
travelled the *Tōkaidō* as a lowly retainer in an
entourage escorting a gift of horses to the
emperor in Kyoto, and it is thought possible
that he sketched as he went giving his prints
a true flavour of the road and the people who
travelled it. Likewise, illustrated books and
prints of scenes in the burgeoning metropolis
of Edo would have prepared new arrivals and
informed the people back home of the ways
of the city. Even dialect manuals were
produced to help visitors or newcomers
understand Edo's distinctive language.

Watching over this bustling city of Edo was
(and on a clear day still is) one of Japan's
sacred mountains. Mount Fuji was recognised
as not only a beauty spot but also thought to
represent the Pure Land Buddhist paradise.
High mountains were also believed to house
ancestral spirits and deities, and apart from
an open period when commoners could enter,
were off limits. Although Fuji's deity was
considered female, until 1892 women were
prohibited from entering holy mountains. In
the early 17th century, associations (*Fujikō*)
which combined Buddhist and Shinto
elements but which worshipped Fuji were
founded and grew in popularity (there were
more than 800 in Edo alone) organising
devotional trips to the mountain. This activity

fitted with the prevailing travel boom, but
initially excluded women and the infirm who
physically could not make the journey.
Alternative Fujis were needed as a substitute
and a practical solution was found in the
construction of replica miniature Fujis in Edo
(some survive today) incorporating lava from
the real Fuji. They were no more than a few
metres high and climbing a replica Fuji soon
became part of the round of annual events
beloved of Edoites. During Hokusai and
Hiroshige's time, there were ten replica Fujis
in Edo.

By 1887, with the building of a 33 metre
(108 feet) Fuji in Asakusa (see fig. 185, p.171),
devotion to the mountain had entered the
world of popular entertainment. The value
placed on the symbolic presence of the
mountain, particularly by the citizens of Edo,
is reflected in the many prints showing Mount
Fuji, the most famous, of course, being
Hokusai's *36 Views* and the many other Edo
views which include it. Some cut-out prints
offered a flat view which could be made up
into a 3D model of the mountain. Maps were
also printed which could be made up into a
cone shape showing the main roads and inns
at the foot of the mountain and the paths
leading up to the peak. To the inhabitants of
what was effectively a 'new town' of Edo, the

fig. 61
**Onoterasaki Shrine,
Taitō-ku, Tokyo**
Replica Fuji
1828

Originally built in 1728, but re-built
in 1828, this replica Fuji is barely
5 metres (5.5 yards) high, is made
from lava and survives today tucked
away in the shrine compound.
The path to the top twists and
turns in imitation of the real path.
The summit is rather plainly marked
with an iron pole.

sacred Mount Fuji offered a local tourist symbol to rival the many splendours of the imperial capital of Kyoto.

The landscape prints of Hokusai and Hiroshige with the signature brushed Prussian blue skies are still the images of Japan favoured by souvenir producers with a Western audience in mind. The freshness of the compositions and richness of colour continue to please the foreign eye and prolong their dreams of a Japan which has long since gone. The 19th century landscape scenes were designed to prompt dreams among a populace who, although benefiting from a period of peace and relative economic prosperity, were denied real access to or much knowledge of the outside world. These prints are the high-profile end of a genre of woodblock ranging from simple black and white maps to complex guides which helped to feed an extraordinary culture of domestic travel. The information held in both words and pictures recreates powerful images of a nation at play, intoxicated with the liberation of travel. In the words of Jippensha Ikku's heroes Yaji and Kita as they set off on their journey:

'Now is the time to visit all the celebrated places in the country and fill our heads with what we have seen, so that when we become old and bald we shall have something to talk about over the teacups.' [10]

(left and above)
fig. 62
A Pictorial Representation of Mount Fuji
Fujisan shinkei zenzu
Hashimoto (Utagawa) Sadahide
1848

Produced to coincide with the boom in Fuji worship this dramatic aerial view of Mount Fuji is designed so that the centre rises into a cone shape. The real Fuji includes womb-like caves; here two cave-dwelling ascetics appear to have lived to be 102 and 63. A flap (top left) lifts to show the inside of a cave. A group of pilgrims is about to embark on the climb.

fig. 63
A woodblock printed 3D map of Mount Fuji. Printed flat and then made up, it shows the road round the bottom with details of inns, stops, etc. and then the paths branching off up the mountain.

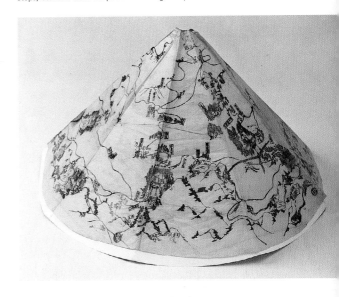

10 Jippensha Ikku (1960) *Tōkaidōchu hizakurige* or *Shanks' Mare* tr. Thomas Satchell, Charles E. Tuttle, USA/Japan, p. 23.

Advertising *hikifuda*

fig. 64
Acrobatics
Karuwaza
Matsuura Moriyoshi
c.1853

This is a handbill for a performance by one of the 3 leading circuses in the late Edo period. Acts included the high wire, swings, sword throwing, escaping from a basket and tricks with ladders.

The potential of woodblock printing, combined with a production system able to produce 50,000 advertisements for one of the major Edo stores, was clearly a force to be reckoned with. This scale of output would have needed the combined efforts of many carvers and printers and gives an indication of quite how formidable the print business was. Woodblock's ability to produce cheap but colourful and attractive images was quickly harnessed by the shrewd merchants of Edo, and their flair and entrepreneurial spirit took the art of advertising to new heights. From

humble black and white beginnings in the late 17th century, Japanese advertising entered the 20th century in full colour, ready for the even greater possibilities offered by mechanical printing.

Handbills (called *hikifuda* in Edo and *chirashi* in Kyoto/Osaka) were originally hand-written, but with the advent of woodblock began to be produced in black print. Japanese woodblock's flexibility in combining word and picture as seen in illustrated books was soon exploited for commercial ends in *hikifuda*. With a brush-written language based on

pictorial characters, the link in Japan between word and image has always been strong. Before printing made advertising a mass medium, the visual sweep of Japanese streets had been shaped by commercial shop signs (*kanban*) based on ideograms linked with powerful imagery. This highly developed visual language moved from the townscape into print where it reappeared as handbills, posters, logos and product placement.

The early copywriters of *hikifuda* were literary figures or scholars but as the business developed, production became part of the dynamic world of popular print and best-selling authors such as Santō Kyōden¹¹ became not just a copywriter but a fledgling art director. Kyōden epitomised the genre: he was not only an author and poet, but also an illustrator, ukiyo-e artist and Edo shopkeeper. Apart from the most basic designs which were probably drawn and cut by the carver, *hikifuda* used the established woodblock quartet of publisher, artist, carver and printer. In addition to this group, lantern makers contributed calligraphy skills already honed on lanterns and outdoor signs. Some of the designs included a blank space in which the business could hand-write their name, others used the *umeki* method to inlay and carve a fresh piece of wood into a standard design and reprint it for a new customer. Masterminding the production were the familiar publishers, particularly the most famous, Tsutaya Jūzaburō and many well-known artists, Utamaro, Hiroshige, Hokusai, Kuniyoshi and Eisen did advertising-related work. Starring the leading actors and courtesans of the time, advertisements

produced by top writers and artists became a feature of Edo society.

There was a saying that the only two trades that did not need to advertise were pawnbrokers and coffin makers. It comes as no surprise to find that over 50% of advertisements, and historically the oldest, were for patent medicines. Dry goods merchants became major advertisers around 1700, followed by the food business in the early 19th century. Early medical *hikifuda* tended to be wordy, as in an age without scientific proof it was important to warn the purchaser of imitations and convince them that this particular family recipe was produced with divine assistance and is therefore more efficacious. Relief from the perennial agony of toothache was promised in many *hikifuda* and others, as a last resort, offered fine boxwood and soapstone false teeth capable of chewing dried squid. Toothpaste, by contrast, was a good example of the skill of the Edo merchant in attracting the celebrity endorsement of the Ichikawa acting dynasty. Kabuki actors not only appeared in advertisements, they mentioned brands in their plays and some even owned shops. Product names were also mentioned in popular literature.

One of the most effectively advertised products was a white face powder (*oshiroi*) called *Senjokō* made by the Sakamoto family in the heart of Edo. Sakamoto's ancestors had been part of the ukiyo-e print world so he was particularly adept at the use of print in promotion. He was responsible for many examples of what would now be called 'product placement'. The name *Senjokō* appeared innocently in prints as a sign on a

wall or a discarded wrapper, or more overtly with copy extolling its virtues in the background of a 'beauty' print. Many of Hirsoshige's prints in the *Hundred Famous Views of Edo* series likewise show shop and product signs as part of the townscape. These prints were not only guides to the city for travellers but were also taken back home as souvenirs, spreading knowledge of both Edo as a city and its products.

Some of the most colourful advertisements were produced in a partnership between the major stores such as Daimaru or Echigoya (now Mitsukoshi) and the print publishers. They of course were always keen to find ways to subsidise their output, so by including elements of advertising in the prints they shared their costs and the store got a printed

advertisement. Very often they featured glamorous courtesans dressed in the latest textiles and fashions, and in the background the logo of the store subtly told the viewer where to shop. The style and dress of the courtesans made them the supermodels of their day and through featuring in these advertisements the trends they set in kimono fabric, hairstyle, etc. spread at remarkable speed across the city and beyond.

Government reforms in the early 1840s (*Tenpō* Reforms, see p. 78) made yet another attempt to clamp down on excess by forbidding the portrayal in print of actors or courtesans. An ingenious print series by Utagawa Kunisada (1786–1864) called *Contemporary Stripes Woven to Order* was produced ostensibly to advertise the latest

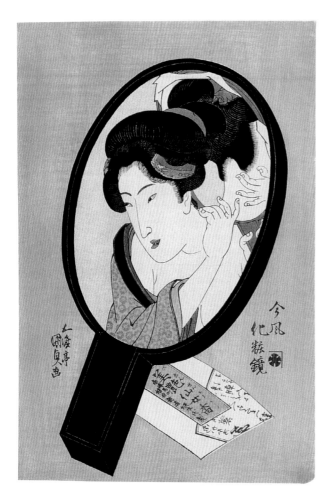

fig. 66

Contemporary make-up mirror
Imafū keshō kagami – awasegami
Utagawa Kunisada
1823

Around 1821 *Senjokō* face powder (also called *Biensennyokō*) became the leading brand for the Sakamoto store and as part of the advertising campaign the name appeared in numerous prints and novels making sure it was identified with the idols of the day. It was said to have been named after the famous kabuki actor who played female roles, Segawa Kikunojō III, whose stage name became Segawa Senjō. This print shows a beauty using two mirrors to carefully apply powder to the nape of her neck – a traditional Japanese erogenous zone.

She is wearing a tasteful kimono with a small crysanthemum design, loosened provocatively. The wrapper showing the name of the product lies casually beneath the mirror.

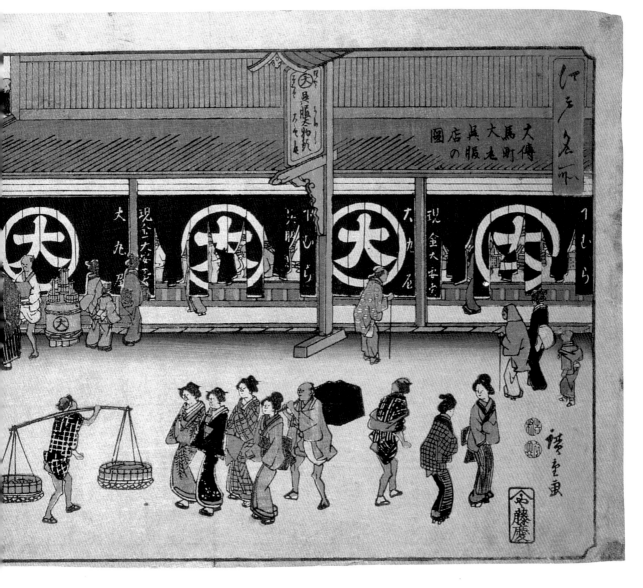

fig. 67

Famous Places in Edo – a view of Daimaru (clothing) store in Ōtenbachō

Edo meisho Ōtenbachō Daimaru gofukutennozu
Utagawa Hiroshige
c.1852

Daimaru was one of Edo's three main stores and was originally from Kyoto. It became easily recognizable by its logo mark (the character for large = *dai* shown in a circle = *maru*) which appears in this print on the shop curtains (*noren*). It was also used on wrapping cloths (*furoshiki*) and freight ships they owned. In Kyoto, Daimaru increased customer goodwill by not only ensuring their logo appeared on lanterns for festivals, they also gave old clothes and money to the poor in winter.

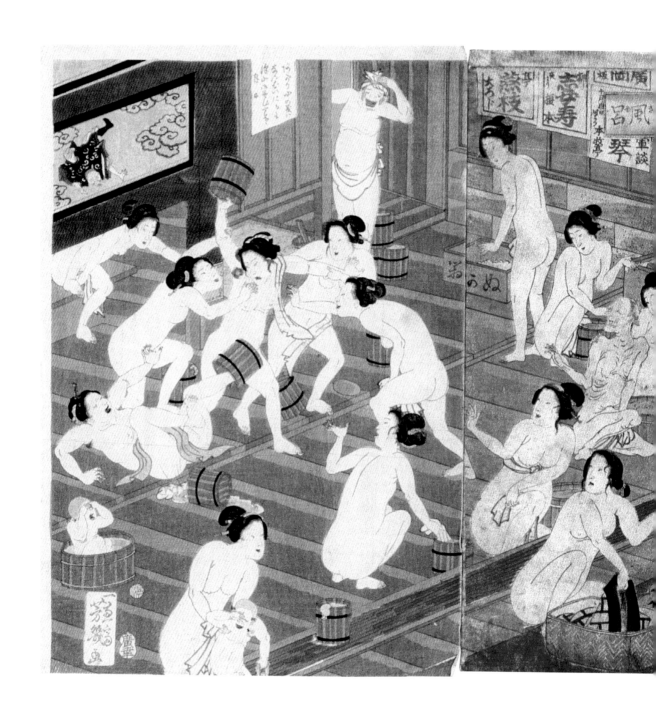

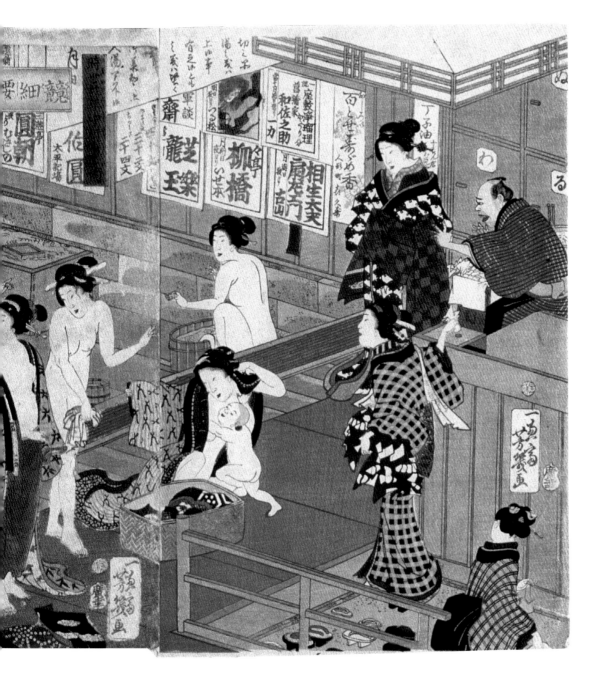

fig. 68

Snow-laden Willows (Women with Slim Waists) in the Public Bath
(*from* Seasonal Aspects of Women *series*)
Kurabekoshiyuki no yanagiyu
Utagawa Yoshiiku
1868

Public baths were popular places for posting and distributing advertisements, but in this triptych all attention seems to be focussed on the tub-wielding participants in a fight. Some of the posters in the background are for variety shows including a magic lantern picture show. (See also fig. 20, p. 31.)

striped kimono fabrics (see fig. 69, p. 79). The fabrics were featured in the background and by sheer chance there was a close-up portrait of a woman in the foreground. The market for portraits was satisfied and the authorities fooled.

The courtesans of Yoshiwara were not only popular as models in advertisements but they too used *hikifuda* to advertise themselves. Printed calling cards were distributed to the tea houses (*chaya*) to spread their names, and flyers for annual events featuring Yoshiwara beauties were also distributed. Rather more poignantly, in the confusion and unrest of the final years of Tokugawa rule, the regulated Yoshiwara system was rivalled by 'unofficial' (and cheaper) pleasure quarters so the Yoshiwara ladies produced *hikifuda* advertising price reductions on their services.

Some of the most effective advertisements were those with an added purpose such as calendars, games or fans which ensured them a longer than normal life. Umbrellas were given away when it rained, or lanterns to light the way home, all bearing the logo mark of the sponsor. The medicine industry of Toyama became well-known for developing a successful system of free gifts (see p. 114). One of the closest of these commercial links, however, was between advertising and travel when it spread from being the preserve of official business to becoming a popular pastime. Guide books and maps were produced in huge quantities to satisfy the thirst for information and allay traveller's fears, and they were very often sponsored by advertisers. As most of the travel was on foot, a network of inns spaced at regular intervals developed to feed and house the weary. Some offered very basic services, others included female company and advertising was an effective way to attract custom. Inns printed *hikifuda* name cards in the votive slip format (*senjafuda*) used for pilgrimage and distributed them to travellers and more importantly other innkeepers on the same route. It seems that a hand-written endorsement on one of these *hikifuda* given to a trusted traveller acted as a recommendation from one innkeeper to another. On his arrival at the next stop the traveller already had in his hands the name and details of the inn for the night and when he handed over the card, a guaranteed welcome.

Commercial interests were not slow to capitalise on the profits to be made from leisure travel loosely disguised as pilgrimage. They opened shops near the popular destinations and used advertising to identify their product with that particular shrine or temple. Curiously, producers of breath fresheners seem to have been particularly effective in this; they worked to link themselves with Ise shrine, the destination for mass pilgrimage, and became a souvenir of choice.

The end of the Edo and the beginning of the Meiji period ushered in social changes already outlined which were reflected in the style and content of *hikifuda*. Prints produced in Nagasaki and Yokohama featuring foreigners and their habits influenced the imagery, and foreign words started to appear in the copy. *Hikifuda* became yet another part of the government-initiated move towards 'civilisation and enlightenment' (*bunmeikaika*). Initially woodblock continued to be the medium until the inevitable switch to take advantage of the mass production potential of lithography. It offered the ability to print on both sides of the paper (impossible with woodblock because the colour penetrates the paper fibres) thus allowing the reverse of receipts to be used for advertising. In addition lithography could include photographs and print tonally, which had always been difficult to achieve in woodblock.

The advertising audience changed too. In the Edo period it had been a relatively local business with the advertiser close to the customer. With the advent of advertisements in newspapers, this relationship became more distant and distribution changed too. *Hikifuda* had traditionally been distributed door to door, handed out or placed where people assembled such as theatres, festivals, pleasure quarters, baths or barbers. Poster advertisements (*bira*) were also pasted up in such places and at busy crossroads. Newspaper advertising changed everything.

The pioneering advertisers of Edo period Japan had two huge advantages in establishing a business. On a technical

[12] THE *TENPŌ* REFORMS

The *Tenpō* Reforms of the early 1840s were yet another attempt by the Tokugawa shogunate to re-assert control and restore the spirit of earlier reforms; *Kyōhō* Reforms 1716–45 and *Kansei* Reforms 1787–93. After serious crop failures in the 1830s, increase in food production became a priority and many who had moved to Edo were forced to return to their villages. Corruption was punished and frugality encouraged with the re-issue of sumptuary regulations clamping down on luxury. Merchants, great consumers of luxury given the chance, were ordered to reduce their prices. In the print world, portraits were restricted leading to artists finding imaginative ways round the restriction.

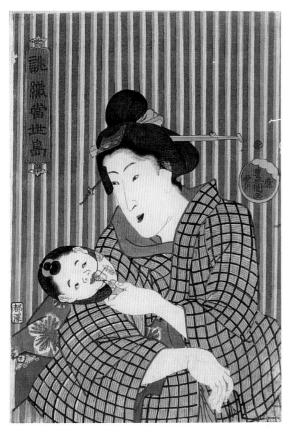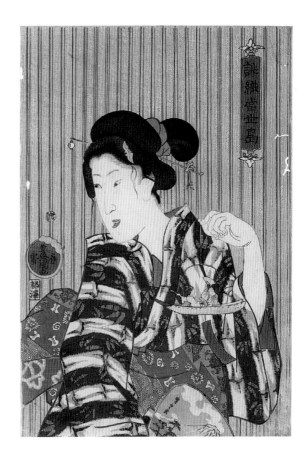

fig. 69

Contemporary Stripes Woven to Order

Chōshoku tōsei shima
Utagawa Kunisada
c.1843–46

This series of prints was devised as a way round restrictions on beauty prints imposed after the *Tenpō* Reforms[12]. Portraits of women against a striped background were ostensibly produced to promote new designs of cloth but were probably appreciated for other reasons. The subtle striped fabrics are typical of the *iki* style of Edo. The woman on the left cradles a flat fan (*uchiwa*) with the face of a child on it. On the right, the woman holds a toy boat in one hand and an *uchiwa* with a design of Mount Fuji in the other. *Uchiwa* were used particularly by women in the heat of the summer so they can have suggestive connotations.

level they could tap into the reservoir of skills in the woodblock world and harness the eye-catching qualities of full-colour prints to commercial ends. The illustrated book tradition plus the artistic qualities of calligraphy made the combination of word and image a natural partnership. On a cultural level, with a sophisticated visual culture and a society practised in the art of deciphering visual code they had a huge repertoire of ideas with which to work. Pictures within pictures, puns and satire all became pillars of advertising. In particular, the Edo penchant for stylish word play found a natural outlet in copywriting, especially in the hands of the best popular authors of the day. A homogeneous society such as Edo period Japan, well-versed both verbally and visually and skilled at reading encoded messages, encouraged advertisers to imply or say much more than simply 'buy this, it's the best'. The surviving advertisements, from the simplest black and white *hikifuda* to the full-colour courtesan pin-ups, are testament to that sophistication.

The outside world *Nagasaki-e, Yokohama-e* and *Saya-e*

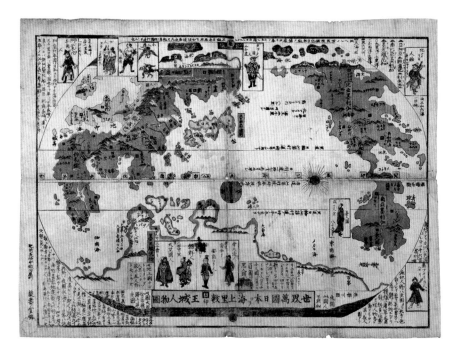

Japan's relations with the outside world have been marked by a curious mixture of enthusiasm and suspicion, initially with regard to the cultural colossus over the water, China, and later the West. Early years of engagement with what the Japanese called 'southern barbarians' were dominated by thriving trade and a surprisingly rapid spread of Christianity by Jesuits, aided by the printing press and moveable type. The influence of Christianity and the potential for foreign meddling were feared by the Tokugawa dynasty as they tried to consolidate their hold on the newly pacified country. They cracked down brutally on Christianity and in 1641 began a policy of exclusion; only the Dutch and Chinese were allowed to remain and contact was through the port of Nagasaki. Thirty Chinese and two Dutch vessels were permitted annual visits. The man-made island of Deshima in the harbour became home for the Protestant Dutch, who had managed to distance themselves in the eyes of the authorities from the missionary activities of the Portugese. Japanese people were forbidden to travel so their only knowledge of and contact with the outside world was filtered through Nagasaki. As is so often the case, official attempts at control foundered in the face of curiosity. As the country turned inward, the metropolitan culture of Edo became a magnet for novelty of all kinds and some of the more fascinating novelties could be found in the western ideas and artefacts seeping in through Nagasaki. A coterie of eager scholars became specialists in *Rangaku* (Dutch studies). In 1720, the ban on foreign books (other than those related to proselytising Christianity) was lifted and the slow run-up to the complete re-opening of Japan nearly 150 years later began. Any hopes the Tokugawa shoguns may have had of preserving their position through seclusion were effectively doomed.

Woodblock in its role as the 'circulation

system' of the body of Edo bourgeois culture, is an excellent barometer of the spread of Western influence. One of the earliest examples came in *uki-e* (perspective prints) which show a clear reference to, if not understanding of, Western perspective. The Chinese, and by extension the Japanese, pictorial systems did not have a tradition of linear perspective or attempting to capture the reality of the 3D world in a 2D format. The arrival (possibly via Jesuits in China) of the European system of perspective must have been electrifying. An Asian tradition of composition, which valued the power of empty space in attempting to enhance the mood or essence of a subject, met with a European scientific method of depiction.

Okumura Masanobu is credited with being the first print artist to produce *uki-e* around the 1730s and he was followed by many others. From then onwards, although by no means implemented in a strictly correct manner, linear perspective became part of the popular print vocabulary, often creatively combined with the traditional flat representation of Japanese art. The same playfully inaccurate attitude applied to the inclusion of light and shade into the traditionally flat colour of Japanese prints. Scant regard was paid to the rules of a single light source, more attention being afforded to the design possibilities of the shadow. By the time landscape prints flourished in the early 19th century, these imported European conventions had become an integral part of print language, and for many artists a printed imitation of a Western picture frame encircling the composition completed the picture.

The import of a viewing device which came to be known as *Oranda megane* (Dutch glasses) led to a new genre of perspective prints (*megane-e*) either modelled directly on European images or more probably on Chinese perspective prints from Suzhou. The European obsession with optics, aided by developments in glass technology and lenses, coupled with representational experimentation in art, all found its way to a largely glassless Japan, and very quickly became part of the novelty whirlwind of Edo. Prints show beauties playing with the

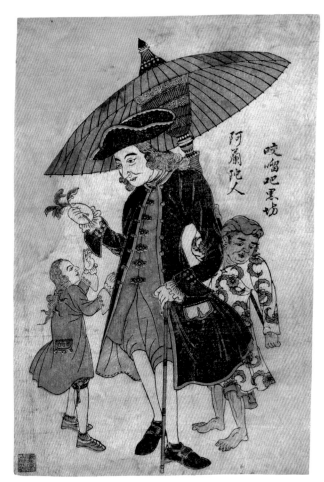

imported technology and peepshows and lens-based devices such as telescopes became popular sideshow attractions. Shadows projected onto the *shōji* (paper screens) and projected images as an attraction at the gates of Yoshiwara, reveal the speed with which the new gadgets were absorbed.

Nagasaki-e

The port of Nagasaki acted as midwife to these new trends but made its own print contribution through the medium of *Nagasaki-e* (Nagasaki prints) which reflected ('imagined' might be a more accurate word) the lives and customs of the mysterious foreigners on the island of Deshima. So near, yet so far – the Japanese were forbidden to cross to the island so the prints are more speculation than accurate representations. They first appeared in the 1750s, probably as souvenirs for visitors to Nagasaki to take

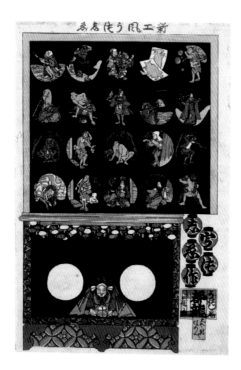

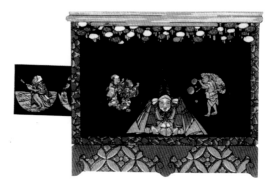

fig. 72
New-style magic lantern picture
Shinkufū utsushi-e
Utagawa Yoshifuji
late 1850s

The theme of this toy print was no doubt prompted by the popularity of magic lantern picture shows (see also fig.192, p.180). The stage is cut out and the printed circles cut into strips and passed through. The circles are spaced so that alternate images appear. The pictures include many monsters, several *Ōtsu-e* images (see pp.108–109), including a praying goblin, the lucky god Daikoku shaving the dome-headed Fukurokuju, Fujimusume (wisteria maiden) and a falconer.

home as both curiosities and evidence of the bizarre behaviour of foreigners. Until later in the 19th century when other nationals arrived, the main subjects were Dutch and Chinese men, their strange antics and accoutrements. The prints display a direct, almost naive curiosity about their subjects which greatly adds to their charm. Prints also

fig. 73
The Beast that is the Camel
Rakuda to iu kedamono
Kansai Ichirentei
c.1847–52

For the inhabitants of Edo the camel was a strange but popular sight at sideshows. This camel, however, is a parody of the spectacle. His body is made from other things – his head is a tied-up hood, he has a straw cape on his chest and his body contains the treasure ship (*takarabune*) of Japan's Seven Lucky Gods (see p.95).

featured exotic animals brought in as sideshow attractions, and most exotic of all, European women occasionally appeared. Their fates differed; women were forbidden on Deshima so they were expelled, the camels brought from Persia via Nagasaki in 1821 became popular exhibits in Edo before dying. In 1727 an elephant left Nagasaki for Edo to be shown to the shogun after which it had a long career as a novelty. When it died, its skin and skeleton became the exhibit.

Compared to the complex *nishiki-e* produced in Edo, Nagasaki prints were technically crude and unsophisticated. Their origins lay in Chinese New Year prints produced cheaply in Suzhou, which may explain the technical differences between Nagasaki and Edo prints. In both cases the earliest form was a black outline which was then hand-coloured. Edo, however, moved on from hand-colouring to the *kentō* registration system whereas in Nagasaki a stencil method (*kappazuri*) was used. A stencil for each colour was cut out of thick paper, placed over the black outline and the colour applied with a stiff brush. The coloured areas are not as accurately registered within the black outline as with the *kentō* method and inevitably a

thick ridge of colour builds up at the edge of each stencilled area as it is brushed. Compared to the Edo multicoloured method, stencilling gives the print a coarser, more hand-made feel. Stencilling is a technique commonly used in textiles and it is still employed today in the production of playing cards (see p.187). This may well be because European cards entered Japan through Nagasaki and that area became the initial centre of production. Not all *Nagasaki-e* were produced with this stencil method however; possibly through the migration of craftsmen, the Edo registration technique also came into use.

Whereas elsewhere in Japan, long-fibred Japanese papers were used for prints, Nagasaki prints used short-fibred Chinese paper giving a softer appearance to the printed line. Instead of the Japanese bamboo-covered *baren* a Chinese-style horse hair burnisher was used. As the Nagasaki print business was overall much smaller than Edo, and did not have the same enormous and eager audience, print publishers were mostly small family firms which covered all the stages of production, rather than the separate enterprises characteristic of the system in Edo. By the late 1850s *Nagasaki-e* were moving into decline as the focus of interaction with the outside world moved east to Yokohama.

Yokohama-e

In 1853, with the appearance off the coast of Commodore Perry and four 'black ships' the concept of foreigners suddenly became a subject of much more urgency. They were clearly no longer contained within the tidy world of Deshima acting as relatively benign purveyors of novelty. The demand for Japan to open up to trade was now backed by a threat of force superior to anything the Japanese could muster, and it was sitting just offshore in Edo Bay. The period of negotiation between Perry's first appearance and the official treaty of 1859, opening Yokohama as an eastern version of Nagasaki, has left many print

records of the events. *Shinbun nishiki-e* (see p.60) covered the American arrival thoroughly and many other prints recorded the mix of fear and curiosity with which the 'barbarians' were viewed. As the new home to these bizarre arrivals, Yokohama became the focus for print artists keen to exploit the commercial opportunity. Many of them must have looked to *Nagasaki-e* for hints as to how to handle the exotic subject matter. In the earliest days of open Yokohama, contact with foreigners was discouraged, but there was still an appetite for prints, so the artists had to work with information from images already available in *Nagasaki-e* and imported Western prints. For the first ten years or so, the prints concentrated on images of the people, their customs and behaviour, although in a rather unspecific way. Although there were many nationalities in Yokohama, the artists did not necessarily pay much attention to the detail of the differences between them. For the general print audience, the overall weirdness of a generic foreigner was sufficient.

The fascination with the cast of characters which had arrived in Yokohama was relatively

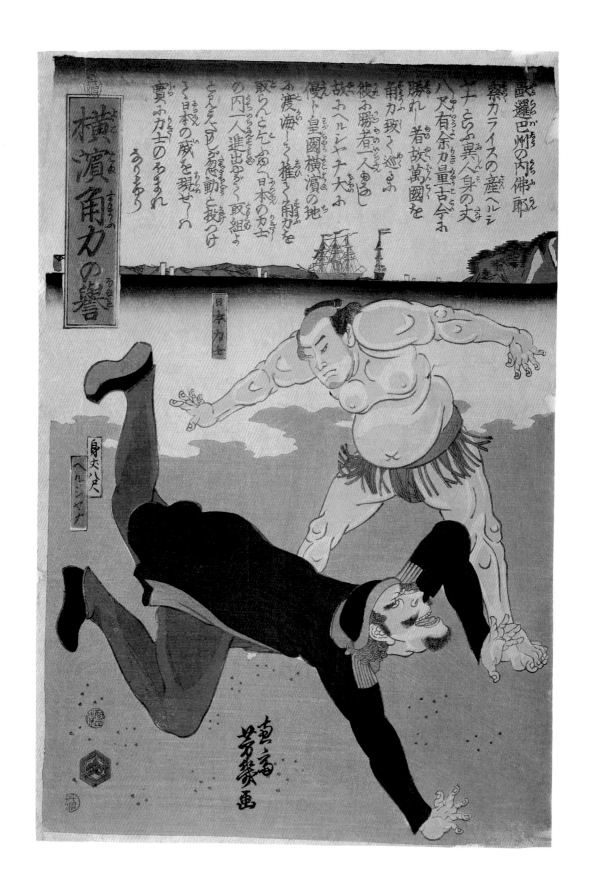

fig. 76

The Theory of Physics
Butsuri no genrizu
Anon
1873

This anonymous educational print of 1873 shows the old and the new Japan exploring simple laws of physics. On the left, steps make descending a slope easier while on the right, a slope is used to load weighty barrels.

(left)

fig. 75

Sumo Wrestler Tossing a Foreigner
Utagawa Yoshiiku
1861

In this humorous print produced by Yoshiiku, as foreign ships loom over the horizon, a sumo wrestler (representing Japan) unceremoniously upends the foreign upstart. According to the inscription, Herushana was a foreign wrestler over 2.6 m (8 ft 6 in.) tall who had travelled undefeated until his arrival (expecting further triumph) in Yokohama. At a time of sensitivity over Japan's relative level of development and ability to resist Western advances and firepower, this wrestling triumph must have been reassuring!

fig. 77

Audubon Discovering his Sketches Eaten by Rats
possibly by Utagawa Kuniteru II
1873

Audubon packed his precious bird sketches in a box which he entrusted to a relative while he travelled. On his return he discovered that a rat had nested in the box and his drawings were destroyed. After a few days of despair, he began the process of re-drawing them all.

This series of prints introduced the Japanese audience to important figures of Western learning and this story reinforced Japanese values of perseverance in the cause of scholarship. In addition, the 1871 translation of *Self-Help* by Samuel Smiles (biographies of eminent Westerners) had become a bestseller, creating an appetite for 'uplifting' tales.

short-lived. Attention soon turned towards the infrastructure of the place they inhabited. After a disastrous fire laid waste to both Japanese and foreign sections of Yokohama, the town plan was changed and Western-style fireproof buildings were constructed. They became favourite subjects for artists. The people were relegated to walk-on parts; the drama was in the development. Japan had embarked upon a policy of modernisation at breakneck speed, with the Meiji era slogan of *bunmeikaika* (civilisation and enlightenment) as the banner. 1872–73 was a momentous time in the advance of modernity with the

inauguration of the first train line, the founding of a postal system, adoption of the Gregorian calendar and the publication of the first newspapers.

Pupils of one of the last great print artists, Utagawa Kuniyoshi, were at the forefront of the attempt to capture the rapid changes in the character of their country. One of the most prolific was Utagawa Yoshitora, his dates are unknown but he was active between the 1850s and the 1870s. Other artists, Yoshiiku (1833–1904), founder of *Tokyo Nichinichi Shinbun*, Yoshikazu (active 1850–1870), Yoshitoshi (1839–92) of *Yūbin Hōchi Shinbun*, Yoshimori (1830–84), Yoshitoyo (1830–66), Yoshifuji (1828–87) and Yoshitsuya (1822–66), all from the Utagawa stable, were active to a greater or lesser extent. Kunisada III (1848–1920), Hiroshige II (1829–69) and Hiroshige III (1843–94) also worked in the genre. The artists active at this time had at least one thing in common; they had the misfortune to be working at a point when woodblock and the system and audience which supported it were in decline. There is a certain poignancy to the enthusiasm with which the artists portrayed the foreign influence, because it was the arrival of imported print technology which ultimately took away their livelihood.

Many of these artists also tried to prolong their working lives by producing some of the essentially ephemeral objects in this book such as *sugoroku* (see p.164) and *omocha-e* (see p.132). The rush to modernisation and the influx of new knowledge was reflected in

fig. 78

A Reading Primer
Redoru no oshiegusa
Shōsai Ikkei
1872

1872 was the year that marked the beginning of Japan's modern education system based on a centralised model rather than the local schools and *terakoya* that had gone before. Teaching materials changed too from the individual workbook style *ōraimono* (see fig. 32, p. 46) to visually attractive materials with high impact. Colour woodblock was perfect for the task.

This diptych illustrates English phrases which actually make little sense to a native speaker. Chinese texts could be read by the Japanese by annotating the sentence to fit Japanese word order. Here the English words are re-ordered to fit Japanese and annotated on one side with the pronunciation, on the other with the Japanese meaning.

these modest pieces, but there was no doubt that the skills of woodblock artists and craftsmen were no longer being used to the full. Hiroshige II's later years were spent producing labels for export tea crates and in 1892 Yoshitoshi, the most volatile and bizarrely talented of the late ukiyo-e artists, died, his heart supposedly broken by his conviction that ukiyo-e was over. He would perhaps be consoled by the fact that over 100 years later the technique of woodblock (if not ukiyo-e) survives and is practised in many countries besides Japan.

As the symbols of modernity associated with the West were absorbed and disseminated throughout Japan, demand for *Yokohama-e* depicting the ways of the newcomers declined. Woodblock had been tremendously efficient at facilitating the spread of an image of a new progressive future. Although this future was comprehensively based on ideas from the West, it was actually more of a surface image than a reality. Many of the changes appeared fundamental and drastic, but were in fact grafted onto an already functioning Japanese model. A more profound level of change would take considerably longer, but a pattern of technological absorption and innovation had been set.

13 Wright, Lawrence (1983) *Perspective in Perspective*, Routledge & Kegan Paul, London, p89.

Scabbard prints – *saya-e*

Saya-e are a particularly intriguing example of the Japanese adaptation of imported know-how. The direct translation of *saya-e* is scabbard prints and the reason for the name will become obvious. The most immediately noticeable characteristic of *saya-e* is the extraordinary distortion of the images, and these were produced using a drafting method imported from Europe called anamorphosis, 'the creation of a distortion by angular projection, and its correction by angular viewing of the result'.[13] Perhaps one of the best known pictures using the technique of anamorphosis is Holbein's *The Ambassadors* (1533) in the National Gallery in London. At the bottom of the picture is a distorted rendering of a skull, which reveals its correct appearance only when viewed along the picture plane from the right. Anamorphosis enjoyed a boom in 17th century Europe, so it seems possible that knowledge of the technique entered Japan via the Dutch enclave off Nagasaki. As knowledge of perspective and such 'tricks' of artistic deception were known and passed on by the Jesuits, particularly in China, this may also have been the route into Japan. The novelty of it, however, was soon recognised and

figs. 79 and 80
Mirror Pictures (Scabbard Pictures)
Kyōchūzu
Ōneisai
1750

These two illustrations come from a series of seven produced by Ōneisai, an artist trained in the Kanō school of painting, and show how relatively early Western learning had been absorbed. The pictures were produced by hand-colouring a woodblock outline. The circles mark the place to put the scabbard for a correct reflection.

fig. 79
Hotei Arm Wrestling with Daikokuten

The wrestling match is between two of Japan's Seven Lucky Gods – the semi-naked Hotei (originally a Chinese hermit) and Daikokuten, dressed as a prosperous Chinese gentleman.

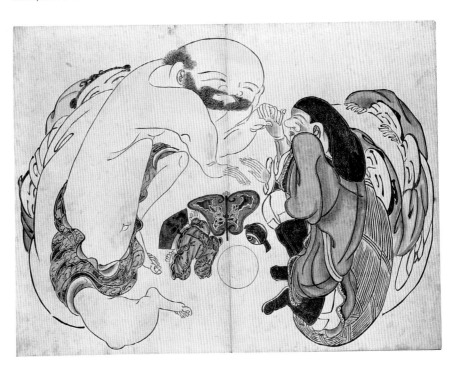

fig. 80

The Lady Author and her Two Lovers

This aerial view of the lady writer is an extraordinarily complex exercise in visualization and drafting. She is seen at her desk writing (right) while her two lovers peep through two separate sets of sliding doors.

To view the print, place a cylinder of mirror paper on the centre circle.

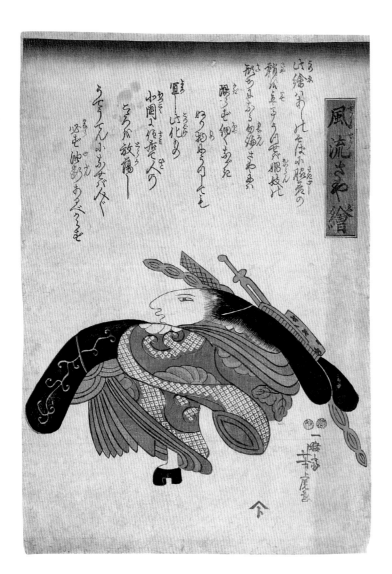

風流さや繪

fig. 81

Elegant Scabbard Print of a Courtesan

Fūryū saya-e – oiran

Utagawa Yoshitora

1847–52

In this print there is no circle to mark the position for the scabbard; the instructions are contained in the inscription. A lacquered sword scabbard placed just below the courtesan's foot would give a reflection of an elegant denizen of the entertainment world. Even though swords had to be left at the gate of the Yoshiwara, *saya-e* could still be enjoyed using a lacquered tube (probabaly bamboo) instead. Many a viewer, however, must have been puzzled by this print and its distortion and assumed that she was merely a strangely grotesque courtesan.

fig. 82

Courtesan *saya-e*

Anon

This print in poor condition shows just the outline of a courtesan in black and an inscription in red. It is similar to the Yoshitora print (left) which itself was based on an earlier picture from the 1830s.

absorbed into woodblock and resulted in a wave of popularity, although exceedingly few prints survive.

The technique of distortion used for these Japanese prints is cylindrical mirror anamorphosis. A cylindrical mirror is placed at a fixed point on the picture, and the reflected image shows the true representation. As there were no cylindrical mirrors available in Japan, they improvised using the shiny black lacquer scabbards of swords, placed upright on the print, hence the name *saya* (scabbard) prints.

The *saya-e* boom of the late 18th century was fuelled by the warrior classes as they were permitted to carry swords and therefore were in a position to enjoy the prints. The potential audience for these prints was therefore much smaller so it is unsurprising that few survive.

Some of the extant prints are simply a printed black outline with hand-colouring, others are printed in colour in the normal way. The most complicated part of the process comes at the beginning with the production of the distorted master drawing, although

fig. 83

fig. 85
The print reflected in a mirrored cylinder to show the undistorted figure.

fig. 84

Based on the print shown in fig. 82 in Bristol City Museum and Art Gallery, I reconstructed the process by which a *saya-e* would have been produced. An original correct drawing was placed on a square grid (fig. 83) then using the coordinates of this grid, the drawing was distorted for cylindrical anamorphosis onto a fan-shaped grid (fig. 84). The outline of the distorted figure would then have been traced onto thin paper, reversed and pasted onto a block to be carved.

given the drafting skills of the Japanese artists, once they had understood the theory it is unlikely that they would have had any trouble with the practice. An original drawing (a correct view) was first squared up on a normal grid, then redrawn, line by line, on the curved grid to give the distorted view. The distorted outline would have been traced on thin paper, reversed and pasted onto the cherry block and carved in the normal way to give an outline print (see p.19).

So few *saya-e* survive it is hard to draw too many conclusions about their use or subject matter. What can be concluded though is that Japanese artists once again seized upon an imported European method of representation, recognised the possibilities and made it their own through subject matter and use. A technique employed by Holbein found its way east to become part of the Edo delight in visual play.

faith
fortune
well-being

fig. 86

A Guide to Healthy Eating and Drinking
Inshoku yōjo kagami
Anon
late Edo period

For the Edoite notorious for over-indulgence, this
anatomical chart with a rather industrious interpretation
of the digestion process must have been illuminating.
Balanced intake of food and drink was considered
important in maintaining vital internal harmony and
living a long life.

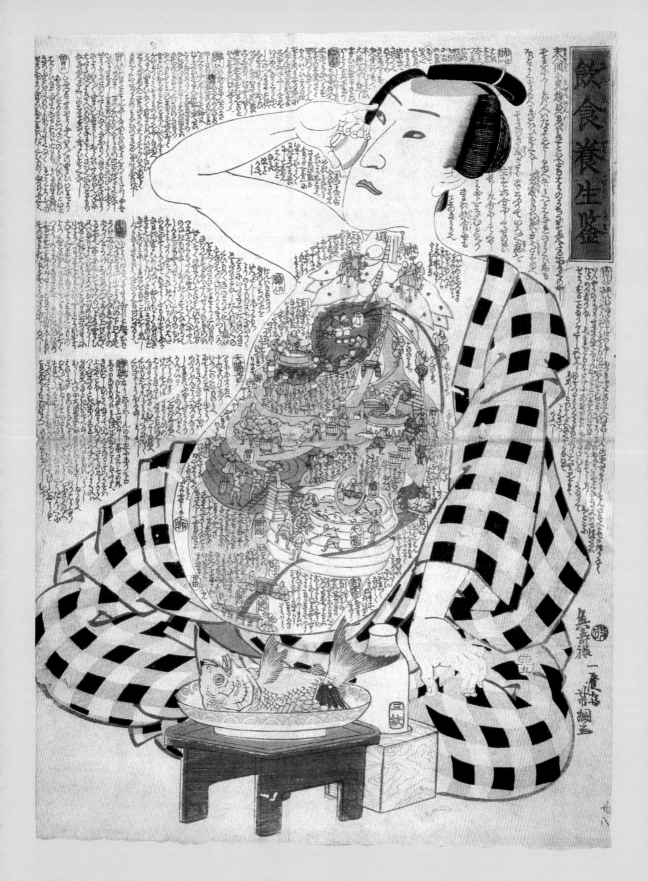

Votive slips and exchange slips *senjafuda* and *kōkanfuda*

fig. 87
Ema – votive picture tablet

The word *ema* literally means 'horse picture'. In Shinto the white horse was considered sacred, as they are supposed to carry messages to the gods, and one was often presented and kept at a shrine (see fig. 43, p. 55). Paintings of a horse on wood came to be a substitute offering of the real thing and over time the practice extended to include a request for a grace or favour. There are links between the origins of *ema* pictorial requests and *senjafuda* pilgrimages.

This *ema* shows a portrait of a *namazu* (catfish) – a picture play exploiting Japanese's homophonic nature. *Namazu* also refers to a skin disease (leukoderma) from which presumably the supplicant was suffering.

The traditional link between religious devotion and travel must, in the mind of the pilgrim, have been a calculated balance between the anticipated benefits and the possible dangers on the road. Apart from the obvious real perils of illness or accident, the pilgrim also feared roads infested with demons or wandering spirits with evil intent. Travellers would not only carry a paper amulet, but also sand or earth from their local shrine which they could swallow mixed with water if faced with danger on the journey. Votive prayer slips [14] (*senjafuda*) are descendants not only of the practice of pilgrimage but also show a deep link between the journey and writing. Chinese pilgrims carried a protective seal which they impressed in the soil of the road to ward off evil spirits as they went. In Japan, it was recommended to write the *kanji* for 'tiger' on the palm of the hand to terrify wild animals and evil spirits. When crossing a river, the traveller was advised to carry something bearing the *kanji* for 'earth/ground' to ensure safe passage to the other bank. *Senjafuda*

(literally 'thousand shrine slip') are an extension of the belief in the power of the word (or really the written ideogram) but focussed not only on the person but also on the act of offering through pilgrimage.

According to legend, in 988 the retired priestly Emperor Kazan wrote and presented (or by some accounts had carved in stone) a poem (*waka*) at Kokawa temple (in Wakayama prefecture), which was devoted to the goddess of mercy, Kannon (see p. 64). This act is generally regarded as the first instance of votive writing as an offering, and began a custom which developed into not only a trend for mass pilgrimages but also a thriving genre of woodblock print based around *senjafuda*. The practice continues today, with *senjafuda* enthusiasts each commissioning a votive slip bearing their name to be designed and printed. They then travel round, usually *en masse*, to paste a slip onto a building at each holy site. As we saw with the development of travel and pilgrimage in Japan, this activity was, and is, a blurring of leisure and faith,

[14] *FUDA*

Fuda were produced in standard sizes to make the most economical use of a sheet of paper. The single *fuda* was approximately 15 cm (5 in.) high and 5 cm (2 in.) wide. Multiples of this unit size as 2, 4, 8 and even 16 unit *fuda* were also produced.

although this tradition's roots lie clearly in the latter.

By the late 11th century, Kazan's devotion had developed into a more formalised pilgrimage route of 33 temples around Kyoto and Nara dedicated to Kannon. At each temple the pilgrim would leave their details and a devotional phrase written on a piece of wood (called a *nōsatsu*), often nailed to the building. By the early Edo period, paper was more widely available and popular because it was easier to carry. Some pilgrims also wrote directly on the building, the oldest known graffiti dating back to the 1500s. The *nōsatsu* which have survived give an indication of the identities of the pilgrims, where they had travelled from and the kind of divine favours they sought.

In the early years, the act of pilgrimage would only have been possible for those who had financial resources, and of course who were able to write. With the explosive trend for travel in the Edo period and the many pilgrimage routes developed to satisfy it, *senjafuda* and the act of pasting them up became very popular too. The chosen destination could be temples, shrines (especially those devoted to Inari, the god of harvests), sacred mountain beliefs or circuits devoted to the Seven Lucky Gods[15]. Visitors to Japan today can still see the continuation of the tradition of leaving a prayer behind at temples and shrines although now the most common request is for examination success.

fig. 88
An 8 unit *fuda* (see p.105) from 1914 showing weary pilgrims in traditional white outfits on their way up Mount Fuji.

These are often left as *ema*, a separate but related tradition of votive pictures (see fig. 87).

The close relationship between woodblock printing and votive offerings can also be seen in 12th century *suribotoke* (printed Buddhas). They were a simple image of Buddha carved in wood and then printed on paper, often cut into the shape of a lotus leaf. The devotee's name was written on the reverse before the slip was placed inside the statue of Buddha. The earliest *senjafuda* began as hand-written slips of paper (later printed) bearing just the personal details of the pilgrim and no request.

[15] THE SEVEN LUCKY GODS OF JAPAN

The Seven Lucky Gods of Japan (*Shichi fukujin*) frequently appear in Japanese art, often treated light-heartedly.

They are:
Fukurokuju – the god of wisdom recognisable by his abnormally large forehead
Daikokuten – the god of riches shown carrying a mallet and sitting on rice bales.
Ebisu – the god of food. He wears a black cap and usually holds a large *tai* (bream) fish.
Hotei – the god of contentment is usually shown half-naked, looking rather jolly.
Jurōjin – the god of learning with a penchant for drink. He is usually accompanied by a black deer; an animal thought to be wise.
Benten – the goddess of fertility and music. She often carries a *biwa* (stringed instrument).
Bishamon – often called the god of war, he is actually a guardian of Buddhist virtues. He appears in full armour.

All seven gods are frequently portrayed on board their treasure ship (*takarabune*) which is supposed to sail into port on New Year's Eve bearing treasure. The ship is usually escorted by the crane and tortoise, both symbols of long life (see fig.114, p.111).

fig. 89
Plain *sumi* ink votive slips for pasting showing just the name. Unlike *kōkanfuda*, (exchange *fuda*, see p.101) they do not have a border.

fig. 90
Worn *senjafuda* pasted at Kyōō-ji, a temple in Tokyo. The paper wears away in the weather leaving the printed ink behind.

They were known as *daimei* and by being pasted on the temple were believed to bring good fortune, prosperity for the family and freedom from illness. In the earliest days of Kannon worship the devotee was expected to spend the night keeping vigil in the Kannon hall; the *daimei* pasted on the temple was believed to be a substitute for the pilgrim's overnight presence and bring the same benefits. If there was no time to actually go to the temple, instead the hard-pressed supplicant could chant '*daimei*, *daimei*, *daimei*' and be similarly assured of blessings.

The popularity of pasting slips as part of a pilgrimage peaked in the Edo period and may have been connected with the explosive development of the cult of Inari *senjamairi* (pilgrimage to a thousand Inari shrines dedicated to the god of harvests). The practice became formalised with the establishment of groups of enthusiasts called *nōsatsukai* who organised the production of votive slips followed by communal trips to paste at shrines and temples. These same groups subsequently developed into exchange meetings where more luxurious exchange slips (called *kōkanfuda*) were commissioned and then swapped between members. A group member would produce two types of *fuda*; *senjafuda* for pasting and elaborate *kōkanfuda* to exchange at meetings.

The classic *senjafuda* for pasting was and still is a woodblock, printed in *sumi* ink on a slip of paper about 15 cm (5 in.) high by 5 cm (2 in.) wide. They were produced using the usual print network as the craftsmen themselves were often active members of *nōsatsukai* and so had all the skills to hand. This also explains close stylistic links between the world of ukiyo-e and *fuda*, particularly in the more elaborate *kōkanfuda*. On *senjafuda* used for pasting, the name was of paramount importance and was usually written using *kanji* (occasionally, the *kana* syllabary), often substituting more auspicious *kanji* with the same sound. The writing itself was done by calligraphers, many of whom, as lantern makers, would have also been group members. The style of script used was chosen by the individual but would have fitted with the style of Edo lettering as used in *banzuke*

and *kabuki* (see p. 53). In later years an official style of writing called *senjafudamoji* was developed which continues to this day. The style of *senjafuda* and their script crossed over into other areas: they appeared in single sheet prints and the format was much copied, for example in advertisements.

There were many different types of *senjafuda* for different purposes:

Daimei nōsatsu showing just the name, were meant for pasting.

Kawanagare nōsatsu were designed to be washed away in a river.

Shikoku henro nōsatsu were used for the 88 temples of Shikoku and *Funai henro nōsatsu* for the substitute circuit of 88 Shikoku temples in Edo.

Fujikō nōsatsu, printed with a sign of Fuji, were left at hotels and tea houses on pilgrimage to Fuji.

Senjamairi nōsatsu were pasted at 1000 shrines; this was particularly popular in the 1780s and as the more accessible spots filled up with pasted slips, enthusiasts sought ever more remote shrines and temples. The equipment associated with pasting was developed during this boom.

The composition of the *fuda* was given much thought. The calligraphy needed to fit the narrow format, occasionally a colour seal or mark was added, or a design symbolising the person's trade. Above all else it was important that the *senjafuda* should look

fig. 92
Printing a *senjafuda* using *sumi* ink

good seen from below, when pasted in a high place on a building. The finished composition was drawn out in ink on thin *mino* paper which was pasted (reversed) onto a block of cherry (both sides were used) from Fukushima or Ibaraki prefectures. The block was carved and then printed in black *sumi* ink using *masa* or *hosokawa* papers made in Edo around Edogawabashi. *Hosokawa* was a strong but thin paper and therefore hard to paste. It was said that it took ten years of practice before a member was ready to graduate to pasting the more awkward *hosokawa* paper. Treating the paper with strong size made from *nikawa* (gelatin) gave it added strength when pasted. When a batch of *fuda* had been printed the block was handed to the client for safekeeping in case of reprints.

The act of visiting the temples and shrines to paste *fuda* appeared to be more fun than devotional, and became particularly unpopular with those in charge of the buildings who saw it as a form of vandalism akin to graffiti nowadays. This is an even greater problem today, when *fuda* are mass-produced as sticky seals which can damage buildings; the original paste was at least the relatively harmless *nori* (rice paste). Many shrines and temples now outlaw the activity, although this can act as encouragement to renegade pasters who try it anyway.

The art of pasting the *fuda* underwent technical development too. Originally they were stuck by hand in low places, but it then came to be seen as a challenge to paste them as high up as possible. An extraordinary early technique was called *nagebari*; a pasted fuda was placed on a damp towel and hurled high

fig. 91
Block for printing votive slips (*senjafuda*)

The *kentō* (registration marks) for printing are clearly shown. To achieve a dense black the slip might be printed more than once. (The top is to the left.)

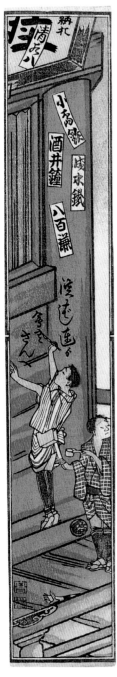

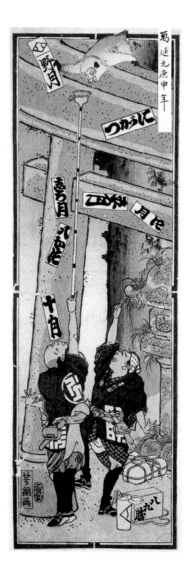

up at a beam or the ceiling. This may have been effective, but it lacked the control over position and placement, which was important for the Edoite competitive spirit inherent in pasting. The preference was for a prominent spot where everyone could see and appreciate not only the design of the *fuda* but also acknowledge that the person had visited. These spots were called *hitomi* (literally 'seen by people'), but had their disadvantages: the pasted *fuda* was more vulnerable to the ravages of the weather and more likely to be pasted over or removed by others. Collecting other pasters' *fuda* was another element to the activity. The alternative method was *kakushibari* (secret pasting); pasting in a hidden spot where your *fuda* could last 50–60 years out of the wind and rain, and very importantly still be there to be seen on return visits. Connoisseurs did, however, appreciate the appearance of prominently pasted weather-beaten *fuda*; the paper wore away first leaving the *sumi* ink letters almost tattooed on the wood (see fig. 90, p. 96).

The invention of an extending pole, now fibreglass but originally bamboo and jokingly called a *'nihonbashi'* (after the Edo bridge with reference to spanning a gap) made highly specific positioning and pasting possible. A specially made double brush, *meotobake* (literally 'husband and wife brush') with a clip to hold the pasted slip was fixed on the end of the pole. One part of the brush was used to clean the chosen area of dust, the pasted *fuda* held in the clip was flipped into place and smoothed down using the other part of the brush. The *fuda* paster also went equipped with a box (*gebako*) to hold the *fuda* and paste. There was a certain amount of rivalry between members, regarding both equipment and conduct. Young group members were often considered over-enthusiastic for running around pasting in as many places as possible; veterans on the other hand preferred to savour the moment and offer a quiet prayer. A saying *'ashi yori mo kubi no kutabireru senjafuda'* – 'it is your neck rather than your feet exhausted by *senjafuda'* gives a feel for the experience of a *fuda*-pasting pilgrimage.

Influenced by the understandable

fig. 93

This two-unit *fuda* (see p.105) was probably produced to mark a special occasion. The origins of *fuda* pasting lay in graffiti and here two young men are shown writing a name, 'Ukin san', in *sumi* ink directly on the building. The five names pasted higher up on slips may have been the fellow members (of the Yodobashiren possibly) who commissioned this *fuda* in honour of Ukin san.

fig. 94

Egoyomi – pictorial calendar
Utagawa Yoshitsuna
1860

An *egoyomi* from 1860 in the form of a four-unit *fuda*. Two men, probably carpenters belonging to the *Chiyodaren* (Chiyoda group) are attempting to paste a *fuda* onto a *torii* (gateway) at a Shinto shrine using the special brush (*meotobake,* see p.99) on a pole. The mischievous monkey (1860's zodiac animal) holds a *fuda* in his hand titled 'short months'. The *fuda* stuck on the *torii* already identify the short months for the year – 2, 4, 5, 7, 8 and 10.

JAPANESE POPULAR PRINTS

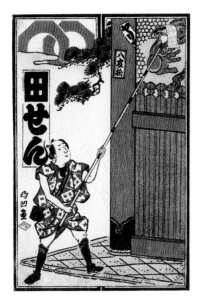

fig. 95
Fuda (prayer slip)
Woodblock print, ink and colours on paper,
14.7 × 9.7 cm / 6 × 4 in.

This late 19th century two-unit *fuda* shows
Tasen (his kimono is decorated with the
character *ta*), a member of the *Hakkaku ren*
(represented by the linked red octagons)
pasting his *fuda* through the torn chicken
wire supposed to protect a guardian statue.

fig 97
Making *meotobake* at Miyakawa
Brushes, Ueno, Tokyo

Meotobake are made by hand and are
particularly fiddly as the head is curved.
Horse hair (tail) is cut to length and secured
through drilled holes in the wooden brush
head using wire. The handles are made
square in section so that the purchaser can
customise the brush. It can be screwed
directly onto a pole, or the handle rounded
and slotted into bamboo. Some enthusiasts
even have the wood lacquered and
decorated before the brush is made up.

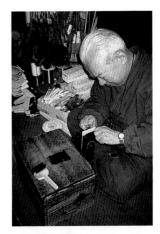

Horsehair and
meotobake
The smallest brush
(bottom left) called
ainuki (through the net)
is made specially to fit
through the chicken wire
mesh used to protect
statues at sacred sites.
The paster has the thrill
of pasting where he
should not (see fig. 95).

fig. 96
A paster's box with drawer

This box is larger than normal and
contains a selection of *fuda* plus
space for paste, brushes etc.

reservations of the building owners, especially
at popular sites, the groups did try to impose
standards of behaviour with house rules
governing how and where to paste, and also
tried to curb excessive spending on *fuda* and
travel leading to financial and family ruin.
Some, however, did become obsessed,
particularly with the quest for the ultimate
pasting experience. The penalty for the thrill
of pasting a *fuda* (clearly showing the name)
in a temple where they had been expressly
forbidden could be serious. There are records
of an enthusiast finally pasting a slip after
many attempts then being traced by his
name and sentenced to a period of exile on
a remote island.

Amongst group members a secret slang
language developed referring not only to
the equipment and practices of pasting,
but also giving an indication of the reception
one might expect to receive at the various
destinations. For example *hakoiri musume*
(literally 'daughter in a box' or 'virgin')
denoted a temple with no *senjafuda* pasted
yet, *kakoimono* ('a mistress kept in seclusion')
indicated that it was sometimes difficult to
paste, *yasukakoi* ('cheaply-kept mistress')
meant do not be afraid to try, and *shūto*
('mother-in-law') meant there was a complete
prohibition, you had to give up and accept
the situation! The wit concealed in these
terms is a clear indication of the degree to

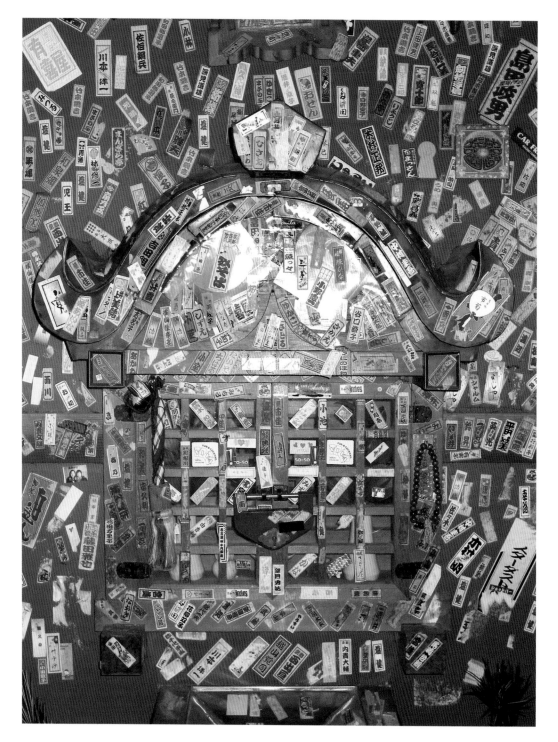

fig. 98

A small shrine, Jūgodaimyōjin in Pontochō, covered in *fuda*, is hidden in a
courtyard in one of the entertainment districts of Kyoto. It is dedicated to
a pottery statue of a *tanuki* (racoon dog) made in the nearby town of
Shigaraki. According to legend, a fire broke out in the area but stopped as
it reached the roof of the business where the statue stood – the *tanuki* was
broken in two but the building was saved.

fig. 99
Senjafuda pasted at the entrance to Shitaya Shrine, Ueno in Tokyo. On some, a logo mark above the name identifies the group to which the person belongs.

fig. 100
Senjafuda pasted on the ceiling at Kyōō-ji, a temple in Yanaka, Tokyo.

which the world of *senjafuda* was imbued with the Edo spirit of word play, and of course the universality of mother-in-law jokes.

The practice of exchanging *fuda* at meetings (*kōkankai*) is thought to date from about 1799, possibly starting as a more formal way for people who had met on the road on pasting trips to get to know each other. They would have been familiar with each others' names and *senjafuda,* so *kōkankai* not only offered the opportunity to have a gathering but was also the trigger for commissioning an elaborate *fuda* to be exchanged. The members were, of course, all male and often practiced typical Edo trades such as lantern-maker, brush-maker, umbrella-maker, woodblock carver/printer, food/restaurant business or building-related trades. To encourage high standards of production within the group, membership fees were often increased to discourage those not inclined to invest a suitable amount. At a time of continued attempts by the authorities to govern behaviour, these meetings were yet another outlet for the Edo appetite for living and spending for the moment. The number of groups proliferated and they had to find ever larger venues to meet in. They began to

identify themselves with a group (*ren*) mark and name, some of which were geographical referring to a part of Edo – *Fukugawaren* (from the Fukugawa area), others more poetic – *sakuraren* (cherry blossom group) or humorous *mushikuiren* (worm-eaten group). Joint meetings between *ren* were also held which offered the mainly merchant/craftsman class members a chance to meet and network. Some samurai also joined (they had to leave their swords at the door) giving the groups an identity which cut across class barriers. Membership did, however, require money and a certain amount of free time to go off on pilgrimages. Although group rules tried to impress upon members the importance of financial prudence, there were many stories of families and businesses brought to near ruin by the addiction to the production of ever more elaborate *fuda*. With some groups recorded as meeting as many as five times a month, the costs were considerable. After the terrible earthquake of 1855 (see fig. 48, p. 59), which boosted the income of those connected with the construction trade (who often belonged to these groups) some particularly fancy *fuda* were produced for meetings, especially one

fig. 101
A participant in the Sanja Festival (one of Edo's three great traditional festivals) held in May at Asakusa in Tokyo – a *senjafuda* is tattooed on his bottom!

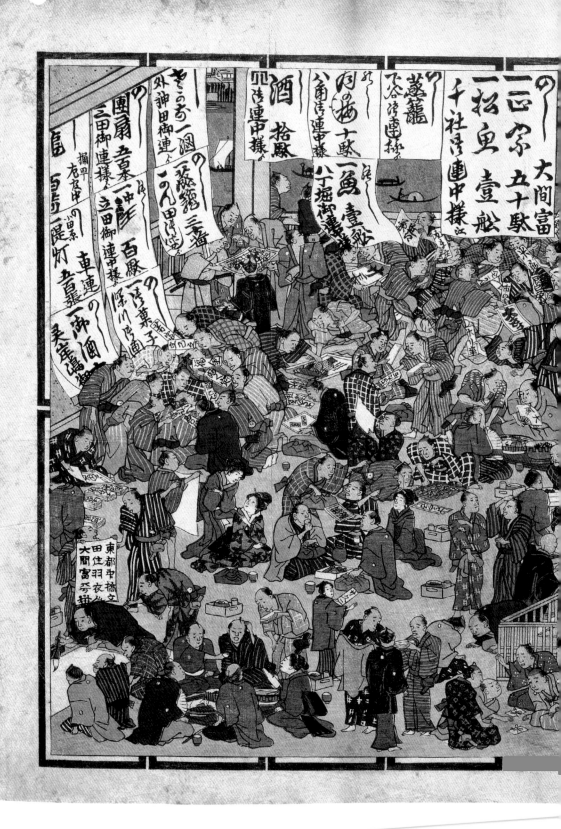

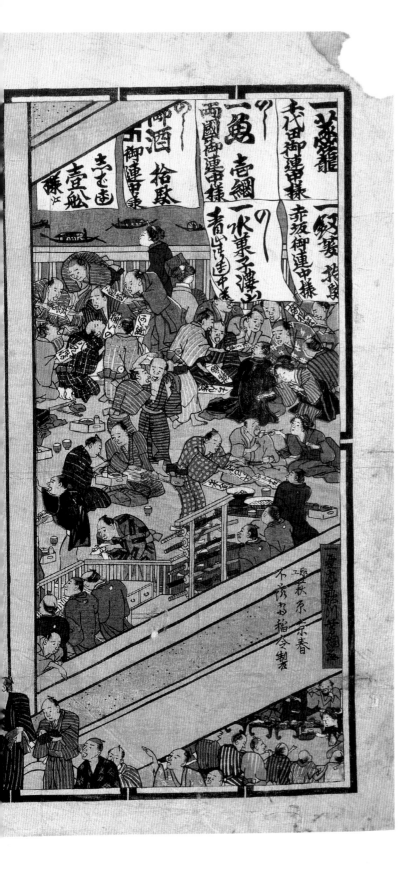

fig. 102

A 16-unit *fuda* produced for the Great Meeting of 1859, showing the Meeting itself
Utagawa Yoshitsuna

A joint meeting of two *fuda* groups was held on 20 June 1859 at a riverside restaurant in Higashi Ryōgoku. It is known that six giant 16-unit *fuda* were produced for the occasion, but only three remain. This one was produced by Yoshimura Keizo, a master plasterer and *fuda* enthusiast. He left his business affairs to his underlings and indulged his *fuda* addiction – allegedly going to as many as five exchange meetings a month, something only the very wealthy could afford. Another of the giant *fuda* (fig. 106, p.106) produced by Ōkyū is shown in this print being admired by enthusiasts (at the foot of the pillar on the upper left). The 16-unit *fuda* are the same size as a single sheet print but can be distinguished by the notched edge outlining the 16 individual *fuda* units.

The composition of this *fuda* is dramatically divided by the building's pillars. Several samurai were obviously present as their swords are placed in a rack near the reception desk. Hand-written signs hanging in the background record greetings from other groups and various contributions to the meeting. The participants are wearing the striped and checked kimono considered stylish (*iki*) in Edo. Women appear serving food and drink and even feeding a guest with chopsticks (centre right). Bottom left, a calligrapher is poised over a large sheet of paper, brush loaded with ink ready to write as people look on expectantly.

fig. 103
This two-unit *fuda* was produced by Tataume (his name is shown top right) in 1914 and is a map of the area in Asakusa, Tokyo around his *tatami* mat shop.

fig. 104
This four-unit *fuda* was produced for an exchange meeting in 1912. It shows double-page spreads from two open Japanese-style books and the scenes are again inspired by the Rabelaisian exploits of Yaji and Kita on the *Tōkaidō* in *Hizakurige* by Jippensha Ikku (see p. 66).

of the largest meetings ever in 1859.

The commissioning of *fuda* for these meetings fitted perfectly into the woodblock production system. The groups of *fuda* enthusiasts were in many ways similar to dilettanti groups credited with the introduction of full-colour printing. The *fuda* were privately ordered so they could indulge the 'money no object' freedom to pursue the quality seen in *surimono* and they were also beyond the reach of the censor[16]. It is possible too that *fuda* production went directly to the craftsmen who were fellow group members rather than through a publisher as intermediary. Popular writers of the time also belonged to groups so would have contributed to the selection of themes and ideas for meetings. Artists such as Hiroshige, Kuniyoshi and Eisen are all known to have

designed *kōkanfuda*; Hiroshige belonged to a group and even produced a *53 Stages of the Tōkaidō* set of *fuda*. In later *fuda*, the names of the artist, carver and printer often appeared.

Choosing and commissioning a *fuda* for a meeting would begin with consultations with senior group members, looking at sample books and taking advice from printers. A group member would be responsible for coordination of the production. Costs depended on the complexity of the design, and the number of letters and colours used. A convention developed to frame the image with two stripes, called *komochiiki* ('stripe with child') a thick stripe on the outside, a thinner one inside. This was a popular Edo textile pattern and was thought to reflect '*iki*' taste. Name *fuda* for pasting can be

[16] CENSORSHIP

In keeping with its feudal nature, the Tokugawa government felt empowered to control anything considered a threat to the status quo. In the early years censorship was carried out locally, but in 1790 the system became more regulated and books and publications were subject to scrutiny and if approved were fixed with the seal *kiwame* (approval). This was slightly altered in 1804, and then in the Tenpō Reforms of 1841–43 was replaced with the seal of a censor. Later this was replaced with *aratame* (approved) until the system was abolished in 1876, although artists were still sometimes required to include their name and address. Private publications such as *surimono* and underground publications such as *namazu-e* were outside the system and generally do not carry seals.

fig.105
Exchange slips (*kōkanfuda*) of one-unit size on the right showing the name (Doi) and group mark.

The other two are part of a series based on the theme of *hanafuda* (flower cards, see p.185). All three compositions are surrounded by a line border characteristic of *kōkanfuda*.

differentiated as they do not have the stripes. Themes chosen for *kōkanfuda* were many and varied including religious, seasonal, historical, literary images or those related to the craft or occupation of the member. Skilled use of imagery and composition was highly valued, especially witty use of word- and picture-play. The artists worked to standard sizes of *fuda* based on the most economical use of a sheet of paper (39 × 53 cm/15 × 21 in.). Divided into 16, this gave the basic format of *ichōfuda* (one unit), into eight gave *nichōfuda* (two units), into four gave *yonchōfuda* (four units) into half gave *hatchōfuda* (eight units) and occasionally a full sheet, *jūrokuchōfuda* (16 units). It is thought that six large 16-unit *fuda* were produced as a conspicuous display of wealth for the great meeting of 1859, although most are now lost. In between sizes were rare as they would waste precious paper although tiny *fuda* not much more than 2.5 × 1 cm/1 × 0.3 in. designed to be pinned in courtesan's hair were made. *Ichōfuda* (one unit) was and still is the basic size used for both *senjafuda* and *kōkanfuda*. As the

passion for *kōkanfuda* grew and larger sizes were commissioned, in order to differentiate them from single sheet ukiyo-e of the same size they show the notched outline of standard one-unit *fuda* in the margin outside the picture.

Nowadays temples are popular venues, but in the Edo period the exchange meetings were often held in tea houses or restaurants as eating and drinking was part of the attraction. They generally began at 1 pm and lasted until 5 pm, with the *fuda* distributed at around 4 pm. On arrival, the member pays a subscription at the reception desk and hands over his pack of exchange *fuda* (containing one for each person present) and in return is given a small envelope in which to put the *fuda* he receives. At the appointed time the members line up in rows facing each other while officials distribute the *fuda*, some of them fresh from the printers. Members will sometimes commission a special additional *fuda* (perhaps two-unit size) to distribute in commemoration of a special event such as marriage or retirement. If someone is absent,

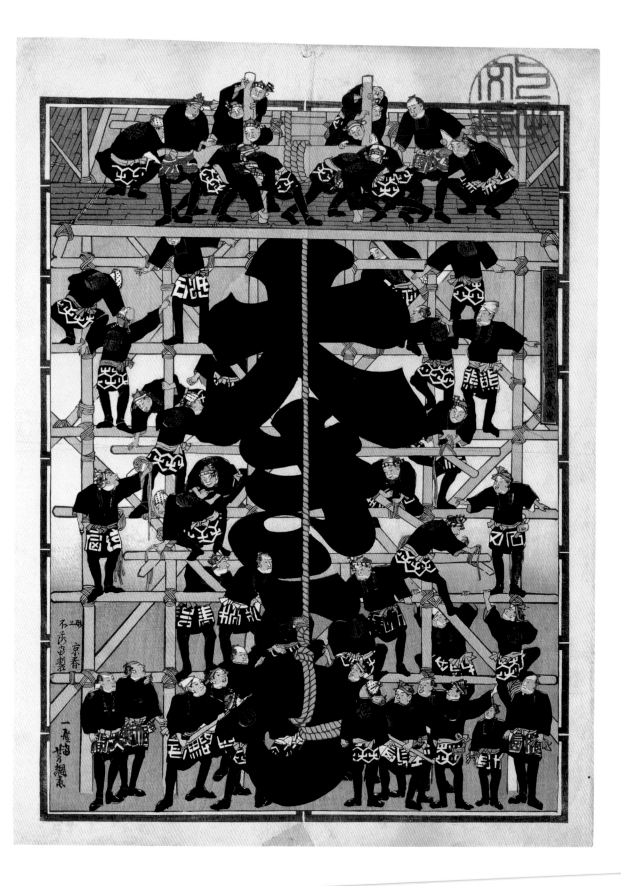

An eight-unit *fuda* produced in imitation of the
banzuke (see pp. 53–54) format as an invitation to
a meeting in May 1911 when 36 *fuda* on a theme
of sumo wrestlers were submitted.

fig. 108
A two-unit *fuda* showing a typically hairy
foreigner preparing his food – possibly a
lump of meat! The style of the design is
very similar to the series of prints showing
eminent foreigners (see fig. 77, p. 85).

(left) fig. 106
Another 16-unit *fuda* produced for
the great meeting of 1859. This one
was commissioned from the artist
Utagawa Yoshitsuna by Ōkyū – a
fuda enthusiast and carpenter
which is reflected in the theme.
A group of carpenters balanced
on bamboo scaffolding are using
a winch to erect a large sign of his
name. They are wearing *hanten*
(work clothes) with a crest in red on
the back and a towel (*tenugui*) tied
on their heads (see fig. 212, p. 196).
It is likely that Ōkyū too had made a
lot of money in the aftermath of the
1855 earthquake and could indulge
his *fuda* hobby.

a friend can collect on his behalf but he
does not receive the special *fuda*. When the
distribution is completed, there is a shout of
deatama da yo (attention), a rousing song,
one clap and the meeting is over.

The living art of *senjafuda* began many
centuries ago as a simple act of religious
devotion with roots in the perceived power
of the inscribed word. From those humble
beginnings, spurred by the powerful
commercial and artistic forces of the Edo

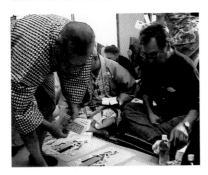

fig. 109
A contemporary exchange meeting in Tokyo
showing the *fuda* being distributed.

period, it became an art form representing
not only the skills of the artists and craftsmen
but also the appetite of the enthusiasts for
the best that money could buy. Deprived of
meaningful access to power, their energies
and resources were diverted, amongst other
things, into the production of these glorious
slips of printed paper which, although modest
in size, display the sophistication of both
subject and production which made their
ukiyo-e relatives known worldwide. The
signatures and marks are difficult for the
foreign viewer to decipher, but the sheer
mastery of the composition and colour of the
images confined within their narrow borders
is unmistakable.

Catfish prints *namazu-e*

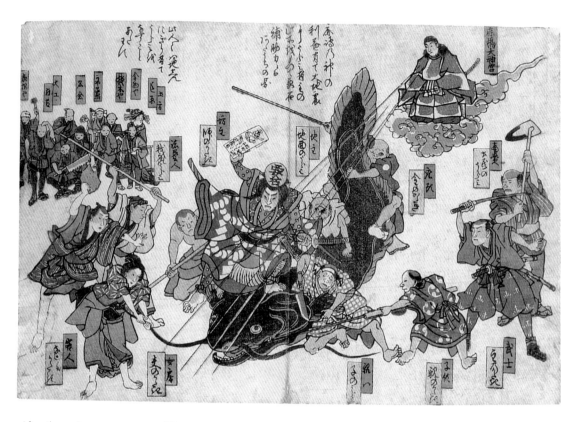

After the ominous appearance of Perry's 'black ships' off Edo in 1853 and 1854, the catastrophic earthquake with its epicentre under Edo in 1855 must have not only shaken the feisty inhabitants of Edo physically, but also added to their psychological unease about the future. The Tokugawa political edifice was proving all too fallible faced with the challenge of relations with the outside world, and now a further calamity had been visited upon the populace. Of all the 'acts of God' to which the people were subject, earthquake followed by ravenous fire must have been the most terrifying. As well as the many *kawaraban* (see p.59) produced to report on events, there was another printed response to the insecurities aroused by disaster. The prints are called *namazu-e*

(catfish prints) and over 400 were produced after the 1855 earthquake alone, a clear indication of an audience eager for solace and explanation.

Namazu-e grew out of a long tradition of pictorial amulets or devotional images such as *ema* (votive tablets) which date from around the 8th century and are still offered in shrines and temples. A closer ancestor of *namazu-e* were perhaps *Ōtsu-e* (Ōtsu paintings) from the early 17th century. They were first produced in Ōtsu near Kyoto, featured religious and folk images and were mainly bought by pilgrims and travellers. As one of the 53 stops on the *Tōkaidō*, Ōtsu was well-placed to exploit the commercial potential of that geographical position. *Ōtsu-e* were produced anonymously by what would now be called folk artists and

fig.110
The God of Kashima
Kashima no kami no arite

In this print the priest of Kashima shrine has charged the *kaname* stone with pasting a *fuda* (amulet) against earthquakes on the reluctant *namazu*. The *kaname* stone is shown in the character of Gongorō from the kabuki play Shibaraku. Those who have suffered – children who are orphaned, tradesmen who have lost their livelihood join in berating the fish. Looking on top left are those who stand to gain – timber merchants, carpenters, Yoshiwara courtesans, etc.

so, not bearing the official imprimatur of a temple, are an accurate and lively reflection of common beliefs. They are mostly unsigned and undated. Their subject matter graduated from the religious to include the secular in response to the economic boom at the turn of the 18th century. Humorous and sometimes satirical interpretations of contemporary mores and beliefs became part of the genre and can be considered to have been one of the inspirations for later cartoons and satirical prints.

Namazu-e, even though they were printed in response to a disaster, reflect a similarly animated spirit and were also produced anonymously. In order to understand the prints, the relationship between the catfish and earthquakes requires explanation. It seems that originally Japan shared the Chinese belief that the world rested on a

At one point the real stone in the shrine was actually fastened to the ground with wisteria vines to secure it. This simple tale explains one of the main incarnations of the catfish in prints. He looms large within the picture frame, a stone securely tied to his back, clearly having escaped his underground lair and caused havoc as a result. Interestingly, recent scientific tests have attempted to link abnormal behaviour in fish with the prediction of earthquakes.

Of the many prints produced portraying the *namazu*, some have him in his fishy guise, but the majority show him dressed up as a human. He can be identified by the mark of water or a gourd (see below) often on his clothing, and he frequently appears in the guise of various workers. He can also be disguised as a monk, a nun or appear in kabuki. A traditional comical theatrical role

fig. 111
Ōtsu pictures
Ōtsu-e

Ōtsu-e were originally hand-painted, but these examples are printed in woodblock and made into tiny envelopes for gifts of money (*pochibukuro*, see p.197).

Two classic *Ōtsu-e* scenes appear – a white fox riding a horse and a monkey carrying a pole with a bell and a lantern (which of course should be the lighter). It was a light-hearted warning to beware of monkey logic.

dragon and its thrashing caused earthquakes. The Japanese substituted the local catfish for the foreign Chinese dragon, and by the 18th century he shouldered the blame. When the giant underground catfish moved, chaos ensued.

Kashima shrine in Ibaraki prefecture not far from Tokyo's Narita airport, contains a special foundation stone (*kaname ishi*) charged with the task of 'sealing' the earthquake god (*Nai no kami*) underground. This heroic feat was achieved by one of the great Shinto warrior gods, Take-mika-zuchi. So in the popular mind, it was believed that the *kaname ishi* was charged with holding down the catfish and preventing trouble (see fig.110, p.108).

of a rather ineffective catfish priest appears in some prints with the earthquake fish.

As a fish he represents the perpetrator of earthquakes, and his image on votive pictures also acts as a protective amulet. Even immediately after an earthquake, *namazu-e* were pasted on walls as defence. Some of the prints show the catfish writing Sanskrit charms, to be cut out and pasted to face north, south, east and west on the house. The *namazu* is also often shown being wrestled by the deity of Kashima shrine armed with the stone, a sword, or curiously, a gourd. The gourd image is a reference to a 15th century painting of a man trying to catch a catfish with a gourd to illustrate the Zen idea

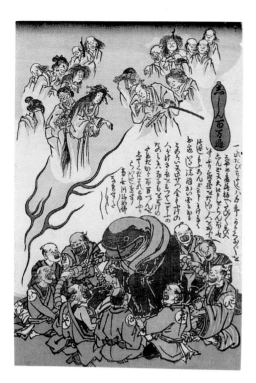

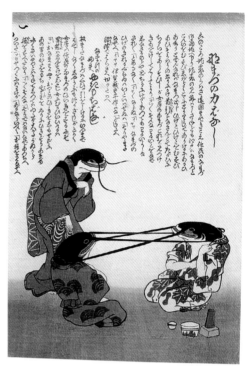

fig. 112

A Million Prayers for the Earthquake
Jishinhyakumanben

Having caused an earthquake, the robed figure of the *namazu* is sitting in the middle of a giant rosary held by those who have profited from his misdeeds – carpenters, firemen, plasterers, roofers – who are reciting a million prayers. Their mouths are red and gaping as they chant in an echo of the bared teeth of the rather smug-looking *namazu*. The ghostly apparitions of those who have suffered – samurai, courtesans and ordinary people – look on from above.

fig. 113

A Tale of the *Namazu*'s Strength
Namazu no chikarabanashi

Neck-tugging as a trial of strength features in many *namazu-e*, sometimes in a political twist shown as a contest between a foreigner and a *namazu*. In this print two *namazu* use their whiskers, as a third, in a rare depiction of a *namazu* as a woman, referees. One *namazu* represents the Shinshū earthquake of 1847 (see fig. 47, p. 58), the other the Edo quake of 1855 (see fig. 48, p. 59). The kimono worn by the catfish on the right has a gourd pattern associated with the *namazu*.

that is beyond one's grasp and which has come to mean roughly 'the impossibly futile'. Occasionally the catfish is being wrestled by two of Japan's Seven Lucky Gods, Ebisu and Daikoku. The earthquake of 1855 happened in October (called *kannazuki* – the godless month) when it is believed that Japan's gods are 'away' staying at Izumo Shrine. In this godless state, Ebisu (he was deaf and didn't hear the summons) and Daikoku are supposed to look after things, including keeping the catfish in his lair.

The catfish is also shown being punished for his misbehaviour by being eaten by the enraged victims of his activities. *Unagi no kabayaki* (grilled eel) was a popular dish in the Kyoto/Osaka area and grilled catfish became the Edo substitute, believed to be especially

energising during the dog days of summer. Those shown punishing the catfish and bemoaning their plight were often the rich who now had to use up some of their wealth re-building their lives. This was particularly tough for those on a fixed stipend of rice. By the same token, those who stood to gain from the disaster (especially in the building trade) lavishly entertain the helpful catfish. There is often a sharp touch of satire in these prints.

Although the *namazu* images appear light-hearted, the sub-text of the prints was of a more serious nature. An ancient oriental belief in a causal link between disaster and governmental maladministration implied that the action of the *namazu* which caused the earthquake was a reaction to the status quo. Taking the metaphor of the 'body politic'

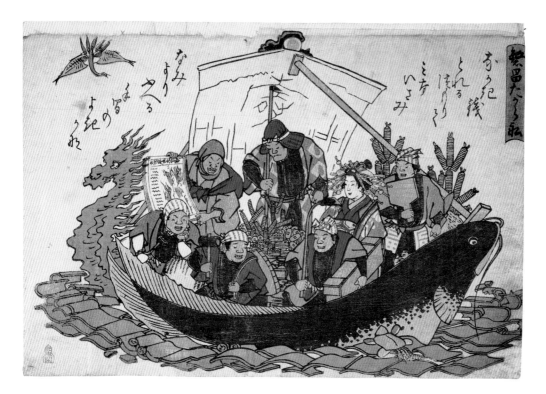

The Treasure Ship of Prosperity
Hanjō takarabune
1855–6

On the second night of the new year it is traditional to slip a picture of Japan's Seven Lucky Gods on board the treasure ship (*takarabune*) under the pillow to ensure a lucky dream and good fortune for the year. This *namazu-e* subverts that dream.

Floating on a sea of blue roof tiles, the boat is shown as a huge catfish with a fiery dragon at its stern. In some interpretations a link is made between the catfish and Perry's black ships and the propensity of both to provoke change. The dilapidated sail is the crumbling facade of a traditional storehouse (*kura*) and on board are the Seven Lucky Gods (see p. 95) substituted with trades which profit from disaster:

Ebisu is a carpenter, Daikoku a labourer, Bishamon a fireman, Benten a prostitute, Hotei a thatcher and Fukurokuju a *kawaraban* (newssheet) seller holding a rudimentary print showing the earthquake damage. The *takarabune* is traditionally accompanied by the auspicious symbols of a tortoise and crane – here the crane is made up from a collection of fish!

literally, earthquakes were seen as an attempt to restore balance and harmony thereby correcting the circulation of an unhealthy organism. Although hardship was inevitably caused, the obstruction was cleared and health restored. Money, for example, which had collected in the hands of a few was forced by the action of the *namazu* back into circulation to be spread more widely. In some prints this belief in the medical metaphor is reflected in the disguise of the catfish as an itinerant medicine seller. In others he is shown showering money or forcing the rich to vomit money. This belief in drastic circumstances re-ordering the status quo extended in the minds

of some to a welcome for Perry's arrival on the grounds that the shock would produce a beneficial effect.

In their exploitation of a folk belief about the catfish and the many guises in which he appeared, the artists were able to imply criticism of the status quo and satisfy the popular and rather subversive appetite for concealed satire. Although the catfish was clearly responsible for the misery, at the same time he came to enjoy a dual role as champion of the people, an upholder of social justice. Many of the prints show images of those destined to be made even more wealthy through others' misfortune (the builders and

carpenters) and those who have suffered (merchants who have lost their stock or prostitutes who will have fewer customers because the merchant is impoverished). The disguise of the catfish allowed him to appear to be on the side of the common people in the nascent movement for social reform (*yonaoshi*). Clear links were beginning to be made between the lot of the poorest in society and that of those above them. These were links which would have been particularly unwelcome to a government already wrestling with the untimely arrival of the outside world in the 'black ships' and the ensuing challenge to their rule. Attempts to control publication of *namazu-e* were largely unsuccessful as they were almost always unsigned, undated and had not been through the system of censors.

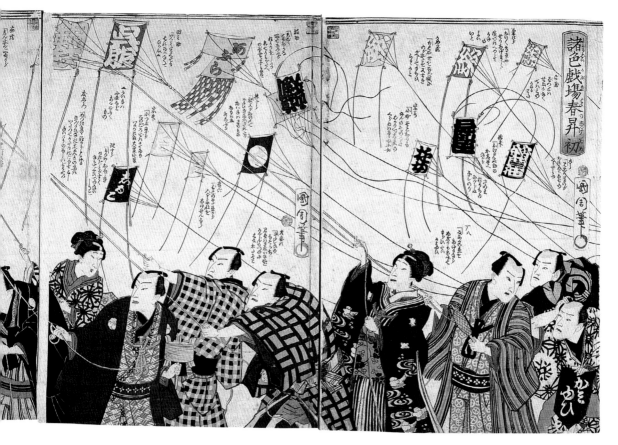

fig. 115

Kabuki Actors Playing at Kite Flying
Shōbai kabuki haruno agezome
Toyohara Kunichika
late Edo period

At first glance this triptych by Kunichika appears to show an enjoyable scene at new year of famous kabuki actors taking part in traditional kite flying. This is clearly the interpretation the artist hoped the authorities would make. Closer inspection reveals a sub-text which would, however, have been of serious concern to them had they spotted it. The print is an outspoken comment on the economic malaise of the late Edo period which led to harsh price rises. The writing on the kites indicates the commodities which have gone up in price. The highest priced kites/commodities include oil, paper, cotton and clothing. Commodities thought likely to go up in price before long are written on kites flying lower in the sky.

Working under real threat of punishment, artists in the Edo period became masters at concealment, confident that they had an audience capable of unpicking the layers and appreciating the real meaning. A direct political attack would have been pointless, but satirical comment carefully disguised was able to pass the censors and enter the public domain.

In the guise of a troublesome catfish, the genie of political and social reform appeared to be out of the bottle. With an undercurrent of political comment, *namazu-e* show the emergence of a more acute awareness of the order of things and in their hidden satire, a desire for change.

Very much a product of urban Edo, *namazu-e* show both a continuation of traditional rural folk beliefs and a sharpening attitude to authority. In times of stress they provided both comfort and relief from societal pressure. With roots in souvenir paintings from Ōtsu and woodblock print, *namazu-e* developed into 'folk prints with attitude'. The outpouring of images after the 1855 earthquake lasted barely a few months, but the *namazu* lived on, reappearing in political cartoons of the Meiji period.

fig.116

A Mass of Interesting People
Omoshiroku atsumaru hito ga yorikatari

This *namazu-e* is a direct reference to a famous print by Kuniyoshi (*Mikake wa kowaii ga tonda ii hito da*) (see p.138). Kuniyoshi was known to have produced satirical works, so it could easily be by him. As with the original, the face and hand are made out of a jumble of bodies. The pattern on the figure's kimono is composed of timber, carpenter's and plasterer's tools and straw sandals and in his hand he holds a coin representing profits made from the construction boom. In the background a catfish dressed as a Shinto priest radiates authority as he distributes largesse.

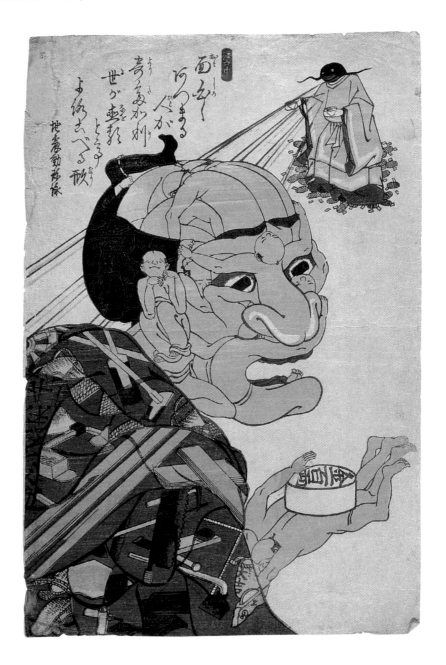

Medicine prints *baiyaku-e*

An alternative name for *baiyaku-e* is *Toyama-e*
(Toyama prints) which demonstrates the close
link between the coastal city of Toyama and
the production and distribution of medicines.
The medicine connection began with the 17th
century regional daimyo, Maeda Seiho, who
took an active interest in the spread of
education and public health within his
domain. He carried with him at all times a
medicine called *Hangontan* (allegedly a tonic
that could raise the dead) the recipe for which
a physician from another domain had brought
to him because of his interest in the subject.
Legend has it that on one of Maeda's tours of
duty in Edo the shogun was taken ill. Maeda
administered a dose of trusty *Hangontan*, the
recovery was instant and Toyama secured its
position as the centre of Japan's medicine
industry. Despite customary misgivings about
encroachment on other regional domains,
daimyo pleaded with Maeda to send his
medicine vendors to their districts. The
medicines were produced by small family
businesses in Toyama, packaged and

distributed nationwide by itinerant peddlers
who, with cloth-covered wicker baskets on
their backs, became a familiar sight on the
roads of Japan. By 1875, it is estimated that
there were about 5000 peddlers in total.
They were divided into bands, each assigned
a specific region to which they returned on an
annual basis. A group would leave together
carrying their stock and from a convenient
regional base each peddler embarked on his
own circuit. New recruits were trained by their
seniors in both the ways of the business and
manners. As a trust-based enterprise it was
vital that the peddler knew his etiquette and
was accepted by his customers. On his return
to Toyama, the peddler turned to
manufacturing or farming until the next trip.
After the 1868 Meiji Restoration when the
samurai lost their traditional warrior role,
many of them took up the medicine business,
swapping their swords for wicker baskets.

The system of distribution and payment was
unusual and is said to have been devised by
the benevolent Maeda Seiho. In addition to
supplying small retail outlets, peddlers visited
families in person. They left the family with
sufficient medicine to last the year, and on
their next visit collected the money only for
the amount which had been used, replaced
the leftover with new stock and supplied
extra for the next year. For impoverished rural
populations this extension of credit must have
been a lifeline. The business was covered by a
strict code; Toyama peddlers did not compete
with each other for business and you could
not leave medicine if someone had already
supplied the customer.

The peddlers became eagerly anticipated

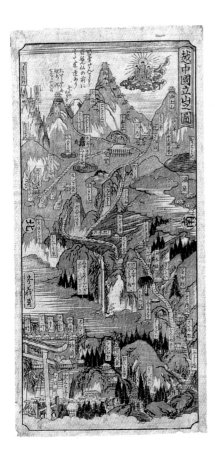

A *baiyaku-e* showing the routes up the local sacred mountain, Tateyama. The traditional Oriental pictorial device of cloud-like bands conceals discrepancies in the topography. Tateyama is a particularly active mountain, so smoking hellish chasms are marked, as are more benign hot springs.

replacing old, unused medicine with new (free of charge) he maintained trust in his product, and by being a valued visitor he helped to ensure his safety on the road. Walking alone on remote roads carrying both stock and money he would have been vulnerable without the protection of the community. This personalised system of distribution thrived until the 1880s when a rather clumsy sales tax precipitated its decline and the switch from family to company-based business.

The Toyama link between medicine and woodblock printing was historic and on many levels. Near Toyama is Mount Tateyama, one of Japan's three sacred mountains and centre of *Tateyama shinkō*, a complex mix of early mountain worship, Shinto and Buddhism. Religious centres needed to produce images, texts, maps and amulets, so required a printing capability. Wandering missionaries from Tateyama had apparently handed out medicine with their amulets, so this additional link boosted the budding medicinal industry. The itinerant medicine sellers, on the other hand, were strictly forbidden to proselytise. As the Toyama area predominantly followed *Jōdō Shinshū*, the True Pure Land school of Buddhism, the peddlers were given free passage in domains supportive of other sects contingent upon not seeking converts.

As the medicine business grew, a cottage industry developed in Toyama supplying printed packaging and labels. Early packages were very simple, printed in black possibly with an added vermilion seal. The envelope

visitors, bringing not only medicine but also practical knowledge with them. They would have been literate enough for basic record-keeping so could act as a scribe for villagers, or through contacts made on their travels act as matchmakers for marriageable daughters. For the peddler, trust and goodwill were vital not only to his business but his safety. By

(right)
fig.118
Medicines were wrapped in an individual envelope (*uwabukuro*) and then all placed in an outer envelope (*azukebukuro*) for which this is the block. There are no registration marks as it is only one colour.

The design bears the official government permission, the name and address of the maker and a portrait of the fierce Shōki – a mythical being able to drive away plague (see p.121).

(far right)
A rough printing of the *azukebukuro* block.

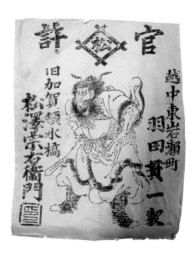

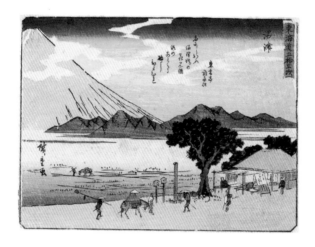

fig. 120

Numazu stage 13 from the *Kyōka 53 Stages of the Tōkaidō*
Utagawa Hiroshige
c.1840

This view of Numazu (21 × 15.5 cm / 8 × 6 in.) shows a teahouse and weary pilgrims in the foreground and a handsome view of Fuji in the distance. The scudding clouds waft across a poem (*kyōka*) in the sky, highlighted with a brushed blue gradation (*bokashi*). The viewpoint is clearly recognisable in the two prints below.

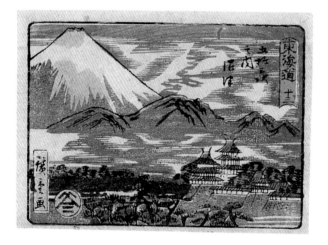

fig. 121

Numazu
Utagawa Hiroshige
late Edo period

The blocks for this even smaller version (10.8 × 15 cm / 4 × 6 in.) of Numazu by Hiroshige seem to have been purchased by a Toyama publisher, Kuriyama. His circular seal has been added bottom left.

The composition is very similar to the version shown above but has been simplified to keep costs down – for example no gradation has been used and the poem has gone.

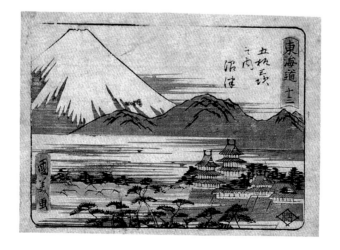

fig. 122

Numazu
Matsuura Moriyoshi
late Edo period

A third, locally produced version of Numazu by the Toyama artist Matsuura Moriyoshi. The composition remains but it has been simplified even further. It indicates clearly how certain popular views spread through the medium of print to even remote parts of Japan.

would show the maker's name, a word or picture to explain the purpose of the contents (for example 'child' for childrens' medicine) in simple calligraphy possibly done by a teacher at the local school. Blocks were carved by a professional carver, but the printing and making-up of the envelopes would all have been done as part of the family business. Medicines were wrapped in paper, placed in an envelope and then in another thick paper envelope or box when they were handed to the customer. All were printed with the maker's name.

Out of this rudimentary woodblock industry emerged the other Toyama innovation of *baiyaku-e* (patent medicine prints) which helped to found Japan's massive free gifts industry. The peddlers carried these woodblock prints with them to give away as gifts representing about 5% of the sales value. Initially the prints were sourced from woodblock centres such as Edo and Kyoto, but by 1830 an indigenous system of print publishers emerged in Toyama. *Baiyaku-e*, designed as they were to be given away, had to be cheap so were not the most skilled end of the print business. They used few colours, initially using traditional pigments until the arrival of aniline colours. Time-consuming special effects like *bokashi* (gradation) were eschewed and the paper was rough and of poor quality from nearby Yatsuo district. The prints were generally smaller than usual ukiyo-e (medium size was 22 × 15 cm / 8 × 6 in.);

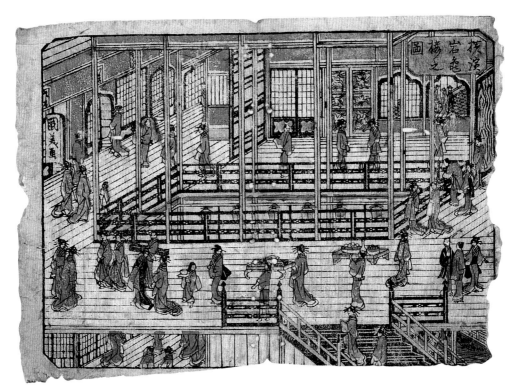

fig.123

Picture of Gankirō in Yokohama
Yokohama Gankirō no zu
Matsuura Moriyoshi
late Edo period

This print shows Matsuura experimenting with the use of perspective but also offers a glimpse of a glamorous Chinese-style pavilion in Yokohama famous for the presence of foreigners and the sad suicide of a courtesan. Opened as part of the 'foreign zone' in 1859, it was destroyed in the fire of 1866.

this was practical because the peddler had to carry them on his back with his stock of medicines. Although *baiyaku-e* cannot make any great technical claims, they are, however, fascinating for the cultural links they show which reinforced the spread of information around the country.

At first it appears that Toyama publishers bought used blocks by artists such as Hiroshige, Kuniyoshi and Eisen and reprinted them locally. At the peak of production there were probably around ten publishers, although it seems they changed or went out of business fairly regularly. By 1848 the first significant local artist, Matsuura Moriyoshi (1824–86), appeared. Thematic images were similar to the Edo bestsellers: kabuki, pleasure quarters and pictures of famous places. When Japan reopened in the Meiji period, pictures of foreign activities in Yokohama and the fruits of modernisation also appeared. Although Matsuura's work shows very clear references to Edo imagery and so could be dismissed as mere imitation, this judgement would have been of little concern to the inhabitants of Japan's remote villages for whom these free prints would have been a glimpse of another world, beyond the drudgery of daily life. The free gifts were occasionally practical too, combining images with agricultural calendars, or lists of foods which should not be eaten together or printed

fig. 124
Silkworm Factory
Kaiko seizōjo no zu
Ōtake Kunikazu
early Meiji period

Ōtake's working career covered the many changes brought to Japan in the Meiji period. This print shows women dressed in kimono working in a traditional industry (silk) but in the unfamiliar setting of a factory. News and information on changes in the early Meiji period would have spread to remote areas through the medium of *baiyaku-e*.

fig. 125
2 sheets of 15 miniature *noshi*

It was a Japanese tradition to attach strips of dried abalone (*noshiawabi*) to gifts on auspicious occasions (see *pochibukuro*, p.197). Over time, the abalone came to be represented by either the written word '*noshi*' or an image of paper folded round a strip of abalone (as here). These printed mini-*noshi* could be cut out and used on gifts – some such as the maple leaf pattern would suit certain seasons.

with *noshi* patterns which could be cut out and attached to gifts (see fig.125, p.118).

After Matsuura's death, another prolific artist appeared to take his place, Ōtake Kunikazu (1868–1932). He came from Niigata (north of Toyama) and was one of four brothers, three of whom became artists. His actor prints were so dynamic it was as if he had crammed the contents of an entire Edo ukiyo-e triptych into one energetic composition. He also worked when imported aniline colours were favoured, which gives the prints a brasher character. His career, however, spanned the decline of first woodblock (which ultimately lost out to lithography) and then the print as a free gift. Around the turn of the 20th century, the focus of free gifts changed to kites, paper balloons, aeroplanes, etc., aimed at children, and the Toyama print business breathed its last.

The legacy of *baiyaku-e* was not just in print. The more lasting effects of their spread around the countryside were less tangible. As the peddlers walked the byways of Japan they took with them a range of knowledge and information. They passed on stories and gossip, news of events and, as they often came from farming backgrounds, agricultural tips. It is possible that a particularly robust strain of rice was distributed by the peddlers, likewise seeds of a lotus plant strong enough to survive northern winters. When Japan's northernmost island, Hokkaido, was settled by, amongst others, people from Toyama, the trusted peddlers followed. Familiar cures and tonics were much needed by both people and their animals as they struggled to survive in the harsh Hokkaido conditions.

It would be an exaggeration to claim technical virtuosity or artistic innovation for *baiyaku-e*, but they have a simple charm which is reinforced by knowledge of the modest role they played in rural areas as a conduit for news. The Toyama artists clearly looked to the urban centres of woodblock for inspiration, but their interpretations of classic Edo themes should not be completely dismissed. Images which had already become widespread through ukiyo-e production found an even wider audience via re-interpretation in Toyama and free distribution. As the itinerant

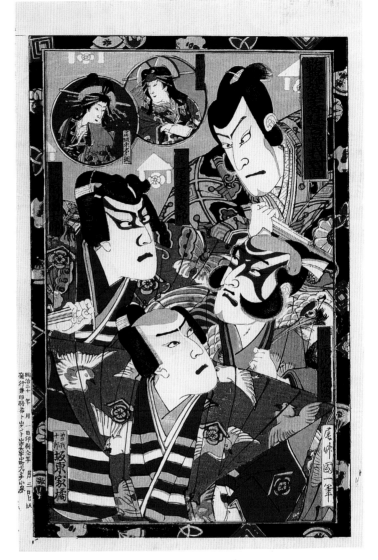

fig.126
Kabuki – Revenge of the Brothers Soga
Kabukiza haru kyōgen soga no taimen
Ōtake Kunikazu
1887

The aniline colours make this Ōtake print appear even more riotously colourful than the kabuki from which it is derived. The imitation picture frame struggles to contain the portraits of four actors plus vignettes of two *onnagata*. The inclusion (centre) of the great triumvirate of the early Meiji years – Ichikawa Danjūrō IX, Ichikawa Sadanji I and Onoe Kikugorō V – would have guaranteed popularity for the print (see also fig.185, p.171).
The theme, the revenge of the Soga brothers for the murder of their father, was one of the most popular kabuki dramas.

peddler wandered the byways of Japan bringing life-saving medicine, he also left behind a legacy of news, information and in the prints, both simple enjoyment and images of another world.

Smallpox prints and measles prints *hōsō-e* and *hashika-e*

Toyama's wonderdrug Hangontan may have revived an ailing shogun, but sadly it was no match for two of nature's most terrifying diseases; smallpox and measles. References to smallpox can be traced back to 735 and from then until the early Meiji period there were over 100 known outbreaks. Measles epidemics often arrived at the same time and initially it seems likely that little distinction was made between the two. Ultimately, however, the differing outcome of the two diseases, particularly the seriousness of measles in adults and the scarring left by smallpox, was recognised in a short saying:

> 'hashika wa inochi sadame,
> hōsō wa kiryō sadame'
> (measles can take your life,
> smallpox can take your beauty)

With little by way of medicine to treat either condition, people understandably turned to folk remedies and religion to try and cope, hoping either to protect their families from infection in the first place or to lessen the

illness if they had already succumbed. A Chinese concept of demons of disease translated into a Japanese belief that a *kami* (Shinto term for god, divinity) was responsible for bringing the illness (rather than curing it) and therefore had to be kept away from the home or village. The smallpox *kami* was said to be especially fond of babies. There were regional variations to the practices employed to deal with the disease and celebrate recovery but they all involved a combination of faith and practical advice. Woodblock prints came to play a part in this process as 'charms' to be pasted at the door to keep the malign *kami* away, as gifts to the suffering patient and as illustrated health advice. Books were still relatively expensive so, particularly in the case of measles prints, advice was offered in the format of the cheaper single sheet print. Artists including Utamaro II, Kunitora, Kuniyasu and Kunimaru produced smallpox prints; Yoshitora, Yoshifuji and Yoshitoyo produced measles prints.

Hōsō-e (smallpox prints)

Hōsō-e are also known as *aka-e* (red prints) and probably have their roots in China. They became particularly popular during the smallpox epidemics of 1830, 1838 and 1849. The prints were produced in just one colour, red (from *benibana*, safflower) because there was an old wives' tale that if you dressed a smallpox patient in red, the attack would be mild. It was believed that red was an apotropaic colour, that the smallpox demon liked it so much he would be pleased at the sight of red garments and deal gently with the wearer. In some parts of Japan the patient

was even painted with rouge to mollify the smallpox *kami*. *Gohei* (white sacred paper strips) used in Shinto rites, were made instead out of red paper and placed near the patient or on the threshold of the house. Paper was dyed red, oiled and used to colour the light cast by the sickroom lamp, by which an examination (beginning with the feet) was made. There is an elegant symmetry in the use of red to counter a disease notable for its red spots.

Prevention was infinitely preferable to dealing with the illness, so efforts were made to confuse the smallpox *kami* and make him go elsewhere. In some parts of Japan, to protect newborns, the character for dog would be written on the child's forehead to fool the *kami* into not recognising it as a human child. If the worst happened and the disease was contracted then all the effort went into making sure it was as mild as possible. A list of dos and don'ts included: no saké for 100 days; avoiding spicy and salty food; avoiding those with smelly armpits and avoiding the smell of latrines and burning hair and the comings and goings of religious people! A mixture of musk, cinnabar and castor oil plant was applied to the patient with a spell. It was painted between their eyebrows, on the bridge of the nose, hollow of the stomach, hands and feet, and the mixing bowl and brush were then thrown into the river. Alternatively, a printed calendar of the year of the child's birth was taken, their date of birth cut out and burned and the residue fed to the patient. This belief in the power of paper and *sumi* ink (and the written/printed word) was found in the practice of pilgrimage. If lucky enough to be given a votive slip by a pilgrim who had performed the circuit many times, it was said to be particularly beneficial to soak the slip in water and eat it.

Divinities deified in major Shinto shrines at Ise, Izumo and Sumiyoshi, as well as traditional heroes, were all called upon for protection. The legendary figures and symbols charged with the task of expelling the smallpox *kami* from the patient and the village can all be found in the smallpox prints. One of the most prominent was the swashbuckling

hero Minamoto no Tametomo (1139–70). Known as an exceptional archer he can be recognised by his splendidly muscular physique. He spent his life in internal exile in battle which qualified him for the struggle against the smallpox *kami*. A fellow dispeller of demons often seen in prints is Shōki, a mythical Chinese character who committed suicide after failing his civil-service

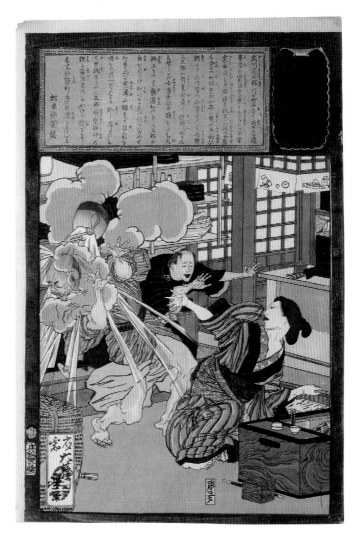

fig. 128

Post Office News no 600
Yūbin Hōchi Shimbun no 600
Tsukioka Yoshitoshi
1870s

Not exactly a recommended cure for smallpox – this newspaper print set in Kawaguchi tells the tale of the wife of a noodle shop owner Sangoro, who throws the kettle and scalds him with boiling water. Miraculously, after one month, not only has his face healed but his smallpox scars have gone too. As in fig. 29, p. 41, this newspaper design separates text and image in a format more common with moveable type.

examinations, but compensated for his failure by quelling demons in the next world. In Japan he is shown with bulging eyes, full beard, wearing Chinese robes and brandishing a sword. Both these heroes also featured in prints to ward off measles. From the animal kingdom an imaginary beast known for his skill at exorcism, *shishi* (lion) was recruited. A lion dance with a fierce *shishi* head worn by the dancer was used to drive out demons and likewise a look from the *shishi* was considered enough to drive the smallpox *kami* away.

The alternative to driving the *kami* away through fear was bravado, to display a childish, almost light-hearted spirit; this was the theme of many other prints. Familiar toys with auspicious associations were selected. These included Daruma, the bringer of good luck and, as a reminder of the annual fresh start, the hobby horse which itinerant performers used going door to door celebrating New Year, or images of the sacred Mount Fuji. Pictures of healthy child heroes such as Kintarō (a prodigy of huge strength who wrestled bears and beasts) also feature. Japan's homophonic language accounts for the inclusion of images of bream (called *tai*, considered short for *medetai* or celebratory), a monkey (*saru* which also means 'go away') and a dog (*inu* which also means 'not there'), the latter two suggestions aimed at the smallpox *kami*.

The delivery from the disease was marked by several rituals. The presents of toys and prints which neighbours had brought were burned (one reason why few prints remain), celebratory sticky rice with red beans (the red pleased the *kami*) was distributed to neighbours and the recovered patient was at last allowed to bathe in hot water fragranced with bamboo grass leaves (*sasa*). The smallpox *kami* may have been temporarily defeated, but it was not until the 1850s that vaccination was used in Japan and the smallpox *kami* finally met its match.

Hashika-e (measles prints)

The measles *kami* was not deemed to have the same liking for red, so measles prints tend to have the appearance of normal multicoloured prints usually combining text and image. Most of the measles prints were produced in response to the terrible epidemic of 1862 which claimed many lives. At its summer peak, Edo coffin-makers could hardly keep up with a daily rate of about 200 funerals. Western remedies had started to arrive in Japan, but were not available for the majority who had to fall back on the combination of persuading the measles *kami* to leave and a regime of traditional cures, advice and if possible prevention.

Homophonous Japanese linked *hashika* (measles) with *hashika* (the beard on wheat) so wheat features in the symbolism of the illness. As prevention a holly leaf (a protector against evil spirits) was inscribed with a poem about wheat, plus the name and age of the child not yet affected and thrown into the river. As an alternative, a print might include a holly leaf and the purchaser was invited to cut out the leaf and cast it into the river instead. Legendary heroes and Shinto deities were also called upon for protection, but if the illness had already struck, the prints contained endless lists of things considered good and bad for the patient. Remedies such as ground horn of the black rhinoceros were prohibitively expensive, so good nutrition was the only alternative. Foods considered beneficial included beans, lotus root, kumquat, abalone and apples; bad foods included eggs, aubergines, river fish, spinach and noodles. There were of course many contradictions in these lists.

A huge number of activities were also advised against including taking baths, sexual relations and going to the barbers; all these prohibitions had economic consequences, particularly in the pleasure quarters. More esoteric prohibitions included the smell of burned hair, garlic, armpits, sewers, situations where people are angry or agitated and, rather strangely, the sight of a woman dressing her hair. The exhalation of a drunken person who had eaten leeks and tuna was also considered inadvisable!

Hashika-e very often combined these gems of advice with a relevant image of a vengeful hero driving away the disease, a battle between the disease and a hero (the disease loses), a doctor examining a patient or celebrations when it is all over. The measles

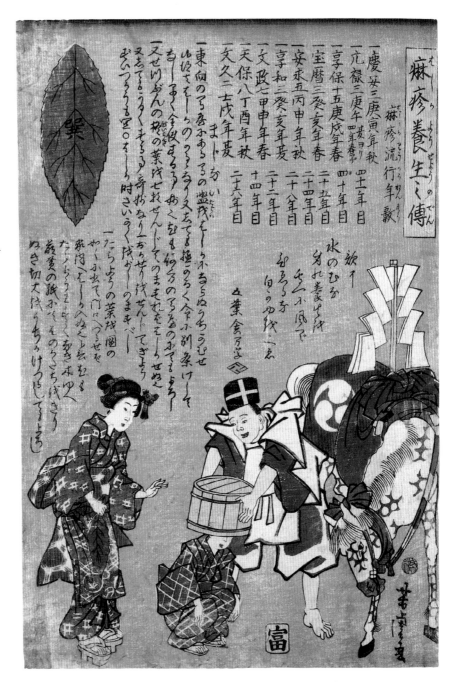

fig. 129

Methods for Curing Measles
Hashika Yōjōden
Utagawa Yoshitora
1840s

One of the more bizarre magic cures for measles was to cover the child's head with a bucket, which is possibly a link with its use to contain horse-fodder (*hashika*). The print also features the protective holly leaf at the top and held in the mother's hand. Holly could be infused and drunk or pinned over the door as an amulet. In times of calamity there were stories of sacred horses coming to the rescue. Here the sacred white horse of Ise, bearing paper strips on his back, joins the fight against measles.

was sometimes personified as a monster measles baby driving out the illness or as one child being punished by another carrying a bunch of symbolic wheat. Occasionally the measles demon was shown accompanied by two other harbingers of misfortune, the dysentery and cholera demons. A cholera epidemic of 1858, soon after the 1855 earthquakes, took the lives of many, possibly including Hiroshige. Considering the overcrowding in the cities, however, cholera outbreaks were relatively rare compared to European cities. A simple farming practice which used human waste instead of animal manure meant that it was too valuable a commodity to be thrown in the street and was actually sold to farmers. Generally water was drunk boiled with tea, thus reducing

fig.130

Expelling the Measles *kami*
Hashikataiji tawamure no zu
Utagawa Yoshifuji
1862

This print was produced as an amulet in 1862, the year of a terrible measles epidemic. It was believed that the disease was brought by the measles *kami* and here as a spotted monster he is being subdued by the crowds. On his back, armed with a sword, is the legendary military hero Minamoto no Tametomo. Joining in the effort on the left are the magic hay bucket (see fig.129, p.123) thought to relieve symptoms, a doctor, a prostitute brandishing her pillow and a *tōgan* (Chinese watermelon, recommended food for the patient). Dietary recommendations are listed at the top. On the right a father carries his motherless child and waves a packet of substitute breast milk. A pregnant woman, a packet of medicine wearing a kimono decorated with medicine wrappers and a pharmacist add to the mêlée. The inclusion of doctors and pharmacists in many prints can hint at criticism of the ineffectiveness of their cures, and the money they made. The 'punishment' of the measles *kami* is not unlike that meted out to the catfish after an earthquake (see fig.110, p.108).

water-borne diseases and by the Meiji Restoration it is believed that the water in Tokyo was cleaner than in London.

Because of their primary use as amulets, few *hōsō-e* or *hashika-e* survived, although they must have been produced in huge quantities. Their use contained the seeds of their own destruction; they were pasted, cut up or burned as part of the desperate measures taken to mollify the bringers of disease. The few prints that do survive, however, afford us an insight into the attempt to deal with serious epidemics armed with little more than strong beliefs and home remedies.

Memorial prints *shini-e*

In the absence of newspapers in the Edo period, it fell to woodblock prints to assume the role of the obituary column in the form of obituary (or memorial) prints. These obituaries were for the celebrities of the day such as kabuki actors, writers or artists. Like the newspaper illustrations (see p. 60), their content lacked the visual appeal of the popular single sheet prints so *shini-e* are relatively unknown outside Japan. Although *shini-e* had a strong news element, their often overtly Buddhist nature introduced a religious edge to their appearance. They were essentially a rather curious, occasionally grisly, sub-set of the more famous actor portraits in which the actor was celebrated in all his theatrical glory. The more sombre *shini-e* served as a sad reminder of their mortality.

Memorial prints first became popular around 1790, with many produced between 1804 and 1818. Although actors were the most common subjects, famous artists also featured. Kuniyoshi's obituary portrait, for example, was produced by two of his pupils, Yoshiiku and Yoshitomi, and Kunisada was

fig. 131

Memorial print of Ichikawa Danjūrō VIII
1854

This striking portrait shows Ichikawa Danjūrō VIII dressed in pale-blue and white ceremonial robes holding a sword wrapped in cloth just before he committed suicide. There is a poignant contrast between the delicate features of his face and the angularity with which his clothes are drawn. The red glimpsed in the undergarment seems to hint at the blood about to be spilled. A straightforward portrait print such as this with little complex carving and few colours would have been on the streets fairly soon after his death.

Courtesy of the National Museum of Japanese History

嘉永七甲寅年八月六日於大坂没ス

八代目 市川團十郎 行年三十二才

法名 篤誉浄莚實忍信士

大坂天王寺村一心寺江葬ル

fig. 132

Ichikawa Danjūrō VIII and Bandō Shiuka Memorial Print
1856

This is an unusually fine memorial print showing the two stars who often played male and female leads together and who died within a year of each other. It is called *Journey to Paradise* and is thought to be by Kuniyoshi.

Danjūrō is to the far right carrying a pipe in his hand and Bandō is second from left. They both wear travelling outfits. Expert opinion as to the identity of their companions varies; some say they are two of Danjūrō's disciples, others Danjūrō's half-brother and a fellow actor. Amongst the heavenly throng awaiting them are other stars such as Matsumoto Kōshiro VI, Nakamura Utaemon IV and directly behind Bandō, possibly Danjūrō's rival half-brother Enzō (also known as Ichikawa Saruzō I).

The print has been beautifully produced with gradation behind the figures and fine detail in the kimono. Danjūrō is wearing a classic Edo lattice pattern (*sanshōkōshi*) and Bandō's kimono is produced using a wood grain printed over grey. The undergarment of the figure on the far left may be a clue to the artist – it has a paulownia motif which was Kuniyoshi's signature mark.

fig. 133

Memorial print of Ichikawa Danjūrō VIII

This fine quality but rather gory portrait shows
Ichikawa Danjūrō VIII framed in a cartouche made from
a rosary in the act of piercing his throat with a short
sword. The title of the print, '*kokoro no uchi*' (in my
heart), is shown above his head. The character for
heart appears to drip from the top bead of the rosary,
much as his blood drips onto a theatrical programme
with the triple box logo of the Ichikawa dynasty. The
programme uses the kabuki script and must have been
a challenge to draw in perspective.

The real interest, however, lies in the monochrome
background of distraught onlookers. It is said to show
Danjūrō's father, tonsured and sitting upright with Enzō
(the son by his mistress Otame) bowing low in front of
him. Otame herself is being beaten over the head with
a rosary by the father's real wife, Osumi.

responsible for a particularly fine *shini-e* of
Hiroshige as a Buddhist monk. After a famous
death it was only a matter of days before the
prints were available on the street. Although
mostly unsigned, some did carry a signature
and official seal. There tended to be a
common format, the deceased was portrayed
in pale blue formal robes often worn for ritual
suicide or actors were sometimes shown
costumed for their most noteworthy roles.
The posthumous name, date of death and
age, place of burial and occasionally a
memorial verse were all included in the
composition, though factual mistakes
are common.

The greatest number of *shini-e* produced,
however, was as a reflection of the massive
outpouring of grief at the suicide on 6 August
1854 of Ichikawa Danjūrō VIII, an actor and
superstar of his day. As a member of the most
illustrious Edo acting family, exponents of the
popular *aragoto* (rough) style, his sudden
death was a huge shock. He had gone to
Osaka to perform with his father, and was
found in his lodgings having cut his throat
twice with a short sword at the young age
of 32. He was wearing pale blue robes under
his traditional formal clothes bearing his
famous family crest of triple concentric boxes
(*mimasu*). Leaving no letter giving the reason
for his suicide, Edo was awash with rumours.
He had taken over the responsibility and
become Danjūrō VIII at the young age of 20,
before his father was exiled from Edo for

contravening the Luxury Ban decree in
1842. Danjūrō VII's personal life was suitably
complex with a wife, two concubines and
many children of whom Danjūrō VIII (his
childhood name was Shinnosuke) was the
eldest son. After his death, grief-stricken
fans chose to believe wild rumours about
the ambition of his father's favourite
concubine, Otame, to oust him in favour of
her own son, Enzō. The truth seems likely to
have been less dramatic. It appears Danjūrō
VIII himself had debts which drove him to
despair and suicide. Certainly the portraits
of him all show a man with a distinctively
elegant but highly-strung appearance. For
the Ichikawa family, the tragedy was not
over. The rival half-brother Enzō died in 1856,
and his father died in 1861 followed a few
months later by his favoured concubine
Otame. In 1855, Bandō Shiuka, who often
played the female lead opposite Danjūrō VIII,
also died. They appear together in some
shini-e (see fig.132, pp.126–7).

The response of the woodblock print world
to the need for both news and consolation
was swift and effective. Between 100 and
200 different prints were produced showing
Danjūrō VIII in many guises; in his burial
clothes, in a famous role, as a sleeping
Buddha or in more graphic scenes showing
the act of suicide itself. Some prints show a
simple figure against a white ground, which
must have been quick to produce; others
employ the full range of multicolour special

fig. 134

**Memorial Print of Ichikawa
Danjūrō VIII**
1854

A strikingly modern close-up
portrait of Ichikawa Danjūrō VIII is
displayed as a traditional hanging
scroll with a lotus flower and leaf
pattern mount. The picture of grief
surrounding him is extraordinary.
They are all women (about 30 in all)
ranging from a glamorous courtesan
and a nun to women with babies.
Their contortions produce a mêlée
of outstretched hands, gaping red
mouths and dots of black hair.
Weeping into their handkerchiefs
and kimono sleeves, they appear
inconsolable. Even the cat (centre
front) is distraught.

Courtesy of the National Museum of
Japanese History

effects, including embossing, and would
have incurred quite high production costs
and taken longer to reach the market. The
target audience was the many kabuki fans,
predominantly women, who would no doubt
have bought a print as a momento or as a
way of finding out more about the death of
an idol. Commemorating famous stars began
with memorial picture books (*tsuizen
kusazōshi*), developed into a boom of
memorial prints (*shini-e*) with the death
of Danjūrō VIII and then went into decline.
By the early 20th century they had almost
completely disappeared, superceded by
photography which had developed rapidly in
response to the 1903–04 Russo-Japanese war.

leisure
pleasure
play

fig.135
Humorous *pochibukuro* (see p.197) showing some
of the more ludicrous party tricks and games from
plate-spinning and nose tugging to a stamina contest
with a fan wedged between two foreheads.

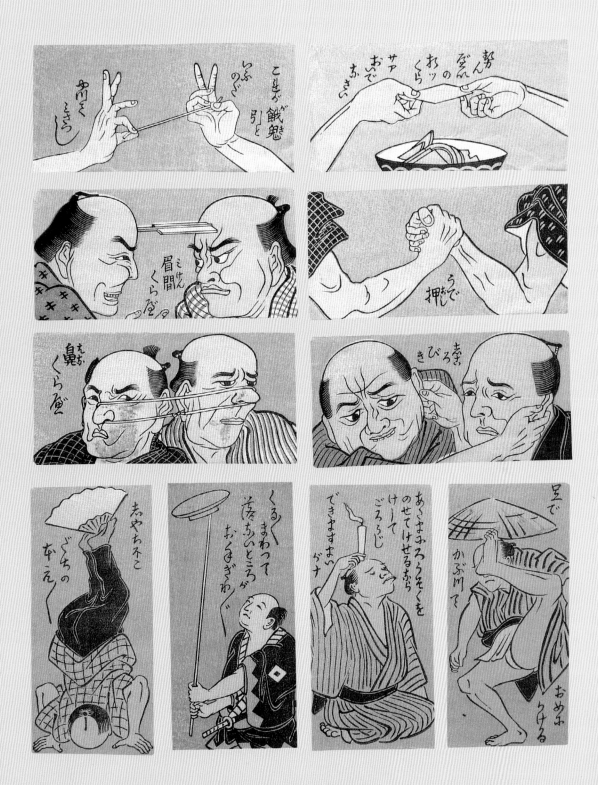

Playful prints and toy prints *asobi-e* and *omocha-e*

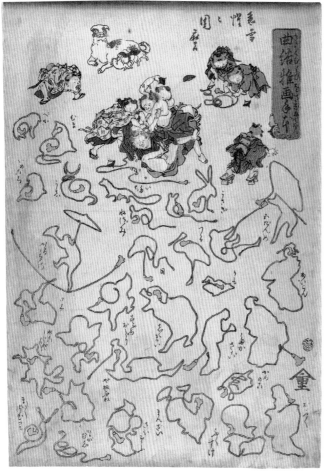

fig.136

String Compositions for Children

Kyokumusubi osana e tehon

Kawanabe Kyōsai

1864

This print by the witty Kawanabe Kyōsai is known as a *himo-e* (string or cord print).
It is essentially a primer for children (but enjoyable for adults too) to show the shapes
that can be made by laying out the string from a spinning top. A dog feeding her pups
looks on quietly as fighting breaks out and tops fly. In a playful attention to detail, the
cartouche is framed by a top and its unravelled cord.

In a paper on *The Games and Sports of Japanese Children* read to the Asiatic Society of Japan on 18 March 1874, Professor W. E. Griffis made the following comment: 'Among a nation of players such as the Japanese may be said to have been, it is not always easy to draw the line of demarcation between the diversions of children proper and those of a larger growth. Indeed it might be said that during the last two centuries and a half, previous to the coming of foreigners, the main business of this nation was play.'[17]

This observation betrays a degree of condescension common to Griffis and many other early Western visitors to Japan, but his comment does highlight a playful character which runs through many areas of Japanese culture, and the print world is no exception. There are two genres of print, *asobi-e* (playful prints) and *omocha-e* (toy prints) which cover exactly this area of play and playfulness not necessarily anchored in either the adult or child worlds. Although often treated separately I have combined the two categories because in many cases the audience was both adult and child.

A sense of play or playfulness as manifested in Edo era prints was not new; from earliest times Japanese culture used the element of play as part of cultural expression in both sacred and secular spheres. The predecessors of many of the playful conventions found in prints can be traced back to Heian court culture. The practice of *awase* (matching), for example, as seen in poetry or shell matching contests was a way of ordering and playing

17 *Transactions of the Asiatic Society of Japan*, vol 1–2, p.140

with the world, the influence of which can be seen in *karuta* (playing cards) (see p.183) and some toy prints. Sorting and ranking by categories and enumeration, again dating back to the Heian period, can be seen in *zukushi* (see p.54) and the *banzuke* (see p.51). Activities which began as the preserve of upper class adults, over the years permeated through society and came to influence the games of children of all classes.

The playful spirit of so much of Edo period culture should, however, be viewed correctly in the political and social context of the time. While games for children may not have been contentious, the activities of adults very definitely were, and the authorities used considerable energy and various decrees to try and tame the wilder excesses. The excesses of most concern were of course political, so for the frustrated Edoite, the disguise of play was an invaluable way to poke fun at the authorities without spending days in chains

as punishment. Disguised satirical comment, as caricature for example, could slip past the censor's beady eye but be understood by the audience. Without background explanation and context, however, these prints lose their full impact and are particularly hard for foreigners to grasp. Others are more straightforward in their demonstration of a sophisticated delight in visual tricks, some exploring the zone between reality and illusion. In a closed homogeneous society, Japanese artists could call on a huge reservoir of signs and symbols which would be instantly recognisable to the majority of viewers. The print could be 'read' and understood in an efficient, mutually comprehensible, visual shorthand.

Mitate-e, commonly called parody-pictures (*mitate* means 'choice', 'select') demanded a deep but by no means uncommon knowledge of Japan's history and cultural canon. They operated by exploiting the frisson

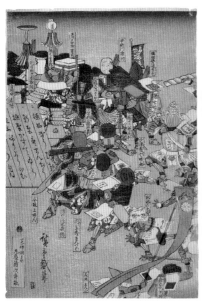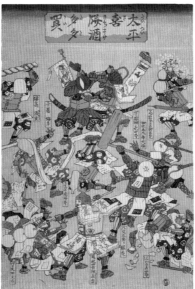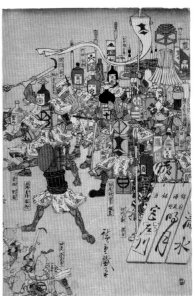

fig.137

Taiheiki – a battle between rice cakes and saké
Taiheikimochisake tatakai
Utagawa Hiroshige
1843–47

This parody triptych by Hiroshige is based on the *Taiheiki* – a 14th century epic tale of war set in a time of turmoil when the natural order of things seemed to be being threatened by the 'low' replacing the 'high'. In his version, Hiroshige pits the rice cakes, *mochi*, (left) against the saké barrels and bottles (right) in a mock battle between devotees of sweet or sour. Both sides are dressed in 'themed' armour made up of *mochi* or saké-related elements. Although the momentous changes of the late 19th century were yet to come, after famine and epidemic in the 1830s, prints were reflecting the signs of societal change.

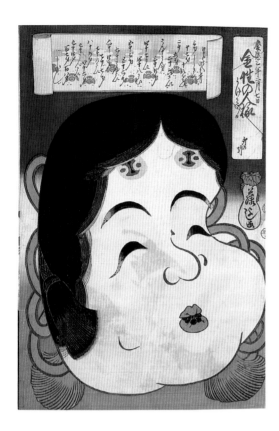

fig. 138

Lucky print – the mask of Ofuku
Kinshō no hitosama uke ni iru
Fujiyoshi
1867

This print uses letters as part of the picture but is also an example of an *uke-e* (lucky print). According to the ancient Chinese system of zodiac animals and divination, good and bad luck ran in 12 year cycles. On entering a good luck phase a person would receive gifts such as this print containing seven words beginning with the syllable *'fu'* (from *fuku* = happiness).

In this print the seven are:

1 the face is the mask of Ofuku (her plumpness symbolizes prosperity) (see fig. 46 p. 57)
2 hair = *fusa* (tassel)
3 eyebrows and eyes = *fude* (brush) strokes
4 nose = the letter *'fu'*
5 forehead = *fundō* (weights)
6 mouth = *fukuro* (pouch)
7 the artist's signature within a cartouche shaped like a gourd = *fukube*.

of excitement that comes with the recognition of the unfamiliar in familiar places. Classical themes were appropriated and reworked with contemporary imagery engaging the viewer in a sophisticated game of recognition. For these tricks to work, there had to be a high level of not only visual literacy but also classical knowledge. A surface reading of the picture misses the point and it loses its meaning and impact; but that very same surface reading may well have fooled the censors into passing the print. *Mitate-e* epitomise the world of bluff and double-bluff which sustained cultural life under Tokugawa rule.

One of the largest groups of prints, but for non-Japanese speakers hardest to fathom, plays with both the written word and the possibilities for word-play and punning offered by the homophonous nature and ambiguity of the Japanese language. Japanese is the perfect language for the lover of puns and word tricks, and the print artists of the Edo period exploited this facility to its full, and the results were not lost on a literate society. These word games were particularly popular

amongst the aficionados of the semi-closed world of the Yoshiwara *demi-monde*, which offered a perfect setting for the *risque double-entendre*.

The dual nature of ideographic writing as word and as picture had been exploited by artists and calligraphers for centuries, and in the Edo period this pictorial quality to the writing became yet another weapon in the playful arsenal of the artist. With a stroke, the cryptic word became a cryptic word-picture. These word-pictures had been an elegant pastime for Heian period ladies and later a method of teaching in Zen Buddhism, but in print they became playthings for all who could read. On a more practical level, humorous letter forms were produced to teach children to read as Japan moved into a world of full-time primary education (see fig. 1, p. 7).

Asobi-e, largely designed for adults equipped with a reasonably broad cultural knowledge may exhibit many of the sophistications outlined above, but *omocha-e* (toy prints) designed for children were more

straightforward in their content and offered both pure play and education disguised as play. Their genesis lies in a tradition of illustrated books, originally for adults, but with the appearance of *akahon* (red books) in the mid-Edo period, an enjoyment extended to children. *Akahon* concentrated on traditional tales, told over a few black and white illustrated pages. As the world of illustrated adult, often comical, book publishing took off, children lost out in favour of the larger adult market. Single sheet prints produced cheaply with children in mind filled the gap in an initial boom in the early 19th century. The second boom came in the early Meiji period and the introduction of a primary education system. The system of *terakoya* schools had worked to relatively high standards but had kept to a traditional curriculum of reading, writing and abacus. The educational possibilities offered by the visually attractive prints for children were seen as a way to broaden the curriculum and were of great help to many teachers who would have been completely unfamiliar with much of the knowledge being brought in from the West. Information traditionally absorbed in black and white form in *ōraimono* (copybooks, textbooks) (see fig. 32, p.46) was liberated and appeared in glorious colour on a single sheet.

Omocha-e can be divided broadly into two

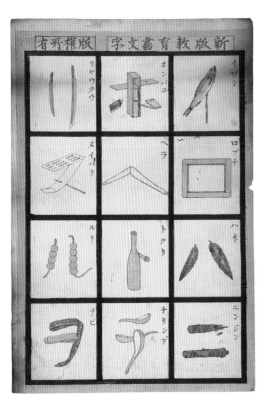

fig. 139

Educational picture words

Shinpan kyōiku moji

Yaita Takematsu

1893

A Meiji period example of a pictorial alphabet in the familiar *iroha* order. Top right 'i' is represented by a sardine (*iwashi*), bottom right 'ni' is represented by carrots (*ninjin*). The picture is also made into the shape of the letter. The plain background and bold grid give the print a modern feel.

fig. 140

A Cut-out-and-Dress Sea Bathing Print

Kyōiku kaisuiyoku kisekae

Ikko

1917

In this late example of woodblock, the figure is shown with a Western hairstyle and underwear but traditional kimono for her trip to the seaside – which in itself was an imported Western pastime. The rear views of the clothes have small tabs to use to construct the outfits.

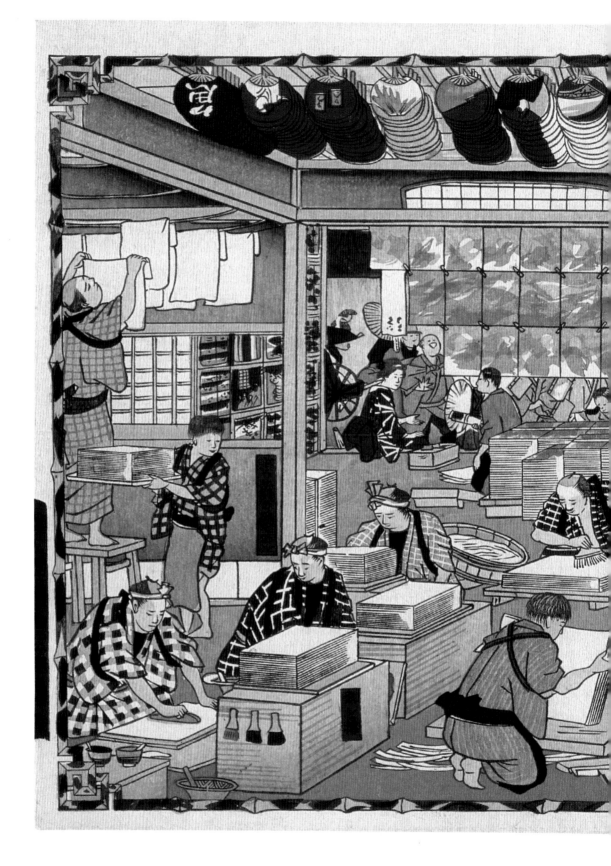

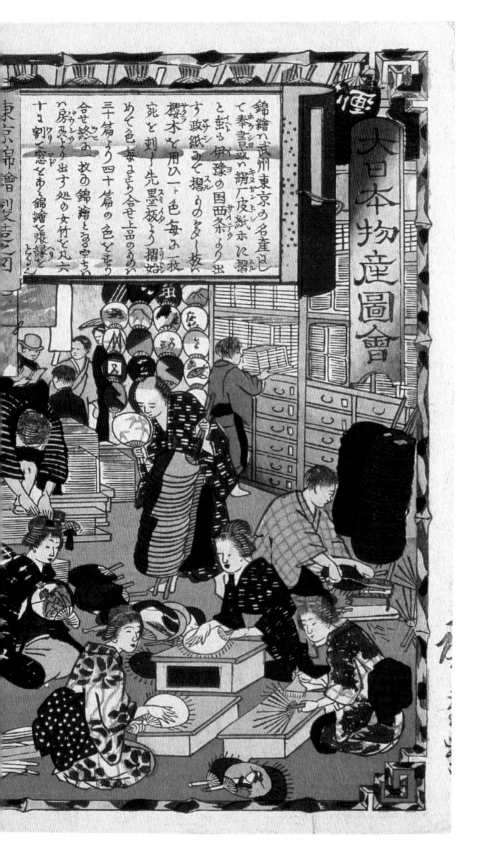

fig. 142

He Looks Scary, but
He's Actually Fine
Mikake wa kowai ga – tonda
ii hito
Utagawa Kuniyoshi
1850s

The keyblock for this well-known
Kuniyoshi print (*yose-e*) spent
years in a private collection in
Italy before returning to Japan.

fig. 143
The black outline printed from
the Kuniyoshi block above
clearly shows the two *kentō* for
registration. This outline would
be pasted (reversed) onto each
colour block and the relevant
area carved.

fig. 144
This modern re-print of the
Kuniyoshi print uses the
original outline block but with
re-carved colour blocks. The
flesh of the figure is made up
from a writhing mass of bodies,
the hair from a black figure
wielding a stick. A very similar
format is used for a catfish
print (see fig. 116, p. 113).

groups: those designed to be looked at in flat
sheet form and those designed to be cut out,
constructed and played with. Selling for a
small amount of money, these printed sheets
would have been within the purchasing
power of an urban child, although rural
children may well have had to make do with
simpler toys. A visit to the *ezōshiya* (print
shop) or *dagashiya* (candy/sweet shop) to buy
the latest print must have been a journey of
delight and anticipation for an Edo or Meiji
period child. The complicated construction of
many of the cut-out prints clearly required
adult help, and their cut-out and build nature
means that very few have survived in pristine
form. Thanks to the occasional child unwilling
or unable to take the scissors to a print, a few
copies have been left intact giving us an idea
of the compositional and technical skill of the
artists and craftsmen who produced them.
One artist's name, Yoshifuji, became
synonymous with *omocha-e*. His working life
coincided with the decline of ukiyo-e and the
loss of the traditional market so his reputation
was made in this field and some of the most
charming and playful *omocha-e* which survive
are his work.

Flat sheets

Asobi-e (playful prints), designed with adults
in mind, have a longer history than *omocha-e*
(toy prints) for children which became popular
in the late Edo and early Meiji periods and
provided employment for artists and
craftsmen as the decline of ukiyo-e began to
affect their livelihoods. The word *omocha-e*
itself did not exist in the Edo period and was
a late addition to the vocabulary, probably
derived from the expression *temochi asobi*
(play in/with the hands). The most numerous
group of flat sheet prints was *zukushi* (see
p. 54) covering the broadest range of subjects
for children, from school etiquette to ghouls
and ghosts. Some were designed to be
viewed as they were, almost like posters,
others to be cut out and made into books,
toys or objects. Whatever the content, the
sheet size for these prints was approximately
39 × 26.5 cm / 15 × 10 in. and to leave the
purchasers in no doubt that they were getting
the latest product, the title had the prefix

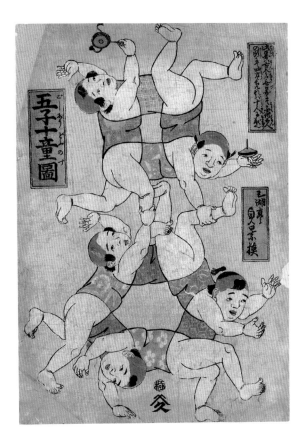

fig. 145

Five Boys or Ten Children
Goshijūdōnozu
Utagawa Sadakage
1830s–40s

This print is thought to be a Japanese example of this Chinese style of trompe l'oeil composition. A group of chubby children with curiously adult faces hold a top and a *dendentaiko* (drum-on-a-stick). The same image was used as a matchbox label and was adapted later by artists such as Yoshifuji who, as Japan reopened, substituted armed soldiers in Western-style uniforms for children.

fig. 146

Tokuyōmuki inu no sanwari
Utagawa Kuniyoshi
c.1847–52

The meaning of the title is not clear, but this print is a classic example of *ittōtadaiga* (one head several bodies) trompe l'oeil. The mêlée of ferocious dogs has managed to overturn the fortune teller, his table and lantern.

Shinpan (new print/edition). Although many of these prints produced for children are clearly technically inferior to earlier ukiyo-e, they still show tremendous flair and care in their composition, use of colour and content. The publishers had a tight brief to keep within a very limited budget, yet produce a colourful, attractive and practical product which would sell in huge quantities. Production values were kept to a minimum: expensive processes such as gradation (*bokashi*) were hard to justify. Although considered of little importance in the hierarchy of the print world, *omocha-e* do have a simple charm and in addition their content can be an invaluable reflection of everyday life of the period.

Some of the most inventive flat sheet *asobi-e* produced were based on visual games and tricks, particularly using the body, and could generally be classed as *damashi-e* (*trompe l'oeil*). One of the most skilled exponents was Utagawa Kuniyoshi, although this aspect of his work is generally less well-known than his more serious warrior prints (*musha-e*). *Yose-e* (or *hame-e*) (see figs.142–144, p.138) depicting a face composed of a jumble of bodies show a clear reference to the 16th century Milanese painter of curiosities, Giuseppe Arcimboldo. It is known that Kuniyoshi was aware of Western

fig. 147

Upside-down Picture
Dōkejōgeminozu
Utagawa Yoshitora
1861–62

An array of extraordinary characters is
completely transformed when turned upside-
down. For example in the right-hand panel,
Fukurokuju (one of the Seven Lucky Gods,
always shown with an abnormally large head),
turns upside-down into a front view of a *tanuki*
(raccoon dog). In the centre panel below the
cartouche the curly-haired character is a
foreigner who turns upside-down to be an
Ainu, native to the northern island of Hokkaido.

fig. 148

Party Tricks *zukushi*
Shusekigei zukushi
Utagawa Hiroshige II
1861

This *miburi-e* (gesture print) by Hiroshige II gives a clear
idea of the enthusiasm for party tricks. Some of these
poses are also seen in prints as projected shadows.
In the centre, an almost-naked man balances several
fans to make the outline of a pine tree, while the
character at bottom right with two pipes tied to his
head is pretending to be a lobster. The man with bottles
on his head and in his mouth is a horned owl.

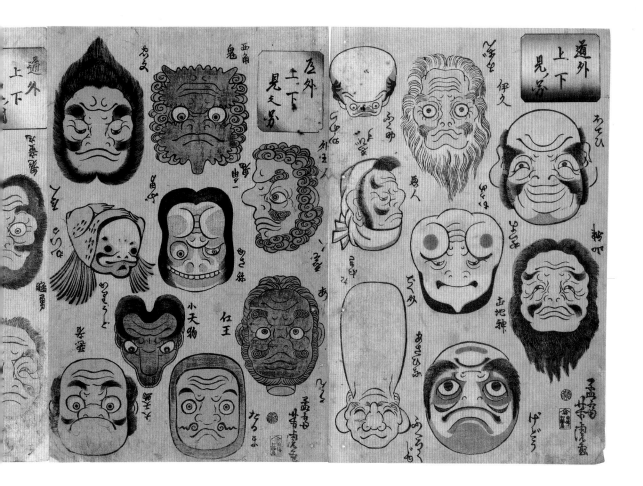

art as he had his own private collection of imported prints, but no direct influence has been clearly established. *Yose-e* were best-sellers in the late Edo period and were reprinted in the Meiji period and appeared in other guises such as *namazu-e* (catfish prints) (see fig.116, p.113).

In a similar playful vein were *gotōjūtaizu* (five heads and ten bodies) thought to be based on a Chinese or Indian concept possibly as a celebration of fertility. The bodies share heads in compositions which morph into a circus-like amalgamation of bodies. The more ingenious the composition the better (see fig.145, p.139). Variations on the same theme were produced, for example *ittōtadaiga* (one head, several bodies) where two or more bodies, human or animal, are locked together by having to share a single head (see fig.146, p.139).

Ueshita-e (upside-down prints) were popular from the 19th century and can be included in the same *damashi-e* group. Known in China as *entenzu* (rolling pictures), they can be viewed from two directions playing on the perceptual confusion created. Kuniyoshi and his pupil Yoshitora were masters, producing bold compositions of bizarre faces, equally strange seen from top or bottom. All these *trompe-l'oeil* prints called for considerable drafting skill and visual wit from the artist. The enjoyment for the viewer is found in the unravelling process from first impression, through the deciphering of layers to an understanding of how the image is composed. Part of the enjoyment too must have come from sharing this process with others. It is not clear whether these prints would have been pasted up on screens or *fusuma* doors in the home, or carefully folded and carried around to be brought out as party entertainment.

Miburi-e (gesture prints) and *kage-e*

fig. 149

Improvised Shadow Figures
Sokkyō kage bōshi zukushi
Utagawa Hiroshige
1840–42

An unusual compendium of *kage-e* by Hiroshige explains the original poses shown in full colour and the shadow (in pale grey) allegedly created on the *shōji* (paper screen). There is some doubt as to how accurate they actually are. However, part of the amusement no doubt lay in the ludicrous effort put into striking the poses rather than a polished performance at the end.

(left)
top: small teapot on a stove
bottom: pot for warming sake

(right)
top: wild goose on a rock
bottom: cat

(shadow prints also known as *utsushi-e*) give us a fascinating insight into Edo period parlour games. *Miburi-e* show body poses (often with the addition of basic props to hand at a party) struck as a popular form of entertainment. Copious supplies of alcohol no doubt loosened inhibitions and led to more risque poses than copying the gestures of famous actors or animals and birds. These prints, as well as being entertaining in their own right, would have acted as a primer to pass on practical information about new poses so that the purchaser could perfect

his art before the next drinking party (see fig. 148, p. 140). Images in shadow prints also encompass the valued concept of *mitate*, of transposing the unrelated, and arriving at something new. The projected shadow evokes a feeling of unreality, a distance created between this familiar world and the other.

Kage-e were an extension of this entertainment which used, in the days before projectors, light from a simple paper-covered lamp to throw shadows onto the *shōji* (paper screens). Until books and prints as manuals were produced, performers would have been

fig. 150
Parlour Shadow Pictures
Shinpan zashiki kage ga
Anon
1885

This toy print shows how to make simple hand shadows which any child could imitate. Printed in the Meiji period, it uses the new aniline colours and is fairly cheaply produced although variety has been introduced in the *shōji* patterns and kimono designs.

From the top, left to right:
hawk, cat; cow, fox; catching small birds with a stick, dog; rabbit, crow

fig. 151
Shadow Print
Shinpan kage-e
Utagawa Kunitoshi
1882

A cavalcade of silhouettes covers the page ranging from the elegant courtesan in the centre to ghosts at the bottom. In a sophisticated compositional touch the umbrella breaks through the top picture frame. A simple two-colour print (with an added touch of gradation at the top) it could be kept as a sheet or cut out and applied to lanterns or screens.

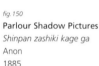

18 Tanizaki Junichirō (1977),
In Praise of Shadows
tr. T.J. Harper and
E.G. Seidensticker,
Leete's Island Books, USA,
pp. 20–24 and p. 38.

paid to demonstrate these tricks as entertainment. The performer would be out of sight on the verandah, his shape projected on the *shōji* and viewed from the room. If the performer was in the next room, the dividing *fusuma* doors were opened slightly and a sheet of oiled paper stretched in the gap on which the image would appear. Some sophisticated tableaux even called for several light sources projected in more than one direction. An appreciation of the silhouette as seen in textile patterns and metalwork and a contrast between light and dark, positive and

negative were important cultural elements in Japan, valued in both poetry and pictures. *Kage-e* continue this tradition. In his book *In Praise of Shadows*, the Japanese novelist Tanizaki Junichirō (1886–1965) laments Japan's post-war addiction to fluorescent lighting and the loss of the aesthetic of the shadow and dim flickering light.[18] It is also of interest that a country with an artistic tradition which eschewed *chiaroscuro* should produce such a rich world of shadows in print.

Familiar and much simpler hand shadows became part of print too. Other sheets were

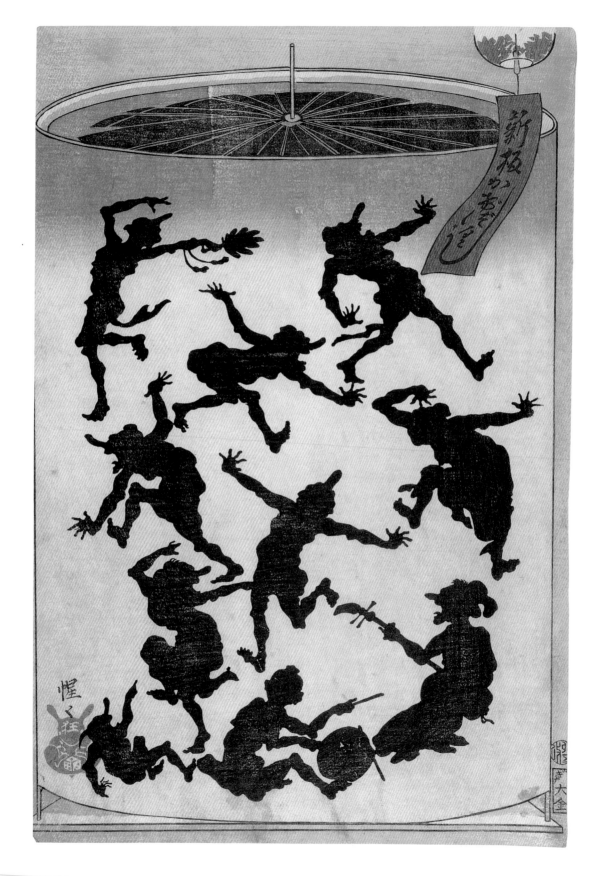

produced printed with black silhouettes which
were cut out, stuck onto paper lanterns, *shōji*
or *fusuma*, or attached to a bamboo skewer
and projected as shadow puppets. To make
the projections more versatile, some figures
were made with moving body parts. In others,
shapes were cut out and placed on the top of
the floor lamp, projecting scary monsters onto
the ceiling, which appeared to move in the
flickering of the flame. Moving shadow
puppets were also part of the *kamishibai*
(picture-story show) tradition which used
either *shōji* or an erected screen to project
the drama. Prints cut from *kawarikage-e*
(changing shadow prints) also produced
moving shadows. Two shapes were cut out
with slits and slotted into each other in a
cross-shape and then fixed to a bamboo stick.
As the stick was twizzled in the hands, the
two different shapes were projected.

Mawaritōrō (revolving lanterns) were
popular as entertainment particularly in the
cool of summer evenings. The paper lantern
was constructed with fins so that it revolved
in the breeze or with the heat from the flame.
Silhouettes cut out from prints and fixed
inside the lantern were projected onto the
paper and appeared to move as the lantern
spun. These lanterns and projected images
in general became popular as part of the

seasonal festivities in Yoshiwara. More
elaborate projections involved the erection
of a screen (about 183 × 90 cm / 6 × 3 ft) made
up of sheets of joined paper, behind which a
box-like projector called a *furo* was used to
project images. Several projectors used
together gave the impression of movement,
like *mawaritōrō*, a precursor of animation.
The magic lantern came to Japan via the
Dutch in Nagasaki and the first record of its
use for entertainment in a tea house dates to
1803. This arrival was a spur for the boom in
shadow games and prints, and woodblock not
only supplied the images needed for these
entertainments, but many prints also showed
them in use (see fig. 72, p.82 and fig. 192,
p.180). Many prints work on several levels;
they provide the shapes that make the
shadows and they then show the shadows
made by the shapes.

The drunken world of the parlour game
makes another print appearance, apart from
the above-mentioned games of improvisation
and shadow. More absurd abilities were called
for in these prints which were, no doubt, also
produced as a primer for extroverts to hone
their performing skills. Different personality
types were parodied through pulled facial
expressions and contortions, and games of
fairly low level skill were played, such as
blowing out a candle with your nose, putting
a string round the neck, nose or ears of two
people and pulling apart. The prints leave us
with an idea of the fun that was had, some of
it no doubt more entertaining after quantities
of saké (see fig. 135, p.131).

In addition to these visual and performance
related enjoyments, another popular and
more cerebral type of print took advantage of
both word-play based on sound/meaning and
the written *kanji* and their pictorial nature.
The highly regarded art of calligraphy had
always explored the potential of the
enjoyment of word as picture and the same
enjoyment was exploited in this genre of
prints. The origin of *moji-e* (letter prints) lies
in cursive Heian period writing of poems
disguised as flowing water or reeds called
ashide-e (reed pictures). The same playful use
of characters can be seen in *Ōtsu-e* and in
egoyomi. The enjoyment lies in the artistic skill

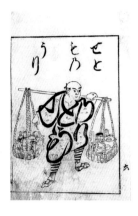

fig. 154
Letter picture *zukushi*
Moji-e zukushi
1685

These simple black letter pictures of various trades were produced fairly early in the Edo period. The name of each trade is given in the title and also concealed in the cursive writing which makes up the figure.

far left
setomonouri: china seller

left
manjūya: bean bun maker

with which the letters (both *kanji* and *kana* alphabets) are disguised and made into pictures, and the playful element found between the meaning of the character and the picture it portrays.

In similar vein *emoji* (picture letters) take the letter form (mostly of the *hiragana* alphabet) and translate them into human or animal shapes as an enjoyable way for children to learn their first alphabet (see fig. 1, p. 7). More sophisticated versions for adults by Kuniyoshi spell a word using letters composed of his signature cats. The tumbling forms of intertwined cats against a shaded background are witty and as masterful a composition as can be found in calligraphy, and show a true knowledge of cats.

Hanji-e (rebus prints) are also part of this group of puzzle prints and amuse by substituting letters, names or words with pictures which suggest the missing element. Sometimes additional pleasure is provided by the use of puns, which are easy to produce in the Japanese language and very popular. Even though Japan boasted a relatively high literacy rate, rebus-based artefacts were commonly produced for practical reasons. Pictorial calendars and agricultural cycles offered vital practical information (see fig. 35, p. 49) and picture-based versions of Buddhist scriptures were produced for the faithful who could not read. This custom found an early place in ukiyo-e in a mid-1790s series of beauty prints by Utamaro, where the courtesan's name is concealed in rebus form in a cartouche at the top of the print. The prominence of Edo

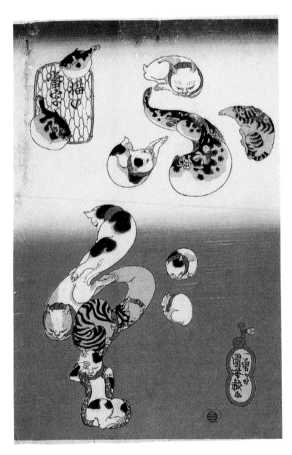

fig. 155
Substitute Character Cats
Neko no ateji
Utagawa Kuniyoshi
c. 1844

A combination of cats and blowfish (*fugu*) spell out the word '*fugu*'. The well-known cat lover Kuniyoshi produced many works featuring cats, but this calligraphic series counts as one of his best. The final touch is the cat's collar complete with bell decorating the cartouche showing the artist's name and a *fugu* and fishnet device for the title.

beauties as celebrities would have guaranteed that their identity was easily deciphered. In the mid-19th century, *hanji-e* became fashionable as a genre almost as a parlour quiz game. Some use pictures alone, others combine word and image with the answers to the riddle printed on the back. Some cultural references are so specific to the period that they are hard to unravel today, and many surviving prints have been mounted, obscuring the answers on the reverse. The answers were printed in pale ink in the dark areas, so you could not cheat by holding the print up to the light.

Jiguchi-e (pun prints) combined both word and image as a visual version of the wit and word-play so beloved of the Edoite. A play on words is accompanied by an amusing illustration, the enjoyment being in the relationship between the real word, the pun and the picture. They were very popular from the mid-18th century until the end of the Edo period and were often used to decorate lanterns sold at festivals. Very few survive (see fig.159, pp.150–51). In a time of tight political control, the subterfuge offered by *hanji-e* or *jiguchi-e* was valuable in slipping prints past the watchful eye of the censor and

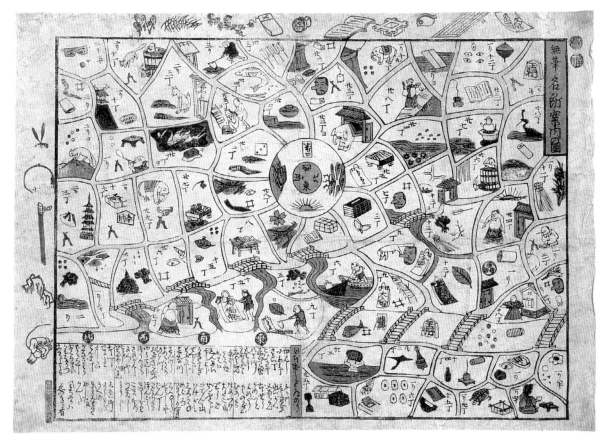

fig.156

A Rebus Guide to the Famous Places of Edo
Muhitsu meisho annai no zu
Anon
1847–52

In this print not only the content but also the title (top margin) and publisher's name (left margin) are given in rebus form. In the circle at the centre is a rebus points of the compass surrounded by all the subdivisions of Edo. For example, in the centre the half (*han*) elephant (*zō*) plus gate (*mon*) spells the district of Hanzōmon and in the top right corner, a spinning top (*koma*), plus five (*go*) eyes (*me*) spell the district of Komagome. The notorious Yoshiwara composed of reeds (*yoshi*) and straw (*wara*) appears to the right below the cartouche.

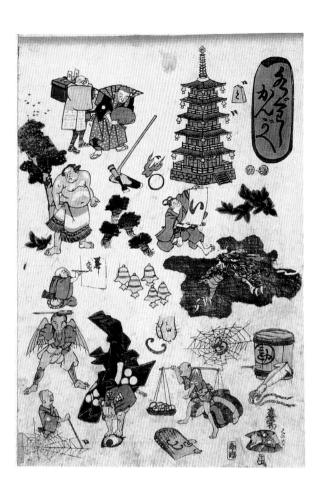

fig. 157
Concerning Fruits
Mizugashi kangae
Utagawa Kunimori
1847–52

The theme of this rebus print is
fruits with each picture combination
making up the name of a fruit.
For example, bottom right a barrel
containing vinegar (*su*) combines
with squid (*ika*) to make *suika*
(watermelon) and in the centre five
(*go*) bells (*rin*) make *ringo* (apple).
The bowing figure right at the
bottom represents the artist.

providing the Edoite with an additional thrill
when the print was deciphered.

Giga (caricatures) and *manga* (cartoons)
offered a purely visual form of fun also suited
to the dark arts of subversion. The terms used
to describe the mix of visual tomfoolery and,
on occasions, satirical comment are so many
and varied that there is not space to explore
them all here in depth. *Manga* combined the
playful and satirical elements in more or less
equal measure; *giga* leaned towards the
playful, *fūshi-ga* (lampoons) towards the
satirical. Every time the authorities attempted
to clamp down on popular prints, the satirical
element grew in importance. The ability to
conceal political discontent within an
innocent-seeming print acted as a safety
valve for the frustration felt through a lack
of legitimate outlets for expression.

Hand-painted picture scrolls (*emakimono*)
are early examples of this spirit of *manga/giga*.
One of the best known is the *Chōjū Giga*

(Scroll of Frolicking Animals) attributed
(at least in part) to a priest, Toba Sōjō
(1053–1140) and now owned by Kōzanji,
a temple in Kyoto (see fig.161, p.152).
The scroll shows ink paintings of frolicking
monkeys, hares, frogs and birds behaving as
humans in imitation of monks, priests and
aristocrats and in the process satirising the
social and political mores of the time.
Emakimono can be credited with being the
origins of the Japanese *manga* and animation
tradition, but being hand-painted, access was
inevitably restricted to the wealthy. With the
growing resources of the mercantile classes in
the Edo period, they co-opted this pictorial
tradition and gave it expression in their chosen
medium, woodblock, initially in book form.
In the early 18th century there are recorded
references to *toba-e* (toba prints – some say
named after the priest author of the frolicking
animals) which were characterised by a fluid
line and figures with absurdly exaggerated

(right)
fig. 158
Kitchen Equipment Rebus Print
Katte dōgu hanjimono ga
Utagawa Shigenobu (Hiroshige II)
1859–52

The theme of this rebus print is
kitchen equipment. Near the top
left a bundle of leaves (*na*) plus a
fart (*he*) makes the word *nabe*
(saucepan). In the bottom right,
printing (*suri*) by a child (*ko*) plus
(*ki*) (the ideogram he is printing), all
spells *surikogi* (pestle). On the right,
a rice field (*ta*) with an eagle (*washi*)
spells *tawashi* (scrubbing brush).
In Japanese there are variations in
the way a letter sounds which
permit these interpretations.

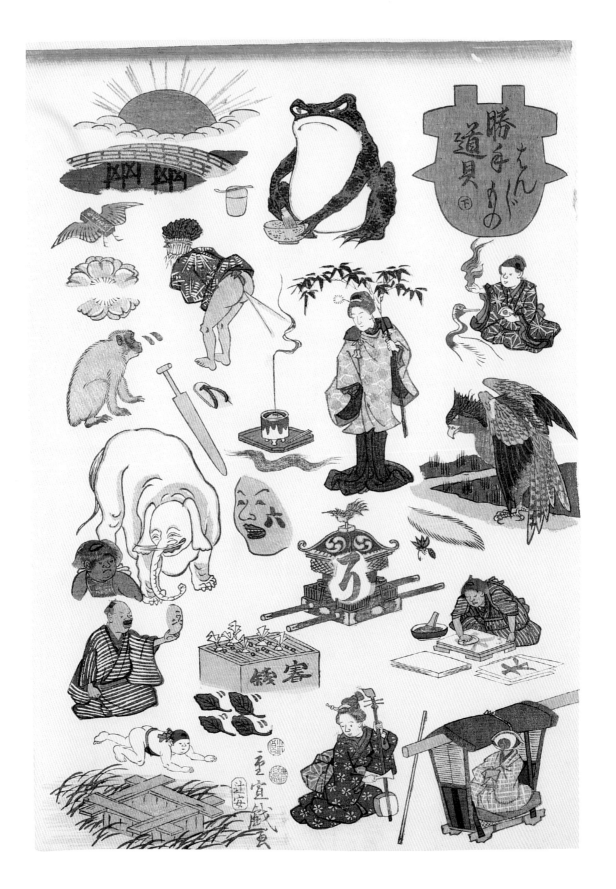

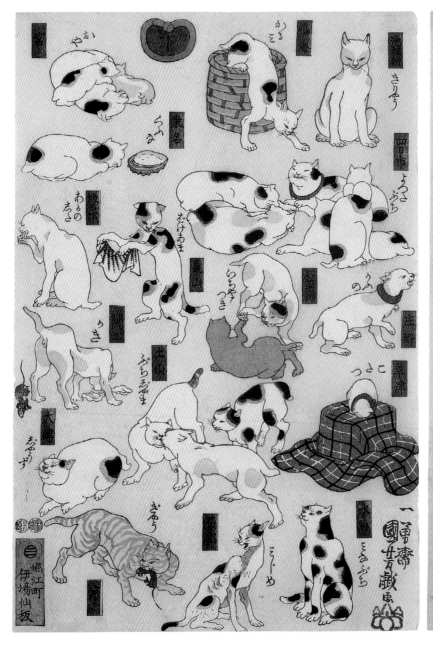
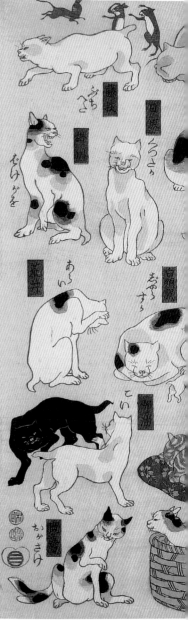

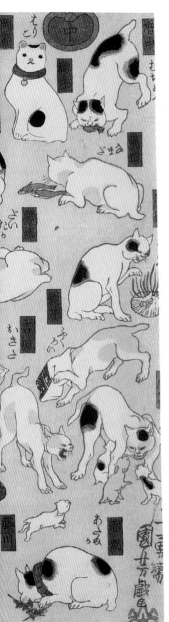
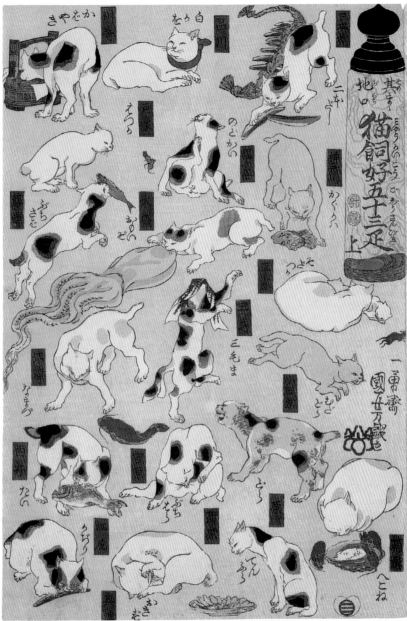

fig. 159

Cat Lover's Animal Puns of the Tōkaidō
Sono mama jiguchi myōkaikō 53 biki
Utagawa Kuniyoshi
1847–52

The *jiguchi* in the title refers to *jiguchi-e* (pun print) and in this masterpiece, Kuniyoshi allocates a cat and a pun to each of the 53 stages of the *Tōkaidō*. Puns have been made on each place name (some of them rather forced) and the cat illustrates the pun. In the centre of the right panel, a cat is struggling with a giant octopus – the place name it represents of Ôiso has been changed to Omoizo which means 'this is a bit heavy'. Below the octopus a white cat confronts a black catfish – the place name Numazu has been changed to *namazu* (catfish). The striped cat, representing the destination of Kyoto (bottom far left), growls '*gya*' through a mouthful of mouse in place of the '*kyo*' of Kyoto. Most of the cats shown are of the short tailed variety particularly popular with artists and courtesans in the Edo period.

fig. 160

A Hundred Victories, A Hundred Laughs
Hyakusen, Hyakushō
Kobayashi Kiyochika

Kiyochika studied both Japanese and Western art and was influenced by lithography and etching. In this satirical print (*fūshi-ga*) from the series *Hyakusen, Hyakushō* showing episodes from the Sino-Japanese (1894–95) and Russo-Japanese (1904–05) wars, he displays his biting satirical (and rather racist) wit. Coming from a samurai family, he had little sympathy for the losing side. Here, in a play on the word *mushaburi* (valour) he adds a vowel and alludes to *mushaburui* (tremble with excitement) and shows a quaking Chinese soldier and his equally terrified horse.

limbs and eyes reduced to a dot or stroke of the brush. *Toba-e* were said to have started in the Kyoto/Osaka area and are characterised by a brevity of form and exaggerated expressive movement. Hokusai produced *toba-e* (see fig. 162, p.153) and Hiroshige shows the influence of this abbreviated style in his humorous rendition of figures especially in the *53 Stages of the Tōkaidō*.

Ōtsu-e do not have the aristocratic picture scroll pedigree of *toba-e*, but they did spread nationwide by way of the great highways and went from being small-town souvenirs to become synonymous with caricature. Their original content was religious, but they broadened to include secular characters which spread beyond their confines to appear in different genre including prints. The bold brushstrokes of the hand-painted *Ōtsu-e* and their gently humorous and sometimes satirical spirit (see p.108) can be recognised in cartoon prints.

One of the giants of 19th century humorous and satirical prints was undoubtedly Kuniyoshi. His wit and skill as a draftsman can be seen in a rare series called *kugi-e* (literally 'nail prints') which eschew the familiar flowing brush line of woodblock in favour of a line which appears to have been scratched with a nail. They are titled *Nitakaragurakabe no mudagaki* (Scribblings on a Storehouse Wall) (see fig. 164, p.154) which hints at the graffiti spirit in which they were produced. They were published in the mid-19th century at a time

when the authorities were showing particular displeasure at the popularity of actor portraits. The scratched images are in fact caricatures of famous actors of the time and would have managed to circumvent the restrictions and satisfy the customer's desire for portraits of their idols.

Gijinga (anthropomorphic prints) were purely visual and commonly showed animals and plants behaving in a human fashion. One of the best known series by Kuniyoshi shows

fig. 161

A scene from the 12th century scroll Frolicking Animals (*Chōjū Giga*) in which frogs, monkeys, rabbits and foxes poke fun at human behaviour. The fluid brush and ink lines are dynamic and expressive and capture the spirit of this scene in which a boastful frog seems to have got the better of the rabbit.

fig.162
Cure-All Salve
Katsushika Hokusai

The *toba-e* (*toba* print) of which this is an example, is a print descendant of Frolicking Animals (fig.161) and is characterised by exaggerated limbs and over-dramatic composition. It is not clear what mishap has befallen the poor man but he may be in need of the advertised 'Cure-All Salve', shown as the product of 'red-haired' foreigners (*kōmō*).

fig.163
Parodies of *Tengu* – the Long-nosed Goblin
Top: *Tengu* caught in a shower – *Tengu no yūdachi*
Bottom: *Tengu* nose decoration – *Tengu no hanakazari*
(a play on two meanings of the word *hana* – flower and nose)
Utagawa Kuniyoshi
1842–43

The origins of the *tengu* (long-nosed goblin) (see p.186) are not clear. In some guises he has part human, part bird form, but the most common shows him with an excessively long nose and red face. He is simultaneously feared as a trickster capable of transformation but also seen as beneficent. In early portraits of Westerners, their large noses were particularly prominent and often appeared to be *tengu*-like in their portrayal.

In these cartoon-style prints, Kuniyoshi gently pokes fun at human behaviour, made to appear even more ludicrous by the ridiculous noses. In the bottom left corner, one of Kuniyoshi's cats sleeps through the antics.

the *hōzuki* plant (Chinese Lantern plant) acting out everyday and historical scenes (see fig.166, p.155). The *hōzuki* was an especially popular summer toy with girls. It could be made to produce a squeaking noise by squeezing and blowing the dried salted berry. The bitter berry was said to be liked by pregnant women so 'to blow the *hōzuki*' in the pleasure quarters was thought to be ominous as it may be an indication of pregnancy which would be bad for business. The *hōzuki* in Kuniyoshi's prints betray no such worldly concerns in their playful re-enactments, and were no doubt enjoyed by both adults and children.

fig.164

Scribblings on a Storehouse Wall

Nitakuragura kabe no mudagaki

Utagawa Kuniyoshi

c. 1848

This series of *kugi-e* (literally 'nail prints') actor portraits were produced in reaction to the reforms in the early 1840s (*Tenpō Reforms*) (see p.78) which outlawed actor prints. Kuniyoshi's response was brilliant. He abandoned the skilled, flowing line characteristic of woodblock and, even though he was in his artistic prime, he deliberately drew crudely – as if the line was being scratched into the white-painted wall of a storehouse. His own signature and his publisher's mark in the black band got the same treatment.

This style also called for considerable skill on the part of the carver who had to transfer the jagged, halting line to wood and the printer who brought out tone in the black.

The actor at the top right is none other than Ichikawa Danjūrō VIII in happier times (see p.128).

(right)

fig.165

Fish with Human Characteristics

Uo no kokoro

Utagawa Kuniyoshi

early 1840s

These fish portraits are, like the *kugi-e* (fig.164), Kuniyoshi's response to the clampdown on actor's portraits. A well-known actor's face (which would have been easily recognisable to fans but not so easy for us now) was grafted onto a fish body. In the presentation of these fish there is an echo of European natural history compendia which were known in Japan.

fig.166

Physalis *Zukushi*

Hōzuki zukushi

Utagawa Kuniyoshi

1843–47

The anthropomorphic hero of these prints is the *hōzuki*, the Chinese Lantern plant (*Physalis alkekengi*) turned inside out with the cherry as the head. Actual plants were used like this as dolls.

Clockwise from top right:

1 Benkei, the warrior monk's armour and seven special tools
2 Parlour games including arm and neck wrestling
3 *Hōzuki* figures take fright at the sight of a 'corn' ghost
4 Sudden shower – with a Kuniyoshi 'leaf' cat making its escape.

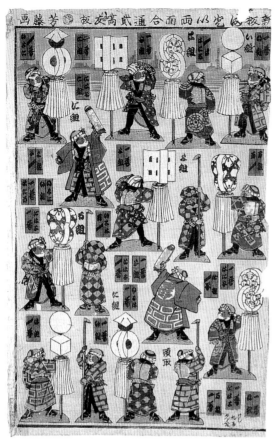

fig. 167

Double Print of Firemen's Standards
Shinpan matoi ryōmen-e
Utagawa Yoshifuji
late Edo period

This *ryōmen-e* (double-sided print) by Yoshifuji has 16 front and back views making up into eight children as firemen. There were 48 town fire brigades in Edo, and from 1720 each had an identifying standard (*matoi*).

The figures would be pasted to thicker paper, cut out and glued to make a freestanding doll (see also fig. 16, p. 27).

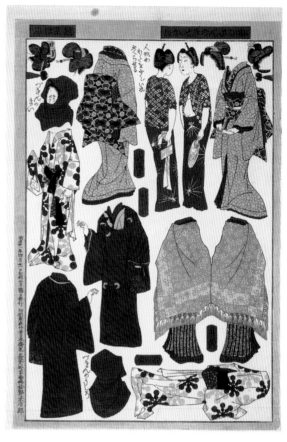

fig. 168

Big Sister Cut-out-and-dress Doll
Nēsan no kisekae
Anon
1898

This elegant sheet offers front and back views of the doll, plus outfits and hairstyles for both formal and informal occasions. The instructions suggest padding the doll figure before sticking it together to make it more realistic. The use of aniline red and purple make the print rather brash but appealing (see also fig. 140, p. 135).

Three-dimensional prints

The simplest print with three-dimensional possibilities belongs to the ever popular group, *zukushi*. Dolls, toys, utensils and animals could all be brought to life by pasting the printed sheet to a thicker piece of paper using *nori* (rice glue) and carefully cutting out the shapes. The more complicated shapes must have required adult help and considerable dexterity. Some sheets were made into card games, board games or toys; others were printed with both a back and front so that, for example, a double-sided doll or sumo wrestler could be made. By making a sandwich of the front and back views around a thicker piece of paper and inserting a bamboo skewer, the dolls could be made to stand up in the ground outside or indoors between floorboards or *tatami* mats.

Kisekaeningyō prints (change-of-clothes doll prints) supplied on one sheet the basic doll figure and a change of wardrobe to accompany him or her. As Japan absorbed the sartorial novelties brought by the Meiji era, they were reflected in the outfits that came with the dolls. A combination of Western and Japanese dress and hairstyles became popular. The kabuki theme was present in this group

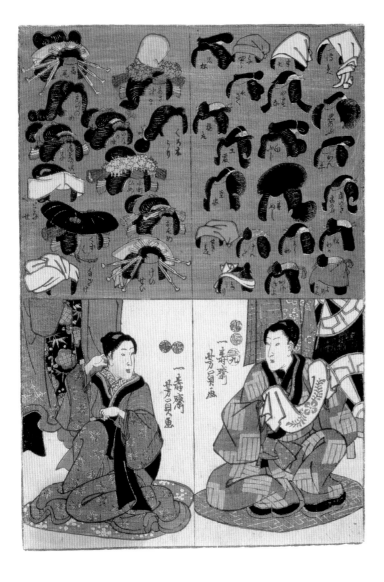

fig. 169
Matching Wigs
Katsura awase
Utagawa Yoshikazu
1853

A male and female actor doll pose at the bottom of the print and the top half boasts a comprehensive selection of wigs for a variety of roles.

too; prints offered alternative costumes and wigs in imitation of the swift scene and costume changes in real kabuki. The obvious fact that these prints were cut out and played with means inevitably that few survive, especially in sheet form.

The technical challenge for three-dimensional prints was in the drafting and tracing stage. For the different elements to fit exactly when they were cut out, the original drawing and subsequent tracings and carving needed to be very accurate. In addition, the layout of the uncut sheet had to be not only economical but also sufficiently attractive to potential buyers.

Print also provided the basics for more physical games. Printed masks were cut out and used to disguise identity, and tiny kites could be made in imitation of the real larger ones, which were also produced by hand-colouring a woodblock outline. The traditional New Year's game of battledore required decorated *hagoita* (a type of wooden bat/racket) which, for those able to afford it, were hand-painted or decorated with *oshi-e* (padded pictures) cut from silk. For those with less money, woodblock printed *hagoita* designs were produced which could be cut out and pasted to a plain bat in imitation of the more expensive padded versions. Kabuki actors were popular images on *hagoita*.

A three-dimensional element based on paper folding was offered by the *tatamikawari-e* (or *orikawari-e* folding print). They were either printed as a single print or as part of a sheet of toys and cut out and folded from there. New images were created through folding the sheet to hide or reveal different parts of the composition. The pleasure was in the transformation of one image into another with a simple fold (see fig. 171, p.158 and fig. 172, p.159). By contrast *shikake-e* (mechanical prints) have a separate piece of

fig. 170
A basic toy kite made from a sheet of thin paper with hand-colouring in a woodblock outline. The print is pasted to bamboo stretchers. In full-size kites the frame was made by bamboo blind makers (*sudareya*) and the picture pasted by lantern makers or scroll mounters. The pictures themselves were sometimes drawn by impoverished minor samurai, later as part-time work for ukiyo-e artists.

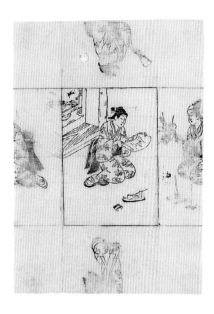

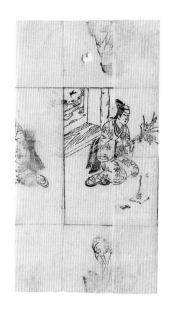

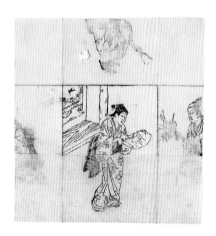

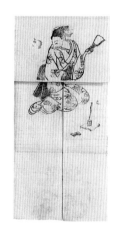

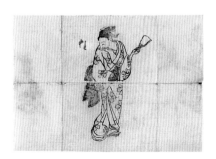

Folding Print
Kawari-e
Anon
woodblock with hand-colouring
c.1716–36

A piece of paper 30 × 21.5cm /12 × 8in. can be folded
into 11 different pictures. Printed simply in black, a
beautiful woman, a fox and a young man appear and
disappear, sit or stand, depending on the folds. Later
versions of folding prints became more complex.

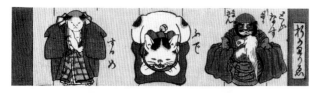

fig.172

This Contains Lots of Interesting Things

Kononaka wa omoshirokimono

Utagawa Yoshifuji

c.1865–67

Yoshifuji, the master of toy prints, packed a single sheet with delights from which these two are cut.

above left

A folding print which folds so the figure on the left becomes a squid, centre, a brush and right, a pumpkin.

above right

A folding print of animals: two figures, one a chicken admiring itself in a mirror and the other – a cat reading, change by folding into other animals – a dog, a mouse, a sparrow, a rabbit etc. The black line indicates the fold line.

fig.173

Children's Gymnastic Equipment

Jidō kikai taisōzu

Anon

Meiji period

A two-sheet construction print showing the interest aroused by Western ways. A well-dressed but rather solemn audience looks on as children demonstrate various pieces of novel gymnastic equipment. The simplified picture (top right corner) gives an idea of the finished construction.

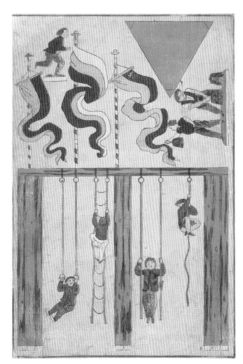

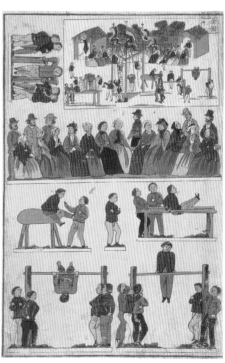

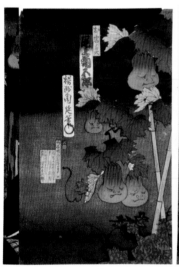
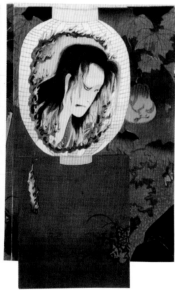
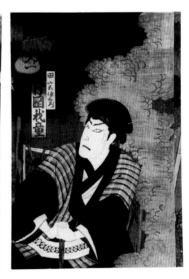

fig.174

Ghost Story of Yotsuya on the *Tōkaidō*
Tōkaidō Yotsuya Kaidan – Oiwa
Yōshū Chikanobu (1838–1912)
1884

This *shikake-e* (mechanical print) shows a scene from the popular play
Tōkaidō Yotsuya Kaidan by Tsuruya Namboku, first performed in 1825. An
extra flap is attached over the lantern which folds down to reveal the ghostly
image of Oiwa as she appears to haunt her husband Ie'mon who instigated
her poisoning so that he could marry someone else. In its mechanical element
the print imitates the quick scene change effects in the actual play.

The Tsubouchi Memorial Museum nos. 402-0236, 402-0238

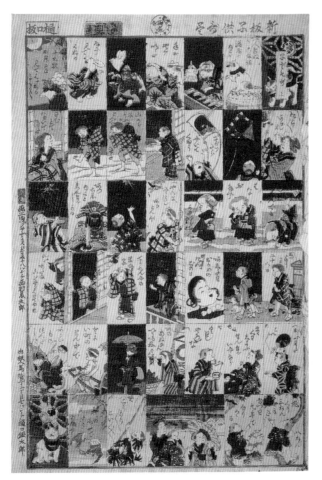

fig.175
Child's Song *zukushi*
Kodomo uta zukushi
Utagawa Yoshifuji
1884

A brightly coloured grid of picture boxes which could either be enjoyed as a single sheet or cut out and made into a tiny book. The riot of brash colour would, no doubt, have appealed to children and, to some extent, it masks the poor quality of printing and registration.

adult prints. The development of colour newspapers for adults was imitated for children with *Shinbun zukushi* (newspaper *zukushi*). Each square on the sheet told a story gleaned from the adult versions. Yoshifuji, the acknowledged master of *omocha-e* and pupil of Kuniyoshi, the master of *asobi-e*, produced a newspaper sheet for children based on real stories but dressed up as traditional tales.

The apogee of paper engineering and print combined was reached with the completely three-dimensional constructions known variously as *kumiage-e*, *kumitate-e* and, in the Kyoto/Osaka area, *tatebanko* (construction prints). They appear to have first been produced in that region in the mid-Edo period and may have developed out of paper models which were produced as maquettes of tea houses for tea masters. A link has also been suggested between early *tatebanko* and the production of *uki-e* (perspective prints) which may have been sketched from a built paper model. The first widely available construction print was the *kirikumitōrō* (cut out and build lantern) (fig.177, p.163) and was printed to be made into a lantern used at the summer Bon festival to honour dead ancestors. The printed lantern was pasted onto paper, cut out and constructed, and put outside the door with a light inside on summer nights. In appearance they imitated cut glass lanterns which would not have been widely available at the time. By mid to late Edo, construction prints had made the transition to becoming toys.

The more ambitious three-dimensional constructions sometimes spread over as many as 12 sheets and were surely beyond the building capabilities of children, and, I suspect, many adults. The first sheet often, but not

paper carefully pasted over one section of the main print; lifting or turning this piece changes the scene and shows in a very simple form the evolution of a narrative akin to theatre. The ever-popular kabuki was full of tricks which came in some way to be imitated in paper and print. The actors underwent on-stage rapid costume changes and the development of sophisticated stage technology made instant scene shifts possible. The three-dimensional element to the print and increasingly skilful paper engineering thrived on this appetite for the excitement of the dramatic moment of change fundamental to kabuki.

Less dramatic but equally pleasurable for children were the single sheets designed and printed to be cut and folded into tiny picture books. Familiar traditional tales were popular as well as humorous stories showing the same love of cartoon, caricature and wit as the

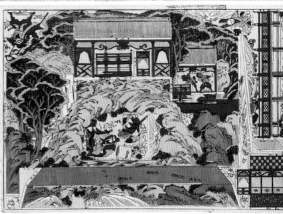

always, included a small picture with an inspiring view of the finished scene; the constituent parts were scattered artistically and very economically across the remaining sheets. Parts to be pasted and joined were printed with a very narrow white border which was folded and glued. Popular themes ranged from daily life to great historical scenes, famous beauty spots, festivals and of course kabuki. Unlike Western model theatres, which were designed to be used to give performances, Japanese versions were static scenes in imitation of the set-piece climaxes in a kabuki performance. Enjoyment was in the construction process and subsequent appreciation rather than using the toy to re-enact an event.

Well-known artists such as Hokusai responded to the challenge of composition and construction that these prints presented, although sadly few of his works survive. The finished constructions must have been impressive, although given their technical complexity one can imagine many children's hopes ended in disappointment. The skill of the original team that produced the prints should not be overlooked. A finished concept had to be imagined and then 'de-constructed' in such a way that it could be drafted and the constituent parts dispersed as efficiently and as attractively as possible within the confines of the printed sheets. The uncut sheets themselves are masterpieces of composition, lost in the building process. Single sheet prints composed of four miniaturised construction sheets printed together were also produced. Far too small to be cut out and built they were surely sold to be kept intact as a keepsake, perhaps as a homage to the 'uncut' compositional skills of the artists.

Although largely overlooked within the broader woodblock canon *omocha-e* and

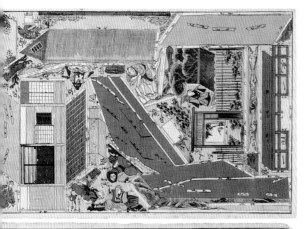

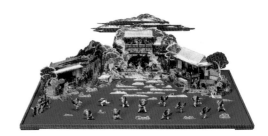

fig. 176
Tongue-cut Sparrow and Momotarō Scene
Shitakiri suzume Momotarō ichidaki
Hasegawa Sadanobu II
1891

Made up of six sheets, this construction print by the Osaka masters of the genre, the Hasegawa family, must have been extraordinarily difficult to construct. Only a simple black outline of the finished construction is given (bottom left sheet). The position of the main characters is marked on the base of each scene. It combines the settings for two classic Japanese stories, *Shitakiri Suzume*'s inn scene (Tongue-cut Sparrow) on the left, Momotarō's driving out of the devils scene in the centre and Momotarō's house to the right.

The reconstruction (above) shows just how complex the completed scene is.

asobi-e together offer a fascinating insight into the true spirit of woodblock. The fact that so many of the prints were designed to be cut up and thereby destroyed serves to reinforce the often misunderstood nature of Japanese woodblock, not as a precious untouchable work of art but as a familiar and affordable part of everyday life. The same technique which produced colour prints that now grace the walls of the worlds' major museums was also used to print throwaway toys for not particularly affluent children and playful prints to amuse and delight drunken party guests. The fact that these humble products of the woodblock process are also works of visual sophistication and invention is a credit to the extraordinary skill and talent of the artists and craftsmen.

fig. 177
Cut Out and Build Lantern
Kirikumitōrō
Utagawa Sadayoshi
late Edo period

A very elaborate cut-out lantern, with a black and white outline (top right) to give an idea of the finished article. The triangular facets are patterned with a traditional trailing gourd design (see also fig.153, p.145).

Board games *sugoroku, jūrokumusashi* and *menko*

Sugoroku

The most common translation of the word *sugoroku* as backgammon leads to immediate confusion as the game comes in two very different forms. *Bansugoroku* (recognisable to a backgammon player) is played on a wooden box-like board, has two players and two dice and was played in Japan from Heian times, especially by well-bred young ladies. Later its image changed as it became linked with gambling. The much more common *sugoroku* game (often called *e-sugoroku*, picture *sugoroku*) is a competitive race game played on a printed sheet of paper using dice and a piece/counter (made of paper) for each player. The piece is moved round the board towards the goal following the throw of the dice. In many ways it resembles snakes and ladders. It was this paper form of *sugoroku* which became another vehicle for the extraordinary vitality and creativity of Japanese woodblock. The game begins with a starting point (*furidashi*) and leads to a finishing point (*agari*). Progress round the board is in one of two ways and it is not clear which is the older form; *mawari* (roundabout) *sugoroku* proceeds in order, *tobi* (jumping) *sugoroku* allows the player to 'jump' squares according to the instructions given. Occasionally a board combined both *mawari* and *tobi* and some, called *furiwake*, had two separate routes to the goal, but whatever the method *sugoroku* was always governed by the chance inherent in the throw of the dice.

Sugoroku were commissioned and printed using the same team of publisher, artist, carver and printer as produced single sheet prints. Originally black and white (occasionally

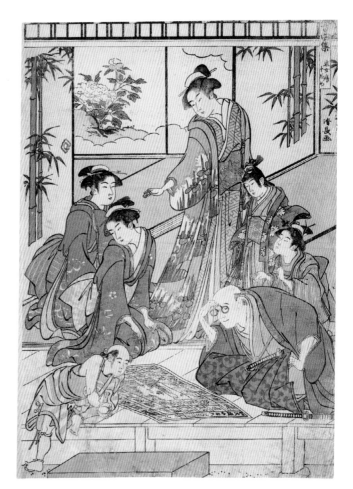

fig.178

A Man Playing the Board Game *sugoroku* in a Teahouse
Ongyoku-shu
Torii Kiyonaga
*c.*1789

The central panel from a triptych, this prints shows a scene from the popular drama *Koi nyōbō somewake tazuna* (Lovesick ladies in waiting – reins dyed various colours). Princess Shirabe is not keen to leave home for her politically-arranged marriage so, to amuse her, a young driver is brought in with his *dōchū sugoroku*. He loses and she is sufficiently cheered up to embark on the real journey just won 'virtually' in the *sugoroku* game.

hand-coloured), with the advent of multicoloured print they expanded to cover as many as nine sheets of paper, which after printing were pasted together to produce a single image sometimes as large as 92 × 74 cm/36 × 29 in. The finished *sugoroku* was carefully folded and placed for sale in a printed outer envelope which was usually lavishly decorated to encourage sales. Often a different (and sometimes more famous) artist was used to design the envelope.

As woodblock developed technically these changes were reflected in the complexity of the *sugoroku* produced, each square on the board becoming a miniature work of art in its own right. The name of the person who originated the idea for that particular game, plus the name of the carver and printer were frequently recorded, which implies that they had pride in their work even though historically the artistry of *sugoroku* has largely been overlooked compared to that of ukiyo-e. Some *sugoroku* show censor's seals, others not. *Sugoroku* were fairly cheap to buy and new versions would have been produced regularly to satisfy demand, although relatively few have survived. Ephemeral by nature, they shared the fate of many prints; being discarded after use, pasted to a screen or wall as decoration or destroyed in one of the many disasters that befell Japanese communities.

Sugoroku's origins are unclear. Tang period China (618–907) produced spiral format board game versions of the promotional road map through the labyrinthine Chinese civil administrative system. Board games with religious themes existed in India and Tibet, and by way of China they may well have been the template for the earliest Japanese *sugoroku* which were Buddhist in content. It is also conceivable that the European game of 'Goose' found its way to Japan before her doors closed, and the two versions of the game met and blossomed into Japanese *sugoroku* or it may indeed have its own indigenous roots. A Chinese Buddhist custom of spreading out a mandala and throwing a flower (*tōgetokubutsu*) may have spread to Japan in the Kamakura period. A bodhisattva was selected for the novice depending on where the flower landed. It is tempting to

draw a visual link between the cosmic blueprint in a mandala and the orderly progress of squares on the sugoroku board. The earliest Japanese *Buppō* (Buddhist law) *sugoroku* possibly date back to the 13th century and were printed in black *sumi* ink on paper and used to teach novice monks of the Tendai sect the tenets of Buddhism. A Chinese alternative to dice was used, consisting of four- or six-sided pieces of wood with a character inscribed on each face. The characters were later transferred to the faces of the dice, before they subsequently took on the familiar one-to-six format used now.

Buppō sugoroku acted as the template for the later Buddhist version of *Jōdo* (Pure Land) *sugoroku* which became particularly common in the early years of Edo, peaking in popularity in the first decade of the 1700s. Their decline was pretty swift thereafter, and *Jōdo sugoroku* had more or less disappeared by 1800 giving way to *sugoroku* with more earthly concerns.

Jōdo or Pure Land Buddhism which developed out of the earlier Tendai sect stressed the contrast between the impure world of human habitation and the pure realm inhabited by Buddhas and bodhisattvas. This belief system took pictorial form with the

fig.179
Buppō sugoroku

A classic vertical format Buddhist *sugoroku* reminds the player of the horrors of hell, and the comforts of paradise at the top. The ascending format echoes the composition of Buddhist paintings and differs from the spiral format used in Chinese promotional board games. This vertical 'aspirational' form also appears in *Shusse sugoroku* (see fig.187, p.173). As well as Buddhist figures, characters from popular beliefs such as the Seven Lucky Gods and ghosts and monsters also appear.

fig. 180

Backstage *sugoroku*
Ôatari rakuga sugoroku
Toyohara Kunichika
1865

A *sugoroku* for the kabuki fan, this print satisfies the appetite for information on their idols by showing an imaginary backstage scene. The backstage area (*gakuya*) included dressing rooms, waiting rooms and lounges. Top actors would have had private rooms.

Here the player starts by the entrance (lower right) and makes his/her way through the throng of stars to finish top right where Ichikawa Shinnosuke appears to be involved in a confrontation with Ichimura Uzaemon. The top actors are portrayed and named and it must have been of particular interest for female fans (not allowed backstage) to see their idols without make-up.

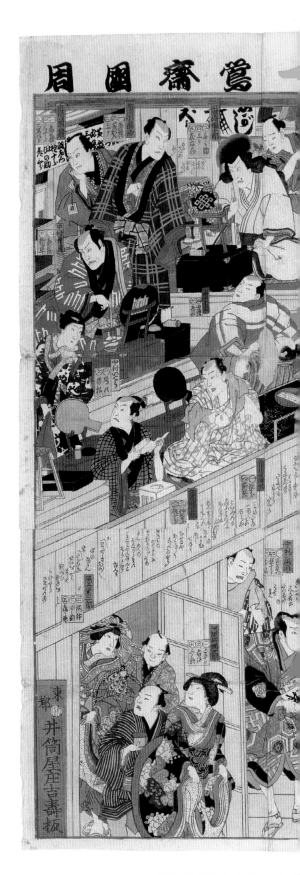

earthly world represented at the bottom, and the road leading to paradise at the top. *Jōdo sugoroku* followed this linear, vertical format. The early years of the Edo period, although peaceful, had an underlying uncertainty so it is no surprise that an anxious people would take refuge in a game which offered paradise, although the presence of hell was a stark reminder of the alternative. The concept of the game was based on the simple moral device of rewarding good and punishing evil. The players set off from the starting point (*furidashi*) hoping to reach paradise, but a particularly alarming addition was a blank square called *yochin* (see fig. 182, p. 168). The unfortunate player despatched to that square would sink into an underworld hell with no escape and was disqualified from the game. *Jōdo sugoroku* were still printed in black and white, possibly with hand-colouring, but made the transition from being an instrument of Buddhist instruction to a popular game with a moral twist for lay people.

Having left its Buddhist past behind, and found a place in popular affections, *sugoroku* flowered in many and various forms. This close cultural relationship is reflected in the most popular themes for *sugoroku*; kabuki, pleasure quarters, travel, education and later the innovations of modernisation. As well as reflecting the spirit and concerns of the time, *sugoroku* also acted as a medium of instruction and disseminator of information. As the lives of the people became more complex, so the types of *sugoroku* and their content mirrored that complexity.

The earliest kabuki *sugoroku* were called *yarō* (fellow, chap) *sugoroku* and were

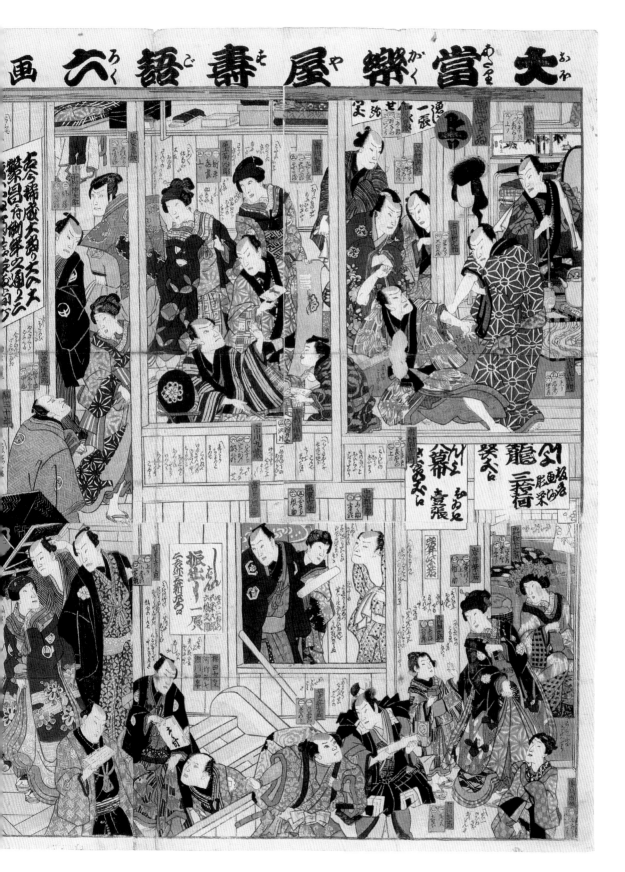

produced at around the same time (mid-17th century) that kabuki changed from female to male performers. Young men (*yarō*) took over as performers but their services often extended to offstage favours of concern to the straight-laced authorities. They were thus required to shave their forelocks to appear manly and reduce their attractiveness. Nevertheless they became popular idols, reflected in the number of *sugoroku* and *karuta* (cards) which featured them. Unfortunately few *yarō sugoroku* survive, but we know they were simply produced in black and white, occasionally with stencil or hand-colouring.

As kabuki developed and became an integral part of Edo period life, its glories were reflected in the well-known actor prints (*yakusha-e*) and equally in the less well-known *yakusha* (actor) *sugoroku*. Indeed in many cases the same artists worked in both genres. *Yakusha sugoroku* varied; some showed famous actors in their most popular roles, others scenes from the best-known plays. Knowledge of kabuki was so extensive amongst enthusiasts that with a mere hint of a name or a scene, they could fill in the rest of the context. In some *sugoroku* the audience were included as part of the composition. Visually some of the most extraordinary compositions are the *sugoroku* which condense a close-up portrait of an actor into each square on the board. In addition to the human interest of kabuki in the lives and loves of the actors, the Edo period audiences were also fascinated by the technical innovations in kabuki which made the special effects possible. The visual excitement of devices such as the revolving stage first used in 1758 were echoed in the

design of *sugoroku*. The riotous compositions (particularly in *sugoroku* by Kunichika) reflected the excitement of performances, particularly in the finishing point (*agari*) which often featured a dramatic close-up or climactic scene. Many of these *sugoroku* were played using the *tobi sugoroku* method, jumping from square to square in an echo of the thrills of both the narrative and the performance.

Perhaps the Edo period leisure pursuit which adapted best to the *sugoroku* format was travel. *Dōchū* (travel) *sugoroku* are probably the largest group to survive. The staged journeys with inns and stops along the main highways of Japan were easily adjusted to fit the square-by-square format of the *sugoroku* board. Most follow a spiral format (like Chinese promotion games) beginning on the outside and travelling towards the finish in the centre. Others imitate the meandering progress of the road itself, often drawn from a dramatic bird's eye vantage point (see fig. 5, p. 16).

There are records of *dōchū sugoroku* as early as 1692 when travel was still not widely

fig. 182
An example of the blank square (*yochin*) from a very large early Meiji period *Buppō sugoroku* published in Tokyo.

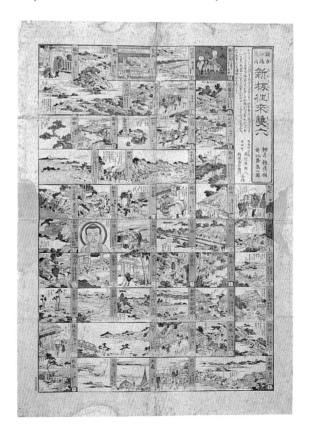

fig. 181
Kamakura, Enoshima Ōyama Circuit *sugoroku*
Kamakura, Enoshima Ōyama ōrai sugoroku
Katsushika Hokusai
c.1820s

This is one of the few *sugoroku* produced by the master Hokusai to survive. The player leaves from the familiar Nihonbashi at the heart of Edo (lower right) on a circular tour to the Great Buddha at Kamakura, the beautiful island of Enoshima, the sacred Mount Ōyama before arriving back at Nihonbashi. Each square is a gem-like landscape composition.

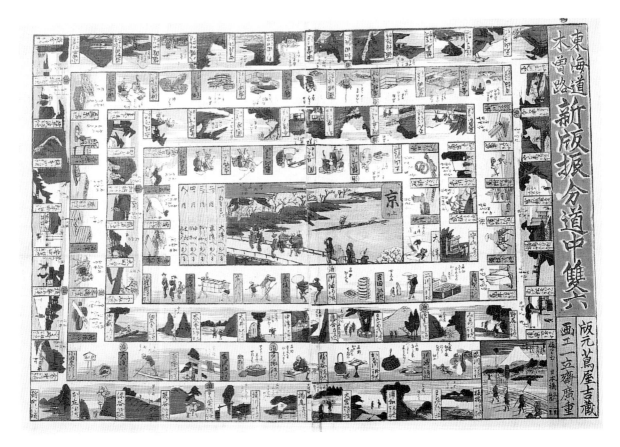

fig. 183

Tōkaidō* and *Kisokaidō sugoroku
Shinpan furiwake dōchū sugoroku
Utagawa Hiroshige
late Edo period

This *sugoroku* is an excellent example of *furiwake* (divided) *sugoroku* in which two separate paths lead to the same destination. In this print the players all leave from the traditional departure point of Nihonbashi (lower right) but can either travel by the familiar *Tōkaidō* or the alternative *Kisokaidō* to the same finishing point, Sanjo Bridge in Kyoto (centre). The double spiral of the journeys is complex and visually exciting but simplified slightly by the representation of the *Kisokaidō* route in shades of blue and the *Tōkaidō* in multi-colour (detail right).

available to ordinary people. As the ability to travel spread, people from different areas were brought into contact, not only with each other, but also with the customs and produce of the regions, all of which became popular subjects for *sugoroku* producers. The earliest *dōchū sugoroku* were black and white with not much more than an indication of important topographical features. With the advent of colour, the artistic compositional quality and the quantity of information included changed dramatically. As well as showing more detailed geography, they included representations of inns, hot springs, special food, almost anything that could be encountered on the road. The best *dōchū sugoroku* were complex visual guide books. They were not only purchased by those who had actually made the journey but would also have been of some consolation to those left behind who, by simply throwing dice, could vicariously enjoy the drama of life on the

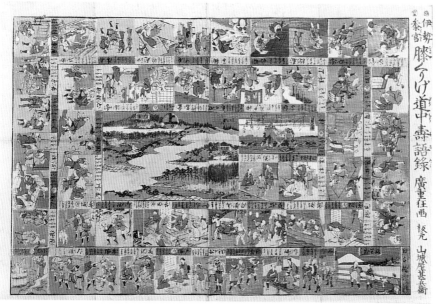

(left)
fig. 184

Ise Hizakurige travel *sugoroku*
Ise Hizakurige dōchū sugoroku
Utagawa Hiroshige
late Edo period

This *sugoroku* follows the pilgrimage route from Edo to Ise Shrine in the spirit of the two heroes Yaji and Kita from Jippensha Ikku's popular 'road' tale *Hizakurige* (see p. 66). They set off from Nihonbashi and after an eventful journey through the Japanese countryside, they arrive at the finishing point, the inner and outer shrines at Ise. Only about five or six colours are used in the composition, but its limited palette is more than compensated for by the witty vignettes of life on the road (detail below).

road. The squares of many a *sugoroku* reveal scenes of merry-making (and much more) which was one of the main attractions of the escape travel offered from the straightjacket of everyday life. Some *sugoroku* even managed to combine travel and kabuki, showing the glamourous heroes of the kabuki stage as they processed along the famous highways.

Of the five major highways, unsurprisingly the *53 Stages of the Tōkaidō* which joined Edo with the old imperial capital of Kyoto became the most popular theme. During the Edo period, the starting point for these *sugoroku* (and the real journey) was in Edo, Nihonbashi (Japan Bridge), and the finishing point was in Kyoto, generally at Sanjo Bridge. With the political changes of the Meiji Restoration, however, when the emperor moved to Edo (and it became Tokyo) the *sugoroku* mirrored these political changes with the start in Kyoto and the finish in Tokyo. Both *sugoroku* offer a concise insight into the changing fortunes and relative power of the cities. The early *Tōkaidō sugoroku* included as many as 150 stops along the way with numerous diversions into side roads. Later versions settled on the 53-stage format. The squares on the board were based on the actual barriers/rests which punctuated the route between the cities. Some *sugoroku*

included useful advice as to what to eat at each stop, the distance between inns, what to see while you were there and even 'punishments' for forgetting your papers, which would send the player right back to the beginning. Natural events intervened on occasions, holding the players at a certain square because of flooding, for example. In addition, the 'blank' square which had been a feature of *Jōdo sugoroku* casting the player into eternal despair was echoed in *dōchū sugoroku* with an enforced 'rest'. The travel format was so popular that it was copied regionally, including versions based on the districts within Edo itself. Other travel *sugoroku* concentrated on pilgrimage routes or famous sites all over the country and the attractions on offer there for the traveller, real or virtual.

When Japan re-opened to the outside

(right)
fig. 185

Successful Actors Climb Mount Fuji
Haiyū shusse Fuji tōzan sugoroku
Utagawa Kunisada III
1887

As part of the boom in imitation Mount Fujis, a 33-metre (105 ft) high version was built using a wooden frame covered in plaster in Asakusa Park in Tokyo and became a very popular attraction. This *shusse* (success) *sugoroku* harnesses both that popularity and that of top actors as they start bottom right and make their way up the 73 stages of Fuji to success and the viewing platform (complete with weather vane) at the top. On the way they pass imitations of genuine features of the mountain such as womb-like caves with resident ascetic. Waiting at the summit are the three popular heroes of early Meiji theatre – Ichikawa Danjūrō IX (wearing Western dress), Ichikawa Sadanji I and Onoe Kikugorō V (see fig. 126 p. 119). Danjūrō and Sadanji are giving a hand up to an *onnagata* from the level below, possibly Nakamura Fukusuke III, originally from Kyoto. The real Fuji is a quiet presence on the horizon.

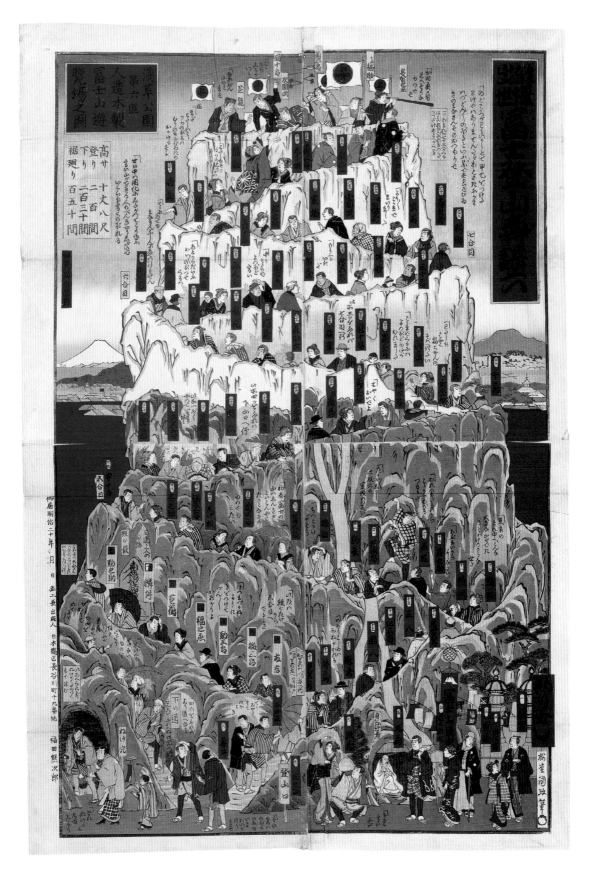

fig. 186

Five Confucian Virtues *sugoroku*

Jingigojō furiwake sugoroku
Utagawa Kunisada
Utagawa Kuniyoshi
Utagawa Hiroshige
1858

This *sugoroku* is the combined work of three artists and must have been one of the last pieces by Hiroshige, who died soon afterwards. It is another example of *furiwake* (divided) sugoroku with two routes by way of five of the Confucian virtues of justice, humanity, wisdom, fidelity and propriety to the goal. If the throw of the dice sends you off in the wrong moral direction, it takes longer to reach the end. The virtues are illustrated through scenes from plays, literature or history, each of which could stand as individual prints. The quality of the artists is clearly reflected in the composition and the complexity of the carving and printing.

world, the travel theme became international, including some highly imaginative adventure *sugoroku* to remote and wild places. As railways were introduced and spread across Japan they featured in *sugoroku* replacing the traditional travel by foot from inn to inn. Through the simple *sugoroku* format, produced at an affordable price, the ordinary people of Japan could taste the delights of a wider and more exciting world than the one in which they were confined on a daily basis.

Shusse (success) *sugoroku* were a genre particularly suited to exploring the social changes which Japanese society underwent during the late Edo period and early Meiji years. *Shusse sugoroku* and the related *kyōkun* (moral instruction) *sugoroku* both had elements of the moral content of earlier Buddhist forms, although with subtle differences. *Kyōkun sugoroku* were exhortatory in tone, rather than the simpler good- or bad-path Buddhist versions. *Shusse sugoroku* focussed on the goal of success (represented by the finishing point) but emphasised that it would be achieved through diligence and hard work and, certainly in the stratified society of the Edo period, an

acceptance of the social status quo. As social constraints loosened in the Meiji and later Taishō periods, these *sugoroku* offered a broader interpretation of what might be achievable by the ambitious.

Historical *sugoroku*, as well as reproducing heroes and heroic adventures of the past for sheer amusement, were also part of the process of social reinforcement, particularly for boys of the warrior classes. Playing these games acted as a powerful role model for male behaviour which in the nationalistic early years of the 20th century led to a genre of war *sugoroku*. The latter years of woodblock's use for *sugoroku* included bloodthirsty renderings of Japan's exploits in wars with China (1894–95) and Russia (1904–05). This militaristic theme continued to be popular in lithographic form right through to the Second World War.

The educational and informative element within *sugoroku*, however, had a happier history. Many concentrate on what now seem dated themes of 'etiquette for ladies' or 'suitable occupations for boys' but others found a serious role as part of the newly established educational system of the early

fig. 187

Women's Path through Life *sugoroku*
Onna kyōkun shusse sugoroku
Utagawa Toyokuni III
1840s–1850s

A *tobi* style *sugoroku* guides the player through the various female roles in society. An anxious-looking young girl occupies the departure square (bottom right) contemplating the uncertainty of her future and at the top an elderly woman enjoys a retirement of respect and plenty. On the way round the board the player encounters all types of womanhood, ranging from an aristocratic wife to a nagging wife, and from a concubine to a street prostitute. The structure of the 'jumping' format of the game allows the young girl to improve her lot in life through chance – essentially through meeting the right man.

fig. 188

Education from First Grade to Graduation
Shōgakkō zenka shugyo sugoroku
Utagawa Kunisada III
1898

The eager young pupils (girls in Japanese dress, boys in Western uniforms) set off on their school careers (bottom right). The path round the board to the graduation ceremony at the centre with proud families looking on is not only filled with the joys of learning, both Western and Japanese, but also squares which represent failure at examinations. Pupils are shown grappling with calligraphy, the abacus, physical exercises, singing, science and even conversing in a foreign language with a moustachioed foreigner. By the time the real child arrived at school, he/she would have no doubt of the challenge ahead. Foreign visitors to Japan in the 1870s were impressed with the spread and standard of Japanese elementary education which was of course built on a relatively high level of school attendance in the Edo period.

fig. 189

Elementary School Instruction
sugoroku
Shōgakkō sugoroku
early Meiji period

Each square is presented as an instructional wall chart which were widely used in the new school system from 1873. By allowing classes to study together from one sheet, these wall charts overcame a shortage of textbooks for the poorest pupils. In the traditional *terakoya* schools pupils had worked individually at their own speed – with these charts, the whole class worked as one.

Both the departure and finishing points feature Western-style rooms with strikingly patterned carpets and wallpaper. The player navigates the board through picture dictionaries, colours and their combinations, various numerals and alphabets, weights and measures and advice on clothing, health and nutrition. The illustration for the departure point shows a teacher using an illustrated chart with her pupils – the chart itself forms part of the *sugoroku* (bottom right).

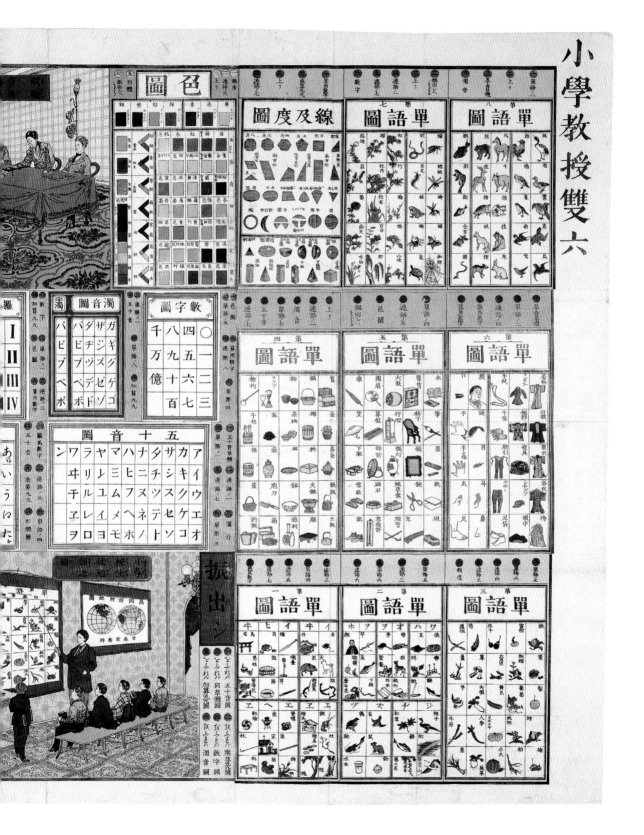

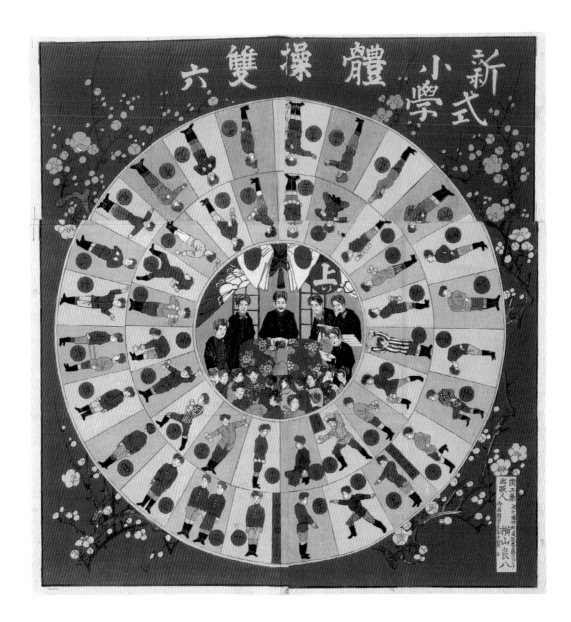

(above)

fig. 190

New-style Elementary School *sugoroku*

Shinshiki shōgakkō sugoroku

Yokoyama Ryōhachi

1886

This *sugoroku* would have helped to give children an idea of what to expect at school. The tousle-haired figures, all in Western dress, are performing 44 exercise routines, before proudly receiving a certificate from a row of stern-looking adults. The outer circle illustrates basic stretching exercises, the inner circle a routine using dumbbells (see also fig.173, p.159). The *sugoroku* was issued in December but the plum blossom background anticipates the spring and the new school year.

(right)

fig. 191

Ryōunkaku tower *sugoroku*

Ryōunkaku e-sugoroku

Utagawa Kunisada III (Kunimasa IV)

1890

The Ryōunkaku (Cloud-surpassing Pavilion) was built in 1890 and was 12 storeys high so would have been the one building which could afford a sweeping view of Tokyo. It was built in Asakusa by a Briton, W. K. Barton, to an octagonal plan using a wooden frame and brick. There was a viewing platform at the top and the great novelty of a lift to the 8th floor (though it was soon taken out of service because it was considered dangerous). The tower itself was damaged in both the 1894 and 1923 earthquakes and was then demolished.

The *sugoroku* version survives to record the attractions from the ticket booth (departure point) at the bottom to the destination (viewing platform) at the top. Flaps on the print open to reveal internal views – including the workings of the lift. The brick pattern of the tower looks particularly striking against the red gradation in the background.

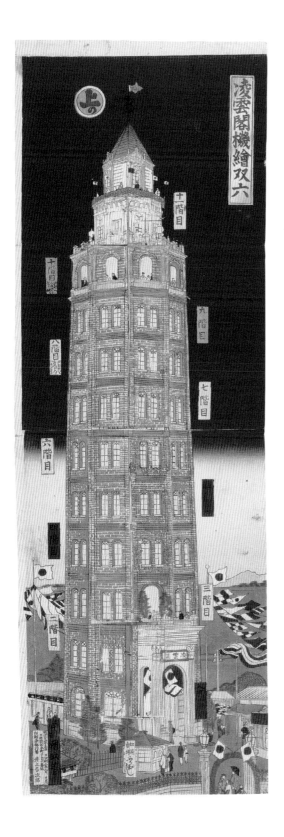
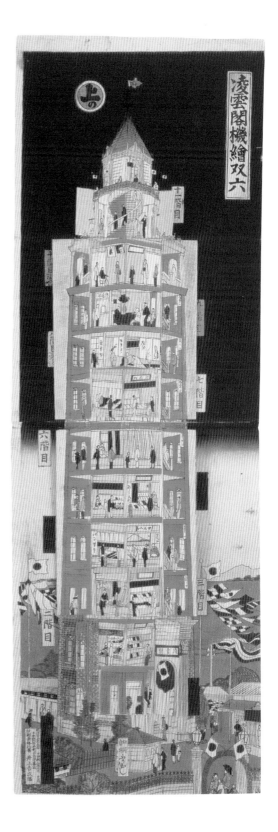

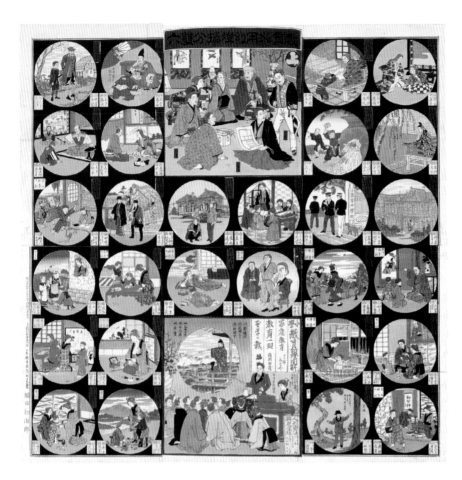

fig. 192

The Essentials of Education
Kyōiku hitsuyō gentō furiwake sugoroku
1896

In this *furiwake* (divided) *sugoroku*, the circular format of magic lantern slides (see also fig. 72, p. 82) is used for 28 scenes showing a child's upbringing at school and home. The benefits of study through school to university are shown, as well as the pitfalls of bad behaviour. Models of exemplary behaviour, such as George Washington (top left), are shown. The goal is a scene with a wealthy retired couple celebrating the success of four young people. Fukurokuju, the god of happiness (see p. 95) looks on from the background.

The departure square shows an eager audience looking at a projected image of the 4th century emperor Nintoku. The magic lantern was imported for educational purposes from 1874 and, with the production of a Japanese model in 1880, they became much more widespread. Women are still generally dressed in kimono with Japanese hairstyles, but men are shown with both Western clothes and haircuts.

Meiji years. With the introduction of a modern school system in 1872, *sugoroku* rose to the challenge of making learning fun by producing vocabulary and knowledge-based games. It also proved a particularly enjoyable way of familiarising new elementary school pupils with a basic English vocabulary. *Sugoroku* showing children what to expect from school and how they should behave when they got there were particularly popular. Apparently bizarre physical exercises practiced by foreigners and adopted in Japanese schools were also explained through *sugoroku*.

As Japan opened up, popular subjects moved from showing traditional Japanese accomplishments – such as the tea ceremony, flower arranging, Japanese dance or literature – to explaining the new imported ways which were a fundamental part of the government's trumpeted 'civilisation and enlightenment' programme. Exciting innovations such as the railway and postal systems all appeared in *sugoroku* as well as Edo's very own skyscraper, Ryōunkaku, built in 1890. Projectors, imported as educational aids, also featured, as did information on the new scientific subjects of Western medicine, chemistry and physics. An exceptional level of visual literacy enabled the absorption of an extraordinary quantity of unfamiliar information through its sophisticated presentation in a visual form such as *sugoroku*.

A more mundane but no less influential use for *sugoroku* was in the world of advertising. As highlighted on page 72, woodblock's potential had been recognised and harnessed to oil the wheels of commerce. It is arguable that in their representations of actors and the world of theatre, *yakusha sugoroku* were a form of advertising, and certainly the occasional signboard displayed in *dōchū sugoroku* must surely count as the Edo period equivalent of a subliminal message. By the late Edo period, the names of inns are shown

clearly, thus becoming a mix between travel and advertising *sugoroku*. As time passed and *sugoroku* became entrenched as a pastime, particularly as a popular New Year game, the sponsorship of their production by businesses became more overt. *Sugoroku* devoted to one particular product were produced or as advertisements for a tourist attraction like a hot spring. The link with New Year was so strong that *sugoroku* became popular free gifts for both adults and children. By the end of the Meiji period, with the arrival of easy mechanical reproduction, *sugoroku* had become essentially focussed on children especially as free gifts. The *sugoroku* journey, which began with the elevated aim of instructing novice monks, ended as a childrens' giveaway. The first *sugoroku* boom from the late 17th to early 19th centuries had been the preserve of adults and had thus aroused the usual official concern over gambling and accompanying bans. By the second boom in the late 19th and early 20th centuries, *sugoroku* had become largely a game for children.

The visual devices used in *sugoroku* became more sophisticated as both adults and later children became more discerning. The straightforward procession of square boxes metamorphosed into other shapes such as fans, shells and with the arrival of the magic lantern, circles, in imitation of their picture formats. The content ranged from the intellectually demanding, for example a thorough knowledge of the classic novel *The Tale of Genji*, to the bawdy based on the word-play wit beloved of the true Edoite. The *sugoroku* format acted as instructor in wifely etiquette for the samurai daughter, and at the same time offered the dream of travel to the farming family in a remote village. In a society still bound within the strictures of a feudal system, a game which offered a world of possibility at the roll of the dice was guaranteed popularity. The early Chinese forms of the game acted as a route map through the hierarchy of Chinese administration, and for the Japanese the same format played the role of guide, first to the culture and geography of their own country, and later to the ways of the outside world.

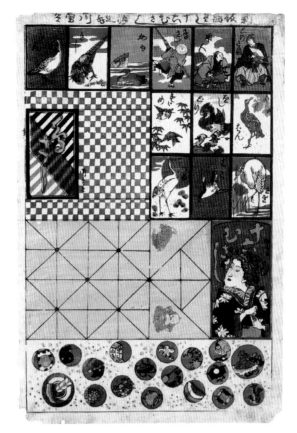

fig.193
Torisashi and jūrokumusashi Toy Print
Shinpan torisashi, jūrokumusashi
Utagawa Chikashige
1869

This toy print contains two games to be cut out. At the bottom, a *jūrokumusashi* board and counters and at the top a game based around *torisashi* – catching birds with a bamboo pole with birdlime on the end. It is a scaled-down version of a popular Edo game with a lord, his steward and a birdcatcher plus cards (usually 13) of birds to be caught by order of the lord. The birds include a goose, pheasant, duck and sparrows.

A single sheet of printed paper was the catalyst for a world of dreams and possibilities, originally produced in woodblock, later in lithography. The sadness is that their inherent flimsiness and use as a game mean that few *sugoroku* survive to fully illustrate the creativity and ingenuity of the people who produced them. Artists renowned for actor prints, such as Kunichika, produced over 30 actor *sugoroku* and the three generations of the Hiroshige school produced over 40 travel *sugoroku*. Yoshifuji, the master of toy prints, was responsible for more than 20 *sugoroku*. Enough examples of their work remain, however, to hint at the treasures that may have been lost to the ravages of time.

Jūrokumusashi

Jūrokumusashi is a descendant of the Hindu game of *Parchisi* also known in the West as 'Fox and Geese'. It has been recorded in Japan since the mid-17th century and is named after the legendary 12th century warrior monk Musashibo Benkei. He was known for his

martial ability, cunning, skill and above all loyalty and courage. *Jūrokumusashi* was originally used for gambling but over the years shed those associations and became another popular New Year's game for children. The rise of militarism after the Meiji period was reflected in the themes of *jūrokumusashi* which reinforced its role as a game to teach boys military strategy.

Compared to the more elaborate *sugoroku*, the board appears plain. The game is a race between one master piece (a general) and 16 secondary pieces (the soldiers), the aim being to 'contain' the master. The master begins on the central black spot and if he allows himself to be surrounded and driven into a corner, the soldiers have won. If the master can place himself between two soldiers, they can be taken. If five or six soldiers are taken, the master has won.

Jūrokumusashi games were often printed on one sheet, including the board and pieces, and sold as a toy print. The print would be pasted onto thicker paper with *nori* (rice glue) and then cut out ready for play. The theme of the game and pieces changed in keeping with the time when it was produced.

Menko

The artistic and printing skills of woodblock extended to the production of a simple game, *menko* (not strictly a board game), dating back to the Kamakura period (1185–1333) when it was called *mengata*. *Menko* made from printed paper became popular in the late Edo period and featured the familiar subjects of warriors, heroes, soldiers and particularly sumo which would appeal to boys. The *menko* circles were printed in colour on a single sheet which could then be backed on thicker paper and cut out. Compared to single-sheet prints, the technical quality of these *menko* sheets is poor, but they would have been cheap to buy and made the game of *menko* available to an eager audience of children.

Menko were originally made of 5 cm (2 in.) circles of clay, pressed in a mould with a design in relief on the surface, and then baked at a low temperature. The designs included seasonal motifs, warriors and the Seven Lucky Gods. They were produced in great quantities in the Asakusa area of Edo, and have been found buried in landfill in areas outside Tokyo to which Edo's rubbish was traditionally taken for disposal. Finer detailed versions were made in lead, occasionally with applied colour, but after incidents of lead-poisoning, paper became more popular. In addition to circular *menko*, rectangular and shaped ones were also made.

Menko can be used in a variety of ways. The classic game is to place one player's *menko* on the ground, their opponent attempts to flip it over by throwing his own *menko* at it. In another version one player's *menko* set is spread out on the ground, the other tosses a *menko* in the air and tries to grab as many as possible of his opponent's pieces before his own lands. *Menko* were also used for a version of the old game of *anaichi* in which a circle was drawn on the ground with a line in front of it, from which *menko* were tossed into the ring to displace *menko* spread in the circle.

Although clay and lead *menko* survive, few woodblock printed paper *menko* exist. The printed single sheets would have been eagerly cut up for play and thus destroyed, and used *menko* would have suffered the fate of so many paper artefacts. *Menko* continued to be produced after the demise of woodblock using mechanical means, and the subjects changed over time from traditional warriors to cartoon characters and comic-book heroes.

fig. 194
A collection of paper *menko* showing classic heroes – far left is one of the Seven Lucky Gods Fukurokuju. Few woodblock examples survive (see also fig. 46, p. 57).

Playing cards *karuta*

A game of cards was one of those innocent-seeming diversions which managed to attract the attention of the Tokugawa authorities because it so easily turned into gambling, which they never wanted to encourage. *Karuta* (from the Portugese *carta*) arrived in Japan via the Dutch or Portugese in the mid-16th century and their portability made them a popular leisure pastime with campaigning warriors. Known as *Tenshōkaruta*, the early packs had 48 cards in four suits; batons, coins, cups and swords and were initially all imported. As peace took hold in the early Edo period, the playing of cards moved through all layers of society and they began to be produced in Japan, initially at Miike near Nagasaki but later in Kyoto too. The cards were either hand-painted or used a black woodblock-printed outline which was then hand-coloured or stencilled using the same technique as Nagasaki prints (see pp. 82–3). Later, in Edo, *karuta* took advantage of the local woodblock printing skills and were printed in full colour. Packs of cards designed by such print artists as Hokusai and Hiroshige survive today.

The game of cards which had arrived with the Europeans met with an indigenous Japanese matching game, originally played with shells and resulted in two strands of *karuta*, one which developed out of the European style *Tenshōkaruta*, the other a variation on the shell-matching game. Since the Heian period the Japanese upper classes had played a game in which 180 naturally matching pairs of clamshells were spread out, and using the patterns on the shells the players had to find the exact match. Later versions used shells luxuriously painted on the inside. The symbolism of there being only one natural match for each clamshell meant that this game was often included in the *trousseau* of a wealthy bride. Subsequent versions became more educational in intent by writing one half of a *tanka* poem (31 syllables) on each half of a pair of shells and players matched the poems.

The arrival of paper *Tenshōkaruta* prompted a move from natural shells to shell-shaped paper, and later standard rectangles. Shells had been a low-cost natural resource at a time when domestic paper production was mostly exhausted in the publication of Buddhist material. Luxurious packs of cards were hand-painted, but woodblock enabled them to be mass-produced and distributed to a wider and very receptive audience. In Kyoto the outlines were woodblock with hand-applied colour, in Edo the full multicoloured woodblock process was used. These cards were known as *uta karuta* (poem cards) and used a variety of poems. The most popular today is called *Hyakunin Isshu* (100 Poems by 100 Poets) based on an anthology of 100 poems compiled in 1235 by the poet Fujiwara no Teika at is mountain retreat near Kyoto.

The Japanese concept of matching (*awase*) underlies this strand of cards and the educational nature of the game was used to try and differentiate it from gambling games which were regularly subjected to government

fig. 195
A modern re-cut outline block, outline print and finished *Tenshōkaruta* copied from the cards which arrived from Portugal. A set of original blocks survives in the collection of Kobe City Museum made into a nest of boxes (*jūbako*). This game had four suits (48 cards) – later Japanese versions had five suits.

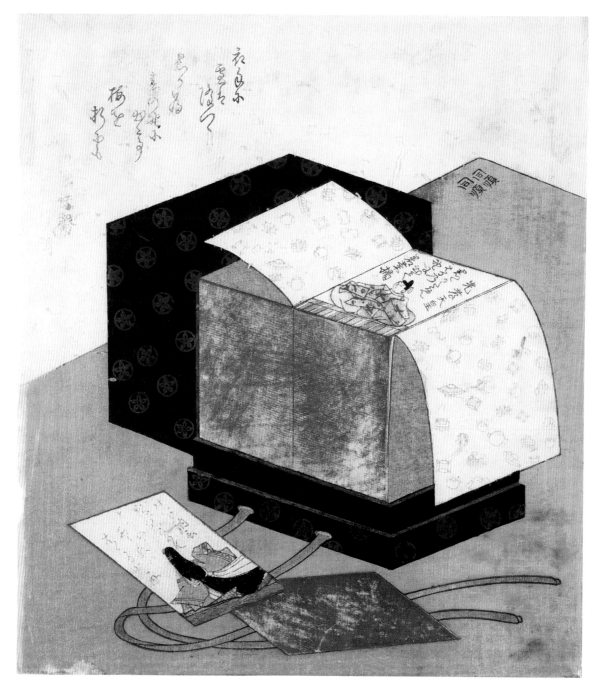

fig. 196

Poetry Game Card Set *surimono*

Anon

1800–49

The juxtaposition of text and image central to *surimono* is echoed here in the portrayal of a set of *Hyakunin Isshu* cards. The poems are taken from a 1235 anthology by Fujiwara no Teika.

 Half the 200 cards have a picture of the poet and the opening lines of the poem, the other half have just the text of the remainder of the poem. The opening line is read out and players scramble to match it with the cards spread out in front of them. *Hyakunin Isshu* is a classic Japanese matching (*awase*) game.

Elegant Poem Cards
Fūryū Genji utakaruta
Katsushika Hokusai
late Edo period

A set of woodblock-printed cards by Hokusai based on the chapters of the great 11th century novel by Murasaki Shikibu, *The Tale of Genji*. Each chapter of the book has a distinguishing crest made up from long and short lines. Each verse is split between a pair of illuminated cards, both bearing the crest. The cards are backed with gold decorated paper which has been folded to the front in the traditional way.

Above: The right hand card represents the first chapter of the book *Kiritsubo* and shows a pawlownia (*kiri*) tree plus the crest.

banning orders. Matching games developed to use pictures, and then later a popular version using the first letters of one of the Japanese alphabets (*hiragana*) called *iroha karuta*. The first letter of a well-known proverb was matched with a picture, the proverb on the other card was read out and the players scrambled to claim the relevant picture. *Iroha karuta* was said to have started in the Kyoto/Osaka area in the late 18th century from where it spread to Edo and beyond. The selection of proverbs used in the two regions was different. *Iroha karuta* were mostly printed in woodblock and tended to be roughly made as they were often used and thrown away. Both *Hyakunin Isshu* and *iroha karuta* are still popular New Year's family games.

The alternative European strand of playing cards developed its domestic forms but continued to attract official opprobrium. The European style of the first imported cards was slowly simplified and abstracted to suit Japanese tastes and survives today in regional variations such as *mekurikaruta* and

kabukaruta. The cup or chalice on the European cards was an object no Japanese would have seen or known so it became abstracted to a dot shape. The cards were hand-painted or woodblock printed in mostly black and red on a white ground. Suits were added, the designs developed and the games changed over time, but the common feature remained gambling. The cat and mouse with the authorities inspired ingenious subversions of the acceptable educational game of *Hyakunin Isshu* which could be used for gambling. The mention of card games in the best-selling literature of the time attest to their popularity. However, in the *Kansei* Reforms of 1787–93 the exasperated authorities banned all cards except *Hyakunin Isshu*, driving all others underground until the Meiji period.

It was during this time underground that a new matching game, *hanafuda* (flower cards) appeared and to the Western eye it is still one of the most visually appealing. Its appearance is, however, misleading. The innocent themes

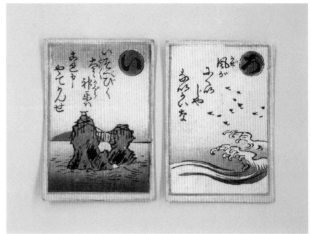

of the 48 cards are seasonal Japanese flowers, but the main use of the game was gambling. *Hanafuda* emerged from the underground in 1885–86 when they were allowed to be sold in Tokyo, but it was not until 1902 that the Japanese government began to relax all restrictions. Influenced by Europe and America they realised that applying tax to cards (except the educational ones) combined a major rise in their cost with welcome tax revenue. The effect on the card makers was dire. Kyoto had been at the heart of production, together with regional centres around the country which had been particularly useful during times of repression, but with the imposition of tax, many cardmakers went out of business.

The name *hanafuda* combined with the official suppression led to the association of an intriguing symbol with card makers. The word for flower (*hana*) and nose (*hana*) sound the same in Japanese, so when cards were banned and only available under the counter from certain shops, the prospective purchaser could make his requirements known by rubbing his nose. Hence *tengu*, a mythical part-human creature of obscure origins with a very long, usually bright red, nose, became the logo mark of many cardmakers and is still used today.

Cards are still made by hand but only in a very few places. One of the main traditional Kyoto manufacturers, Nintendo has become known in a completely different area of computer games. The majority of cards are now mass-produced, although some are still hand-stencilled using an outline printed mechanically rather than by woodblock. The detail on woodblock can start to break down after 1500–2000 impressions so for quantity production, mechanical reproduction became more practical. It is likely too that the simplification of the card designs over the years was, to some extent, driven by the fact that finely carved woodblock could not survive too many printings.

Card making

Japanese playing cards are much thicker than Western cards due to the way in which they are constructed from layers of paper. The

fig. 199
A traditional woodblock outline block and print for a set of 48 *hanafuda* cards.

fig. 200
A set of *hanafuda* cards. They are hand-stencilled but no longer use a woodblock-printed outline.

picture layer of good Japanese paper is first printed with the black outline (originally by woodblock) then mounted onto a substrate of layers of thicker paper, such as *gayōshi* (thick Western-style paper), but now cardboard is used. The finished 'sandwich' had to be tough enough not to curl in use and to produce the right sharp sound as the cards are slapped on the table. The glue used adds volume and is made from *funori* (made from seaweed) mixed with *tonoko* (finely ground heated yellow earth, also used to sharpen swords and as base to lacquer). Fine adjustments to the amount of glue used and thickness of the paper guarantee that the cards end up of similar weight.

When the sheet is dry, the top picture layer is brushed with a coat of thinned starch paste, then the colour is applied to the outline block using stencils in a technique similar to

methods used in textiles since the 14th century. Stencils are cut from *aburagami* (oil paper), Japanese paper which has been soaked in rape seed oil for a week. When a stencil for each colour has been cut it is brushed with wax, which means that if a part of the stencil becomes bent it can be coaxed back into its original position with a little heat. *Aburagami* was preferred to the more common dark brown stencil paper (*shibugami*) used for textiles, because the oil turned the paper translucent which made placement of the stencil on the black outline easier. Transparent plastic is mostly used now.

The stencil is carefully pinned in place on the outline and each colour added in turn using a soft round stencil brush and textile dyes. Originally traditional natural pigments would have been used, but they lack the translucence of the dyes and tend to 'sit' on

(below left)
fig. 201
Applying yellow to a sheet of *hanafuda* using a soft brush. The stencil is pinned in place on the outline sheet. Textile colours are now used as they are more vibrant than traditional pigments.

(below)
fig. 202
Paper stencils for applying colour.

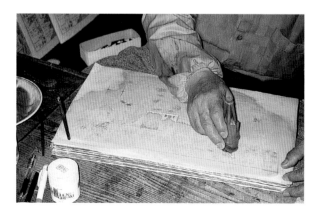

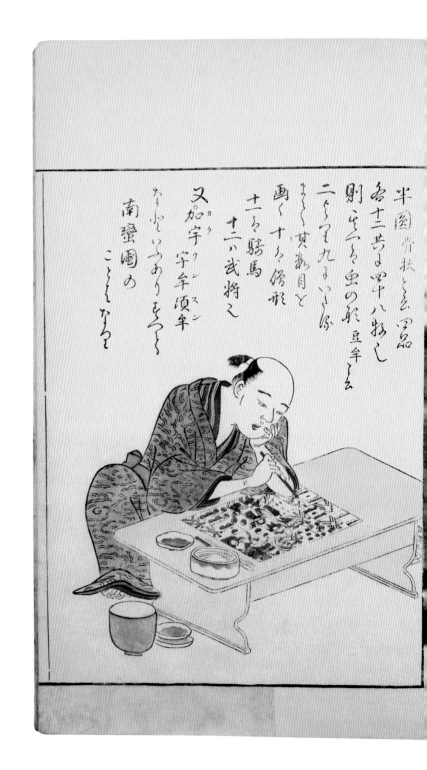

fig. 203

Coloured Pictures of Various Artisans

Saiga Shokunin Burui

Tachibana Minkō

1770

This fascinating stencil (*kappazuri*) book on various crafts, includes two illustrations of card makers at work. On the left he is applying colour by hand to a sheet of *unsunkaruta*, a descendant of the Western-style *Tenshōkaruta*. Meanwhile, on the right, his colleague is running the finished cards through the camellia-wood roller operated by hand and treadle.

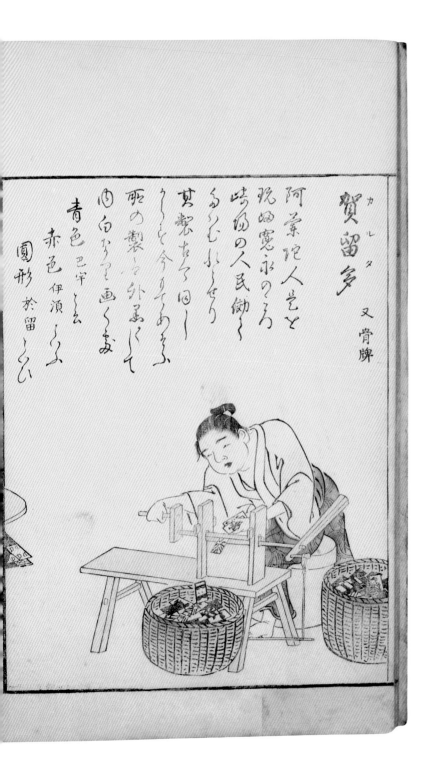

賀留多 カルタ 又骨牌

青色巴牟云云
赤色伊須云云
圓形於留云云

白かりて画くなり
弊の製ハ外表くして
うして今すくあるふ
其製むて回し
るむむくくせり
峙場の人民働く
睨囲寛永の為
阿蘭陀人云と

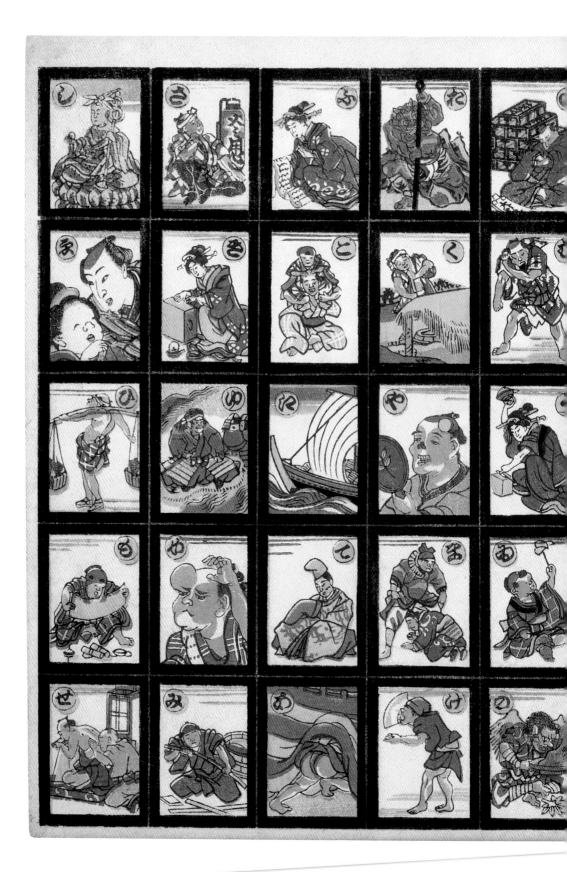

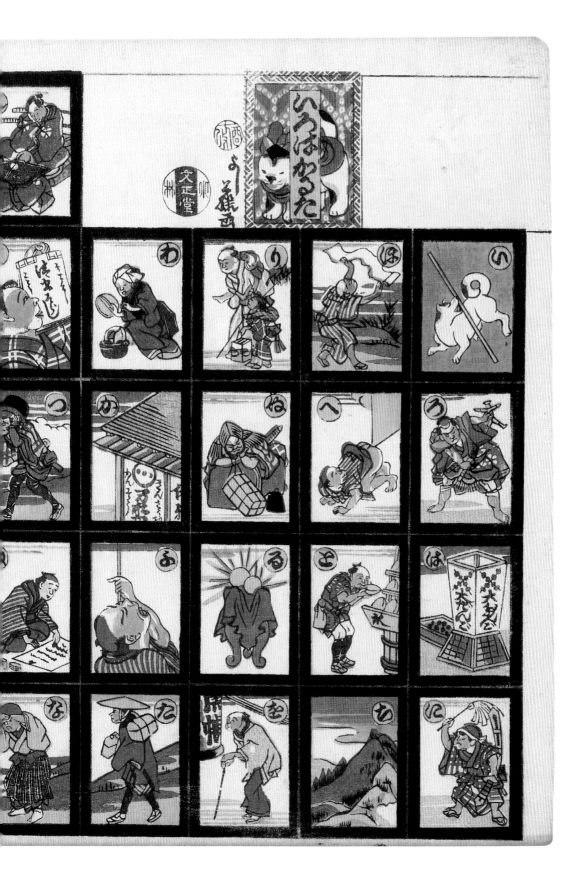

fig. 204
Iroha cards
Irohakaruta
Utagawa Yoshifuji
1861

A rare toy print of uncut *iroha* picture cards beginning to the right with 'i' for *inu* (dog). The traditional first proverb used in Edo *irohakaruta* was '*inu mo arukeba bō ni ataru*' (even a dog, if it walks around, will collide with a stick) – essentially 'every dog has his day'. The print would have been pasted to thicker paper before being cut and used as cards.

fig. 205
Thin backing paper brush-dyed black or red and cut slightly larger than the *hanafuda* to be backed.

(right)
fig. 206
Pasting the backing sheets by hand and folding the border round to the front of the card.

the surface and build up around the edges of the stencil shape. Dark colours take longer than pale colours but on average one colour can be applied to 200–250 sheets per day. When the sheet is completed, it is cut by hand along the printed lines into individual cards. In Edo, however, where cards were made using woodblock, the outline and colours would have been registered and printed in the traditional way before the sheet was mounted onto the thicker paper and cut (see fig. 204, pp. 190–91).

In the last stage of manufacture, each card is backed with another thin sheet of paper cut slightly larger and wrapped round to overlap the front by a few millimetres. This labour-intensive and exact work was often carried out by the women of the family. The backing

paper has to be of the finest quality and traditionally came from Mino (Gifu prefecture). It has to be completely smooth without any noticeable fibres or imperfections (which could be remembered and used to mark a card during a game, particularly when gambling). The backing paper is hand brushed with colour, usually an iron oxide red or black made from pine soot. More luxurious versions use decorative or gold-leaf papers. It is then sealed with brushed *kakishibu* (a traditional Japanese waterproofer/protector made from persimmon juice) or nowadays, thinned shellac. Shellac-coated paper can be used immediately, *kakishibu* needs to be left to

'mature' for six months. The paper is cut to size (slightly larger than the cards) pasted to the back using starch paste and then folded neatly and evenly over the edge to the front. When the finished cards are completely dry they are rolled with a roller made from camellia wood, which has the dual effect of slightly polishing the surface with the natural oil of the camellia and compressing the layers into a finished card which will make the characteristic crisp sound as it lands on the table. The thin coating of starch paste on the front prevents the oil from sinking into the paper and helps bring out the vibrancy of the colours. Woodblock colour prints flat, whereas stencilled colour inevitably builds up a 'ridge' round the edge of the shape during application. If these ridges are not flattened by the roller, the pack of cards will not sit evenly.

The cheaper alternative to hand-made cards, again made possible by woodblock, was to buy a pre-printed sheet of a card design in full colour woodblock, stick it down to thicker paper and then cut out the cards. These sheets were available at very little cost and would have featured the educational cards aimed at children. As card games were played at New Year, they would have been produced to satisfy that demand and most probably thrown away after use in anticipation of a new design appearing the next year.

Alongside this innocent use of cards, the gambling connection continues to this day. The cards (*tehonbiki*) used by yakuza (gangsters) for gambling are produced in a different way. Each yakuza group has its own design so would buy blank cards and paint them 'in-house'. A new set would be used for each game and the old ones destroyed. There are tantalising stories of concealed pins in the cards and other devices to change the face of the card by sleight of hand, thus guaranteeing that amateurs inevitably lose. The vast majority of cards used for this niche market and the general consumer are now machine-made so woodblock has all but relinquished another one of its toeholds in Japanese society.

Decorative papers *karakami, chiyogami, pochibukoro* and *fūtō*

fig. 207
Anesama dolls (modern)

Designed to be seen from behind
to show off the kimono, these
paper dolls were traditionally
made from *chiyogami* and in
Edo had white crepe paper for
the hair.

Karakami

In a culture such as Japan where paper
plays an important role, it is no surprise to
find an equally prominent place for the art
of decorative paper. The genre covers a vast
area from hand-decorated notepaper to
mass-produced wrapping paper. I propose
to narrow this down to the papers produced
using woodblock and their cultural and
historical forbears. The most well-known and,
to the Western eye, visually appealing paper is
woodblock *chiyogami* still produced in a few
places including Tokyo, Osaka and *chiyogami*'s
home, Kyoto.

It is possible that the impetus for highly
decorated papers was as prosaic as a shortage
of materials for papermaking and a need to
disguise the rather dull appearance of recycled
paper. Brushed textile dyes, pigments,
marbling and gold and silver leaf made

recycled paper acceptable for use for writing
poetry, calligraphy and anthologies. *Karakami*
(which literally means 'paper from China') was
a decorated paper based on a Chinese import
which used simple designs in sparkling mica
and pigment on a plain ground. Beginning as
a writing paper, it evolved to become one of
the most popular papers for internal sliding
doors (*fusuma*) and is still produced today
to traditional designs using the woodblock
technique in both Kyoto and Tokyo. In a
dimly lit room, the mica patterns would have
glistened elegantly in the half-light.

Although *karakami* is produced by
woodblock, the method is different from
the familiar *nishiki-e* method. In some ways
it resembles traditional textile block printing.
The blocks are carved deeper than those for
prints and use *hō* (*Magnolia obovata*) wood
rather than cherry. The design is drawn so
that, like printed textiles, there is a concealed
repeat. Each printed sheet had to be able to
match its neighbour when used to cover a
fusuma door. The size of the block varied but
was essentially governed by the size of the
paper available, although larger sheets are
used now. Papers used varied but included
hōsho from Echizen (also used for prints),
Sugiwara paper and *torinoko* also from
Echizen. Before printing, the paper was
sized and often brush dyed with background
colour. The colour for printing was produced
by mixing mica with *nori* (rice paste) and
pigment with *funori* (paste from seaweed).
Instead of applying this to the block with a
brush as in normal woodblock, it is brushed
onto silk gauze stretched over a hoop of
wood (called a *furui*). The silk surface loaded

fig. 208
A *hō* block for printing Edo *karakami* – the design is drafted to enable a matching repeat on the sides so that paper can be joined to cover a door.

with pigment is then 'tapped' onto the block, the paper positioned in the *kentō* (registration marks) and rubbed on the reverse with the palm of the hand rather than a *baren*. The method of applying the colour and the hand-rubbing gives *karakami* a characteristically soft appearance. The application of the colour by brush in traditional woodblock results in a sharper printed edge than *karakami* which can appear more 'stamped' than printed.

The designs used on *karakami* divide into four main cultural areas:

Court – ancient court motifs, mythical beasts, flowers and Chinese designs.
Tea – seasonal flowers, plant-based abstracted designs.
Temples/shrines – clouds, animals, plants.
Samurai/townsmen – many of the above were popular in addition to geometrical patterns.

Many of these traditional designs crossed over into *chiyogami* which came to prominence using the mass production which became possible with the advent of

multicoloured woodblock. Although other woodblock printed objects have lost their social and cultural role and disappeared, both *karakami* and *chiyogami* have quietly maintained a following.

Chiyogami

The origin of the name *chiyogami* is unclear, but it is known that it was first produced in Kyoto as part of the repertoire of hand-decorated papers used for wrapping, crafts and writing. Some sources suggest a link with Chiyonogosho, an aristocratic nunnery in Kyoto with paper-making connections, others that a princess called Chiyo was particularly fond of decorated papers. Whatever its origins, *chiyogami* is recorded as being on sale by the early 1700s. *Chiyogami* was first produced using hand techniques; inking up and impressing leaves, marbling and sprayed colour. From there it followed the familiar path to mass production, starting in its earliest incarnation using the stencilling technique (*kappazuri*) derived from the textile industry, which was centred in Kyoto. Many designs betray the close links between the two industries. The arrival of woodblock brought a one-colour outline to be hand-coloured or

fig. 209
Chiyogami sheet and print block showing 16 designs for kabuki face make-up (*kumadori*) from the selection of 18 classic plays chosen by the Ichikawa acting dynasty (*Ichikawa Jūhachiban*). The two major styles consist of predominantly red or blue lines.

fig. 210
In the centre is a modern re-print of a classic Kyoto design *asa no ha* (hemp leaf) with the pale mauve block on the left, the darker purple on the right. This design (used in textiles, too) was frequently chosen for baby clothing – possibly hoping for a fortuitous link between the strength of hemp thread and the child's health.

stencil coloured, and finally the development of multicolour printing brought full colour. With these technical advances came a wider and more diverse audience. From being the preserve of the leisured aristocrat, the delights of decorated paper became available to a much broader audience.

By the early 19th century *chiyogami* had spread from Kyoto to become a part of popular Edo culture and was taken back to the regions as a souvenir of the city. It was produced by the same system of publishers and craftsmen responsible for the print business, and artists such as Hiroshige, Kunisada and Eisen are known to have produced *chiyogami* designs. By contrast, Kyoto *chiyogami* designers remained anonymous and were most probably the artists responsible for supplying the Kyoto

textile industry with designs. Kyoto designs reveal hints of its aristocratic past, while Edo designs clearly reflect the city's bourgeois culture. The world of theatre proved a rich seam of inspiration as well as the world of classical literature and letters. Seasonal, floral-based patterns, abstract and geometrical patterns were all best-sellers. *Chiyogami* also reflected the minutiae of daily life with pictures of toys, household goods and much later imported imagery including cartoon characters. Although ukiyo-e are now generally valued as they offer an interesting insight into a historical period, the more modest role of *chiyogami* as a reflection of the times has received less attention.

The size of *chiyogami* was, like *karakami*, largely governed by practical concerns. Whole sheets using the full paper size of

fig. 211
Modern *chiyogami*

left to right:

Ichimatsu
A simple geometric pattern associated with the Kyoto-based kabuki actor Sanogawa Ichimatsu (1722–62). This design (based on a stone wall pattern) was used for the *hakama* (formal trousers) of Ichimatsu's costume in a performance of *Kōyasan Shinjū* (Mount Kōya Suicide) at Nakamura-za in Edo in 1741 and as a result became a popular pattern amongst Edo women.

Kanoko
A classic Kyoto design used in textiles for young girls. Kabuki actors playing the role of a young girl would wear this design.

Jōshikimaku
The official three Edo theatres (Nakamura-za, Morita-za and Ichimura-za) used a variation on stripes of black, persimmon and green for the curtain. This chiyogami example shows the Morita-za stripes.

Umi
This is a simplified version of another Edo period classic called *umi* (sea). A one-stroke brushed gradation (*bokashi*) was used on the 'peaks'.

Iris Bridge at Yatsuhashi
This design classic of a staggered bridge through irises was inspired by the Tale of Ise (*Ise Monogatari*).

A 'scatter' *chiyogami* sheet of *anesama* dolls.

A 'scatter' *chiyogami* sheet of traditional toys.

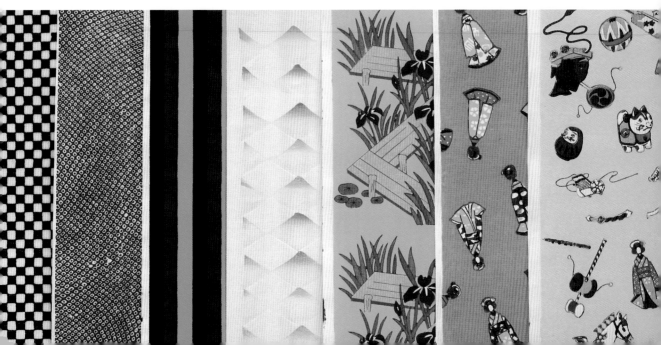

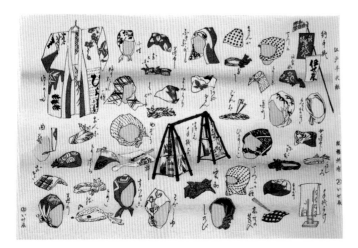

fig.212
A modern re-print of an Edo period *chiyogami* sheet showing the many ways in which the 90cm (36in.) long Japanese towel (*tenugui*) can be tied and worn. The versatile *tenugui* was also used as a towel or washcloth and often given as a gift.

approximately 39 × 53 cm / 15 × 21 in. (*ōbōshoban*) were produced but they were technically challenging. Inking up the block, positioning and printing the large sheet of paper before the colour dried was not easy. The most common size was half *ōbōshoban* (26.5 × 39 cm / 10 × 15 in.) and called *ōban*. For the multicoloured prints a reasonably thick *hōsho* paper from Echizen needed to be used to take the layers of colour. Hand-stencilled or coloured *chiyogami* could be produced on lighter papers. Quality of paper was important as it had to withstand not only the printing process but also the subsequent folding, cutting and pasting that came with use. During the Second World War, lack of materials reduced some *chiyogami* to a single colour on thin paper. Even so, according to the current owner of Sakurai-ya, a *chiyogami* publisher in Kyoto, there were queues down the street during the war when new designs went on sale. As with ukiyo-e, the blocks were made of cherry and carved on both sides. Sadly few old blocks have survived the ravages of war and earthquake or the mundane requirement for dry firewood. Although produced using the *nishiki-e* technique, *chiyogami* do not use as many colours or special effects such as gradation, as these would have increased the final cost. Many designs feature a flat background, (printed or plain) to which a scattered pattern is added, and as with *karakami* some patterns were designed to repeat edge to edge without showing the join.

The many and various final uses for *chiyogami* to some extent influenced the composition of the single sheet as sold. Collecting new *chiyogami* designs and keeping them as intact sheets has always been a popular hobby. Its main use, however, was to wrap, to make envelopes/wallets/folders, to make small craft items like boxes, to cover books, to make origami and paper dolls such as *anesama ningyō* (elder sister dolls). These diverse uses meant that the paper not only had to have appeal when displayed as a single sheet for sale but also had to translate successfully into the individual item. Some of the designs clearly have a top and bottom, the majority are all-over patterns. Those used to make the dolls had to scale down the traditional designs to fit. *Anesama* dolls (see fig.207, p.193) are simple playthings made from paper folded round a core, noticeable for their blank faces. They are designed to be seen from behind to show off the patterned kimono and *obi* (tied belt) and the complex hair arrangement made from crepe paper. These elegant paper dolls may have their origins in the tradition of casting a paper doll into the river to wash away childhood illness. Dressed in the finest *chiyogami*, *anesama* dolls became powerful ambassadors for the latest kimono and hair fashions.

The *chiyogami* that is produced today, mainly for the craft and souvenir market, still keeps alive a tradition with deep, decorative roots in the refined world of Heian period Kyoto. Over the years the designs have adapted and changed, but the underlying enjoyment of colour, composition and play remains. Although produced using the same technique as prints, *chiyogami* has somehow always found itself marginalised. Technically it cannot claim to rival the most complex of *nishiki-e*, but the richness of colour and design characteristic of the best *chiyogami* confirms their common ancestry. Because of its close commercial links with its target market of women and children, *chiyogami* was adept at responding to changes in fashion. Its success lay in its ability to pick up on and reflect the dreams and aspirations of its audience, women and children. From the prevailing trends of Edo culture through to the popular 20th century cartoon characters,

chiyogami has quietly reflected some of the changes experienced by Japanese society in general and women and children in particular.

Stationery: *Pochibukuro – Fūtō*

Pochibukuro are printed envelopes used for giving small gifts of money and are just the right size to fit in the palm of the hand. The word *pochi* is Kyoto dialect for 'just a little', a clear indication that, whatever the contents of the envelope, it is the thought that counts. They are also called *shūgibukuro* (gift envelopes) and in a reference to an older custom, *noshibukuro*. *Noshi* were strips of dried abalone attached to presents, which later became a general symbol of gift giving (see fig.125, p.118). *Pochibukuro* are a highly decorative relative of the *noshi* strips and a rich example of the importance of appearance and etiquette in gift giving in Japan, and in particular a cultural resistance to handling money 'naked'. The simple device of a

decorated envelope covers the embarrassment of both the giver and receiver and, if well chosen, reflects the sensibilities of both.

Pochibukuro came to prominence among the Edo period mercantile culture, although their exact origins are unclear. They may be a formalisation of a simple custom called *ohineri* of wrapping a temple or shrine offering of a coin or rice in a twist of paper. Likewise, tips showered on kabuki actors from the audience were also wrapped in paper. It is said too that if an actor fluffed his lines, in recompense he would distribute a small sum to everyone backstage, supposedly to buy noodles. *Tochiri soba* (*tochiri* means fluffed, *soba* is noodles) means 'to eat humble pie'.

As the name *pochibukuro* implies, the thought is more important than the amount of money inside. So the choice of design on the envelope became a significant element of the gift exchange. Simple designs were available for general use, but many designs

fig. 213
early 20th century

A set of 8 *pochibukuro* which, when placed in a block, make up a Kyoto scene from the accession of the emperor.

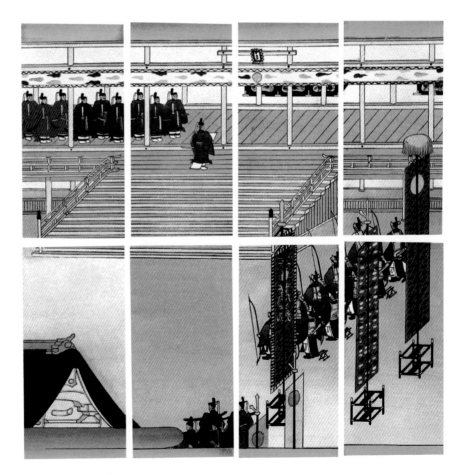

fig. 214
Twelve-animal zodiac *pochibukuro*
designed in the 1920s by the Kyoto
textile artist Matsumura Suihō.

fig. 215
Three blocks for printing the zodiac
pochibukuro with two sections per block.

(far right)
fig. 216
Printing the zodiac *pochibukuro*.

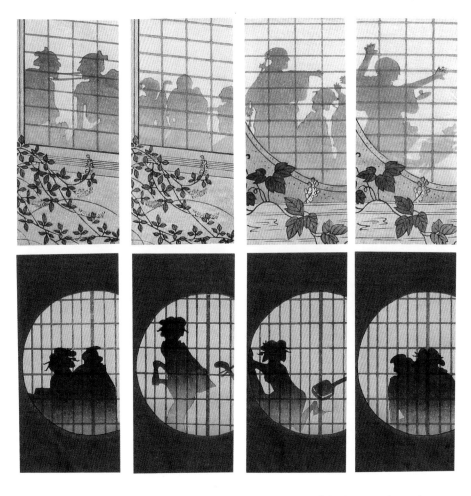

were created for specific occasions, and choosing and using the right one at the right time reflected the key Edo aesthetic of *iki* (see p. 30). Many of the designs display the verbal and visual wit and punning fashionable at the time; some are erotic (probably for the pleasure quarters) others can be plain vulgar. The artists are generally unknown (*pochibukuro* are unsigned), although many designs have clearly taken hints from well-known images elsewhere. A successful man about town would carry a selection of designs with him so that he could always match the spirit of whatever situation he found himself in. The timing and discretion of the handover itself and the anticipation of the recipient to see the choice of envelope, were all part of the appreciation of the good taste of the moment. The handover should not be too flamboyant, and was sometimes in advance of expected service, sometimes afterwards.

Specific words of thanks were often written or printed on the envelope.

Although the most common use for *pochibukuro* now is for the gift of money to children at New Year, they developed out of the etiquette of the kabuki and courtesan worlds. Designs derived from those worlds were popular for use in those circumstances. Traditional motifs and especially *komon* (fine patterns) motifs used in textiles were considered suitable for staff at inns, as were poems and ditties for tradesmen/craftsmen. Slightly larger envelopes are still used today to hand over payment for traditional arts classes.

As well as the impression created by the choice of design, the feel of the envelope itself as it was handed over was important too. The money was folded tightly inside to disguise the amount, the Japanese paper used for the envelope would display its quality in its soft fibrous nature and the way it absorbed

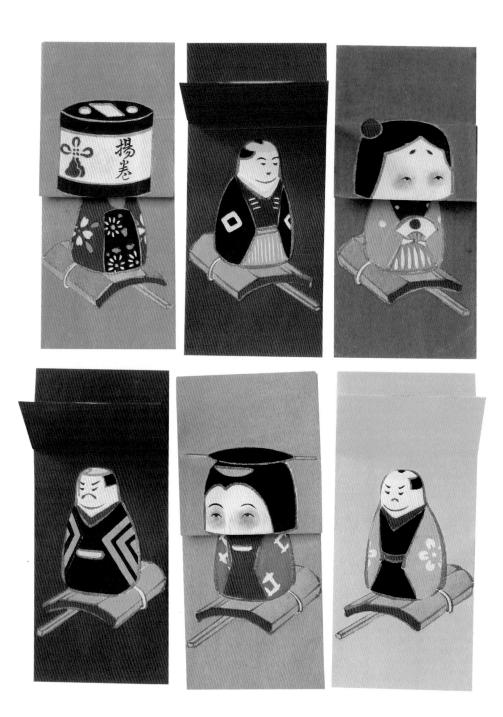

fig. 218

Jumping Toys
Tondari, hanetari

Traditional Edo toys made from bamboo which jumped when
flipped. In these *pochibukuro*, when the head covering is
lifted, a doll's face appears.

colour. The printing itself was in many cases very fine, with attention to detail in the use of gradation and particularly blind embossing; a barely visible but tactile indication of care and cost. It was important too that during the discreet hand-to-hand transaction the printed colour did not smudge, so extra *dosa* (size/binder) was used to stabilise the pigments. The fact that old *pochibukuro* can still be found today is an indication that they were treasured by the recipients as tiny works of art, far too good to throw away.

Fūtō

As *pochibukuro* developed as an elegant way to wrap money, likewise printed envelopes (*fūtō*) developed to 'wrap' words. The written word and the nature of its presentation to the intended recipient has always played an important part in Japanese culture, and woodblock printed stationery extended that tradition. Hand-decorated writing paper lay behind the development of *karakami* and those decorative skills were harnessed with the advent of colour woodblock to produce both paper and envelopes. The long, narrow format of the traditional envelope was a particular compositional challenge to the artists. Designs for both paper and envelopes drew on the familiar pool of traditional motifs of birds, flowers, classical scenes, customs and famous places. Hiroshige even extended the *53 Stages of the Tōkaidō* theme by producing a set of envelopes each with a scene from the journey.

As with *pochibukuro* the quality of the finished item was of great importance in recognition of its role as an emissary of the sender. The paper was of sufficient quality to take both embossed areas within the design and delicate colour and line. Some of the best envelopes display similar quality to *surimono* which, as they were privately commissioned, indulged the highest skills of the printers and carvers. Whether in the humble envelope or the more sophisticated *surimono*, the ability of the craftsmen and artists to respond to the standards demanded by the discerning private connoisseur brought out the very best that could be produced by the simple combination of wood, paper and pigment.

fig. 219
Crossword puzzle *pochibukuro*

Humorous envelopes based on the Western crossword puzzle. The word *'noshi'* (see p.197) has already been filled in (top right). The clues have been completed on the left.

fig. 220
Two 1920s envelopes of elegant kimono-clad dolls by Yamakawa Shūhō, an artist known for portraying beauties. The exchange of letters was covered by complex rules of etiquette. Printed envelopes simplified matters for those unsure of the rules.

And finally...

It would be a largely pointless argument to claim that many of the prints I have included in this book can rival the finest output of Japan's Golden Age of printing. There is little doubt that there was a decline in technical prowess and materials as the traditional print market diminished, and as natural pigments became expensive the less subtle aniline colours prevailed. But by resisting the temptation to indulge in the very Japanese habit of ranking things, I would argue that a place can be found for even the most basic toy print designed for a child. The playful spirit that binds rather than divides the print world is, in my view as an artist, more important than establishing a hierarchy of value. Acknowledgement of the qualities of woodblock's more ephemeral output by no means diminishes the best works of the Golden Age. The finest Hokusai and the anonymous toy print have in common the singular eye of the artist. And when the Japanese prints reached the West, it was again the eye of the artist that felt drawn to them. Whether trained in an Eastern or Western tradition I would suggest that the artistic eye tends to be curious for visual novelty without regard for its provenance, and fairly promiscuous in its adaptation and use. I doubt whether the Japanese artist, unfamiliar with the ground rules of Western perspective, cared as he explored the visual excitement of receding lines. Artists of both traditions 'played' with what they found novel without in any way diminishing the intent or integrity of the work of art.

The indulgence of play has a long and honourable history in Japanese art and should not be taken as an indication of a lack of seriousness. In a regulated society, play offered an escape. In many of the prints in this book the play is purely visual, in others it is aimed at children, but in the most complex, play works on several levels. Concealed visual and verbal messages attest to a highly sophisticated and literate audience for whom 'play' was firmly part of the adult world. In Western culture familiar with St Paul's observation that *'when I became a man I put away childish things'*[19] the link between play and childhood is very strong. In Japan, play is for life. Its form may change but as these prints show, its presence in many guises was to be celebrated. I hope this collection helps to recognise the work of the artists and largely unknown craftsmen who worked with wood, paper and pigment to reflect, however modestly, the spirit of the playful culture in which they lived.

The somewhat melancholy Tokyo writer Nagai Kafū (1879–1959) appreciated the contribution of woodblock and its craftsmen and felt a deep understanding of the role they played in Edo society. In a series of essays he laments the misunderstanding of ukiyo-e:

'Admiration for ukiyo-e does not stop with me, as it seems to with foreigners, at ukiyo-e as art. It induces in me feelings almost religious. Ukiyo-e was the special art form of the oppressed Edo plebeian, created in the face of constant harassment. The Kanō line, or the Academy of the 18th century, which had the protection of the government failed to pass on to us the true artistic glories of its day. That task was performed instead by the despised artist of the town, virtually in shackles, even threatened with banishment. Is not ukiyo-e the triumphal song of the common man who refused to bow down?...'[20]

fig. 221
Close-up of two carvers – one diligently carving the fine line, the other clearing large areas with a mallet.

From Hokusai's *Manga (Random Sketches)*, volume 1

19 1 Corinthians 13:11.
20 Seidensticker, Edward (1965), *Kafū the Scribbler: the Life and Writing of Nagai Kafū 1879–1959*, Stanford University Press, USA, p. 71.

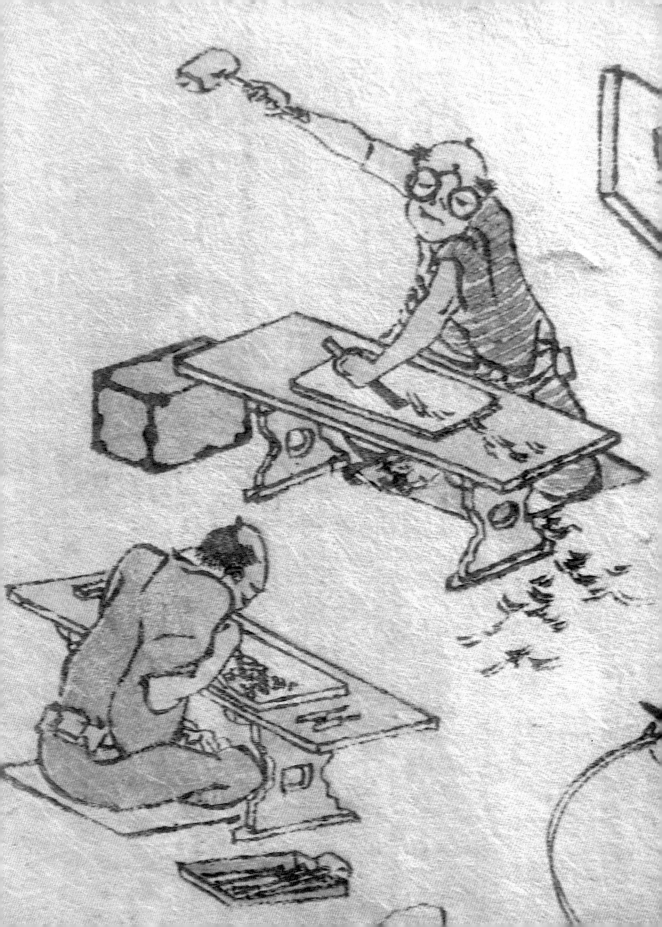

Artists' outlines

Utagawa School

The school was founded by **Utagawa Toyoharu 1735–1814** and became one of the most influential schools in the 19th century. His two pupils, **Toyokuni I 1769–1825** and **Toyohiro 1773–1828** were popular teachers and their pupils came to dominate the print world. Kunisada and Kuniyoshi were pupils of Toyokuni and Hiroshige of Toyohiro.

Utagawa Kunisada 1786–1864 (also known as **Toyokuni III**) a senior pupil of **Utagawa Toyokuni 1769–1825** and leader of Utagawa school after his death.

Kunisada II 1823–80 (also known as **Kunimasa III**) a pupil of Kunisada.

Kunisada III 1848–1920 (also known as **Kunimasa IV**) a pupil of Kunisada II.

Kunitora c.1804–30 a pupil of Toyokuni, unknown biography.

Kunimasa 1773–1810 a pupil of Toyokuni, known for actor prints.

Kunimori active c.1820s–30s a pupil of Toyokuni II.

Kunichika 1835–1900 a pupil of Kunisada.

Chikashige c.1869–1882 a pupil of Kunichika.

Chikanobu 1838–1912 a pupil of Kunichika.

Kunihisa II 1832–1891 pupil and son-in-law of Kunisada

Kunimaro active c.1850–75 a pupil of Kunisada.

Kunimori II active c.1830s–1850s a pupil of Kunisada.

Kuninobu active 1860s a pupil of Kunisada.

Kunisato died 1858 a pupil of Kunisada.

Kuniteru II 1829–1874 pupil of Kunisada. Produced *sumo-e* and Western/modernisation prints

Kunitoshi active 1847–99 a pupil of Kunisada and Kunitsugu.

Sadahide active 1850s–70s one of Kunisada's best pupils. Exhibited at 1868 Paris Exposition.

Sadakage active c.1820s–30s a pupil of Kunisada.

Sadayoshi active 1830s–50s a pupil of Kunisada. Osaka school.

Utagawa Kuniyoshi 1797–1861 together with Kunisada, a leading pupil of Toyokuni's studio. He had numerous pupils.

Yoshifuji 1828–87 a pupil of Kuniyoshi known especially for *Yokohama-e* and *omocha-e* (toy prints).

Fujiyoshi active late 19th century a pupil of Yoshifuji

Yoshiiku 1833–1904 the son of a Yoshiwara tea house owner he was a pupil of Kuniyoshi. In the early Meiji years he was known as a newspaper illustrator.

Yoshikazu active c.1850s–60s a pupil of Kuniyoshi.

Yoshitomi active c.1850s–70s a pupil of Kuniyoshi who worked in Yokohama from 1873.

Yoshitora active c.1850s–70s a pupil of Kuniyoshi.

Yoshitoyo 1830–66 a pupil of first Kunisada and then Kuniyoshi. Known for prints of imported animals.

Yoshitsuna active c.1850s–60s a pupil of Kuniyoshi.

Yoshitsuya 1822–66 a pupil of Kuniyoshi.

Tsukioka Yoshitoshi 1839–92 a pupil of Kuniyoshi and one of the most prominent artists of the Meiji period.

Utagawa Hiroshige 1797–1858 a pupil of Utagawa Toyohiro 1763–1828 he became one of the leading late masters, particularly known for his landscape prints.

Hiroshige II 1826–69 the adopted son and pupil of Hiroshige, he married his daughter after the master's death and took his name. The marriage didn't last and he moved to Yokohama and resumed the name **Shigenobu**.

Hiroshige III 1843–94 a pupil of Hiroshige, he took the name after Hiroshige II moved to Yokohama.

Shōsai Ikkei active c.1870 a pupil of Hiroshige III.

Other artists

Hishikawa Moronobu 1625–94 son of a textile artist, Moronobu was one of the earliest artists to explore the possibilities of woodblock as an art.

Okumura Masanobu 1685–1764 an artist, illustrator and publisher, Masanobu's work exemplifies the humour of Edo.

Suzuki Harunobu c.1724–70 an early *ukiyoe* artist who played a significant role in the early development of colour printing.

Tachibana Minkō active 1760s moved from Kyoto to Edo where he was a follower of Harunobu.

Ōkubo Kyosen active 1760s a poet and print designer, he was active in the groups of aesthetes who commissioned the 1765 calendar prints (*egoyomi*).

Tōshūsai Sharaku active 1794–95 an unknown genius of actor portraits published by Tsutaya Jūzaburō.

Torii Kiyonaga 1752–1815 one of the leading artists of his day and the last master of the Torii school, he explored beyond the kabuki theme which was the traditional subject for the school.

Keisai Eisen 1790–1848 he studied both painting in the traditional Kanō school and print. Known for prints of women and landscapes done in collaboration with Hiroshige.

Katsushika Hokusai 1760–1849 a member of the Katsukawa school, Hokusai was born in Edo but little is known of his origins. He was one of the most prolific and original artists of the last century of woodblock.

Kitagawa Utamaro 1753–1806 known especially for his beauty portraits. Arrested and held in 1804 for prints which were not in line with the censorship regulations.

Utamaro II active c.1804–17 died c.1831 a pupil of Utamaro, he married his master's widow and assumed the name.

Kawanabe Kyōsai 1831–89 the son of a samurai, he studied as a child under Kuniyoshi.

Hasegawa Sadanobu II active 1867–1910 an Osaka print artist known for construction prints.

Kobayashi Kiyochika 1847–1915 growing up at a time of great change, Kiyochika studied both Japanese and Western art, the latter under the English painter Charles Wirgman.

Yamakawa Shūhō 1874–1944 primarily a painter who also worked in print.

Matsuura Moriyoshi 1824–86 one of the main arists responsible for *Toyama-e* (*baiyaku-e*).

Ōtake Kunikazu 1868–1932 an artist from Niigata prefecture who worked in Toyoma producing *baiyaku-e* before moving to Osaka as the woodblock business declined.

Glossary

Aburagami	oiled stencil paper
Agari	finishing point in *sugoroku* games
Aka-e	red prints (also known as *hōsō-e*), smallpox prints
Akahon	red books
Anesama ningyō	elder sister dolls
Aohon	blue-green books
Aragoto	bravura style of kabuki acting
Aratame	censorship seal, abolished in 1876
Ashide-e	reed-writing pictures
Ashigei	tricks performed with the feet
Asobi-e	playful prints
Atamabori	literally 'head-carving', i.e. most highly trained carver
Awase	matching
Baiyaku-e	patent medicine prints also known as *Toyama-e*
Bakufu	the military government of the Tokugawa shogunate
Bansugoroku	backgammon (using a wooden board)
Banzuke	ranking lists
Baren	bamboo-covered pad used for printing
Benibana	safflower, used as red colour in prints
Bokashi	printed gradation
Bunmeikaika	civilisation and enlightenment
Buppō sugoroku	Buddhist law *sugoroku*
Chaya	tea house
Chirashi	flier, leaflet
Chiyogami	decorative paper
Chōnin	townspeople
Chūban	paper size approximately 26.5 × 19 cm / 10 × 8 in.
Dagashiya	candy/sweet store which also sold cheap prints for children
Daimei	name
Daimyo	feudal lords
Damashi-e	*trompe l-oeil* prints
Dekata	guides attached to tea houses near kabuki theatres
Dobori	literally 'body carving', i.e. less-skilled carvers
Dosa	gelatin, size
Dōchū sugoroku	travel *sugoroku*
Edokko	native of Edo
Egoyomi	picture calendars
Ehon banzuke	illustrated theatre guides
Ema	votive pictures
Emakimono	picture scroll
Emoji	picture words

Entenzu	rolling picture
E-sugoroku	picture *sugoroku*
Ezōshiya	print shop
Fuda	amulet
Fujikō	Fuji worship confraternities
Funori	paste made from seaweed
Furidashi	departure point on *sugoroku* board
Furiwake sugoroku	divided path *sugoroku*
Furo	projector
Furui	silk-gauze covered hoop used in printing *karakami*
Fusuma	sliding doors
Fūshi-ga	satirical prints
Gayōshi	thick paper
Gebako	box used to carry supplies for pasting *senjafuda*
Giga	playful prints, caricatures
Gijinga	anthropomorphic prints
Gohei	sacred paper strips used in Shinto rituals
Gotōjūtaizu	playful prints showing contorted figures of five heads and ten bodies
Gōkan	bound volumes
Hame-e	playful prints showing bodies grouped into another form, also called *yose-e*
Hana	nose, also flower
Hanafuda	flower cards
Hangitō	knife-like carving tool
Hangontan	patent medicine
Hanji-e	rebus prints
Hanshita-e	master copy
Hari	spirit, will-power
Hashika	head of wheat
Hashika-e	measles print
Hikifuda	handbill, advertisement
Hikitsuke	short registration mark on block
Hiragana	phonetic alphabet
Hitomi	spot to paste *senjafuda* in full view
Hosokawa	type of paper made near Edo
Hōsho	thick paper made in Echizen, often used for prints
Hōsō-e	smallpox prints (also known as *aka-e*)
Hōzuki	Chinese lantern plant (Physalis alkekengi)
Hyakunin Isshu	one hundred poets, one hundred poems
Iki	chic, smart
Iroha karuta	iroha (alphabet) cards

Ittōtadaiga	playful print showing figures with one head and several bodies
Jiguchi-e	pun prints
Jōruri	chanted drama
Jōdo sugoroku	Pure Land *sugoroku*
Jōdoshinshū	Pure Land School of Buddhism
Jūrokumusashi	fox and geese, *parchisi* board game
Kabukaruta	playing cards based on European style
Kage-e	shadow prints
Kagi kentō	right-angled registration mark on block
Kakishibu	persimmon juice, natural waterproofer
Kakushibari	concealed spot for pasting *senjafuda*
Kami	Shinto deity
Kamishibai	picture-story show
Kaname ishi	sacred stone at Kashima Shrine
Kanban	signboard
Kanji	Chinese ideograms used in Japanese
Kannazuki	another name for the month of October when it is believed the gods are away
Kanō	official school of painting for shogunate
Kanteiryū	calligraphic style used for kabuki notices
Kappazuri	stencil printing
Karakami	literally 'Chinese paper', decorative woodblock printed paper
Karazuri	blind embossing
Karuta	playing cards
Kashihonya	commercial lending library
Kawaraban	news-sheets (literally 'tile prints')
Kawarikage-e	moving shadow prints
Kibyōshi	yellow books, mostly humorous tales of pleasure quarter life
Kiriezu	detailed maps
Kirikumitōrō	cut-out-and-build lanterns
Kisekaeningyō	clothes-changing doll
Kiwame	censorship seal
Kiwamonouri	catchpenny salesman
Komochiiki	thick and thin stripe framing *kōkanfuda*
Komon	small textile patterns
Kō	confraternity

Kōdōbunka	culture of movement
Kōkanfuda	exchange slips
Koyomi	calendar
Kugi-e	nail prints
Kumadori	face make-up used in kabuki
Kumiage-e	construction print, also *kumitate-e, tatebanko*
Kurohon	black books
Kuruwa kotoba	special language used in the Yoshiwara
Kusazōshi	illustrated tales
Kyōkun sugoroku	moral instruction *sugoroku*
Manga	cartoons, sketches
Matoi	standard with different design for each local group of firemen
Mawari sugoroku	style of *sugoroku* where the player progresses round the board in order
Mawaritōrō	revolving lantern
Megane-e	perspective prints used with viewer
Meisho zue	gazetteer of famous places
Mekuragoyomi	literally blind calendars, i.e. rebus calendars produced for the illiterate
Mekurikaruta	playing cards based on European style
Menko	counters made of lead or paper used to play a children's game
Meotobake	brush used for pasting *senjafuda* onto buildings
Miburi-e	gesture prints
Mimasu	concentric box motif of Ichikawa family
Mino	paper made in Mino, Gifu prefecture
Misemono	spectacle, sideshow
Mitate-e	parody print
Moji-e	word prints
Mon banzuke	programme showing actor's crests
Mon	gate, crest, unit of currency
Mono no aware	'the pity of things'
Musha-e	warrior prints
Nagashizuki	method of making Japanese paper
Nagebari	method of throwing *senjafuda* to paste them in place on a building
Namazu-e	catfish prints
Nikawa	glue, gelatin
Ninjōbon	romantic novels
Nishiki-e	brocade prints, full colour prints
Nori	rice paste glue
Noshi	symbol of a gift, originally strips of abalone
Nōsatsu	votive slip
Nōsatsukai	meeting for pasting slips
Nukemairi	unauthorised pilgrimages

Ōban	paper size approximately 39×26.5 cm /15×10 in.
Ōbōsho	paper size approximately 39×53 cm /15×21 in.
Obi	belt worn to secure kimono
Ohineri	twist of paper tied round money/gift as an offering
Oiran	high class courtesan
Okagemairi	officially sanctioned pilgrimage
Omocha-e	toy prints
Onnagata	kabuki actor playing female roles
Oranda megane	Dutch glasses (viewing device)
Orikawari-e	folding print
Oshi	low ranking Shinto priest
Oshi-e	pasted fabric picture
Ōraimono	copybook, letter writer
Pochibukuro	gift envelope
Rangaku	Dutch studies, Western studies
Ren	group of *senjafuda*/ *kōkanfuda* enthusiasts
Rubi	phonetic annotation used with *kanji*
Sagabon	books produced in Saga, near Kyoto
Sakoku	period of Japan's closure to the outside world, c.17th–19th century
Sankin kōtai	alternate attendance in Edo by daimyo
Saya-e	scabbard prints
Senjafuda	votive prayer slips
Senjafudamoji	calligraphic style used in votive slips
Senjamairi	thousand shrine pilgrimage
Setsuyō	dictionary, manual
Share	jest, joke, play on words, wit
Sharebon	witty books, set in Yoshiwara
Shibugami	paper coated with *kakishibu* and used for stencils
Shikake-e	mechanical prints
Shinbun nishiki-e	illustrated newspaper prints
Shini-e	memorial prints
Shinpan	new edition
Shishi	lion
Shitamachi	downtown
Shōji	paper screens
Shōki	demon god of Chinese origin
Shusse sugoroku	success *sugoroku*
Sugoroku	competitive board game played with counter and dice
Sumi	black ink made from soot
Suributoke	printed Buddha images
Surihon	printed book
Surimono	literally 'printed thing', privately commissioned prints
Tan-e	simple colour print using red oxide
Tanka	31-syllable poem

Tatami	rush mats
Tatamikawari-e	folding print
Tatebanko	construction print (Kyoto/Osaka term)
Tehonbiki	card game used for gambling
Tendai	Buddhist sect
Tenugui	cloth towel
Tengu	mythical long-nosed goblin
Tenshōkaruta	cards based on European model
Terakoya	temple schools
Toba-e	caricature prints
Tobisugoroku	way of playing *sugoroku* in which the player jumps squares according to the throw of the dice
Tonoko	crushed heated earth mixed with starch paste used to make cards
Torinoko	egg-shell coloured paper
Tōgetokubutsu	ceremony of tossing a flower onto a mandala to choose a bodhisattva
Toyama-e	also known as *baiyaku-e* (patent medicine prints)
Tsuji banzuke	programmes posted at crossroads
Tsū	connoisseurship
Ueshita-e	upside-down print
Uki-e	perspective print
Umeki	wood inlaid into block in particular area
Urushi-e	lacquer print
Utakaruta	poem cards
Utsushi-e	also known as *kage-e* (shadow prints)
Wagoto	soft style of kabuki acting, speciality of Kyoto area
Waka	31-syllable poem
Yabo	boor
Yakusha sugoroku	actor *sugoroku*
Yakusha-e	actor print
Yakuwari banzuke	programme of kabuki names, crests and rankings
Yakuza	gangsters
Yamato-e	Japanese-style painting
Yarō	fellow, chap
Yarō sugoroku	young actor *sugoroku*
Yochin	*sugoroku* square from which there was no escape
Yomiuri	news-sheet sellers
Yonaoshi	social reform
Yose	vaudeville theatre
Yose-e	also known as *hame-e*, groups of bodies forming a figure
Zukushi	printed sheets of enumerated objects

Selected bibliography

Caillois, Roger. *Man, Play and Games*. London: Thames & Hudson, 1962.

Edo Tokyo Bunka Kenkyūkai. *Nōsatsu Taikan* (reprint). Tokyo, 2001.

Edo Tokyo Hakubutsukan, ed. *Nishiki-e no tanjō: Edo shominbunka no kaika*. Tokyo: Edo Tokyo Hakubutsukan, 1996.

Formanek, S and Linhart, S, ed. *Buch und Bild als gesellschaftliche Kommunikationsmittel in Japan einst und jetzt*. Vienna: Literas, 1995.

Forrer, Matthi. *Egoyomi and Surimono: their History and Development*. Uithoorn: JC Gieben, 1979.

French, Cal. ed. *Through Closed Doors: Western Influence on Japanese Art 1639–1853*. US: Meadow Brook Art Gallery, 1977.

Guth, Christine. *Asobi: Play in the Arts of Japan*. Katonah Museum of Art, 1992.

Hur, Nam-Lin. *Prayer and Play in Late Tokugawa Japan: Asakusa Sensōji and Edo Society*. Cambridge: Harvard University Asia Centre, 2000.

Iizawa Tadasu, Hirose Tatsugorō. *Omocha-e*. Tokyo: Tokuma Shoten, 1974.

Inagaki Shin'ichi. *Edo no asobi-e*. Tokyo: Tokyo Shoseki, 1988.

Insatsu Hakubutsukan, Tokyo, ed. *Edo jidai no insatsubunka: Ieyasu, katsuji ningen*. Tokyo: Insatsu Hakubutsukan, 2000.

Iwasaki Hitoshi. *Edo Hanji-e*. Tokyo: Shogakkan, 2004.

Jansen, Marius B. *The Making of Modern Japan*. Cambridge Mass: Harvard University Press, 2002.

Jippensha Ikku. *Hizakurige (Shanks' Mare)*. Tr. Thomas Satchell. Rutland, Vt. and Tokyo: Charles E. Tuttle Co, 1960.

Kidō Hiroko. *Pochibukuro: Beautiful Japanese Tradition*. Tokyo: Super Edition, 2003.

Kornicki, Peter. *The Book in Japan – A Cultural History from the Beginnings to the Nineteenth Century*. Leiden: EJ Brill, 1998.

Kume Yasuo. *Kyōkarakami to Edo chiyogami*. Tokyo: Yushodo Shuppan, 1986.

Kumon Kodomo Kenkyujo, ed. *Ukiyo-e ni miru Edo no kodomotachi*. Tokyo: Shogakkan, 2001.

Kusamori Shin'ichi. *Senjafuda – iki no graphism*. Kyoto: Maria Shobō, 1989.

Maekawa Kyūtarō. *Dōgu kara mita Edo no seikatsu*. Tokyo: Pelikansha, 1978.

Masuda Tajirō. *Hikifuda, ebira fūzokushi*. Tokyo: Seibō, 1981.

Masukawa Kōichi. *Sugoroku*. Tokyo: Hōseidaigaku Shuppan, 1995.

Meech-Pakarik, Julia. *The World of the Meiji Print*. New York: Weatherhill, 1986.

Miyamoto Jōichi. *Senjafuda*. Tokyo: Tankōsha, 1975.

Miyata Noboru, Takada Mamoru. *Namazu-e*. Tokyo: Ribun Shuppan, 1995.

Nagira Kenichi, *Tokyo no Edo o asobu*. Tokyo: Chikuma Bunko, 2000.

Nagoya City Museum. *Utagawa Kuniyoshi*. Tokyo: Nihon Keizi Shimbun, 1996.

Nakada Setsuko. *Kōkoku de miru Edo jidai*. Tokyo: Kadokawa Shoten, 1977.

Nakagawa Yoshitaka. ed. *Ukiyo-e no naka no kodomotachi*. Tokyo: Kumon Shuppan, 1993.

Nakamura Mitsuo. *Yoshifuji. Kodomo no ukiyo-e*. Tokyo: Fuji Shuppan, 1990.

Nishiyama Matsunosuke. *Edo Culture*. Honolulu: University of Hawai'i Press, 1997.

Ōtani Memorial Museum. *Kuniyoshi Geijutsu Zembō*. Tokyo: 1999.

Ouwehand, C. *Namazu-e and their Themes*. Leiden: EJ Brill, 1964.

Reader, Ian and Tanabe, George J. *Practically Religious*. Honolulu: University of Hawai'i Press, 1998.

Rekishi Kōron no 113. *Edo Jidai no Insatsubunka*. Tokyo: Yūzankaku Shuppan, 1985.

Robinson, B.W. *Kuniyoshi*. London: HMSO, 1961.

Rotermund, Hartmund O. *Hōsōgami ou la petite vérole aisément*. France: Maisonneuve et Larose, 1991.

Sakai Takeshi. *Edo omochako*. Tokyo: Kawade Shobo Shinsha, 1980.

Sekioka Senrei. *Nōsatsu to Senjafuda*. Tokyo: Iwasaki Bijutsusha, 1977.

Sekioka Senrei. *Senjafuda*. Tokyo: Kōdansha, 1983.

Shimizu Isao. *Edo no manga*. Tokyo: Kōdansha, 2003.

Shinjō Tsunezō. *Shomin to tabi no rekishi*. Tokyo: NHK Bukkusu, 1971.

Starr, Frederick. *Edokko Studies No. 1*. Seattle: 1932.

Strange, Edward F. *Japanese Colour Prints*. London: Victoria & Albert Museum, 1931.

Tada Michitarō. *Asobi to Nihonjin*. Tokyo: Kadokawa Bunko, 1980.

Takahashi Junji. *Nihon e-sugoroku shūsei*. Tokyo: Kashiwa Bijutsu Shuppan, 1994.

Takahashi Katsuhiko. *Edo no Nyu Media*. Tokyo: Kadakawa Shoten, 1992.

Takahashi Katsuhiko. *Shinbun nishiki-e no sekai*. Tokyo: PHP Kenkyūjō, 1986.

Takahashi Katsuhiko. *Ukiyo-e mystery zone*. Tokyo: 1985.

Takahashi Katsuhiko. *Ukiyo-e Wonderland*. Tokyo: Heibonsha, 2000.

Tanaka Yūko. *Edo no sōzōryoku*. Tokyo: Chikuma Gakugei Bunko, 1992.

Tanizaki Junichirō. *In Praise of Shadows*. New Haven: Leete's Island Books, 1977.

Toyamashi Baiyaku Shiryōkan. *Baiyaku to Insatsu Bunka*. 2000.

Ueno Haruō, Miyakawa Kyūtarō. ed. *Omochae Edo/Meiji*. Tokyo: Tokyo Bunko, 1976.

Vaporis, Constantine Nomikos. *Breaking Barriers: Travel and the State in Early Modern Japan*. Cambridge, Mass.: Harvard University Council on East Asian Studies, 1994.

Wright, Lawrence. *Perspective in Perspective*. London: Routledge & Kegan Paul, 1983.

Yamamoto Keiichi. *Edo no kage-e asobi*. Tokyo: Sōshisha, 1988.

Yamamoto Masakatsu. *Sugoroku Yūbi*. Tokyo: Unsōdō, 1988.

Yoshida Mitsukuni. ed. *Asobi: the sensibilities at Play*. Tokyo: Mazda Motor Corporation, 1987.

Yoshida Teruji. *Ukiyoe Jiten*. Tokyo: Ryokuen Shobō, 1965–1971.

Index

Numbers in *italics* refer to the pages on which illustrations appear

advertising 72–74 *72 73 74 75 76/77* 78–79 *79*
anamorphosis 87 *88/89* 90/91 *90/91*
anesama ningyō 193 196
Asakusa 35 *171 179*
awase 29 183 184
baiyaku-e 34 114–115 *115 116* 117–119 *117 118 119*
banzuke 51–54 *51 52 53 54 107 128*
bath *31 68 76/77*
bird's eye view *16* 63 64
books 42–46 *45 46 67 68*
brushes *99*
calendars 14 47–50 *47 48 49 50*
card making *183* 186–187 *187 188/189 190/191* 192
carving 11 19–21 *20 21 203*
catfish prints 108–113 *108 110 111 113*
censorship *79 104*
chiaroscuro 18 *18 83* 143
Chikanobu *160*
Chikashige *181*
chiyogami 194–196 *194 195 196*
construction prints 156–157 *159* 161–163 *162/163*
cut-out prints *33 54 135 156 157 159*
decorative paper *194 195 196*
earthquakes *58 59 108 110 111 113*
Edo *16* 23–25 *23 24 27 32 59 68 75 147 171 179*
educational prints 7 *55 83 85 86* 135 *135 159 176/177 178 180*
egoyomi 48 *50 98*
ema 94
emoji 146 *146*
entertainment quarters 28 31–33 *51*
exchange groups 101 *103* 104 105 107 *107*
exchange slips 27 95 101 104 105 106 107 108
ezōshiya 22 *22*
fans *25 39 79 136/137*
firemen 27 29 30 *30 156*
Fujikō 65 69 71 95
Fujiyoshi *134*
fūshi-ga 148 *152*
fūtō 201 *201*
giga 148 *153 155*
gijinga 152–153 *155*
goshijūdōnozu 139
guides *51* 66 67 68 69 *93*
hanafuda 105 185–186 *187*
hanji-e 9 146–*147 147 148 149*

harimaze-e 30
hashika-e 122–124 *123 124*
hikifuda 72–74 *72 73 74 75 78–79 79*
himo-e 132
Hiroshige 17 66 68 75 116 *133 142 169 170 172 186*
Hiroshige II *16 55 140 149*
Hiroshige III *136/137*
Hokusai 11 17 *33 64 153 168 185 203*
hōsō-e 120–122 *120*
Hyakunin Isshu 183 *184* 185
Ichikawa Danjūrō 29 *34* 119 125 *126/127 128 129 154 171 194*
iki 30 *79*
iroha alphabet *7 190/191*
Ise *47 170*
ittōtadaiga 139 141
jiguchi-e 147–148 *150/151*
Jippensha Ikku 66 68 71
jūrokumusashi 181–182 *181*
Kabuki *12/13* 15 33–35 *33 34* 52–53 *52 112 119 154 160 166/167 171 195*
kage-e 142–144 *142 143 144*
Kannon 64
Kansai Ichirentei *82*
kappazuri 81 82 194
karakami 193–194 *194*
karuta 185 186 *190/191*
kashihonya 36/37 46
Kawanabe Kyōsai *132 144*
kawaraban 58–60 *58 59 60*
Keisai Eisen *23*
kirikumitōrō 145 161 *163*
kisekaeningyō 135 156 *156 157*
kites *112 157*
Kiyonaga *164*
Kobayashi Kiyochika *152*
kōdōbunka 62
kōkanfuda 27 95 101 104 105 106 107 108
koyomi 47 48 49 50
kugi-e 152 *154*
kumitate-e 159 161–163 *162/163*
Kunichika *112 166/167*
Kunihisa II *30*
Kunimaro *12/13*
Kunimori *148*
Kuninobu *32*
Kunisada *12/13 22 28 36/37 45 74 79 145 172*
Kunisada II *24*
Kunisada III *25 31 171 174/175 179*
Kunisato *43*
Kuniteru II *85*

Kunitoshi *143*
Kuniyoshi 18 *35 65 138 139 146 150/151 153 154 155 172*
Kyoto *24*
maps 9 *16 32 51* 62–63 *63 70 71* 80 104 115 *147*
magic lantern *82 180* 181
Matsuura Moriyoshi *34 72 115 116 117*
mawaritōrō 56 144 144
measles prints 122–124 *123 124*
Meiji Restoration 6
memorial prints 125 *125 126/127* 128–129 *128 129*
menko 57 182 *182*
miburi-e 140 142
misemono 35 *35 38 41 72 82*
mitate 54 *54* 142
mitate-e 133–134 *133*
moji-e 145–146 *146*
Mount Fuji *64 65 68 69 69 70 71 95 171*
Nagasaki-e 80–83 *81*
namazu-e 108–113 *108 110 111 113*
news-sheets 58–61
nishiki-e 15 *25*
Ōkubo Kyosen *50*
omocha-e 55 62 *135 138*–139 *161*
Ōneisai *87, 88/89*
orikawari-e 158 159
Osaka *24*
Otafuku *57 134*
Ōtake Kunikazu *118* 119 *119*
Ōtsu-e *82* 108 *109 152*
pasting fuda 98–99 *98 99* 101
pilgrimage 64 65 66 71 95 96
play 28–30 132–133
pochibukuro 29 *131 197 197 198 199 199 200* 201 *201*
print shops 22 *22*
printing *11* 13–18 21 *21 136/137*
production process 19–22 *136/137*
rebus 9 *49* 146–147 *147 148 149*
registration technique 20
ryōmen-e 156
Sadahide *39 70 71*
Sadakage *139*
Sadanobu II *162/163*
Sadayoshi *163*
sankin kōtai 26
Santō Kyōden 73 *73*
saya-e 87 *88/89 90 91*
schools 43 *174/175 176/177 178*
script 6 7 44 53 134 145–146
senjafuda 78 94–101 *96 97 100 101*

Seven Lucky Gods *57 82 87 95 111 140/141*
shadows *39 142* 143–144 *143 144*
Shigetoshi *62*
shikake-e 157 160 161
shinbun nishiki-e 41 60–61 *61 121*
shini-e 125 *125 126/127* 128–129 *128 129*
Shinto 13
Shōsai Ikkei *86*
sideshows 35 *35 38 41 72 82*
smallpox prints 120–122 *120*
social classes 25
stationery 29 *131 197 197 198* 199 *199 200* 201 *201*
stencil *81* 82–83 *186 187 194*
sugoroku 164–172 *12/13 16 32 41 164 165 166/167 168 170 171 172 173 174/175 176/177 178 179* 180–181 *180*
sumo 35 *36/37* 53–54 *53 84*
surimono 11 48 50 *50 184*
Tachibana Minkō *188/189*
tatamikawari-e 157 158 159
tatebanko 56 161–163 *162/163*
tengu 56 144 153 186
Tenpō Reforms 74 78
toba-e 148 152 *152 153*
Tōkaidō 17 *17 63 64 66 66 68 69 104 150/151 160 169*
Toyokuni III *22 30 173*
travel 26 *26 62 66 66 67 168 169 170*
trompe l'oeil 139
Tsutaya Jūzaburo 19
uke-e 134
uki-e 12/13 23 81 161
ukiyo-e 14
upside-down picture *140/141* 141
utsushi-e 82
votive slips 94–101 *96 97*
western influence 18 60 82 84 85 *87 88/89*
Yamakawa Shuhō *201*
Yokohama-e 83 *83 85 87*
yose 35 *38*
yose-e 17 113 138
Yoshifuji *17 38 55 56 82 124 156 159 161 190/191*
Yoshiiku *18* 20 61 65 *76/77 83 84*
Yoshikazu *157*
Yoshitora 30 90 *123 140/141*
Yoshitoshi 30 41 *121*
Yoshitsuna *102/103 106*
Yoshiwara 15 31–33 *32 51 51*
zukushi 20 *34* 54 55 56 57 *57 153 156 161*